Revolutionary Horizons

Revolutionary Horizons

Art and Polemics in 1950s Cuba

Abigail McEwen

Yale University Press New Haven and London

yalebooks.com/art

Designed by Leslie Fitch
Typeset by Julie Allred, BW&A
Books, Inc.
Printed in China through Oceanic
Graphic International, Inc.

Library of Congress Control
Number: 2015952891
ISBN 978-0-300-21681-3

A catalogue record for this book is
available from the British Library.
This paper meets the require-
ments of ANSI/NISO Z39.48-1992
(Permanence of Paper).

10 9 8 7 6 5 4 3 2 1

Jacket illustrations: (front) Mario Carreño, *Cielos del sur* [Southern Skies], 1950 (detail of fig. 74); (back) Raúl Martínez, *Flight Eight*, 1955 (fig. 64)
Frontispiece: Luis Martínez Pedro, *Untitled, from the series "Aguas territoriales,"* 1964 (detail of fig. 96)

CONTENTS

ACKNOWLEDGMENTS

Among the sundry pleasures of researching this book has been the opportunity to meet so many of its central protagonists, their families, and their friends. From Havana to Paris to Miami, they have invited me into their homes, shared memories and archives, and recounted—tirelessly and thoughtfully—the long decade of the 1950s. For their candor, conversations, and assistance, I thank Jérôme Arcay; Susana Barciela and Manuel Gómez; Ivan and Alba Cañas; Elena Cárdenas Malagodi and Luigi Di Giamberardino; Rita Consuegra; the late Salvador Corratgé; Geny Dignac; the late Viredo Espinosa; the late Abelardo Estorino; Clea and Sebastian Fernández; Julia González Fornés; Carmen Herrera; Eskil Lam; René Llinás; Tomás Oliva, Jr.; Pedro de Oraá; Graziella Pogolotti; the late Nicolás Quintana; Mariana Ravenet Ramírez; Patricia Riverón Lee; José Rosabal; Zilia Sánchez; Imma Mira Sempere; Christoph Singler; Ann Sitkin and Ilse Girona; Magaly Soldevilla and Martha Flora Carranza Barba; Hortensia Soriano; and the late Antonio Vidal. For their assistance in procuring images and introducing me to artists and artworks, I am indebted to a number of colleagues at galleries and auction houses: Francisco Arévalo; Ramón Cernuda; Antonio and Gabriela de la Guardia; Marta Gutiérrez; Irina Levya-Pérez; José Martínez Cañas; Israel Moleiro; Gary Nader; Marysol Nieves; and Aleksandra Petrovic.

Numerous institutions made their collections and archives available for study. At the Art Museum of the Americas, I thank Andrés Navia and Adriana Ospina for facilitating access to archives and artworks. Inés Zalduendo, Special Collections Librarian at the Frances Loeb Library, Harvard Graduate School of Design, provided special assistance with the Josep Lluís Sert Collection. I conducted research at the Archives of American Art, Smithsonian Institution; the Benson Latin American Collection at the University of Texas at Austin; the Cuban Heritage Collection and Lowe Art Museum, University of Miami; the Instituto Cubano de Arte e Industria Cinematográfico, Havana; the Laboratorio Nacional de Música Electroacústica, Havana; the Museo Nacional de Bellas Artes, Havana; the Museo Nacional de la Música, Havana; the Museo Servando Cabrera Moreno, Havana; and the Museum of Modern Art Archives and Library, New York. I am additionally grateful to staff at a number of other institutions for research assistance: Art and Architecture Library, University of Kansas; The Art of Emprise, Emprise Bank,

Wichita; Avery Architectural and Fine Arts Library, Columbia University; the Center for Southwest Research/Special Collections, University Libraries, University of New Mexico; Charles Deering McCormick Library of Special Collections, Northwestern University Library; the Hesburgh Libraries of the University of Notre Dame; Hoover Institution Library and Archives, Stanford University; the John Hay Library, Brown University Library; the Museum of Arts and Sciences, Daytona Beach; Rare Books and Special Collections, Princeton University Library; the Rockefeller Archive Center; Ryerson and Burnham Libraries, Art Institute of Chicago; Special Collections, Northwestern University; and The Wolfsonian, Florida International University.

I am further indebted to many friends and colleagues who not only shared contacts and materials, but also dispensed much good advice and timely encouragement. For their assistance and generosity, I thank Alejandro Alonso; Roberto Cobas Amate; Carol Damian; Orlando Hernández; Juan Martínez; Corina Matamoros; Eduardo Luis Rodríguez; Ramón Vázquez Díaz; and Elsa Vega Dopico. Edward Sullivan has remained a stalwart supporter over many years, and his initial enthusiasm for a dissertation on Cuban art allowed this book to take its first shape. I am additionally grateful to Alejandro Anreus for his continuing mentorship. Aspects of this book have been presented as talks at the College Art Association Annual Conference; the Graduate Center, CUNY; the Haus der Kunst, Munich; the King Juan Carlos Center, New York University; the Smithsonian American Art Museum; the University of Texas at Austin; and the University of Zurich.

Fellowships supported work on this book at crucial stages. A J. Clawson Mills Scholarship from the Metropolitan Museum of Art in 2008–9 allowed me to spend significant time in Miami and Havana. In 2013, a Summer Research and Scholarship Award from the University of Maryland and a Senior Fellowship from the Dedalus Foundation permitted over a year of writing and revision. A subvention from the College of Arts and Humanities at the University of Maryland provided support for the reproduction of images in this book, and I thank graduate students in the Department of Art History and Archaeology for their assistance in preparing many of its illustrations. At Yale University Press, I thank Katherine Boller for her early confidence in this project and Amy Canonico for her expert editorial guidance. Heidi Downey, Mary Mayer, and Tamara Schechter moved the book expeditiously through stages of publication, and Linda Truilo's perceptive copyediting brought clarity to its language. I am additionally grateful to the anonymous readers enlisted by the Press for their thoughtful consideration of the manuscript. I owe far longer-standing debts to two professors at Brown University, Abbott Gleason and Kermit S. Champa, who provided exemplary early models of scholarship and teaching. To family and friends who have followed the book's trajectory for many years, I give my sincerest thanks.

Introduction

"Here everything remains the same. All of a sudden it looks like a set, a city made of cardboard. . . . Have I changed, or has this city changed? . . . Cuba, free and independent . . . who would have thought that this could happen?"[1] Lifelessly voiced over by Sergio, the incapacitated and unfulfilled antihero of the film *Memorias del subdesarrollo* [Memories of Underdevelopment] (1968), directed by Tomás Gutiérrez Alea (1929–1996), the words sting with the stunned disbelief of Cuba's postrevolutionary intelligentsia. Set between the Bay of Pigs invasion (April 17, 1961) and the Missile Crisis the next year, the film pieces Sergio's spiraling self-pity and existential doubt against the black-and-white reality of newsreels and panning photography. As the film opens, he casts a wandering, telescopic eye along Havana's skyline from the Hotel Capri (built 1957), a *batistiana* gambling and mobster mecca, to the monument to Independence hero Antonio Maceo (1845–1896) (fig. 1). The perversity of his situation is plain. An erstwhile bourgeois and errant playboy, he remains in Cuba alone and by choice, having declined the escape of exile—we witness his emotionless farewell to his departing ex-wife and his parents at the airport—for the alienated neurosis of the modern self-exile. A post-Bolshevik "internal émigré" in the pregnant, contemporary sense of Raymond Williams, Sergio stays on principle but in wary, self-disgusted dissent. "This kind of self-exile lives and moves about in the society in which he was born," Williams observed in 1961, "but rejects its purposes and despises its values. . . . Whatever he may come to say or do, he continues, essentially, to walk alone in his society, defending a principle in himself."[2] Sergio neither commits himself to the Revolution nor chooses to leave, acceding to a shadow existence spatialized in the film through his movement through working-class street markets ("I'm not like them!"), urban arteries (the red-light district of La Rampa, the seaside Malecón), and the interior mise-en-scène of his middle-class apartment.

Modern art makes a number of calculated appearances in *Memorias*, facilitated by the friendship between the *abstractos* and Edmundo Desnoes (b. 1930), the author of the novel on which the film was based. A painting by *vanguardia* artist Amelia Peláez (1896–1968) hangs prominently in Sergio's apartment, for instance; a reproduction of Édouard Manet's iconoclastic *Olympia* peeks out wryly from under a notebook during a roundtable on Marxism and underdevelopment. But more telling is the scene shot in

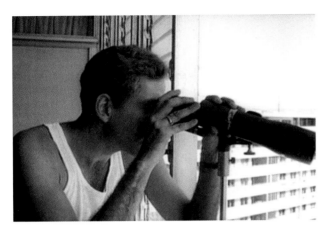
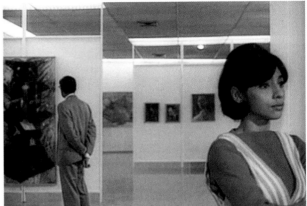

FIGURES 1 AND 2

Memorias del subdesarrollo
[Memories of Underdevelopment],
directed by Tomás Gutiérrez
Alea (1968; Brighton, England:
Mr. Bongo Films, 2008),
film stills, DVD.

the modern galleries of Havana's new Palacio de Bellas Artes (fig. 2), in which Sergio attempts to educate Elena, his paramour and an aspiring actress, in the art of Ángel Acosta León (1930–1964), a contemporary artist in whose work abstraction devolves into Surrealist erotics.[3] Elena is a reluctant student, disinterested and indifferent to the art; as they move through the gallery, Sergio's voice-over explains in resigned defeat, "I always try to live like a European. And Elena forces me to feel underdeveloped at every step."[4] His telltale words ring true: for the postrevolutionary Cuban intellectual, the sense of interminable underdevelopment—felt as a condition of lateness and, eventually, of irrelevance—was entwined in the legacy of the historical *vanguardia* and, consummately, of abstract art, which had defined its third and last generation of the 1950s. Anxieties of underdevelopment had stimulated the period's turn toward abstraction in the first place, couched in languages of cosmopolitanism and modernization spanning the cultural landscape. Yet the futurity of abstract art appeared dim by the mid-1960s, and in its retrenchment and self-exile a process of self-reckoning slowly set in. Why had abstract art been singled out as symptomatic of Cuba's cultural futility? How had it become politicized in the first place? And finally, what did its tumultuous history mean to the historical modernist project whose values it had come to embody?

The Revolution remained a constant and intensely fraught ideological conflict over the course of its first decade, with retrospective implications for the contemporary political and intellectual vanguard. From an ontological point of view, the fact of its progress demanded no less than what the Salvadoran poet Roque Dalton (1935–1975) described as "the permanent incorporation of its totalizing practice," neatly rendered by Fidel Castro (b. 1926) into the notorious mantra: "Within the Revolution, everything; outside it, nothing."[5] The Revolution's totalitarian streak brooked little middle ground, and the provocation of the *desgarramiento* (ideological rupture with the past) touched off a crisis of individualism as artists pondered the ethics of self-determination and Marxist commitment. Within the cultural field, one of the early litmus tests was abstract art,

closely identified with dissident politics and opposition to the dictator Fulgencio Batista (1901–1973) since 1953, the year of the first exhibition of Los Once (The Eleven), Cuba's pioneering group of abstract artists. Abstraction, compromised by its problematic associations with an earlier utopianism and historical *vanguardismo*, found uncertain footing in the immediate postrevolutionary climate, in which even a true believer found himself "often assaulted by existential doubt," as Desnoes admitted. "The decade of the sixties was threatening us with the sterile—and above all, boring—fantasy of socialist realism, and was dazzling us with the overwhelming verbosity of magical realism," he continued. "It was a world in which there was no room for ambiguity and doubt."[6] Abstraction, still cloaked in the aura of liberal idealism that it had worn throughout the 1950s, appeared a potential political liability to the new regime, which distrusted its inscription of an earlier form of *cubanía* that had long served as a touchstone for the vanguardia. The self-critical internalization of the desgarramiento, witnessed cinematically in Sergio's asphyxiated alienation, altered in turn the functional, transformative capacity that had empowered abstraction over the past decade, tacitly excising its ideological critique. The temporal forcework of abstraction in the intervening years, as exercised by both Los Once and the concrete artists later grouped as Los Diez (The Ten) in critical response to the Batista regime, is the subject of this book.

Revolutionary Horizons undertakes a reassessment of Cuban abstraction during the long decade of the 1950s, situating its period history in light of the vanguardia precedent and the generationally driven *cubanista* mentality that inflected the cultural field with keen, if at times inconstant, ideological purchase. The gestation of the third-generation vanguardia is set against the dramatic political theater within which it transpired, bookended by the Batista coup in 1952 and the Revolution in 1959. These artists inserted themselves self-consciously within Cuba's vanguardia lineage, initiated by the lauded Generation of 1927, which launched modernism in Havana as a national project, and the second-generation Havana School that came to prominence in the 1940s with paintings that rendered national identity with an increasingly extravagant aestheticism. In laying claim to this vanguardia inheritance, the artists of Los Once sought to legitimize their practice—abstraction, broadly understood—in familiarly national terms, a desirable association for a generation that in a short time set itself in opposition to the state. Indeed, while the politics of abstraction may appear superficially coincidental, in other words a mere product of historical circumstance, this book argues that they were in fact deeply imbricated within a historicist national discourse—cubanía—that provided both an idealist order and the grassroots impetus for action. As an earlier obsession with *cubanidad* ("Cubanness") evolved into the ideology of cubanía, defined here in Antoni Kapcia's terms as the teleological expression of cubanidad, abstract art took the shape of social praxis, making visible the power relations of dictatorship and revolution.[7] (Note that the terms "cubanía" and "cubanista" are preserved throughout the text to denote the specificity of their ideational reference and the distinction from the overly general

and conventionally nationalist associations of "Cuban." Similarly, while the retention of the Spanish "vanguardia" reflects common usage, it also reinforces the singularity of an avant-garde whose emergence unfolded in a highly localized context.) The hallmark of this emerging vanguardia was its belief in the force of art, what Krzysztof Ziarek has proposed "as a force field, where forces drawn from historical and social reality come to be formed into an alternative relationality."[8] This "forcework" of abstract art, nonviolent and free from the power structures that defined Cuba during this quintessentially capitalist and modernist decade, manifested a radical critique of the world in which it moved and its network of spaces and relations, both national and transnational. This book privileges the social history—the cubanista forcework—of abstraction, situating it in regard to local political and cultural histories and, no less, within contemporary discourses of avant-garde art stretching from Europe to North and South America.

Indeed, inasmuch as *Revolutionary Horizons* immerses itself, intentionally, in 1950s Cuba, no doubt its arguments are enriched by their appearance at what seems an exceptional moment for scholarship on twentieth-century Latin American art and, especially, on its modes of abstraction. Since the exhibition and publication of *Geometric Abstraction: Latin American Art from the Patricia Phelps de Cisneros Collection* (Harvard Art Museums, 2001), academic and curatorial attention to Latin American abstraction has grown spectacularly, matching earlier partialities toward Mexican Muralism and Surrealism. Museums have led the way, with such already-canonical exhibitions as *Inverted Utopias: Avant-Garde Art in Latin America* (Museum of Fine Arts, Houston, 2004) and *Beyond Geometry: Experiments in Form, 1940s–1970s* (Los Angeles County Museum of Art, 2004), and new, monographic attention to artists such as Lygia Clark (Brazil), Carlos Cruz-Diez (Venezuela), Gego (Venezuela), Hélio Oiticica (Brazil), Mira Schendel (Brazil), and Jesús Rafael Soto (Venezuela).[9] Lyrical abstraction has remained comparatively out of the spotlight, arguably overshadowed by the unabating ascendancy of the New York School and its daunting, and at times hegemonic, historiography. The transnational character of much new research within the field goes far to bridge this imbalance, however, with its interests in, for example, the Global South and the hemispheric Americas alongside attendant questions of exile, migration, and diaspora. This book's many citations are in part testament to my admiration of the many scholars, spanning multiple generations, whose work precedes my own. In reaching to a place among these narratives, *Revolutionary Horizons* argues forthrightly for the substance of Cuba's contribution to Latin American abstraction and its transnational history. Too often excepted from these narratives, whether for reasons of ideology or of long-lacking information, the history of Cuban art is, I believe, inimitably important to our field, as the following chapters begin to suggest.

Chapter 1 examines the generational consciousness of the abstractos, siting their origins within an aspirational "horizon of vanguards" that came of age at the beginning of the 1950s. The chapter surveys the cultural disposition of the early Batistato, describing different iterations of cultural *americanismo* in circulation and the futurities of

Cuban art at home and abroad. Tracing the sources of a new Cuban universalism to the 1940s and the literary journal *Orígenes*, the chapter introduces the ideology of cubanía through its intellectual history and the conceptual ground it laid for the youngest-generation vanguardia. Havana's cultural field is further elaborated through its built environment, shaped by a rising architectural vanguard—Arquitectos Unidos—and the emergence of new institutions, among them the progressive Sociedad Cultural Nuestro Tiempo, a clearinghouse for the arts and later an incubator of the communist underground. New discursive space was opened up by the rise of the print medium, exemplified by the modern-minded, artist-run magazine *Noticias de Arte* and its provision of professional arts criticism and intellectual exchange. These makings of a cultural infrastructure provided not only a space of receptivity within which the next generation of artists could emerge but also the beginnings of the cosmopolitan, cubanista orientation that shaped their practice.

This nascent cultural field matured alongside the third-generation vanguardia, and chapter 2 surveys the rapid gestation of Los Once and their activity between 1952 and 1953. The chapter positions the *onceños* in relation to Cuba's historical vanguardia and its legacy of political and intellectual activism from the Generation of 1927 to the Havana School and its florid, nationalizing aesthetics. Laying claim to a sweeping generational mandate, Los Once staged their first exhibitions as a "point of attack" against the charged complacence of the elder-generation vanguardia, plying the shock value of gestural abstraction as a means of raising cubanista consciousness. Tapping into the mythos and momentum emanating from early action against Batista—signally, the Castro-led attack on the Moncada army barracks in 1953—the onceños defined themselves through rhetorics of youth (as the "under-30s") and artistic revolution. Their provocations, at the National Salons and in frequent group exhibitions, catalyzed the arts discourse in Havana over the first half of the decade, and their early exhibition history, generational identity, and americanista interests form the nucleus of the chapter.

Los Once's iconic, cubanista moment arrived in 1954 at the *II Bienal Hispanoamericana*, sent from Francoist Spain to Havana on the centenary of Cuban independence leader José Martí's birth. Mobilizing their practice of abstraction against Batista, and with public support from artists across the Americas, vanguardia artists mounted a countering exhibition-manifesto—the so-called "Anti-Bienal," in homage to Martí—that circuited the island in the months before the Bienal. Chapter 3 reconstructs the histories of the Bienal and the Anti-Bienal, assessing the stakes of vanguardia dissent and the forcework of abstraction as a radical, cubanista enterprise. Pecuniary and other reprisals of the Batista state splintered Los Once in the wake of the Anti-Bienal, and the second part of the chapter examines the group's internal dissension and the missteps of early 1955 that led to its dissolution.

Chapter 4 considers the infrastructure of Havana's cultural field in the wake of Los Once's disbandment, parsing the multiple identities of abstraction and the expanding

international horizons of the third-generation vanguardia. The cultural programming of the new National Institute of Culture is considered in regard to its ideological intent and reception, viewed through the historicizing installation of the new national museum and the heavily boycotted *VIII National Salon* (and its countering "Anti-Salon"). Abstraction made new inroads into the public sphere during this time: on a theoretical plane, with the commission of a modular Pilot Plan for Havana; and in its actual built space, increasingly marked by public murals that imprinted abstraction across the city. International opportunities beckoned for many within the vanguardia, and the second part of this chapter surveys the propagation of modern Cuban art abroad. The work of José Gómez Sicre (1916–1991) at the Pan-American Union and on behalf of Cuban delegations to the São Paulo Bienal during the 1950s is examined, as is the market for (and marketing of) Cuban art in the United States and elsewhere. The core members of Los Once exhibited in late 1955 as "Los Cinco," and their reappearance is discussed in light of the transnational networks across the Americas in which they participated and the debated cultural imperialism of American Abstract Expressionism.

Chapter 5 considers the multiple origins of geometric abstraction in Cuba beginning in the late 1940s and the arguments made on behalf of concrete art by the artists who grouped themselves as Los Diez in 1958. Less stridently political than the onceños, the *concretos* posited abstraction in idealist terms, advancing ordered, Constructivist rhythms as a cubanista allegory of utopia. This chapter describes the formal and philosophical interests of the concretos, assessing their contributions to the vanguardia project through exhibitions and considerable didactic work, which culminated in the opening of the Galería Color-Luz. To a greater degree than Los Once, the concretos cultivated their place within international networks—in their case, less through the United States than across Europe and South America—and they embraced postwar Constructivist precepts of arts integration and collectivity. The humanist, social manifesto of Los Diez (1959–61) and the group's brief exhibition history are reviewed in light of the Revolution and, more expansively, the earlier cubanista premise. The chapter concludes with an extended reflection on the special place of sound in the afterlife of concretism and the sensorial embodiments of changing Cuban identity.

The ideological contingencies of abstraction, more broadly defined, are the subjects of the sixth and final chapter, which assesses the post-history of the vanguardia between 1959 and 1963. The cubanista canon is revisited in light of its radicalization at the behest of the intelligentsia, who took to the print medium—notably, the literary magazine *Ciclón* and eponymous journal of Nuestro Tiempo—to rail against the Batista regime. Ambiguities within the early, postrevolutionary cultural program, from socialist realism (a nonstarter) to mass media campaigns, anticipated the hardening of policy by 1960–61, signaled by the nationalization of the press and censorship of the film *P.M.* The socialist characterization of the Revolution and Castro's cautionary "Words to the Intellectuals" are implicated in changes to the cultural field, hinted in the shuttering

of the weekly *Lunes de Revolución* and the slow turn against abstraction. The revived polemics against abstract art, voiced as early as the National Salon of 1959, effectively shut down both Los Once and Los Diez; their practices of abstraction, stripped of their cubanista forcework, no longer held the ideological valence that had powered their critique over the past decade. Los Once's symbolic final exhibition—*Expresionismo abstracto*—marked the unofficial end to the historical vanguardia and its last generation.

Moving for the most part chronologically through the 1950s and early 1960s, *Revolutionary Horizons* chronicles the trajectories of the third-generation vanguardia—Los Once and Los Diez and their contemporaries—through a combination of period and primary sources and revisionist historical accounts. By design, the book functions in part as a documentary history, distilled through contemporary reviews, published statements and essays, and exhibition records. Oral interviews conducted between 2008 and 2014 in Havana, Miami, Paris, and New York with principals of this generation (in some cases, with their families) provided key clarifications. A final note: the book takes the impassioned terms of the decade—"avant-garde," "ideology," "revolutionary"—largely at face value, in other words as what Andrea Giunta, writing about the situation of the Argentine avant-garde in the 1960s, has described as *"highly disposable verbal artifacts stamped on any individual who chose to be active in the artistic and cultural field of the period."*[10] As such, these words are used here without judgment and in the discursive formations of their time, which is to say in the full sense of their contemporary ambivalence, controversy, and rhetorical reformulations. This book does not claim to reconstruct a single historical "truth," but rather to contribute to a social history of Cuban abstraction in the fullness of its national and cultural contingencies.

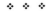

That *Revolutionary Horizons* came to completion in the month that witnessed the reopening of the U.S. Embassy in Havana and new rapprochement between the two countries seems, if a bit serendipitous, more importantly a sign of new horizons to come.

1 The Horizon of Vanguards

"We were a group of idealists," painter Antonio Vidal (1928–2013) said years later of the precocious group of artists and writers who congregated at the mythical café Las Antillas at the beginning of the 1950s.[1] At the corner of San Miguel, between the avenues of Prado and Consulado at the edge of Havana's Parque Central, the nucleus of Cuba's rising-generation vanguardia gathered to discuss modern art and day-to-day political affairs. Their *tertulias* stretched until the early hours of the morning, sustained by what painter Salvador Corratgé (1928–2014) described as *"café con leche de diez kilos,"* and drew the best young minds: writers José Lezama Lima (1910–1976) and Rolando Escardó (1925–1960); painters Raúl Martínez (1927–1995) and Hugo Consuegra (1929–2003); architect Nicolás Quintana (1925–2011); and critic Joaquín Texidor, who emerged as the leading voice of the group. From Texidor, the *"padrino"* of the generation and "a fanatical supporter of everything modern, . . . came the idea of forming a group," Corratgé later explained. "First we called it the 'Twenty-Three and a Half,' because we were twenty-three painters, and he—the art critic—was the half."[2] In much the way that the Cedar Tavern served as a gathering place for the New York School, Las Antillas provided *"los 23 y medio"* with an informal space not only to *"hacer la bohemia,"* in Martínez's laughing remembrance, but also to thrash out ideas about art and activism.[3] "The conversations, or controversies, concerning art and the social reality were essential to my development as an artist," Martínez explained. "They helped me to define the terms and clarify any uncertainties. I became aware of problems that intersected with my work as an artist and that affected, or influenced, the world in which I lived."[4] The group's membership varied over time, as did its number, but its underlying generational identity remained intact over the course of the decade, sustaining a critical and at times insurgent impulse through series of exhibitions and, increasingly over time, through the forms of its art.

This chapter describes the social constructs of modernism on the eve of the Batista coup, shaped by this formative generation and the new media and cultural institutions that supported its work. Early ventures, from publishing platforms to the creation of liberal-democratic organizations, began to position modern Cuban art within transnational cultural networks stretching from Europe to North and South America. The emergence of the Sociedad Cultural Nuestro Tiempo as a haven for the

Detail of fig. 5

youngest-generation vanguardia and the seminal eleven-issue run of *Noticias de Arte*, Cuba's first high-profile arts magazine, marked early milestones. In their efforts to raise Havana's international profile, "los 23 y medio" looked searchingly to the north, not least to the New York School, and to the countercultural (not yet, perhaps, Cold Warrior) ethos of gesture painting. While these *americanista* interests stood in sometimes-frustrated relation to the sweeping United States influence that flooded batistiana Cuba, the contemporary articulation of "Cuban universalism" conceived of American identity in far more idealizing and vanguardist terms. Drawing off the cubanista turn of the cultural vanguard and a restive political culture, the start of the decade beckoned auspiciously toward the generation of "los 23 y medio" as they coalesced around the marble tables of Las Antillas.

THE RISE OF THE BATISTATO

The Batista coup shone a hard light on the systemic political and economic crisis that had faced Cuba in the postwar years and the long entrenched problems of internecine feuding, rampant *gangsterismo*, and unchecked corruption. Batista had first come to power following the military overthrow of Gerardo Machado (1879–1939) in the Revolution of 1933. The prime mover behind the scenes of the seven civilian governments of the 1930s, Batista served as the country's elected president between 1940 and 1944, ruling popularly as a social democrat under the progressive Constitution of 1940. Broad militarization of the island and rising levels of political violence belied boom conditions during the Second Republic, however, and the vaunted social peace and progressive ideals proved a superficial overlay at best. Between 1944 and 1952, the successive *Auténtico* presidencies of Ramón Grau San Martín (1881–1969) and Carlos Prío Socarrás (1903–1977) further miscarried the Constitution, initiating a period that has been described as "the most polarized, corrupt, violent, and undemocratic in Cuba's brief, post-Platt amendment, republican history."[5]

In 1947 the immensely popular radio personality and senator Eduardo Chibás (1907–1951) led a breakaway faction from the governing Auténtico party, christened the Cuban People's Party (*Ortodoxos*). Calling for a Cuba "free from the economic imperialism of Wall Street and from the political imperialism of Rome, Berlin or Moscow," the Ortodoxos assumed the mantle of the republic's original *independista* mandate. Their reformist platform railed against the endemic *compromisos* and gangsterismo—"a scandalous bacchanalia of crimes, robberies and mismanagement"—that had dogged the feeble and increasingly lawless postwar governments.[6] From the bully pulpit of Havana's CMQ radio station, Chibás attacked Cuba's political institutions every Sunday evening, jawing against the island's sugar monoculture and foreign dependence and impugning government officials for alleged embezzlement, drug trafficking, and commodity speculation. On August 5, 1951, amid an escalating firestorm of accusations lodged against a senior minister, Chibás spoke with a clear sense of foreboding: "People of Cuba, arise

and walk! People of Cuba, keep awake. This is my last knock at your door [*aldabonazo*]!"[7] Moments later, he shot himself with a pistol in an apparent act of suicide, a sensational event that scandalized the nation and marked the end of the era inaugurated by the provisional *Pax Batistiana* in 1933.

The political fallout in the aftermath of the Chibás affair, intensified by the proximity of what was anticipated to be a litmus-test election in May 1952, created a frenzied state of behind-the-scenes machinations in the intervening months. Feverish and conspiratorial politicking between the candidates and their parties ended in a bloodless coup, orchestrated by the military, which returned Batista to power on March 10 and effectively brought constitutional rule to an end, fifty years after Cuba had won formal independence. Reprising his reformist mantle of 1933, Batista defended this "liberation movement," promising honest government, needed agrarian and educational reform, and public works. Invoking the name of Cuba's beloved revolutionary José Martí (1853–1895) in his first public speech, Batista "associated himself with the popular aspiration for progress and democracy, and for peace and justice."[8] Chibás had so thoroughly discredited the Prío administration that many in Cuba cautiously placed their faith in Batista, felt to be the country's best chance to restore order and arguably its most internationally charismatic figure. Furthermore, his loyal wartime diplomacy had fostered valuable political connections in Washington, D.C., thought to be advantageous in the new climate of Cold War.

The United States met the overtures of the Batista state with goodwill, following Europe and Latin America in granting official diplomatic recognition to the government on March 27. "Cuba's Batista" graced the cover of *Time* magazine on April 9, Franklin D. Roosevelt's son Elliott paid a visit to Batista, and emissaries from the United States Steel Corporation assured Cuba that American industry had "responded favorably" to their country's swift diplomatic recognition of the new regime.[9] American capital flowed readily into Cuba, drawn by an advantageous tax code and more liberal terms for capital investment. In 1955 the U.S. Department of Commerce projected new, non-sugar investments of $205 million, a 20 percent increase over its previous total, over the following five-year period.[10] The influx of dollars, combined with rising domestic investments, brought high, if uneven, levels of modernization and improved standards of living.[11] While the economic and social development of Cuba kept the new Batistato afloat, the parallel cultural modernization—namely, the Americanization—of the island not only reinforced the fiscal indicators but buttressed them with ideological values as well.

ORÍGENES AND THE SOURCES OF A NEW CUBAN UNIVERSALISM

The twin currents of modernization and Americanization first swept through Cuba during the American military occupation at the turn of the twentieth century. While the Platt Amendment (1903) guaranteed America's neocolonial claim, sanctioning U.S.

intervention in Cuban affairs, softer diplomacy penetrated deeply, even insidiously, into everyday life. From baseball to Protestantism, American popular culture was as ubiquitous as the tony racing set who began to descend upon Havana, spending their winters drinking and gambling in "the closest thing to Paris in a season when Paris is not available," in the breezy words of a contemporary travel guide.[12] Seen even in the wake of independence as "a culturally dependent, satellite entity," Cuba responded by recourse to an ideational obsession with its national identity—*cubanía*—that had ebbed and flowed from the times of Spanish colonization to the "accommodationist" realities of the *neoanexionista* republic. Cubanía was from its beginning, in Antoni Kapcia's sense, "less a 'nationalism' than a political expression of a growing collective desire to rescue and define an 'imagined community,' with all the contradictions that such a search must necessarily entail."[13] The dimensions of this closely held dream for *Cuba Libre* were myriad and incongruous by design, variously encompassing militant nationalism, cultural *americanismo*, and Marxist ideology. By the 1950s, Kapcia argues, Cuba had become a "veritable 'island of dreams,' mixing illusions with teleological visions, and creating 'real' plans on the basis of long-postponed but still believed 'dreams' of utopia."[14] This cubanista mythology, which intensified following Batista's coup and its thwarting of democracy, took root in the cultural field, incubating alongside "los 23 y medio" as they began to position themselves in opposition to the dictatorship. The breach of constitutional trust and the chronic malfeasance of the Batistato created a sense of urgency that this vanguardia repeatedly capitalized on, bringing the cubanista mentality into line with its pursuit of modernism (and, in due course, of abstraction). In this way, the cubanista ethos that had once united the republic was translated, mutatis mutandis, into a medium of institutional critique capable of upsetting the cultural controls of the Batistato.

Yet even before the coup energized a new, generational cubanista response, the ideational reach of "los 23 y medio" tapped into sources of cultural cosmopolitanism that had developed underfoot of the more strident nationalist rhetoric of the 1940s. While the history of modern Cuban art has mostly been considered in the context of nation formation, the legacy of the elder-generation vanguardias may also be seen as what Salah D. Hassan has described as a uniquely "Cuban universalism," drawn from complementary americanista and cosmopolitan cultural visions.[15] This universalist mentality was less evolved in the visual arts than in the contemporary literary culture, and arguably the intellectual origins of the third-generation vanguardia owed more to writers than to the elder vanguardia artists, with whom "los 23 y medio" more often sparred. The exemplary case is the cohort associated with the avant-garde literary magazine *Orígenes* (1944–56), which published forty issues under the editorial leadership of Lezama Lima and José Rodríguez Feo (1920–1993). The enlightened cosmopolitanism of this group laid the cubanista bedrock for the artistic vanguardia of the 1950s, who went on to appropriate the critical space first broken by the origenistas.

Nonpartisan yet invested in the cubanista dream of a collective cultural community, *Orígenes* staked out an innovative, discursive place within Havana's cultural field. Situating its work wholly within the cultural imaginary, the group shunned the political fray, countering nationalism with cosmopolitanism, gangsterismo with aesthetics, and populism with hermeticism. "We were aspiring to an art form not in correspondence with the nation which was indecisive, limping, and amorphous," Lezama Lima explained in retrospect, "but rather art with possibility, with goals, with final values that would unite the march of generations, headed toward a distant but still workable point: a futurity belonging to a tense present with the bow full of elastic energy."[16] Their determinist orientation toward an unknown and far-off future, reminiscent of the cubanista vision of collective utopia, set the *Orígenes* group squarely within the vanguardia tradition. Its signal achievement and legacy lay in the sweeping universal vision through which the journal interpreted and promoted Cuban culture. Against the militant din of nationalist rhetoric echoing across postwar Cuba, *Orígenes* circumscribed an autonomous space for art and literature. The journal privileged formal innovation, featuring a steady diet of avant-garde French literature—Louis Aragon's social polemic and Stéphane Mallarmé's symbolism, for example, in original Spanish translations—and, disproportionately, of poetry. The group's Roman Catholic identity, in an essentially secular nation, subtly distanced it from the dominant popular culture as well, implying a social elitism in addition to the highbrow aestheticism of its work. But most essentially, the group's incipient americanista aesthetic countered what had become an entrenched scholarly Eurocentrism. *Orígenes*, notably, was the first publication in Cuba to showcase modern Latin American intellectuals, from Carlos Fuentes (1928–2012) to Enrique Anderson Imbert (1910–2000).[17] Over the course of its run, the journal became the preeminent vehicle for the Cuban literary vanguard of the Second Republic.[18] Covers featured work by canonical vanguardia artists from Amelia Peláez and Wifredo Lam (1902–1982) to Mario Carreño (1913–1999) and René Portocarrero (1912–1985). In later years, the journal embraced emerging figures like José M. Mijares (1921–2004), whose geometricized cover design signaled an endorsement of the still emergent, "concrete" aesthetics soon championed by Carreño and *Noticias de Arte* (fig. 3).

In its groundbreaking americanista point of view, the journal advanced a compelling humanist and internationalist understanding of culture that resonated with the vanguardia that emerged in the 1950s. Still, the "*flâneur* of Origenista poetics" ultimately "directed himself against the modern, rational, urban, and public structures," as Rafael Rojas has observed.[19] This reluctance to fully engage the public sphere marked an important generational divide as the emergent vanguardia willfully positioned itself within the crosshairs of contemporary politics, enacting its artistic practice as a form of activism. In this regard, the strategies of this generation suggest a throwback not to the *Orígenes* group, which mostly identified with second-generation vanguardia artists like Mariano Rodríguez (1912–1990) and Alfredo Lozano (1913–1997), but to the foundational

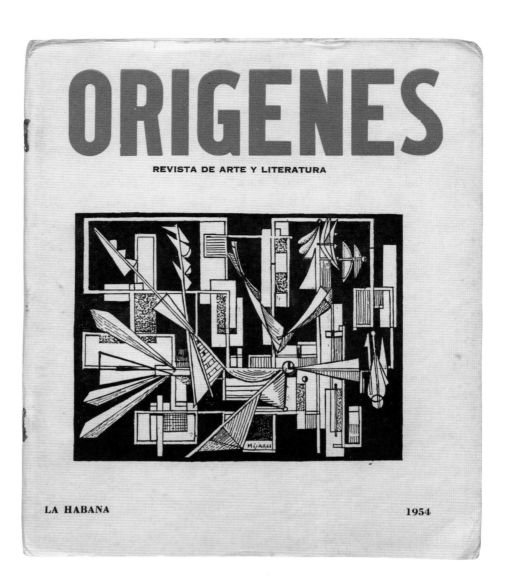

Generation of 1927. Mobilized against the increasing brutalities of the Machado presidency (1925–33), the left-leaning *"minoristas"* agitated against the Machadato in the public sphere and in concert with the vanguardia artists, staging what Rojas has deemed "open radicality" through the Protest of the Thirteen and the peripatetic tertulias held at the Café Martí, the *Figaro* offices, and later at the Hotel Lafayette. Their example of how to broker a more radical cubanista culture "by means of transferring doctrinal and aesthetic avant-gardes into statal initiatives" proved similarly instructive for their successors a quarter-century later.[20] The cohort of "los 23 y medio" thus inherited a double legacy from the elder vanguardias: from the Generation of 1927, a model of commitment to political freedom; and from the *Orígenes* group, a vision of Cuban universalism drawn from broadly americanista roots.

AMERICANISMO IN THE 1950S

That the 1950s marked an extraordinary moment in Cuba's history is almost universally acknowledged. The architect-urbanist Nicolás Quintana, a pioneer of the vernacular interpretation of the International Style known as "modern regionalism," described the outlook at the beginning of the decade as belonging to an auspicious "horizon of vanguards."[21] At key moments, the vanguardia embodied a synergetic esprit de corps that transcended generational lines and aesthetic differences. *La Habana levantó!* the artist and poet Pedro de Oraá (b. 1931) exclaimed of the vanguardia's rapid mobilization in response to the failing political state, underlining the solidarity of the group and the urgency of its call to arms.[22] The climate of political volatility most empowered the youngest generation, who found in the radical ethos of the moment an opportune catalyst for wholesale artistic revolution. Corratgé called the group that radiated from "los 23 y medio" the *generación de oro* (the golden generation); Quintana, too, believed that Cuba experienced a moment of Renaissance during the 1950s, a belief seconded by de Oraá and others.[23] The cultural renaissance unfolded in parallel with the course of modernization that was simultaneously transforming Havana into a tropical metropolis, a city that openly longed to be the "New York of the Caribbean." Havana had long relied on its earlier, and still enduring, self-identification as the "Paris of the Western Hemisphere," the winter home to the leisure class and rum runners, to draw ordinary, middle-class Americans as the business of tourism—the *segunda zafra* (second harvest)—continued in earnest (fig. 4). With buy-in from the Cuban elite, the americanista presence was welcomed in the person of vacationing gringos (less directly, of the *Mafioso* godfathers) and in the coveted material goods that signaled membership within a social-climbing Cuban bourgeoisie.

Writing to José Gómez Sicre, the diplomat and long-serving director of the Visual Arts Section of the Pan-American Union in Washington, D.C., the artist Felipe Orlando (1911–2001) described a changing urban landscape run by "fat cats" and the "culture of the automobile," the symbol par excellence of modern American consumer culture. "The public works that this government has overseen are actually good and well-built," Orlando noted in pleasant surprise. "Today the Malecón is a beautiful, four-lane highway. The economic situation is simply fantastic, [which] has created a distinctive mentality, which I call

FIGURE 4

Postcard, *Impressions of a Visit to Gay Havana, "The Paris of the Western Hemisphere,"* c. 1920. The P. & O. Steamship Company, Jacksonville, publisher; Curt Teich & Co., Inc., Chicago, printer. 5½ × 3½ in. (14 × 8.9 cm).

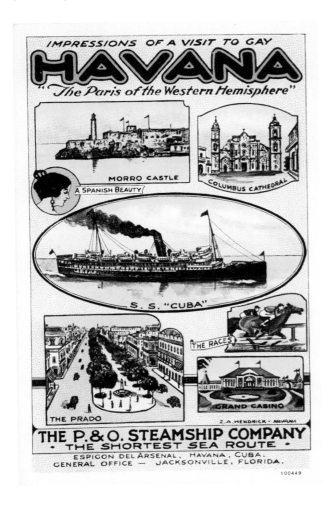

'the culture of the automobile.' You will be surprised at the ways in which conversations, trivial or more serious, touch invariably on the theme of the automobile, which is already an *'obligatto'* [*sic*] parallel to politics."[24] American cars were undoubtedly a ubiquitous presence in republican Cuba, from the Model Ts that first appeared in the 1910s to the Cadillac Fleetwoods, Buick Roadmasters, Dodge Coronets, and ubiquitous Chevrolets in later years. Over eleven thousand new American cars were sold in Cuba in 1956 to a car-crazy population; fanfare over the arrival of the 1957 models from Detroit easily topped news of the clandestine landing of the *Granma* on the other end of the island and its return of the exiled Fidel Castro, along with Ernesto "Che" Guevara, to Cuba. (At the time, the state news agency reported that Castro was among the casualties of a counterattack; only two years later, he personally claimed an abandoned Oldsmobile left in the wake of his Revolution.[25]) The Villoldo family's General Motors dealership reported $15 million in annual sales during the 1950s, figures on a par with the myriad car dealerships, pharmaceutical companies (Parke-Davis, Squibb), and air-conditioned retail chains (Sears and Roebuck, Woolworth) that began to line the streets of Vedado, Havana's new, high-rise commercial center.[26] American firms invested an estimated $713 million annually during the decade, mostly in light industry and the service sector; and brand names from Goodyear to Coca Cola and DuPont appeared throughout the island. The premiere industry, however, was aviation, with gleaming, multinational offices prominently placed along La Rampa, Vedado's central artery. Universal symbols of modernity and, appreciably, the literal means by which Cuba's development would take off, the airlines turned the ninety miles between Miami and Havana into one of the busiest international routes in the world. Pan American Airlines scheduled twenty-eight flights a day on average during the 1940s and 1950s; Cubana Airlines inaugurated an airborne version of the famed Tropicana cabaret on its flights in 1956. Cubans flocked to Miami as well, at a rate of nearly fifty thousand per year throughout the 1950s, as the fascination with all things American extended—for anyone who could afford as little as the standard $30 for a round-trip flight—to travel across the Florida straits.[27]

Whereas Machado had modeled *habanero* culture on the sophisticated urbanity of Paris, Batista entertained what became a more shadowy American underworld presence. Leisurely *paseos* along palm-lined avenues ceded to a stream of duck-tailed convertibles speeding from one nightclub to the next, following Hollywood luminaries to their favorite hotspots—Marlon Brando at Tropicana, Ginger Rogers at the Copa Room, George Raft at the Hotel Capri—and heading to the "Shanghai theater" of Havana's seedy Chinatown for after-hours amusements. Under Batista's aegis, the so-called Havana Mob, which included the notorious Charles "Lucky" Luciano, Meyer Lansky, and Santo Trafficante, provided exotic gaming, narcotics, and prostitution in resort hotel-casinos run free from state interference. The glittering presence of matinee idols and starlets, a few of whom were allegedly in league with the Mafiosos (notably, Frank Sinatra), lent new glamour to a city quickly christened the playground of the mob, brightening its

appeal to star-struck American tourists. The teeming licentiousness and corruption spread through habanero culture, infiltrating neighborhoods even at the city's margins; according to Enrique Cirules, "[T]here was no residential area in the city without a drug supply, a gaming table, a pimp, and hundreds of prostitutes."[28]

A historian of the mob, T. J. English, has described this age as "perhaps the most organic and exotic entertainment era in the history of organized crime."[29] At the height of its empire, the mob envisioned Havana as a front for a multinational criminal state, its accounts publicly backed by a Cuban government that stood to pocket a staggering economic windfall. The casinos and nightclubs bankrolled elaborate public works and plumped a lucrative, and increasingly important tourist industry; to the chagrin and anger of the *fidelista* rebels, their profits mostly lined the pockets of Batista and his cronies. "It would not be accurate to say that the [mobsters] in Havana were the reason for the Revolution," William Galvéz Rodríguez, a commander in the Sierra Maestra, explained years later. "But it is a fact that the casinos and the money—and most importantly the connections among the U.S. gangsters, U.S. corporations, and the Batista regime—became a symbol of corruption to us. Even though we were away in the mountains, we knew of the prostitution, the stealing of government funds, the selling of the country to outside interests. We vowed that *when*—not if; *when*—we were in power this was going to change."[30] The mob's plundering of Havana ended with the flight of Batista himself, on January 1, 1959, and the symbolic vandalism of the casinos, memorably by a truckload of pigs let loose in the lobby of the Riviera, Lansky's flagship emporium. To be sure, the American influence cut several ways. While the glaring fraudulence of the black-market economy cast a pallor over batistiana Americanization, the cultural by-products—from public works to Abstract Expressionism—left a more nuanced legacy for the vanguardia as it contemplated different strategies within the artistic arena.

THE ARQUITECTOS UNIDOS AND THE ARCHITECTURAL AVANT-GARDE

Graziella Pogolotti (b. 1932), a critic who rose to prominence in the late 1950s, remarked that Havana *"cambió en el aspecto humanístico"* (changed in humanistic terms) over the decade, citing the changed urban landscape and corresponding new social structure.[31] The population of metropolitan Havana exceeded 1.2 million in 1958, reflecting a growth rate of nearly 20 percent, and the strong postwar economy supported one of the largest construction booms in the city's history.[32] The Spanish colonial inheritance diminished, along with a venerable way of life: high-rise office buildings and American-inspired single-family homes replaced traditional store-front retailing and balconied *casa-almacenes*, just as supermarkets and department stores edged in on *bodegas* and street vendors.[33] As Habana Vieja, the core of the colonial city, became overcrowded and living conditions deteriorated, urban development focused increasingly on Vedado, the emerging central business district, and on residential Miramar, across the Almendares

urbanismo y planificación

Esta labor tan importante en toda
ciudad moderna; tampoco se ha
descuidado en La Habana de hoy.
En la actualidad trabaja eficien-
temente la Junta Nacional de
Planificación, bajo la dirección
del Ministro de Obras Públicas,
Arquitecto Nicolás Arroyo, con la
asesoría técnica de famosos pla-
nificadores, como los arquitectos
Paul L. Wiener y José Luis Sert,
realizándose proyectos de gran-
des plazas, avenidas, vías monu-
mentales y túneles, para lograr
una ciudad bella y funcional.

Un aspecto de la Avenida General Batista.

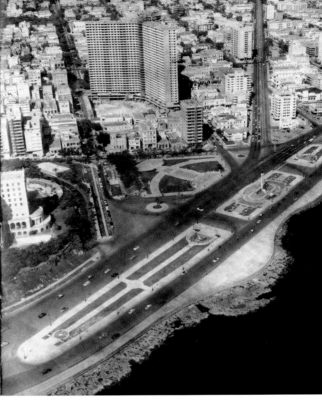

Vista de la calle 23, desde L hacia el mar. Una vista aérea de la entrada del Vedado, desde el mar.

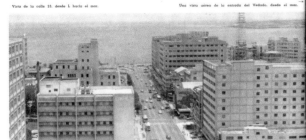

FIGURE 5

"Urbanismo y planificación,"
*Revista del Instituto Nacional
de Cultura* 1, no. 3–4 (June–
September 1956): 30–31.

River and home to the newly affluent, who commissioned modern homes along Quinta
Avenida. A period photo essay documented new, multi-lane thoroughfares running east-
west from the coastline Malecón into Vedado (fig. 5): Línea (renamed Avenida General
Batista), at top left, and La Rampa, lower left, lined with the fashionable edifices of the
entertainment industry (airlines, cinemas, hotels, nightlife). At right is an aerial shot of
the Monument to the Victims of the USS *Maine*, built in 1925 at the end of Línea to honor
the U.S. soldiers who died in the ship's explosion, an event that precipitated the Spanish-
American War. (The American eagle atop the monument was removed in an anti-
imperialist demonstration in 1961, but the complexities of 1898—Cuban independence at
the price of American intervention—had long shadowed the republic.) By the 1950s, the
pressures of a rapidly multiplying population and a booming tourist industry brought a
new mindfulness to the shape of Havana's built environment, and a generation of archi-
tects began to articulate a cubanista style that synthesized the national tradition with a
universal, modernist vision.

"Two fundamental ideas, progressively enriched over the years, now came into their
own," Eduardo Luis Rodríguez has remarked of the postwar era, which he describes as

the "period of greatest formal and conceptual excellence in the history of Cuban architecture: first, the unreserved recognition of modern formal codes as the only acceptable mode of expression; second, the imperative to convey, through architecture, the nature of our national roots without falling into anachronism or mimetism."[34] As Havana transformed from a genteel Antillean capital into a modern municipality, the city's demographic and social mandates manifested themselves in three principal forms. The Batista regime favored modern monumentalism for public works, not as an endorsement of fascist regimes per se but in emulation of European fashion, as in the José Martí Monument (Enrique Luis Varela, 1953–58) and the Palace of Justice (José Pérez Benitoa and Sons, 1953–57). The high-rise office buildings and luxury hotels that sprouted up in Vedado epitomized the International Style, crowned by the American Embassy (Harrison and Abramovitz, 1953), the landmark Habana Riviera Hotel (Polevitzky, Johnson and Associates, 1957), and the Habana Hilton Hotel (Welton Becket and Associates, 1958), famously used as the temporary headquarters for the rebel government in 1959. "The most spectacular growth, however, occurred in the housing domain," María Luisa Lobo Montalvo has argued, and a number of experimental residential projects provided a testing ground for ideas about modern regionalism.[35]

Among the most innovative homes from this period is the Eugenio Leal House (1957) in seaside Miramar, designed by Eduardo Cañas Abril and Nujim Nepomechie. Cañas Abril belongs to the generation inspired by the visit of Josep Lluís Sert (1902–1983), a leading Spanish architect and vice president of CIAM (*Congrès International d'Architecture Moderne* [International Congress of Modern Architecture]), to Havana in 1939.[36] Sert's stopover, on his way to New York as a refugee from the Spanish Civil War, inculcated a generation of CIAM loyalists and opened a dialogue between Cuban architects and Corbusien ideas, consummated in the commission of the Pilot Plan for the city. Walter Gropius (1883–1969), Mies van der Rohe (1886–1969), and Josef Albers (1888–1976) all paid visits to Havana over the following two decades, but the primary reference for the Leal House was the Brazilian modernist Oscar Niemeyer (1907–2012). The Leal House exemplifies the adaptation of a rationalist aesthetic to the American tropics, integrating a geometric, L-shaped main structure with sinuous organic elements that bridge interior and exterior spaces (fig. 6). A pristine outdoor canopy, modeled after Niemeyer's designs for São Paulo's Ibirapuera Park (1954), covers the free-form patio, utilizing the plasticity of concrete in a striking, sculptural way to carve out terraces, gardens, and small ponds. The house originally featured an interior fresco by Peláez, later destroyed during a renovation, in addition to the outdoor ceramic-tile mural by Carreño, among the most celebrated artists of the Havana School and, by the 1950s, an influential

FIGURE 6
Eduardo Cañas Abril and Nujim Nepomechie, Eugenio Leal House, 1957. Calle 18 #115 (between 1 and 3), Miramar, Playa, Havana.

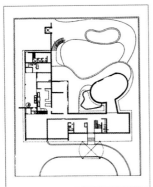 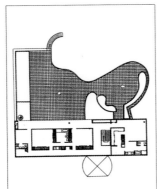

proponent of geometric abstraction (fig. 7). The geometries are subtly modulated in the Leal mural, echoing the slender piloti supporting the canopy and the sinuous curves of tropical vegetation. Set onto a curved wall (the exterior wall of the game room), the mural is both ideally integrated into the architectural space and its pictorial complement: the surface curves and balmy, aquatic colors of the mural temper its basic geometry, just as the elliptical terrace-canopy softens the rationalist rectangle it adjoins.

Dialogues about the integration of modern artworks and architecture surfaced during this period, witnessed in the emergence of public and private murals and in a collaborative approach to design. Ideas about "integrated" artworks took root in the early 1950s, notably in the practice of Hugo Consuegra, both a licensed architect and an abstract painter. The sole crossover artist of this generation, Consuegra belonged to two influential artist groups—Arquitectos Unidos and Los Once—and emerged as one of the strongest generational voices, in print and in international reach, behind abstraction and public works. Among his most innovative commissions from this time was the Emelina Fernández apartment building (fig. 8). Abstract in creative, rather than painterly terms, the building is based on "a hexagonal module that, in elevation, becomes obvious in the shape of the façade," as Rodríguez has stated. "It reflects the modern tendency to work with geometrical modules, a resource that though scarcely new, gained special popularity during this decade."[37] The residence was designed under the auspices of Arquitectos Unidos, an architectural collective that embodied the cubanista outlook of "los 23 y medio."

Within the "horizon of vanguards," a young corps banded together as Arquitectos Unidos under the direction of Humberto Alonso (b. 1924) in 1952. Architecture students at the University of Havana composed the original nucleus of the group; with the later additions of Henry Gutiérrez and Alonso (who, having already graduated, was the group's leader), they became Arquitectos Unidos (also known as Los Espaciales).[38] An informal and short-lived collective, Arquitectos Unidos "[exemplified] a moment at which the participation in the international avant-garde was an important goal in Havana's architectural culture."[39] Taking their cue from the minimalist clarity of the International Style, lately fashionable in the United States and spreading through the Americas, Arquitectos Unidos became known for their successful implementation of modernist, open-plan schemes. Their first commission, the Colegio Instituto Edison (1954), featured a glass curtain-wall aesthetic inside and out and anticipated their best-known design, a rationalist, International Style addition (Rental Office Building) to the Colegio de Arquitectos (1953–56).

FIGURE 7
Mario Carreño, *Mural*, 1957. Eugenio Leal House, Havana.

FIGURE 8
Hugo Consuegra (Arquitectos Unidos), apartment building of Emelina Fernández, 1956. Calle 24 #648 (between 33 and 35), Nuevo Vedado, Plaza, Havana.

"But of equal or greater importance to their built work," John A. Loomis has remarked, "Arquitectos Unidos served as an intellectual forum, a scene of weekly 'tumultuous and uncontrollable tertulias,' salons that debated current issues in architecture, arts, and politics."[40] With José A. Baragaño (1932–1962) and Tomás Oliva (1930–1996), Consuegra organized a weekly tertulia at the offices of Arquitectos Unidos, located at the bottom of La Rampa in Vedado. Shepherded by the same spirit as that which guided "los 23 y medio" at the beginning of the decade, these gatherings began as an intimate "open house" among friends but quickly expanded to include anyone who might chance to drop by between ten and eleven o'clock in the evening, keen for news and lively conversation. "We spoke of everything and nothing, for hours at a time and without a preset agenda," Consuegra reminisced. The group debated "poetry and art but also politics—international and *criollo*—music, literature, and 'being and nothingness,' which was then all the rage."[41] "Arquitectos Unidos would have a great affinity with Los Once," Consuegra notes, in regard to their shared conviction in the social role of art and the futurity of the modernist movement.[42] The connections were more fraternal and ideational in nature than strictly artistic, but Los Once drew on the discursive space opened up by Arquitectos Unidos and the generational solidarity established across disciplines, reinforced by the social spaces—cultural societies, galleries, print magazines— that were beginning to appear.

THE EARLY YEARS OF THE SOCIEDAD CULTURAL NUESTRO TIEMPO

"We are the voice of a new generation that is coming forward at a time in which some would see violence, desperation and death as the only solutions," read the manifesto of the Sociedad Cultural Nuestro Tiempo, formally launched on February 18, 1951, by composers Harold Gramatges (1918–2008), Juan Blanco (1919–2008), and Nilo Rodríguez (1921–1997). Signed by twenty-eight of Cuba's youngest vanguardia, the manifesto concluded, "We define ourselves by the man who is never in crisis, for his work is an enduring essence."[43] The signatories further declared their intention to "bring the people to art," by which they explicitly meant "American art, free from political or religious prejudices, without any concessions."[44] The Sociedad Cultural Nuestro Tiempo emerged as the leading progressive cultural institution of the time, in later years publishing a journal (*Nuestro Tiempo*, 1954–59) and opening a gallery (1955–59) in defiance of the national museum, opened under Batista, and its cultural offices.

Nuestro Tiempo embodied the decade's idiosyncratic "Cuban universalism," and its appearance on the cultural scene—at first, in the space of an old radio station—met with hopeful enthusiasm and critical acclaim. "So many new faces! And so many new names!" enthused Nicolás Guillén (1902–1989), later considered Cuba's national poet, in his review. "There is the palpable presence of an impetus that will go far," he continued, reflecting that "for those who are approaching the half-century mark—that melancholy

station in the long path of life—it is like the shade of a tufted tree, like the enlightened return to the first days of innocence, to a virginal creative state."[45] The emergence of a socially aware vanguardia was personally meaningful to Guillén, a veteran of dissent during the Machadato and later exiled by Batista. Within this rising generation, he "found an enormous anxiety over what is happening outside of Cuba, to know what is happening in other parts of the Americas," noting interest in Venezuela and the possibility of artistic exchange between the lands (and vanguardias) of Simón Bolívar and Martí.[46] Nuestro Tiempo cultivated an international consciousness in its work, though its purview remained more endogenous until its reorientation under the auspices of the Comisión para el Trabajo Intelectual (Commission on Intellectual Work), an organ of the communist Partido Socialista Popular (PSP), in 1953.

Nuestro Tiempo later exercised its political clout against the Batistato, but in its early years the focus was primarily directed toward the fledgling vanguardia. "The climate of spiritual community, where views are exchanged, lectures given, and works read or exhibited, is full of positive benefits for any artist or writer," the critic Salvador Bueno remarked. "For the young, these benefits can only increase."[47] With an average of five or six cultural programs scheduled each month, Nuestro Tiempo fulfilled its mission to provide a center for the cultural arts: theater, music, ballet, cinema, symposia, lectures, and fine art. The lineup for its official opening on the evening of March 10, 1951, suggests the range of programming on offer. At nine o'clock the gallery previewed an exhibition of twenty-eight modern artists, including future onceños Francisco Antigua (1920–1983), Agustín Cárdenas (1927–2001), and Raúl Martínez alongside more established artists of earlier vanguardia generations, among them Peláez, Lam, Portocarrero, and Víctor Manuel García (1897–1969). The evening continued with an address by Raúl Roa (1907–1982), Director of Culture at the Ministry of Education and later a prominent foreign servant; a musical performance under the direction of Edmundo López (1922–1992), of the Conservatorio Amadeo Roldán; and a performance of August Strindberg's *The Stronger* (1889). Nuestro Tiempo survived on a shoestring budget at the beginning, periodically resorting to oil lamps and candles when the electricity was shut off and asking for collections—sometimes, in the form of paintings—from older members.[48] Yet whatever its early struggles, its importance at an increasingly volatile moment can hardly be overstated: Nuestro Tiempo provided a venue, free from the state apparatus, in which the radical aesthetics and politics of a new vanguardia could begin to incubate, with stimulation and support provided by like-minded peers across the disciplines. "We thought that with this work in common, with these colleagues who are committed to the development of their own work," Bueno wrote, that the young vanguardia could "overcome in good measure the attacks which the misunderstanding, the vacuity and the indifference of an entire society" had set upon them.[49] The emergence of an activist corps around Nuestro Tiempo challenged the hermeticism of the *Orígenes* group, a further sign of the generational reshuffling of Havana's artistic landscape.

Havana had a three-tiered cultural hierarchy during this period, which encompassed everything from the venerable institutions founded at the beginning of the republic to the alternative spaces opening around the new vanguardia. At the top of the pyramid remained the formal institutions: the national Dirección de Cultura, which oversaw the National Salons and other exhibitions; the Ateneo Círculo de la Habana (1902–72), dedicated to spreading cultural awareness; the Sociedad Pro-Arte Música (1918–67), a center for theater and ballet energized by the return of legendary ballerina Alicia Alonso (b. 1921) to Cuba in 1950; and the Lyceum Lawn Tennis Club (1928–68), a women's society devoted to social service and education. A stalwart supporter of the vanguardia, the Lyceum nurtured many of the emerging onceños, offering exhibition opportunities and fostering a cultured intellectual climate through sponsorship of numerous academic conferences, a public library, and a literary journal (*Revista Lyceum*). Collectively, these more senior institutions "defined standards and boundaries (through literary prizes, publishing opportunities, and so on) and determined and legitimised cultural production."[50] At the bottom were short-lived vanguardist groups, such as Los Once (1953–55) and the group that gathered around the journal *Ciclón* (1955–57; 1959), a riposte to *Orígenes* launched by Rodríguez Feo after a falling-out with Lezama Lima. These groups, unburdened by institutional obligations, were at liberty to experiment freely with Euro-American forms, which they often did from a radical or countercultural point of view. "Between these two," Kapcia observes, "the main manifestations of a Cuban culture could be found: partly establishment-oriented (led by university-based intellectuals, in private clubs, centres or institutes) but more politically critical and willing to experiment or go outside accepted artistic norms, a 'middle' where prizes, newspapers and other private means of recognition kept writers and artists afloat financially and kept popular and tentatively avant-garde forms in uneasy coexistence."[51] Within this important intermediary space arose, for example, Erik Santamaría's Teatro Experimental de Arte (f. 1952)[52] and the Cine-Club Visión (1955–60), later a fertile recruiting ground for ICAIC (Instituto Cubano de Arte e Industria Cinematográfico).[53] Nuestro Tiempo was preeminent within this "middle" ground: its advocacy on behalf of an embattled vanguardia supported underground resistance efforts against the Batistato, and its journal and exhibition galleries provided a reliable space for cultural activity.

INVENTARIO AND THE STATE OF ART CRITICISM

While the literary culture of the 1950s in general has long been recognized for its innovations, the visual arts—and by extension, art history and criticism—have gone largely unrecognized for their progress and professionalization.[54] In an article unflattering to his peers as well as to more-established curators and critics such as Guy Pérez Cisneros (1915–1953) and Gómez Sicre, Luis Dulzaides Noda took issue with the anachronistic state of art criticism in 1950, faulting a dated belletristic and anecdotal national tradition.

Underlying his censure of the bland reviews of the 1950 National Salon, for example, was ambivalence about both the "formal values" on display and the "discourse" that had failed to properly critique them: "It is curious to observe how in Cuba one doesn't discuss aesthetic questions. The case of the last National Salon is a fine example. Of the ten prizes for painting, there was only one for an academic and not a single public protest. That would suggest that the success of the so-called 'modern' painting is an indisputable fact. And yet this is not in itself a foregone conclusion. For example: no one knows which formal values earned [José M.] Mijares the first prize, nor the reasons why Mariano [Rodríguez] won the second prize. The comments that were made were of the most picturesque kind: 'an elaborate and sincere painting,' 'I like it,' etc. There is no discourse. Is no one interested?"[55] Dulzaides Noda was not wrong to take these reviewers to task for platitudes and empty praise. But criticism of the more analytic kind that he called for was just coming of age in Cuba (and elsewhere) in 1950; and while Greenbergian formalism, for instance, gained little traction in Havana, a new generation of critics led by Texidor and Pogolotti significantly advanced the level of arts writing over the decade, their work evolving in concert with that of the young vanguardia artists whom they championed.[56]

Cuba lacked a dedicated arts magazine until the late 1940s, and published reviews and essays appeared for the most part in literary journals, a likely corollary to their essayistic bent. *Orígenes* occasionally included writing on art, dedicating an issue to Arístides Fernández (1904–1934), for example, on the occasion of his 1950 retrospective, and publishing a survey by Oscar Hurtado of six contemporary sculptors.[57] Features on established artists of Cuba's historical vanguardia and a broadly belletristic treatment of the arts were characteristic of *Orígenes* and other journals, which mostly left off current exhibition reviews, passed over the third-generation vanguardia, and neglected arts news in general. Other publications of this kind included José María Chacón y Calvo's prestigious *Revista Cubana* (1935–57), later edited by an advisory committee under the Dirección de Cultura, and *América* (1939–58), the organ of the Asociación de Escritores y Artistas Americanos, which featured both Cuban and Pan-American contributors. The *Revista Lyceum*, revived in 1950 and published for six years, featured reports on its institutional programming supplemented with thematic issues (for example, Paris in August 1951; Martí in May 1954). "Even culturally oriented or general-interest magazines were in shorter supply, not helped by the influx of syndicated American material," Kapcia has remarked, and there were limited outlets through which the newest vanguardia could establish itself.[58] The newspaper *Diario de la Marina* (1832–1960) and the weekly *Carteles* (1919–60), for example, had designated art columns, written by Rafael Suárez Solis (1881–1968) and Carreño, respectively, but their reviews were limited in scale and directed to a general, rather than an artworld, readership.

Cuba's first dedicated arts magazine was the slightly amateurish and low-budget *Inventario*, published by Dulzaides Noda on a monthly basis (in later years, irregularly) between 1948 and 1952 (fig. 9). The magazine adopted something of a lone-wolf

Inventario

MENSUARIO POLÉMICO DE ARTE Y LITERATURA

INVENTARIO, Mensuario Polémico sobre Arte y Literatura. Año 1, No. 9. Mayo de 1949. Correspondencia al Apartado 368. La Habana, Cuba. Sigue dirigido por LUIS DULZAIDES NODA. Dibujo de la portada de PEDRO ALVAREZ. Impreso por Ayón en su taller de Consejero Arango 270. La Habana

Textos de Robert Altmann, Persiles García, Carlos Ximénez Arroyo, Edgardo Martín, Luis Dulzaides. Por ahora sigue su interior mimeografiado, hasta más ver. No se vende en ninguna parte. Se le reparte gratis a los amigos y a los enemigos, a estos últimos por cortesía. La inserción de artículos firmados no supone obligadamente la opinión del Director.

FIGURE 9

Inventario 1, no. 9 (May 1949).

philosophy, taking on its founder's disputatious personality as well as a self-consciously iconoclastic position. In the second issue, Dulzaides Noda admitted that "no one was looking favorably at the appearance of a magazine like *Inventario*." Yet he remained resolute: "Free of any compromise as concerns schools, trends, groups or individuals, its purpose is to put up a fistfight for the best in art and literature."[59] Dulzaides Noda made no concessions, either with his journal or in his own criticism, hurling scathing and deeply cynical vitriol against nearly all the artists of his time. "The criticism of Luis Dulzaides went far beyond the realm of aesthetics," Consuegra later wrote, "getting into the private lives of those about whom he wrote—hitting them where it hurt—and teeming with what we call in Cuba *'mala leche'* [sour milk]."[60] Over the twenty-seven-issue run of *Inventario*, Dulzaides Noda accused two artists—Enrique Moret (1910–1985) and Lorenzo Romero Arciaga (1905–?)—of Stalinist solicitation during trips to New York, deemed the wedding of Antonia Eiriz (1929–1995) and Manuel Vidal (1929–2004) "scandalous," and alluded derisively to spinal lesions, caused by poliomyelitis, that afflicted Oliva.[61] But gossipy tabloid fodder aside, *Inventario* pioneered a print medium that capably reported on national and international art news, reviewed exhibitions and publications, and featured new work by the vanguardia.

In that latter sense, *Inventario* anticipated the more stylized and objective *Noticias de Arte*, with which it shared a cosmopolitan point of view and broadly americanista orientation. Although Dulzaides Nota authored the majority of the texts, he printed (sometimes on type-written pages) contributions from prominent intellectuals of that time.[62] Guido Llinás (1923–2005), among Dulzaides Noda's favored artists, contributed an article with hand-drawn illustrations, "See the world . . . See Greenwich Village!" to the penultimate issue. His essay reviewed the familiar haunts of the New York School on MacDougal Street (Champagne Gallery, Pangloss BookShop, Rienze Gallery) and commented on the *"bohemia"* of the downtown crowd with not a little admiration. "Some may think that they [the New York School] are European imports, spirited away from Paris and planted in the heart of New York," Llinás concluded. "They may be right (or not?). The interesting thing is that they live with absolute and total honesty in a milieu that is respectable, even with its exaggerations, fabrications and tourists, and though from the margins of the world and of their peers they embody that motto of Yankee happiness: 'Live and let live.'"[63] Among the magazine's other international correspondents was Mario Albano, who wrote from Buenos Aires in praise of the dispatches from Cuba: "Journals from Havana arrive regularly in Buenos Aires. Almost all of them show a concern, an ardent desire to do things in the best way possible so that the freshness of the world imbues their pages. . . . There is something, something evident and enviable, which tells me that these men [the Cubans] are closer to the kernel of life than we are."[64] Albano is piqued by the spunk and determination of *Inventario*, in spite of its material deprivations and the less-developed arts scene of Havana, relative to the sophistications of Buenos Aires. Abstract art was already more advanced in Argentina, developed through

contact with the Uruguayan Constructivist Joaquín Torres-García (1874–1949) and by the *Grupo Madí*, which pioneered geometric abstraction in the Southern Cone in the 1940s. One of the founding *madistas*, Gyula Kosice (b. 1924), was a named contributor to the rival magazine in Havana that appeared in 1952 and eventually supplanted *Inventario* as the journal of record for the artistic vanguardia. Dulzaides Noda dutifully recorded the appearance of *Noticias de Arte* in the twenty-third issue of *Inventario*, noting wryly that its appearance "hardly changed the world." He opined, with characteristic churlishness, "*Noticias de Arte* is an informative newsletter, very balanced, in the manner of stereotypes and Trojan Horses and with fewer pretensions than a sundae."[65] *Noticias de Arte* succeeded nevertheless, immediately raising the quality of art news available in Cuba and positively defending—and, taking care to explain—modern art.

NOTICIAS DE ARTE

Among the many experimental, artist-run magazines hatched during this time in Europe and the Americas, *Noticias de Arte* embodied the interests and activities of Havana's modernist movement in the early 1950s, clearly expressed from the vanguardia's point of view (fig. 10). The magazine was the collaborative effort of three artists: Carreño, a veteran of Havana's second-generation vanguardia; Sandú Darié (1906–1991), a Romanian émigré and life-long abstractionist who settled in Cuba in 1941; and Luis Martínez Pedro (1910–1989), also an artist of the Havana School who worked in geometric abstraction through the end of the decade (fig. 11). Carreño, the most internationally recognized of the three artists and the best connected, took the organizational lead; familiar with the American quarterly *The Tiger's Eye* (1947–49), which promoted Surrealism and the transatlantic avant-garde, and with European imprints including *Arts, Nouvelles Littéraires*, and *The Studio*, Carreño modeled *Noticias* in their mold. The first of eleven issues appeared in September 1952, but planning had begun in earnest over the summer, as detailed in a letter from Carreño to Gómez Sicre on July 22 that sheds light on their early concept. "Thank you for your enthusiastic letter about the magazine project," he began. "I have great hopes that it will be a success. . . . I think that we can count on strong collaborators, for example [Enrique] Labrador [Ruiz] will do the literature page, Edgardo Martín, the one on music; Nicolás Quintana, architecture. Film, [José M.] Valdés Rodríguez y Parés. Theater, Luis Amado Blanco. Additionally, we will collaborate with everyone who wants to help. I will do the section on the visual arts in Cuba and Latin America; Darié will do the section on international art. . . . In any event, send me all the photographic material that you can. We want to have all the material ready around August 15, so that we can have the first issue on the newsstands by the first days of September."[66] The letter goes on to relate some more personal news, and Carreño concludes with a few words about his own work: "I have painted a lot lately. Very somber things, very abstract and with more vibrant colors than the ones that I made in New York, as the *materia* is more rich, more

JUVENTUDES MUSICALES

El día 9 de septiembre llegará a La Habana el Sr. Marcel Cuvelier, Director General de la Sociedad Filarmónica de Bruselas, fundador de las Juventudes Musicales, Director General de Juventudes Musicales de Bruselas, Secretario General de la Federación Internacional de las Juventudes Musicales y Secretario General del Consejo Internacional de Música, creado por la Unesco. El ilustre visitante viene con el encargo conferido por Consejo Internacional de la Música de tratar de constituir un Comité Nacional de dicho Consejo en Cuba y que se integrará por personalidades representativas de todos los sectores musicales. Al mismo tiempo, el señor Marcel Cuvelier trae el propósito de constituir una sección de las Juventudes Musicales, a semejanza de las que ya se han constituido en Europa.

suscitar cambios de opiniones sobre los distintos métodos de enseñanza musical.

El día 10 el señor Cuvelier dictará, a propósito de sus proyectos y de los del Consejo Internacional de Música, una conferencia en el Lyceum.

ARTE CUBISTA Y FUTURISTA

El Museo de Arte Moderno de Nueva York, acaba de inaugurar una exposición de pintura bajo el título de "Arte Cubista y Futurista". Todas las obras expuestas pertenecen a su importante colección, y es la primera vez que son presentadas en su totalidad, ofreciendo un magnífico ejemplo de la evolución de los más importantes movimientos del arte contemporáneo. Se puede observar en ella el desarrollo lógico y las conquistas estéticas de los

el Cubismo y el Futurismo, movimientos que tienen algunos puntos de contacto entre sí.

Junto a esta exposición, el Museo presenta dos más, una de dibujos de Picasso titulada "Picasso entre dos guerras, 1919-1939", y otra organizada por Dorothy Miller en la que aparecen obras de siete pintores americanos: Georgia O'Keefe, John Marin, Morris Graves, Charles Demuth, Ben Shahn, Prendergast y Hooper.

LA "CASA DE LAS AMERICAS"

Armando Maribona, el polifacético miembro del Consejo Consultivo, ha presentado dos proyectos que fueron aprobados por dicho Consejo, de gran interés para los artistas. El primero propone convertir al ex-convento de San Francisco, en la "Casa de las Américas",

NOTICIAS DE Arte

PINTURA
ESCULTURA
MÚSICA
TEATRO - BALLET
ARQUITECTURA
CINE - LITERATURA

AÑO 1 Nº 1 LA HABANA, CUBA SEPTIEMBRE, 1952 PRECIO: 30 CTVS.

El Consejo Internacional de la Música, del que el señor Cuvelier es Secretario General, tiene por objeto: 1) reforzar la cooperación entre las organizaciones musicales internacionales o naciones; 2) promover la creación de nuevas organizaciones internacionales donde aún no existan; 3) Promover en los distintos países la creación de organizaciones musicales y a ser posible de Comités Nacionales; 4) suscitar, coordinar y promover la organización de concursos, festivales, oposiciones musicales y reuniones de expertos, con carácter regional o internacional; 5) ayudar a la difusión de obras musicales, a la distribución de instrumentos de música y al intercambio de personas; 6) estudiar las proposiciones que se le sometan desde todos los campos de las actividades musicales; 7) interesarse por la situación moral y material de los músicos y de las sociedades musicales de profesionales y aficionados; 8) promover la cultura musical en todos sus aspectos en la educación general y

pintores modernos, desde Cezanne hasta Braque y Picasso.

Magníficos ejemplos de Juan Gris, la Fresnaye y Duchamp, demuestran y profetizan la pintura de los artistas de hoy. Es un resumen de cincuenta años de arte presentado con todo su esplendor en el centro de Manhattan; es una contribución internacional y en particular europea, porque a la sombra de los rascacielos se puede apreciar la belleza de tanta pintura ya histórica creada por españoles, italianos, franceses y americanos. El éxito de la exposición, presentada magníficamente, como acostumbra el M.A.M. de Nueva York, se debe especialmente, a su ex-director Mr. Alfred H. Barr Jr. quien actualmente dirige la colección permanente de dicho museo.

Esta exposición promete tener la misma influencia sobre el gran público, como la que en 1936 organizó también el Sr. Barr bajo el título de "Cubismo y Arte Abstracto". En la actual se trata de hacer una comparación entre

una vez que el Ministerio de Comunicaciones, que actualmente ocupa el edificio, se cambie a su nueva sede en la Plaza de la República. En este lugar, que se denominará también "Centro Interamericano de Cultura", se reunirán varias instituciones latinoamericanas de carácter cultural, entre ellas la Galería de Arte "Cuba-Estados Unidos", la cual proyecta hacer un Salón de Arte Contemporáneo de las Américas. La segunda iniciativa es la de que se establezca por Ley Decreto un 6% del costo total de todo edificio público del Estado o del Municipio, y el 3% del costo total de las edificaciones particulares, como cines, hospitales, etc., para decoración de los inmuebles con pinturas y esculturas hechas por artistas cubanos. Ojalá que estas iniciativas no se queden en el "Consultivo" y sean aprobadas por el Consejo de Ministros.

FIGURE 10

Cover, *Noticias de Arte* 1, no. 1

(September 1952): 1.

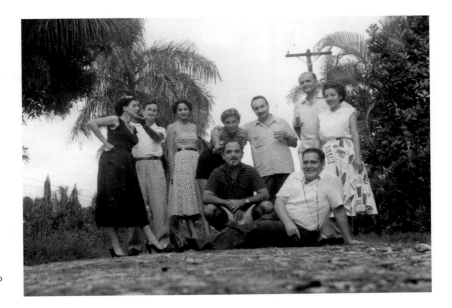

malleable."[67] By mid-decade, Carreño, Darié, and Martínez Pedro would become evangelists for concrete art, but the journal was broadly inclusive of vanguardia practices across the three generations.

The editors laid out the mission of *Noticias de Arte* in the first issue, clearly defining a didactic and a critical purpose. They open their editorial statement by explaining that they did not wish to be "just another magazine"; rather, they intended to expand Cuba's cultural purview through objective reporting on "every manifestation of national and international culture that reflects the concern that animates the ongoing creative activity of artists of today and of all time" (fig. 12). Indeed, they aspired "to be a true source of pride for those who care about improving our cultural environment, for those that fight against mental laziness, apathy and indifference toward art."[68] The magazine, if not quite the first of its kind in Cuba as it claimed, took up its self-appointed mission with serious resolve. Its pages reflect on the one hand its informational character, with articles that attempt to broadly define modernism and its historical and critical situation, and on the other hand its international scope, with reports on art news from around the world. That dual charge—to raise Cuba's cultural awareness and to provide up-to-date news— was well served by a combination of shorter news items and longer features, which covered not only the visual arts but dance, music, literature, and film as well.

What distinguished *Noticias de Arte* from later arts magazine that appeared over the course of the decade was its keen cosmopolitan horizon, which aimed to put modern Cuban art on the international map. The magazine regularly printed articles from a far-ranging community of art historians and critics, among them Alfred H. Barr, Jr. (1902–1981), the first director of the Museum of Modern Art in New York ("¿Es el Arte Moderno

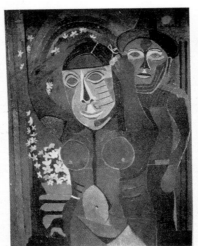

FIGURE 12

"Presentación," *Noticias de Arte* 1,
no. 1 (September 1952): 3.

PRESENTACION

"Carnaval", óleo del pintor mexicano Rufino Tamayo. Colección
Phillips Collection, Washington, D. C.

ARTE MEXICANO EN PARIS

En el Museo de Arte Moderno de París se inauguró en la primavera
una gran exposición de arte mexicano. Es la primera vez que un
país de América ofrece a los franceses y a los europeos en general,
un conjunto tan completo y representativo de obras de arte, de la
época prehispánica hasta nuestros días. En admirable selección, fi-
guran desde los artistas populares hasta los pintores modernos mexi-
canos.

El éxito de la exposición ha sido total y la crítica quedó deslumbrada
ante las maravillas mexicanas como si las descubriera por primera
vez. Para los habaneros, esta exposición probablemente no hubiera
sido del todo una novedad; un conjunto reducido de ella estuvo en
exhibición durante un par de años en el Municipio de La Habana. El
arte mexicano, tanto por tratarse de un país hermano como por la
curiosidad que ha despertado desde hace mucho tiempo entre nosotros,
no tiene, para los cubanos amantes de ese arte, ningún secreto.

Un artista francés destaca el sentimiento de la muerte que aparece
en los dioses esculpidos en piedra tanto como en los más íntimos obje-
tos populares, tal como domina en el pensamiento del mexicano, in-
fluyendo lógicamente en los pintores de la época moderna, más re-
cientes, como Orozco, Diego Rivera, Siqueiros y Rufino Tamayo.
Para el cultivado y refinado francés, el arte mexicano descubre un
nuevo horizonte hacia un mundo maravilloso, hasta hoy desconocido
por él.

Ante las imágenes religiosas de los artesanos mexicanos, la aprecia-
ción de la crítica ha sido encontrar los santos martirizados por segunda
vez. Observan que generalmente el arte mexicano está dominado por
una angustia ancestral, que se refleja en el moderno Tamayo en contras-
te de sombra y luz, testimonio de una poesía íntima. Las críticas más
elogiosas son, sin reserva para el total de la exposición, exceptuando
un grupo de poetas y críticos que, encabezados por Benjamín Peret,
condenaron la representación de Siqueiros, por consideraciones de
orden político, que nada tienen que ver con el arte en sí. Esta magní-
fica exposición, organizada por el Gobierno de México, está exhi-
biéndose actualmente en Estocolmo, Suecia, y probablemente visitará
otras capitales europeas, en vista del interés que ha despertado en el
viejo continente.

NOTICIAS DE ARTE

Es nuestro propósito que NOTICIAS DE ARTE no sea
"una revista más", sino el eco de una imperiosa necesidad
de nuestro medio artístico, el cual reclamaba una publica-
ción que pudiera presentar de manera condensada y selec-
cionada las distintas y variadas actividades intelectuales
que forman la sensibilidad y el devenir del pensamiento
contemporáneo. NOTICIAS DE ARTE no se propone
"llenar un vacío" como dicen pomposamente algunas publi-
caciones noveles, sino contribuir modestamente, de acuerdo
con sus posibilidades, a ensanchar nuestro ambiente cultu-
ral, divulgando sin prejuicios que pudiesen empañar la libre
expresión del pensamiento, toda manifestación cultural na-
cional y extranjera que refleje la inquietud que anima la
constante actividad creadora del artista de hoy y de
siempre.

Queremos que el público pueda estar plenamente infor-
mado de cuanto ocurre de interés en la actualidad artística
internacional y local, y que los artistas encuentren en NO-
TICIAS DE ARTE un medio de difundir y defender sus
ideas y sus anhelos sin discriminaciones de tendencias o
credos. La crítica que dediquemos a los distintos eventos
artístico será muy reducida, muy concisa, debido a la
falta de espacio en nuestras páginas, pero trataremos de
que ésta sea siempre constructiva y orientadora. Obser-
varemos que toda información reproducida contenga abso-
luta seriedad y veracidad.

Como NOTICIAS DE ARTE no es una empresa de lu-
cro, tratándose, como el lector obviamente puede compro-
bar, de un gesto completamente desinteresado, el apoyo
que logre del público será destinado exclusivamente al
mantenimiento y mejoramiento de la publicación, al aumen-
to de sus páginas y de su material gráfico y literario.
Abrigamos grandes esperanzas de que en un futuro no muy
lejano NOTICIAS DE ARTE sea un verdadero orgullo
de aquellos que se preocupan por el mejoramiento de nues-
tro ambiente cultural, de los que luchan contra la pereza
mental, la apatía y la indiferencia hacia el Arte.

Hacemos llegar al público nuestro mejor saludo en la
seguridad de que acogerá con entusiasmo esta publicación
que por su carácter, es la primera que se edita en Cuba.
También queremos expresar nuestro profundo agradeci-
miento a todos los colaboradores por la valiosa, eficiente y
desinteresada labor que prestan a NOTICIAS DE ARTE.

LOS EDITORES.

3

Comunista?" no. 6); Le Corbusier (1887–1965), the modernist architect and utopian urban
reformer ("La Escala Humana en la Arquitectura," no. 3); and Jorge Romero Brest (1905–
1989), the seminal Argentine art critic of the postwar period ("¿Qué es la Escultura?"
no. 2). Not surprisingly, the editors favored New York and the United States in general
with steady coverage, publishing briefs on the Museum of Modern Art's twenty-fourth
birthday (no. 7), for instance; a feature on Adja Yunkers (1900–1983), whom Carreño
knew through his professorship at the New School for Social Research in New York
("Los Grabados de Adja Yunkers," no. 4); and, naturally, a review of *7 Cuban Painters*,

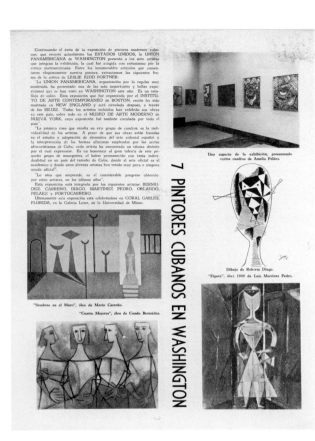

FIGURE 13

"7 pintores cubanos en Washington," *Noticias de Arte* 1, no. 2 (October 1952): 6. The exhibition featured the works of Cundo Bermúdez, Mario Carreño, Roberto Diago, Luis Martínez Pedro, Felipe Orlando, Amelia Peláez, and René Portocarrero.

a traveling exhibition organized by Gómez Sicre (no. 2; fig. 13). The modern, americanista orientation betrayed the aspirational quality of Havana's avant-garde as it looked self-consciously and admiringly to the United States. Writ across the pages of the magazine were not only the visual forms of modern art, impeccably and lavishly illustrated, but also the entire apparatus—in cubanista terms, the integral imagined community—that supported it, which is to say the institutions, exhibitions, critics, and collectors in its midst.

The steady publication of happenings within the international arts community no doubt kept the Cuban vanguardia up-to-date on trends and important personalities. But just as importantly, the magazine broadcast the work and critical activities of the local vanguardia far beyond the island, mailing copies to museums across the Americas and to Europe. *Noticias de Arte* proudly celebrated the participation of its artists in exhibitions abroad, from small write-ups about solo exhibitions to multiple-page spreads for major group shows. The first issue covered Cuba's delegation to the *XXVI Venice Biennale* (1952), which included each of the magazine's editors along with twelve other artists culled from the three vanguardia generations. Invited to exhibit for the first time, Cuba projected a distinct, modern style that inclined toward abstraction, even from older artists such as Portocarrero and Mariano Rodríguez, whose traditionally figurative approaches appeared in unusually simplified forms. Much the same can be said of the Cuban delegation that traveled to the *II São Paulo Bienal* the following year. Each of the thirteen artists was featured in the final issue of *Noticias de Arte*, which published a photograph of the artist alongside reproductions of his or her work and a short biography.

While *Noticias de Arte* played heavily to North American interests, its coverage of the São Paulo Bienal was characteristic of its efforts to forge connections within the Latin American world as well. Reports from Mexico, Argentina, Chile, and Brazil appeared regularly in Darié's "International Art" leader, filed on events ranging from the debut of a prima ballerina at the Teatro Colón in Buenos Aires (no. 3) to the publication of *México y lo mexicano* by the Venezuelan writer Mariano Picón Salas (1901–1965) (no. 7). Of more sustained interest was the collaborative relationship with Kosice, the creative force behind the nonfigurative *Madí* movement in Argentina, established through the friendship of Sandú Darié. In a show of avant-gardist fellowship, Kosice wrote to Darié in support of the magazine, calling *Noticias de Arte* a "transcendent magazine from every

point of view, above all for the training and guidance of young people hungry to see their time and their art publicized, especially within Latin America, in which magazines are counted on to play an essential role in this regard." In closing, he affirmed his interest and asked "to be added to the list of collaborators," offering to send "material for the magazine—essays, paintings, poems, sculptures and also works from [his] Madí colleagues, who delighted over the first issue."[69] The encouragement of the Argentine avant-garde no doubt buoyed the Cubans, confirming their commitment to the modernist enterprise and, in particular, to abstraction, expressed not only as a visual form but also as an ideational culture. The Madí artists believed in the transformative potential of art to serve society—believed, in fact, in art as a new humanism for the postwar century—and that boundless utopianism, hardly unfamiliar to the Cuban vanguardia, suggested a counterpresence to the existential literature reviewed in the same issue in which Kosice's letter appeared.[70]

The earnest ambitions of *Noticias de Arte* and its determined cosmopolitanism set an auspicious tone for Cuba's developing cultural scene over the course of its fourteen-month run. Although the magazine set itself apart with its international coverage, it also aimed to be a comprehensive source of information for art news within Cuba itself—in Havana of course, but also in the outlying provinces, as seen in a feature on Camagüey, located in the center of the island (no. 7).[71] The magazine provided consistent coverage of the local art scene, noting openings, conferences, lectures, and the like on the "Cuban Art" page, edited by Carreño. A harbinger of local architectural discourse, Quintana's article on arts integration (no. 2) included illustrations of a mural by Robert Motherwell at a school in Attleboro, Massachusetts, designed by The Architects' Collaborative, a firm led by Gropius (fig. 14). Unlike the bare-bones nihilism of *Inventario*, *Noticias de Arte* projected a polished and unwaveringly positive future for Cuban art, its prognostications made in hopeful anticipation of things to come. Its utopianism was of a piece with the time, yet by 1953 its fortunes turned in the aftermath of the Batista coup. Tidings of change appeared on the back cover of the final issue in two short announcements: "Contra la Bienal hispana," which notes the protest lodged by many within the vanguardia against the staging of a biennial imported from Francoist Spain, and "El 'Grupo de Los 11' expone," on the breakthrough exhibition of Los Once at the Lyceum. These two events, the Bienal and the emergence of Los Once,

FIGURE 14

Nicolás Quintana, "Arquitectura: Integración," *Noticias de Arte* 1, no. 2 (October 1952): 7.

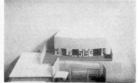

polarized cultural politics over the following year and through the remainder of the Batista regime.

Noticias de Arte ceased publication with this issue, likely on account of financial difficulties and with no printed warning, leaving Havana without a local chronicle of art news. Yet however premature its end, Noticias de Arte had ably distilled the cultural pulse of Havana at the dawn of the "horizon of vanguards": unmatched in its editorial reach and its integration of Cuban and international arts news, it cultivated an updated, modern identity for the vanguardia. More broadly, the turn-of-the-decade emergence of new media—arts magazines, cultural organizations, professional collectives—signaled a paradigm shift for Cuba's modern movement, which for the first time had the beginnings of a self-sustaining infrastructure that could support its artists within local and transnational networks. The futurity of modern Cuban art augured brightly, as its youngest vanguardia converged in cafés and began to render the received discourses of modernism in national and cosmopolitan—and, ultimately, cubanista—terms. That incipient infrastructure was tested relentlessly during the Batistato, and the third-generation vanguardia faced head-on the obstructions of dictatorship as it mobilized in defense of Cuba Libre.

2 Los Once and the Polemics of Abstraction

The "horizon of vanguards" that appeared at the dawn of the 1950s fostered a climate favorable to artistic revolution, and the emergence of Los Once signaled a changing of the guard both in generational respect to Cuba's historical vanguardia and, culturally, within the cubanista compass. A group of nominally eleven, but in practice a fluid number of like-minded and proto-abstract young artists, Los Once constituted themselves in April 1953 and exhibited frequently until their preemptive disbanding in 1955 and final dissolution in 1963. In the simplest sense, the rapid gestation of the onceños fed on the convergence of abstraction, a presence in Cuban art since the 1940s and approaching a critical mass by 1952, and the political fallout from the Batista coup staged in the same year. Yet the conjunction of abstract art and democratic politics was not merely circumstantial, even if it soon seemed providential (certainly, it was opportunistic). Significantly, the alignment of gestural abstraction with the strident generationalist movement reverberating from Moncada marked its protagonists with a powerful sense of their historical destiny and stoked their professional ambitions. Against the backdrop of the New York School and the beginnings of what has been described as a triumphal decade for American painting, Los Once promulgated abstract art as simultaneously Cuban and cosmopolitan (that is, cubanista) and choreographed their rise with a fine degree of international—americanista and transatlantic—self-awareness. "There exists now an opportunity to introduce ourselves," the elder-generation artist Felipe Orlando noted upon his return to Havana in 1952, following extended travel abroad. "Europe is in full artistic effervescence and is looking to America. . . . A policy of targeted dissemination abroad may produce untold results."[1] The prospects, however improbable, of Cuban art rising to a position of authority marked a fundamental shift in perception, inverting historical patterns of cultural exchange and furthering the exceptionalist mentality of the incipient onceños. In a clear shift away from the sublimated nationalist ethos of the historical vanguardia, Los Once staked their generational identity on the iconoclastic gesture of abstraction and its redemptive, cubanista valence.

The production and, almost as meaningfully, the exhibition of cubanista abstraction preoccupied the onceños over the course of the decade. Although public discourse around abstraction encompassed both its gestural and its geometric movements, at

times conflating them, by the opening of their eponymous first exhibition Los Once had become virtually synonymous with (American) Abstract Expressionism. Concrete abstraction, while no less cosmopolitan and in many ways more sophisticated, lacked the essential americanista and generational associations of gesture painting and registered little political purchase until the very end of the decade. The younger onceños, better attuned to the social character of the early Batistato, leveraged abstraction as an ideological platform, harnessing a group-wise and generationalist identity to enfold and legitimize their activity within a radicalized cubanista framework. During Los Once's prime (1952–55), they mounted a succession of exhibitions that cemented their status as a third vanguardia generation (not without controversy, laying claim to the national artistic patrimony). Lodging their activity as "a point of attack [to transform] the aesthetic ambience," in the words of Raúl Martínez, the onceños also claimed activist agency, insisting that their work could fundamentally inscribe itself—as both chronicle and critic—within the contemporary political discourse. "We also discovered that abstract art was the only weapon with which we could frighten people," Martínez explained. "When we mounted an exhibition, people were left in a state of shock. Then it seemed to us that our painting served as a means to raise consciousness."[2] The agitations of the onceños shed light on the reality of vanguardia practice by the 1950s, and the group's struggles—within both the cultural and the political arenas—served, too, as a referendum on the praxis of abstraction across the postwar Americas.

Los Once's early momentum brought international attention to Cuban abstraction by mid-decade, enfolding the group within inter-American and Cold War debates over the cultural politics of modern art. The following two chapters consider the controversy over the *II Bienal Hispanoamericana*, the ensuing fragmentation of Los Once, and the complexities of Cuba's altered cultural field at home and abroad. The group's cubanista provenance ultimately vouched for its credibility in later years, and indeed its genesis in the crosshairs of the rebel *generación del centenario* and the historical vanguardia imparted a strong, national character to its practice of abstraction. By inscribing themselves into the vanguardia tradition as a third generation, the onceños came into a rich inheritance of political activism and modern aesthetics. Tidings of generational succession were in the air by the time of the revived National Salon in 1950, and in fewer than three years the ascension of Los Once marked the beginnings of a decade-long radicalization of art's inflection points within the political arena. Los Once positioned abstraction as the cubanista culmination of Cuba's vanguardia legacy, and their pre-history and first group exhibitions set forth the ideological stakes of their artistic gambits.

THE VANGUARDIA INHERITANCE

Cuba's historical vanguardia spanned three generations—1927, 1938 and, including Los Once, 1953—that spirited the modernizing zeitgeist of the Cuban republic at key junctures. The first generation blazed the oft-declared "critical decade" of modern Cuban art in 1927, breaking ground for the rise of the internationally acclaimed Havana School during the 1940s. In the hands of the second generation, the national iconography and loosely expressionistic style of the original vanguardia remained paradigmatic, even through increasingly florid amplifications. The provisional acceptance of Los Once as a third generation betokened a cultural change beyond the shock value of abstract art, and the irruption of the onceños at the National Salon in 1950 and soon after in their eponymous group exhibitions marked a more profound challenge to the enshrined vanguardia. Los Once surely profited from the cultural capital built up by their vanguardia predecessors, however, and their filial "authenticity" underscored the cubanista rationale behind abstraction.

Cuba's original vanguardia generation reached artistic maturity in the post-independence era and in a definitive way mapped the terms of Cuba's modern movement around contemporary nationalist discourse. Like their colleagues in São Paulo, who drew upon the metaphor of anthropophagy to reorient Brazilian art around a local axis, the Cuban vanguardia evolved "*lo cubano*" through the selective metabolism of foreign and autochthonous sources. Breaking definitively with the outmoded post-Impressionism still taught at the Academia de San Alejandro, a conservative mainstay, the vanguardia looked abroad for new visual ideas and reinscribed them within the Cuban context, often with an emphasis on everyday life and national iconography. Nearly all of this generation studied abroad during the 1920s, and their absorption of European modernist paradigms informed their reengagement with premodern Cuban sources: the sexualized Surrealism of Carlos Enríquez (1900–1957) and its Afro-Cuban derivations, for instance, or the baroque ironwork and stained-glass *vitrales* read through flat-pattern Cubism in the case of Amelia Peláez (fig. 15). As the vanguardia poet and Communist Party leader Juan Marinello (1898–1977) remarked, the mantra of this generation was "to view the indigenous (Spanish-African popular culture) with the eyes of foreigners and to view the foreign with Cuban eyes."[3] Among the defining artworks of this generation, *Gitana tropical* (fig. 16) by Víctor Manuel epitomizes the mestizo imprint within Cuban culture, conjoining School of Paris aesthetics with the local topos ("Cubanizing" color). The first-generation vanguardia traded liberally on this manner of assimilation, redeploying modernist vocabularies through regionally and socially inflected iconography that reinforced the waxing nationalist sentiment.[4]

Their transatlantic voyaging mostly complete by 1927, the vanguardia reassembled in Havana and effectively launched Cuba's modern movement on May 7 of that year with the *Exhibición de arte nuevo*, organized by the cultural magazine *Revista de avance*. At least twenty-one artists participated, among them Eduardo Abela (1889–1965), Fidelio

Ponce de León (1895–1949), Amelia Peláez, Víctor Manuel, Marcelo Pogolotti (1902–1988), and Antonio Gattorno (1904–1980). Pogolotti, who had joined the second-generation Futurist collective in Turin by 1931 and experimented with abstraction and aeropainting, is a particularly noteworthy antecedent to the onceños. Among his most ideational works, *Los campos magnéticos* [*Magnetic Fields*] probes synergies of mind and machine, its industrial parts set against a latently Surrealist ground of elliptical forms (fig. 17). Lauded as "the painter of the most advanced technique and ideas yet produced in [Cuba]" in 1931, Pogolotti committed himself to social values in art, like the other *nuevos* aligning modernist aesthetics with Marxism against the Machadato.[5] The first exhibition in Cuba devoted exclusively to modern art, *Arte nuevo* registered a generational commitment to modernist values, glossed in generalized but unmistakably future-oriented terms. "It represents, and this is essential, the renunciation, the negation of the past," writer Martí Casanovas (1894–1966) declared, locating the work of the nuevos within a broader social

FIGURE 16
Víctor Manuel García, *Gitana tropical* [*Tropical Gypsy*], 1929. Oil on wood. 18¼ × 15 in. (46.5 × 38 cm). Colección Museo Nacional de Bellas Artes de La Habana.

FIGURE 17
Marcelo Pogolotti, *Los campos magnéticos* [*Magnetic Fields*], 1931. Tempera, ink, painted metal collage and nails on paper glued to wood. 13½ × 10½ in. (34.3 × 26.2 cm). Colección Museo Nacional de Bellas Artes de La Habana.

framework of modernization and political reform.[6] "An artist must not turn his back on his society or on the problems and aspirations of his day," Casanovas intoned, calling upon artists to "serve the lofty ideals of culture" in a mandate that reverberated, with increasing urgency, in the discourse that built around the third *vanguardia* generation at the beginning of the 1950s.[7]

In place from the beginning, the activist orientation of the *nuevos* dovetailed with the concurrent rise of the *minoristas*, whose political platform offered visibility across a wider cultural field. Loosely constituted in 1923 as a circle of young, left-leaning intellectuals, the Grupo Minorista (1923–29) issued a *Declaración* on the same day that the *Exhibición de arte nuevo* opened, its release timed to underscore the alignment between vanguard art and the Cuban republic.[8] The de facto manifesto of this generation, the *Declaración* lent support to "vernacular art and, in general, *arte nuevo* in its various manifestations," calling further upon Cuba to assert "economic independence" against "Yankee imperialism," vigorously deriding "political dictatorships" the world over and the "outrages of pseudo-democracy" at home.[9] Marinello warned his compatriots that Cuba would remain only "half free" until the nation could "offer the world a strong and original cultural contribution," and the drive toward what he termed "total liberation" mirrored the totalizing and utopian vision of *cubanía* that drove the generations that

followed.[10] Already rankling in the background were tidings of U.S. loans and continued economic support, secured by Machado just months before he suspended elections and presided over a five-year period of civil discord and violence. As a preemptive staunch against the political course that followed, the *Declaración* established the ideological purchase of the cultural vanguardia and a precedent for collective action. Heterogeneous and largely improvisational as a group, the minoristas nevertheless provided a model for intellectual activism buttressed by the cultural codes of cubanidad. Their equation of artistic production and contemporary labor suggested parallels as well between forms of mechanical and visual innovation, providing an additional measure of support for modern values in painting.

While Cuba's political futures remained embattled through the 1930s, as the country spiraled out of the Machadato through a series of puppet presidents controlled by Batista, acting under the aegis of the military through 1939, the modern art movement progressed along a steadier trajectory. Building upon the work of the first-generation vanguardia, the artists of the Havana School, as they became known, inaugurated a classical phase of Cuban modernism that paralleled the social equilibrium established by the democratic Constitution of 1940. The nature of "lo cubano" continued to preoccupy the principal artists of this generation, among them Mario Carreño, Mariano Rodríguez, Cundo Bermúdez (1914–2008), and René Portocarrero. Their assimilation of modern forms resulted in more painterly and metaphorical expressions of national feeling; by now it seemed possible, even preferable to reference Cuba through idiomatic form and composition alone. "Cubanizing" expression, in the authoritative contemporary opinion of José Gómez Sicre, was realized only "partly through discovering and absorbing the Cuban scene, but even more through the use of color."[11] Carreño established himself as a first-rate colorist early on, and his works from this period—for example, the monumental triptych *El corte de caña*, *Fuego en el batey* (fig. 18), and *Danza afrocubana*, all from 1943— display the baroque sensuality and cultural ethos characteristic of this generation. A poignant embodiment of the agrarian nation, the three figures and the horse depicted in *Fuego en el batey* move stoically as they flee a fire in a sugar-mill town, their heavy, classical bodies rhyming seamlessly and decoratively with the tropical foliage. Such scenes from everyday life and glimmers of the changing social landscape pervade the paintings of the second-generation vanguardia, which largely shed the political militancy and more monolithic nationalism of their predecessors.

The elevation of the second vanguardia happened between the *Exposición nacional de pintura y escultura* of 1935, the first of an irregular cycle of National Salons that proved influential during the 1950s, and the second *Exposición nacional* held three years later. An early validation of the vanguardia, the 1935 Salon showed mature work from the first generation, which occupied the artfully chosen left wing of Havana's Colegio de Arquitectos. The public faced two choices at the entrance to the exhibition: the vanguardia, painting's symbolic "left," opposed the academic "right," whose work filled the

opposite hall. This curatorial segregation reinforced the sentiment that, in its break with the past, the vanguardia better embodied the modernizing Cuban nation, its mood now cautiously flush in the early post-1933 climate. "The left wing contains the greatest potential," Ramón Guirao pronounced, arguing that there "art becomes one with the social determinants and rises to the plane of a representative art, faithful to its times."[12] The first generation was again celebrated two years later at the *Primera exposición de arte moderno*, which further legitimized the vanguardia, by this time a decade removed from the landmark exhibition of the nuevos. New names emerged at the second *Exposición nacional*, and the torch passed symbolically to the second generation, understood as faithful upholders of the modern values enshrined by the Generation of 1927.

The ascendance of this generation crested over the 1940s, corroborated by a number of historicizing exhibitions held in Havana and abroad. Traveling exhibitions formally introduced Cuban art first to the United States, notably at New York's Museum of Modern Art (1944), and in subsequent years to the Soviet Union (1945), South America (1946), and Europe (1951). Closer to home, the vanguardia cemented its credentials in two complementary exhibitions of 1940, *El arte en Cuba: Su evolución en las obras de algunos artistas* [Art in Cuba: Its Evolution in the Works of Some Artists] and *300 años de arte en Cuba* [300 Years of Art in Cuba], both organized by the vanguardia artist Domingo Ravenet (1905–1969) and the critic Guy Pérez Cisneros.[13] Held almost consecutively at the University of Havana, the exhibitions imparted an organic, progressive logic to the

vanguardia's development, assessed first comparatively, with regard to the academy between the years 1920 and 1940, and then teleologically, as the culmination of the history of Cuban art.

Tensions between these two vanguardia generations surfaced at the following year's *Exposición de arte cubano contemporáneo* (Capitolio Nacional, Havana, November 1941). The epithet "contemporary" replaced the originally intended "modern," the organizers acknowledged in the catalogue, due to controversy within the vanguardia over rightful proprietorship of the "modern" appellation. By 1941 there were "indications, strong evidence, of the silent controversy, the rabid rivalry" between the two generations, Pérez Cisneros observed enthusiastically in his review of the exhibition, which he deemed a positive index of the modern movement's "artistic vitality."[14] Having repelled the academic rearguard, the erstwhile nuevos resented their own displacement by a new generation; meanwhile, the younger artists fretted that the sentimental nationalism of their predecessors had itself become academicized, at risk of diluting the artistic currency of "modern" Cuban art. These cavils aside (and allowing for a measure of rhetorical bombast), the exhibition signaled the maturation and steady momentum of the modern movement, which consolidated its cultural authority over the course of the decade.

Working within but slightly to the geographic and social margins of the early vanguardia generations, a handful of artists pursued directions within abstraction as early as the 1930s and 1940s—notably, Enrique Riverón (1902–1998), Ravenet, Roberto Diago (1920–1955), and, later, Julio Girona (1913–2002). Riverón's turn toward abstraction followed earlier engagements with folkloric and Art Deco trends, developed in Europe and exhibited in Havana as early as 1927, as well as acclaimed turns as a cartoonist and illustrator for publications including *Carteles* and *Bohemia* in Cuba and the *New Yorker* and the *New York Times*. By the 1930s, working in New York and among the Latin American artists promoted by Alma Reed's Delphic Studio, he produced numerous paintings, drawings, and collages that show a vibrant spatial lyricism and urban sensibility. Credited by Gómez Sicre as "the first in Cuba to take up nonobjective art," Riverón experimented with lyrical and Hard-Edge abstraction in the 1940s and 1950s following his move to Kansas.[15] Works such as *Persistent Forms* share the brilliant chromatic energy—biomorphic shapes crisscrossed and bounded by bold, graphic patterns—of the works shown at Havana's Lyceum in 1955 (fig. 19); introduced by Carreño, the exhibition was the first to show Riverón's abstract paintings in Cuba.[16] Girona followed a similarly transatlantic, early path, departing for Europe in 1934 and returning briefly to Havana before arriving in New York in 1937 (like Riverón, he began as an illustrator under the guidance of Conrado Massaguer). He moved from sculpture to painting in the late 1940s and committed to abstraction in 1949, working within a lyrical, gestural mode characterized by thin washes of dilating colors. His brushwork and line was compared in a contemporary *New York Times* review to that of Arshile Gorky (1904–1948),

FIGURE 19
Enrique Riverón, *Persistent Forms*,
1947. Oil on canvas. 20 × 16 in.
(50.8 × 40.6 cm). The Art of
Emprise, Emprise Bank, Wichita,
Kans.

the Armenian-born artist whose painterly abstractions prefigured the rise of Abstract
Expressionism, and Girona showed regularly in New York through the late 1950s at
Bertha Schaefer Gallery, where *Conflict* was exhibited in 1956 (fig. 20). Divided diagonally
by a schism of muted, dark-gray shapes, *Conflict* embodies the formal drama of "action
painting," its tonal, amorphous passages of grayish-beige interspersed with scrawling
black lines and flashes of color—flaming orange, marigold, yellow. Girona's free-form
abstractions had regular exposure in Havana and as part of national delegations (for
example, at the XXVI Venice Biennale in 1952); he showed at the University of Havana

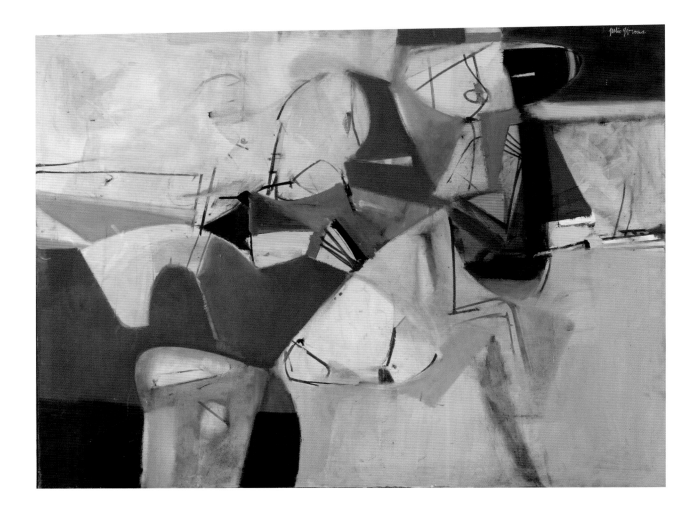

FIGURE 20

Julio Girona, *Conflict*, 1956. Oil on canvas. 38 × 50 in. (96.5 × 127 cm). The Newark Museum, Purchase 1958 Felix Fuld Bequest Fund 58.21.

(1954) and at the Galería Color-Luz (1958).[17] For both Riverón and Girona, permanent residence in the United States afforded a measure of separation from the day-to-day tumult of the Havana artworld, yet the regular visibility of their paintings—no less, the patina of American success—set a leading example for the rising vanguardia.

More immediately in sight were Diago and Ravenet, elder-generation artists whose work explored divergent paths within abstraction. Well known for his draftsmanship and wood engravings, Diago numbered among the first artists promoted at the Pan-American Union by Gómez Sicre, who trenchantly remarked upon his interpretation of Afro-Cuban themes as "expressive of universal values, rather than a mere reflection of regional environment."[18] While Surrealist and Picassian threads inform much of Diago's mature work, toward the end of his brief career his works became increasingly simplified and abstract. Characteristically in *Figure*, illustrated in the catalogue for his show

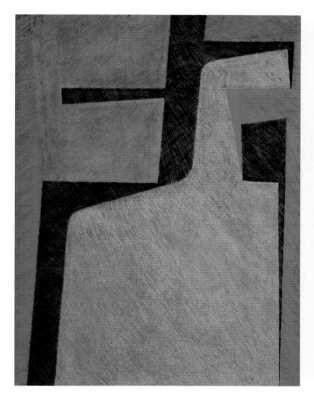

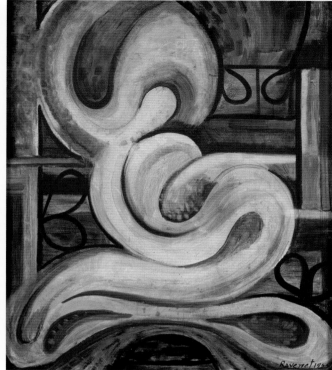

FIGURE 21

Roberto Diago, *Figure*, 1953. Oil
on cardboard. 40 × 29½ in.
(101.6 × 74.9 cm). Private collec-
tion, Miami, Fla.

FIGURE 22

Domingo Ravenet, *Interior*
[*Naturaleza quieta*], 1955. Oil on
Masonite. 28.1 × 24 in. (71.5 ×
61 cm). Private collection.

at the Pan-American Union, the eponymous subject is flattened, silhouetted by differ-
ently textured blocks of color whose geometries echo and offset the curving contour of
the figure's profile (fig. 21). Diago publicly quarreled with Carreño over the *franquista*
Bienal in 1953, and politics may have partly diminished his stature for the onceños; but
without question they were aware of his example, whether from his professorship at the
School of Fine Arts in Matanzas or from his memorial exhibition at the Palacio de Bellas
Artes in 1956.[19] Ravenet fit more readily within the Havana School, socially and aesthet-
ically, through the 1940s, and the progressive abstraction of his work reflected a formal
distillation of earlier, traditional subjects. A reinvention of the classical framing device
of window and balcony, the languid, lyrical *Interior* describes a figure folding gently into
itself in a harmony of mottled, muted colors (fig. 22). Its curves echo both the decorative
ironwork and the plasticity of Ravenet's contemporary sculpture in ceramic, which
shows a similar preoccupation with softness and volume. While these initial instantia-
tions of abstraction preceded the rise of the onceños, they manifested mostly at a dis-
tance from Havana and from each other, their work either belatedly known from abroad
(Riverón, Girona) or more readily enfolded within other artistic paradigms (graphics
and Afrocubanismo for Diago; Fauvist color in the case of Ravenet). Notwithstanding

their limited contemporary reception, these artists established a prior history of abstract art in Cuba under vanguardia auspices. Not surprisingly, Los Once took little public interest in their precedent, preferring to emphasize their generational rupture with the Havana School and the polemics of abstraction within the Batista state. The beginnings of concrete art in Cuba also date to the later 1940s—notably, Diago taught alongside Rafael Soriano (1920–2015) in Matanzas—but its assimilation by many of the second-generation vanguardia within formalist (and commercial) contexts differentiated its trajectory from that of the onceños from the start.

These early winds of abstraction aside, throughout the 1940s the preeminence of the Havana School was assured and its florid aestheticism entrenched, if not already stereotyped as the visual accompaniment to the confident, nation-building enterprise of the republic. In the vanguardia's many anthological and self-historicizing exhibitions of this period, a canon of Cuban art emerged that clearly adjoined the program of modern art with the democratic futurity of the nation. Where the first generation had worked toward inculcating a national iconography, the Havana School eventually took greater pictorial liberties in its projections of "lo cubano," distilling national themes through increasingly baroque and abstracted visual vocabularies. Signs of stagnation began to appear by the turn of the decade, however, and amid a transitional political and cultural climate the revival of the National Salon after a four-year hiatus marked a new reckoning of the arts and of the vanguardia itself.

The *IV National Salon* opened on July 4, 1950, to mixed but mostly unfavorable reviews that reflected a generalized weariness and dissatisfaction with the state of the arts and its petty partisanship. "A great deal of rubbish had to be cleared away from this much anticipated Salon," the rising critic Joaquín Texidor acknowledged, "from the unseemly admission of so much crude dabbling to the difficulties that arose among the members of the jury."[20] A critical chorus faulted the jury, composed of vanguardia portraitist Jorge Arche (1905–1956), minorista José Manuel Acosta (1895–1973), and writer Enrique Labrador Ruíz (1902–1911), for cronyism and conservative bias. The first prize in sculpture was repeatedly singled out: Alfredo Lozano won over the younger Roberto Estopiñán (1921–2015), whose *Ícaro* drew wide acclaim (fig. 23). An abstracted, biomorphic massing of wings and body, the plaster sculpture presented a conventional subject through dramatic dysmorphia, the bony concretions betraying Estopiñán's familiarity with postwar European trends as seen in work by Marino Marini and Henry Moore, for example, introduced through the earlier presence in Havana of the Czech sculptor Bernard Reder.[21] Texidor emphasized Estopiñán's refusal of "metaphor and allusion" in his review, praising the dynamic distribution of forms and spatial, experiential quality of *Ícaro* as "sculpture in the best [i.e., most essential] sense."[22] First prize in painting went to José M. Mijares for *Vida en un interior*, whose post-Cubist faceting anticipated his receptivity to concrete art in a few years' time. To the extent that "time has lessened the gap between the generation of Cuban artists that appeared after 1944—the generation

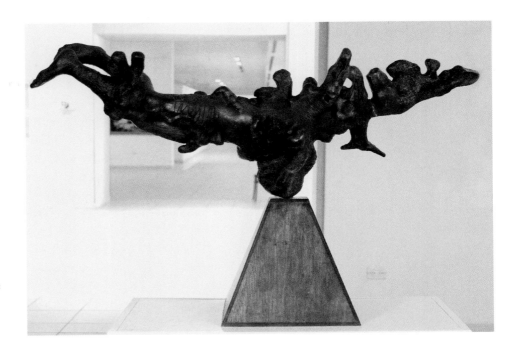

to which Mijares belongs—and the generation which immediately preceded," as Gómez
Sicre later reflected, his work occupied an in-between space: amenably assimilable
within the Havana School, under the auspices of Carreño and Luis Martínez Pedro, but
also part of the *"menores de treinta años"* (the "under-30s"), which included the onceños.[23]
Apart from the oft-cited highlights of Estopiñán, Mijares, and Eugenio Rodríguez
(1917–1968)—all of whose work may have shown a tendency toward abstraction—the
Salon disappointed. Texidor noted the anxious posturing and affectations of the young-
est exhibitors without identifying names. Among the participating "under-30s," as they
were sometimes called (in reference to the eponymous exhibition organized by Texidor
that traveled the island in 1947), were Pedro Álvarez (b. 1922–?), René Ávila (1926–1990),
Sabá Cabrera Infante (1933–2002), Agustín Cárdenas, Martínez, Zilia Sánchez (b. 1928),
and Soriano. Ximénez Arroyo regretted the absence of certain established artists and the
admission of works of dubious quality, though he tepidly declared the Salon a "relative
success."[24]

Scarce critical record has survived of the fifth National Salon, held the following
summer, but its prizewinners and exhibitor list suggest not only its larger and reorga-
nized format but also a more expansive perspective on contemporary art.[25] Wifredo
Lam, whose peripatetic path traversed Europe and the Americas during the 1950s,
took the first prize in painting for *Contrapunto*, a dark, portentous image of elongated
diamond-shaped figures and piercing arrows that suggest the passage between states
of being (fig. 24).[26] Allusive part-bodies, some related to the *femme-cheval* iconography

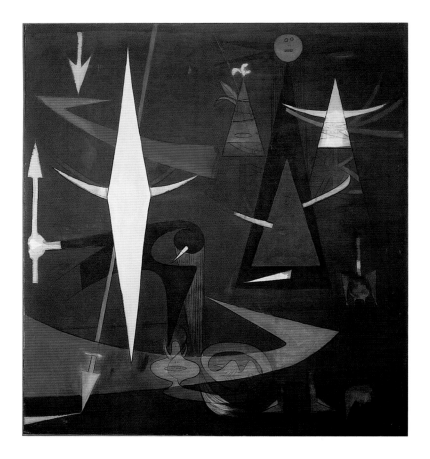

appearing elsewhere in his work at this time, float in numinous, translucent space while horizontal elements—a variety of horns and two opposing shapes in orange—balance ascending, triangular motion. Returned to Cuba earlier that year for the inauguration of his mural at the Esso building and for a solo exhibition at Nuestro Tiempo, Lam held unrivaled prestige; arguably, his distance from Carreño and others of the Havana School who resented his success brought him closer to the onceños, who looked up to his example. Lozano won in sculpture (again over Estopiñán, who shared second prize); Mijares shared third prize in painting, and Girona received mention for *Noche mágica*. The inclusion of artists recently active abroad—notably Carmen Herrera (b. 1915), in addition to Girona and Lam—raised the profile of the Salon and, undeniably, that of abstraction. Diago and Ravenet exhibited, having not participated a year earlier, and the list of "under-30s" grew: Pedro Álvarez, Lucía Alvarez, Francisco Antigua, Ávila, Cabrera Infante, Servando Cabrera Moreno (1923–1981), Corratgé, Martínez, and Soriano. Still the Salon drew scant national attention, perhaps a casualty of the summer calendar and the excitement surrounding the exhibition of Cuban art in Paris earlier that spring and the anticipation building in advance of the first São Paulo Bienal. The

reestablishment of the Salon nevertheless resonated in self-reflexive and local terms for the vanguardia as it took stock of its recent past. However flawed an arbiter of the state of the arts, it foreshadowed the coming generational crisis within the vanguardia and brought to light the ongoing need for rigorous, professional standards within the cultural field (not coincidentally, Nuestro Tiempo and *Noticias de Arte* appeared around this same time).

Thus for the third generation who laid claim to the modern mantle by 1953, the vanguardia inheritance appeared ripe for reinvention. Abstract art had made intermittent appearances, from Pogolotti and Peláez to Diago and Riverón, but mostly as a fringe practice, dissociated from the vanguardia's nationalizing mindset and attached to figures marginalized by gender, race, and geography. In the wake of the renewed Salon and amid an increasingly overwrought political climate, the rapid gestation of abstract art latched onto the convergence of a politically radical, generationalist movement agitating for reform and an aging vanguardia held accountable for a muddled cultural landscape. Invoking both the storied activist history of the original nuevos and the color-driven, cosmopolitan horizons of the Havana School, the onceños claimed abstraction as the consummate, cubanista culmination of modern Cuban art.

THE GENERATION OF LOS ONCE

As Cuba sought to update its national self-image, distancing itself from tropes of tropicalism and underdevelopment—in political terms, breaking with dependency and a narrowly defined nationalism—the romantic flourishes of the Havana School appeared vulnerably decadent, out of touch with the political restlessness and cynical *choteo* that had set in by the turn of the decade. The post-1933 "new Republic," governed constitutionally by Batista since his election in 1940, had arrived at an inflection point by 1952, weakened by failures to secure Cuba's long-term economic independence and a fractured social fabric wary of more "reformism" and destabilized by rising unemployment, destitution, and public debt. The establishment of U.S.-determined sugar quotas, agreed upon in 1934, effectively prolonged Cuba's dependency and stymied other industrialization strategies. Petty gangsterismo, localized around the University of Havana between 1937 and 1947, reflected the devolution of the radical student movement into personal score-settling, further eroding trust in the political system. Socioeconomic markers were flat or declining: postwar growth indicators showed stagnation tendencies between 1946 and 1952 (accelerated between 1952 and 1958), and Havana's rise as an Antillean metropolis was accompanied by shortcomings in urban services and the proliferation of tenements housing more than one-third of the city's population.[27] The mandate of the Auténtico leadership appeared less and less secure as elections loomed in 1952, and Batista's coup on March 10, 1952—in expectation of an electoral victory by the Ortodoxo candidate Roberto Agramonte—marked a crisis of faith in Cuba Libre.

A new generationalist mentality arose amid the surprise and ensuing trauma of the coup, resolved to finally restitute the radical legacy, however lately miscarried, of the early republic. Self-consciously cued to Cuba's fifty-year anniversary of formal independence (1952) and to the centenary of the birth of José Martí (1953), the generación del centenario began to mobilize in pursuit of a moral *soberanía* divested of the corruption and chronic unrest that had plagued the republic. Consecrated during a torchlit march led by Castro and others at the University of Havana on January 26, 1953, the eve of Martí's birthday, the group struck six months later with an assault on the Moncada army barracks in Santiago de Cuba at the far southeastern end of the island, the first act of armed struggle against Batista. Designed to capture weapons from the military's arsenal, the attack also signaled the more artful purpose "to light the flame of a general rising in the country: to be the initiators" of the overthrow of Batista, as Castro's commander at nearby Bayamo, Raúl Martínez Arará, later reflected.[28] Batista, on holiday at Varadero beach at the time of the attack, exacted severe retribution against the unsuccessful revolutionaries, demanding ten bodies for each dead soldier and imposing long prison sentences at their trials, which extended into the fall. Trained as a lawyer, Castro delivered a two-hour oration in self-defense at his trial, naming Martí the "intellectual author of this revolution" and infamously declaring, "History will absolve me."[29] The bloodbath and the ensuing repression did much to turn the tide of public opinion against Batista and to lionize Castro, granted amnesty fewer than two years into a fifteen-year sentence. Moncada marked the beginnings of the revolutionary 26th of July Movement, which fermented during Castro's incarceration and regrouping in Mexico and emerged as one of three ideological forces—with the Federation of University Students and, later, the Communist Party—behind the Revolution. As the cubanista canon congealed in the wake of July 26, its repeated *martiano* accents enfolded contemporary radicalism within "a particularly Cuban sense of history," fortified by conviction in the country's manifest historical destiny.[30] The generational thrust of the 26th of July Movement, propelled by a deeply historicizing logic, primed the country for rebellion, inculcating a climate increasingly receptive to the cubanista project and its charismatic "centenarians."

This aura of predestination, already beginning to cohere in the early months of 1952, penetrated the cultural field, no more so than the mindset of the young "23 y medio" who laid claim to the vanguardia tradition in the revived Salon. By common consensus, the takeaway from the anticlimactic Salons of 1950 and 1951 had been the static state of the modern movement, seen to languish in an intergenerational holding pattern. The onceños capitalized on their cultural synchronicity with the generación del centenario, tapping the rhetorical momentum of Moncada as they began to stake out a group identity for themselves. This is not to imply that the third-generation vanguardia aligned itself with the 26th of July Movement; indeed, the divergent politics of the onceños ultimately spelled their dissolution of the group. But the overwhelming sense

of expectancy that Moncada wrought, as an audacious response to Batista's coup, created a space of receptivity in which the upstart "under-30s" could conceive a rebellion of their own. Their group identity at least as firmly in place as that of their predecessors, the youngest vanguardia gained intangibly by even glancing associations with the "*centenarios.*" Ideological free agents, but perceived within the social context of a young and symbolically *martiano* rebellion building from Oriente, the "under-30s" coalesced in Havana in general opposition to Batista but with no explicit political ties to the impending Revolution.

The generational presence of the "under-30s" was noted as early as 1952 by Carreño, who singled out sixteen artists under thirty, "more or less abstract," to follow.[31] Carreño was arguably the vanguardia's most instrumental, institutional player between 1952 and 1957: following his editorial direction of *Noticias de Arte*, he worked within the Batistato for the Instituto Nacional de Cultura (INC), where he oversaw curatorial initiatives and managed relations with the vanguardia until his departure for Chile by September 1957. However ambivalent his later record in regard to Los Once, he pinpointed the rise of abstraction at a precocious moment and consistently defended it in criticism notable for its keen parsing of the contemporary scene. (To a remarkably self-contradictory degree, Carreño negotiated incongruous positions during the period: he worked under the auspices of the Batista state but publicly protested against it; inasmuch as he once epitomized the Havana School, he emerged as a leading proponent of geometric abstraction during the 1950s, temporarily downplaying his earlier affiliation.) Writing in the aftermath of the Batista coup, Carreño commented upon the absence of a national artistic patrimony, *pace* the historical vanguardia, specifically rejecting the folkloric and mestizo trappings of the past as inauthentically Cuban. In classically cubanista phrasing, he concluded that the posterity ("the future generations") of Cuban art would emerge out of the "profound abstract and universal expression" that characterized "the new art."[32] His reinscription of "lo cubano" around the unproven potential of the "under-30s" and their tentative strides toward abstraction was speculative but ultimately farsighted. "The spirit of a work lay not in *what is painted,*" Carreño admonished, already anticipating the charges soon levied against Los Once, "but in *how it is painted.*"[33] Its North American extraction notwithstanding, his incipient formalist logic took root in early interpretations of Cuban abstraction, marking the distance between the "under-30s" and the elder-generation vanguardia in critical and historiographical, as well as visual terms. Postulated as a categorical break with Cuba's vanguardia past, abstraction was correlated with a futurity pitched in enticingly cubanista terms, far beyond the depredations of the Batista state. A platform capable of provocation ("a point of attack," in Martínez's words) and readymade for publicity, it provided Los Once a medium ideally suited to their evolving cubanista and corresponding americanista agendas. As a tabula rasa, the medium of abstraction appeared ripe for the taking, and its interpretive elasticity enabled it to be profitably instrumentalized by the onceños and others.

As the philosophical ground of abstraction came into focus, the onceños took their first collective steps in a series of exhibitions leading up to their eponymous exhibition in March 1953. Although theirs were not the first exhibitions of abstract art in Cuba, these early shows marked the coalescence of a generational identity around gestural abstraction and brought the "under-30s" into the public eye. The group gained traction across four exhibitions spanning approximately ten months: *28 dibujos y gouaches de Antonia Eiriz, Manuel Vidal, Fayad Jamís, Guido Llinás y Antonio Vidal* (May 30–June 9, 1952); the *VI National Salon* (January 10–25, 1953); *15 pintores y escultores jóvenes* (February 16–26, 1953); and *15 dibujos de pintores y escultores jóvenes* (April 5, 1953). The two smaller shows of 1953 may be considered as part of Los Once's prehistory; the Salon of 1953 ushered them into the national spotlight.

Held at the Confederation of Cuban Workers, on the outskirts of Havana's cultural mainstream, *28 dibujos y gouaches* marked the first exhibition for each of these artists with the exception of Fayad Jamís (1930–1988), who had previously shown in Mexico. Three of the group reunited as founding members of Los Once the following year; the others, Eiriz and Manuel Vidal, remained honorary onceños, generationally allied but independent. A contemporary review, likely by Rafael Marquina, echoed familiar, cubanista themes: "all aspiring to draw attention to freedom," the five artists were "unabashedly ambitious, roused by their responsibility, undaunted by current events, determined to fulfill their destiny."[34] In closing, the reviewer mused again on the awakening of responsibility, triggered by the exhibition and shouldered by the artists who embraced their task.[35] Indeed, the martiano mandate could hardly be more clear: in a nod to the "young men of America rolling up their sleeves" described in Martí's classic treatise "Nuestra América" (1891), Guido Llinás is singled out as one who already laid claim to the americanista mandate. "Guido is ready," the critic declared, identifying an inner logic in his work and suggesting that he stood on the cusp of a major breakthrough.[36]

The oldest onceño at age 29 and the group's putative leader, Llinás shed the painterly facture characteristic of his work from the prior decade between 1952 and 1953, progressing beyond the expressionist experimentation of his youth as he came into contact with other "under-30s" and with American Abstract Expressionism. Self-taught, he identified early models in Vincent van Gogh and Paul Gauguin—seen, for example, in the characteristic heavy impasto and sinuous contour lines of *Florero* (1947)—whose work he came to know through reproductions and, anecdotally, the film *The Moon and Sixpence* (1942).[37] Drawn loosely on Gauguin's biography, the cinematic narrative of artistic self-discovery romanticized the fortunes of the avant-garde artist; for Llinás, its primitivist ending in Tahiti may have also underscored the singularity of his own rise as one of very few Afro-Cuban artists within the vanguardia.[38] His first introduction to gesture painting likely came through Luis Dulzaides Noda, who served as an early mentor, but the impact of the time he spent in the United States can hardly be overstated. Like a number of the "under-30s," Llinás knew modern art firsthand, rather than

FIGURE 25
Guido Llinás, *Pintura*, 1953. Oil.
Location unknown.

through the black-and-white "school of Skira," and his direct exposure to the New York School shaped both his own practice and the generational mentality that he brought to Los Once.[39] Between 1953 and 1957, he spent summers in New York, Washington, D.C., and Philadelphia, taking in major museum collections and digesting the work of artists like Jackson Pollock, Franz Kline, Willem de Kooning, and Robert Motherwell. While charges of Cold War cultural imperialism have colored revisionist accountings of Abstract Expressionism, both in Cuba and in the United States, at first blush Llinás and the onceños perceived "American-style" painting in the cultural terms of vanguardismo rather than as political stratagem.

At the time of this first exhibition, Llinás had not settled decisively upon his own direction within abstraction. Among his first attempts, *Pintura* (1953) already shows a tendency toward the square, from individual brushstroke to outline, and right angles; a Hofmannesque "push-pull" dynamic underlies the tension between the relational structure of color and nonillusionistic space (fig. 25). As Llinás developed his practice, the opportuneness of abstract art, with its built-in aesthetic radicality and immanent

cubanista credentials, made his full turn toward gesture painting seem, in retrospect, all but a foregone conclusion. The ideological uncertainty left in the wake of Batista's coup, enacted two months earlier, turned up the pressure on the artistic vanguardia—not least, the emergent "under-30s"—to articulate a critical position within the cultural field. The gravity of their situation is palpable in a review of their first exhibition, which was said to "immediately awaken a sense of manifest responsibility in art and in the work of these and so many other young artists . . . who understand clearly the work entrusted to them."[40] The freedom that the five artists asserted from earlier conventions of painting was felt implicitly to connote liberties of other, political, kinds; and the review's repeated recourse to the present day cast the exhibition in uncommonly vital and progressive terms. A throwback to the convergence of the "nuevos" and the "minoristas" in 1927, the conceptual rapport between the onceños and the generación del centenario, assembling at the opposite end of the island, implicitly linked the rise of abstraction to the political futurity of the republic.

Held six months later, the *VI National Salon* marked the coming-out of abstraction before the national public, inaugurating a decade-long rhetorical discourse that culminated in the *Salón Anual 1959*. The 1953 Salon dared to hazard its fortunes on the "under-30s," preemptively—indeed, prematurely—forecasting the rise of abstraction amid the conflicted state of contemporary art. The jury of Labrador Ruíz, critic Suárez Solis, and genre painter Enrique Caravia (1905–1992) presided over a show plainly dominated by abstract art, but the Salon fell well short of a triumph for the "under-30s." "Our arts are currently suffering a moment of indecision," Salvador Bueno conceded in a refrain repeated by many others. "We might say that they are at a crossroads—to where or against what, we don't know."[41] Luis Dulzaides Noda quipped that the prizes were nothing but "friendly transactions" and that a nameless member of the jury had been "hypnotized by famous signatures," but the third-generation vanguardia nevertheless made a fair showing.[42] Estopiñán took the first prize in sculpture after consecutive runner-up finishes, and the onceños José Y. Bermúdez (1922–1998), Cárdenas, and Antigua claimed smaller awards. The first prize in painting nevertheless went to the social realist Carmelo González (1920–1990) for *Ismos*, an ironic pastiche of Cubism, academicism, and Surrealism and a send-up of the modern movement tout court.

Jury politics aside, much critical handwringing accompanied the presence of the latter-generation vanguardia, whose historical moment appeared to have arrived in advance of its art. "These debatable works of contemporary art did not occupy a part of the National Salon," an editorial rhetorically titled *Bellas Artes . . . ¿Bellas?* reported. "They occupied it all. . . . The assault of the modern geniuses is across the board."[43] The preponderance of abstraction left it vulnerable to critics seeking more affirmative direction from the arts at a moment of "desperate, exacerbated, 'existentialized' anxiety," as Marquina acknowledged. A Catalan journalist and émigré later supportive of the onceños, Marquina penned a hesitating and mostly frustrated review, deploring the lack

of a baseline by which to judge the work ("*sin canon ni medida*") and, on the part of the exhibiting artists, a pervasive "reiteration" effect, seen in insular navel-gazing and formulaic mannerism.[44] Still, he acknowledged the contributions of Martínez, Mijares, Antigua, and the young Lucía Alvarez, whose proto-Constructivist abstraction—sculpture with little precedent in Cuba—drew his warmest praise. Dulzaides Noda took a more declamatory tack overall, sounding out against the conservative entrenchment, but he saved encouraging words for a number of the onceños, singling out the sculpture of Cárdenas and Antigua and the painters Antonio Vidal and Llinás.[45] "Guido Llinás has progressed a great deal," he allowed, approvingly noting his passage beyond earlier dalliances with Gauguin and Cézanne into abstraction.[46] González, the first-prize winner for painting, judged Llinás' transit into abstraction more harshly, questioning his fixation on the square and warning that it was "not possible to be a rooster in a foreign farmyard" and that abstraction was not his domain.[47] The other onceños were not spared: Ávila showed only "how confused he is," Vidal's entry was deemed a pedantic exercise, and Consuegra insulted "good taste" with work that "pulled the leg of the Jury, public and other exhibitors."[48] However petty and reactionary, González's vitriol threw hard light onto the stakes of abstraction as the "under-30s" entered the national conversation. Even the onceños' most magnanimous supporters (Dulzaides Noda, Bueno) made ample allowances for their youth and inexperience; Texidor, the generation's anointed padrino, all but glossed the art actually exhibited in the Salon in his remarks. Implicit in their sallies back and forth were the values of abstract art, and what becomes clear in reconstituting these early positions is the tension between an ambitious but still adolescent art form and the determinist historical narrative within which it wanted to work.

This incipient will to historicization informed the position of the onceños relative to the vanguardia, and their rise as a bona fide third generation was neither self-evident nor immediately welcome. "The two generations of painters that have given vitality and stature to Cuban art over the past twenty-five years had their sights set on a horizon that was more or less clear," Bueno noted as a matter of course, but he was less sanguine about the younger artists, asking, "In which direction are these artists headed? Against which obsolete past do they want to fight?"[49] Where Bueno wavered, Texidor left no doubt that their arrival marked "the first moments of the renewal initiated by the winds of the generation of 1927." Writing with a measure of cubanista assurance, Texidor marked the onceños as heirs apparent to the first-generation vanguardia: "Contemporary art in Cuba, over the course of thirty long years, has accomplished its mission, namely, a mode of Cuban expression within the universal language of forms that moves today from America to Europe."[50] An early vote of confidence for the onceños, none of whom he named, his words located them squarely within Cuba's modern movement, imparting a historical credibility that their work alone did not yet sustain. Moreover, in placing them at the endpoint of the vanguardia narrative—that is, "the *fait accompli* at the *VI National Salon*"—he applied a persuasive, exegetic logic to their consolidation around abstract

art.[51] Drawing a line between the original nuevos and the onceños, Texidor enfolded their "universal language" (abstraction) within the concurrently universalizing telos of cubanía, positioning the young artists as revolutionaries acting against academic retrenchment and condescension ("ignorance, bad faith, or resentment").[52] Not surprisingly, detractors challenged the ideological acumen of the onceños from the beginning, raising the specter of realism ("the Korean War is not an abstraction") and deflating their perceived inevitability: "Art is not unilateral. . . . The young abstractionists believe that the artist has no other path than that which they have followed, without realizing that no one understands them because they are abstract."[53] Levied by González and others, the realist critique shadowed the onceños throughout the decade. Though of middling political consequence in 1953, it prompted the group's early champions—Carreño and Texidor, principally—to answer for abstraction on moral grounds.

Removed from the specificity of the Salon, the discourse on abstract art took a clear cubanista turn, sublimating the disappointments of the onceños' debut within a generational ethos of cyclical struggle and renewal. As Kapcia has described the situation, the "myth of generations" spun defeat and disappointment into a narrative of organic nationhood, nourishing itself on recourse to an earlier (that is, martiano and centenario) generation's legitimacy.[54] Applied to the cultural vanguardia, that progressive logic would ultimately vindicate the onceños, as Texidor explained. "Art is an organism as alive and active as the human body," he intoned, an entity that "needs to change, to evolve itself in relation with the epoch, the historical moment that it has come to occupy."[55] Abstraction marked the return of art as a humanist and intellectual pursuit, he concluded, removed from facile illusionism and sentimentality; indeed, the "moral factor" of abstract art underpinned Carreño's contemporary arguments as well, with added emphasis on the universal. Published in *Noticias de Arte*, Carreño's sprawling exegesis of abstraction correlated its historical mandate with the spiritual climate of the age (suggestively, it appeared on the pages immediately following the magazine's review of Los Once's eponymous first exhibition). He took his cue from the German art historian Wilhelm Worringer (1881–1965), whose influential treatise *Abstraction and Empathy* (1907) argued that abstraction emerged in societies experiencing anxiety and psychic upheaval, from dynastic Egypt to the Middle Ages, as a means of transcending a hostile, insecure reality. (Naturalistic empathy, on the other hand, reflected the confident, materialist disposition of classical cultures such as ancient Greece and Renaissance Italy.) Cuba's "contemporary abstract painter" did not paint for pure pleasure, Carreño argued, but rather to "recover the feeling of serenity, of eternity" most perfectly realizable in the pictorial equilibrium of (geometric) abstraction.[56] The moral rectitude of pure abstraction, set against what he dismissed as the profane imitations and impurities of even vestigial figuration, epitomized *"el arte de nuestra época,"* defined by its autonomy and, therein, its prized universality. In an argument remarkably akin to that of his friend Gómez Sicre, since 1948 in charge of the Visual Arts Section at the Pan-American Union, Carreño

staked an ethical high ground for abstraction, affirming its legitimacy not as "a passing trend, but as a style, an aesthetic corollary of the historical and spiritual needs of our time."[57] Directed to the vanguardia at large, though most pointedly to its few concretos, his essay imparted a cubanista morality to abstraction, defining an ideological authority apart from the bombast and personal attacks that beset the onceños in the wake of the Salon.

ONCE PINTORES Y ESCULTORES

Taking up the gauntlet thrown down at the Salon, the mostly maligned "under-30s" began to organize themselves in a more intentional way, staging two small exhibitions in the first months of 1953. Three weeks after the Salon closed, fifteen artists participated in an exhibition of drawings at the Sociedad Cultural Nuestro Tiempo, a progressive cultural institution favorably disposed to the onceños and to the generational tide that they represented. The early imprimatur of Nuestro Tiempo supported the group's activist designs, consistent with the society's manifesto—"we are the voice of a new generation that arises at a time when violence, despair, and death threaten to appear the only solutions"—and cubanista mandate.[58] *15 pintores y escultores jóvenes* included the eleven onceños who christened the group just months later; exhibiting with them, and drawn from the ranks of the original "23 y medio," were four others: Corratgé, Julio Matilla (b. 1928), Sánchez, and Manuel Vidal. The group's membership fluctuated throughout the decade, but the decision to formally constitute as a group came out of a desire, broached by Texidor but also generational in kind, to wield a collective—and marketable—identity as they began their professional careers.[59] No doubt stimulated by the wave of generational synchronicity stretching from Oriente to New York, the construction of "Los Once" signaled the group's historical self-awareness from the start. Their provisional first grouping as "Los Quince" is attributed to Consuegra, who with Llinás, Antonio Vidal, Tomás Oliva, and later Martínez formed the group's core. These inaugural quinceños showed just the one time, at Nuestro Tiempo; twelve of them (all but Corratgé, Matilla, and Sánchez) exhibited five weeks later at the Galería de Matanzas, east of Havana. Texidor wrote a brief introduction to the latter show, acknowledging the visual heterogeneity of the group but emphasizing the conceptual unity of their work, stirred by "the same aspiration, the same desire."[60] Somewhat beneath the critical radar, these exhibitions allowed the onceños to establish a group history, however short, and supplied a measure of momentum leading up to their breakthrough exhibition two weeks later.

The exhibition *Once pintores y escultores* branded the onceños for posterity, consolidating their group identity nominally around gestural abstraction but also, unmistakably, in generationalist and vanguardist terms. Scapegoats of the Salon four months earlier, the onceños opened their eponymous exhibition at La Rampa, a gallery in Vedado's modern Centro Comercial, on April 18. Antonio Vidal later acknowledged the arbitrariness of

Pintura. Oleo de Avila.

A PROPOSITO DE LA EXPOSICION DE LOS ONCE

Excusa y justificación.- Con el tiempo.- Pruebas en soslayo.- Alusiones en elusión.- Inicio en final

Por RAFAEL MARQUINA
(De la redacción de INFORMACION)

Una escultura de Antigua: "Metamorfosis".

Antonio Vidal. Gouache número 2.

"Tarde lunada", pintura de Fayad Jamís.

"Oquedad", escultura de José Antonio.

Un óleo de Jorge Y. Bermúdez. Interior.

"Paisaje en tensión". Oleo de Consuegra.

Un óleo de Guido Llinás.

EXCUSA Y JUSTIFICACION

Un poco lejos queda ya el suceso, en cuanto a lo que periodísticamente se debe entender por "actualidad". La exposición ofrecida por once artistas jóvenes en La Rampa estuvo allí instalada, entre un misceláneo hervor de comentarios, durante una decena de días, del 18 al 28, del mes de abril. Un poco tarde es, por tanto, para recoger su existencia, señalándonos a la atención y a la disputa de los hombres. El periodista se siente, ante todo, movido a pedir excusa por este retraso de tanto bulto. Pero bulto al cabo, —cuizá piensa después el periodista— puede ser arrastrado a un lado y desatendido.

Le entra entonces al cronista —que ha entendido no poder soslayar el ya lejano acontecimiento— la comezón de justificar el modo con que pretende ahora traerlo a comparecencia testimonial. Y sin gran esfuerzo halla pronta justificación.

Porque, en fin de cuenta, siempre, en arte y en la vida, la "data", la precisa cronología de un dictamen que sí, no tienen data ni la cultura ni el arte, en el sentido de que no les pueden dañar en su proceso ni hundirlas en caducidad, mientras que, por el contrario, a ellos se acude, en lo permanente, para entender lo que, en suma, vale una data, una era, una época. Y, en definitiva, tanto más es interesante (aún sin entrar en la calibración exacta de sus valores) un suceso de arte cuanto más nos procure, en el presente para el futuro, la cifra y la clave de su tiempo; cuanto más por sí solo nos indique y nos revele cuál y cómo fue la angustia y la conciencia de un tiempo y por ella, por esa conciencia de que son testimonio, perdura data las que someterla.

Por esto, como procurará demostrar ahora este cronista retrasado, bien merece actualidad la exposición de los once en La Rampa.

CON EL TIEMPO

Sirvannos de punto de partida unas palabras que juzgamos exactas y perspicaces con las que Joaquín Texidor encabezaba las que citar diversas técnicas, harto ostensibles en aquella exposición, indudable que en su instante de actualidad según el calendario y mucho más ahora, en actualidad de historia, es indudable que algunas patentes ansias y manifiestos anhelos y una común aspiración de ir, en diversas rutas hacia una misma meta, procuraba a la plural y diverso la cabal unidad de una expresión del arte actual y de lo que hace o quiere hacer en sincronía con su tiempo.

Lo que más vale, por sobre lo de lo que valgan en los senderos esos las obras de cada artista, lo unívoco en esa común presentación es la conciencia de que el arte ha de ir, en hazaña de la libertad, como ocaso pudiera haber dicho Benedetto Croce ¿por voluntad de ser "con el tiempo" en el tiempo y como dice certeramente Joaquín Texidor a buscarle un sentido a la vida, al mundo y al espíritu.

Acaso, en el andar de los años —reduzcámonos a decir: de los días— surjan nuevas inquietudes, mejor dicho, nuevas obsesiones en búsqueda de cuajo de inquietudes idénticas; pero será siempre una gran seguridad, una preciosa lección y, sobre todo, una indispensable acomodación histórica, el testimonio de lo pretérito, el logro de lo anterior. Y la exposición

aparecían con su firma. Son éstas: "Es la eterna y apasionada lucha, la que este grupo de pintores y escultores jóvenes, ha tomado para sí, la de encontrarle sentido al mundo, a la vida, al espíritu, y sobre todo expresarse con la libertad que sólo el arte ofrece felizmente lejos de toda representación naturalista, lo que les permite ser y estar en su tiempo y en el futuro".

Dejando de lado la mayor o menor posibilidad de aceptar de plano el advertido "felizmente" que con tanta seguridad emplea Texidor y que, desde luego, se inserta en zona que no tenemos porque invadir hoy, esas palabras contienen en síntesis todos los motivos —con exclusión de los valores— que le han procurado a la Exposición de los Once su trascendencia, su significación influyente e influida, su vigencia como hecho artístico que reclama, porque la posee intrínseca, su categoría de "data". (Por tanto, en fin de cuentas, su razón periodística).

Al meditar de nuevo en esa exposición, al reanudar diálogos con las obras allí reunidas, lo que, al margen y con independencia de los individuales aportes más o menos valiosos, más o menos asegurados en su criterio y en su técnica, se nos alza señero y firme y afirmativo en la cogitación, impulsándonos a afirmaciones convictas, es, en la miscelánea de lo allí expuesto, la coincidencia, entre las diversidades, de algunos anhelos y de algunos credos que como plural convicción señalan un "momento" del arte; precisamente el de hoy en Cuba y allende.

Si como alguien dijo certeramente el arte moderno es el que se hace no sólo en este tiempo, sino "con" este tiempo, nadie puede negar que el conjunto de obras expuestas por los once en La Rampa es una genuina, idónea, significativa muestra de lo que en el momento de hoy es, o pretende ser, para hoy y "con hoy" y para y con el mañana, el arte plástico.

A despecho de todas las disparidades que pueda hallar un crítico analista —lo mismo que un contemplador profano— entre una cultura de las expuestas por Francisco Antigua y las obras pictóricas de Hugo Consuegra, pongamos por caso; a pesar de las distintas maneras de entender y ejer-

de los once en La Rampa es, a este propósito, una magnífica, una valiente, una sincera prueba de cuáles son las aspiraciones del hoy artístico.

PRUEBAS EN SOSLAYO

Pero, en fin de cuentas, ¿cuáles son esas coincidencias que nos permiten asegurar el hecho de que, juntas todas esas distintas once maneras de arte, marcan una afirmación colectiva concorde y unánime?

Sería prolija una indagación crítica, argumentada y reforzada con aportaciones ejemplarizantes. No es de este lugar. En realidad, esas coincidencias vienen a desenfocar en la práctica y ejercicio de los principales postulados del que se llama arte abstracto, con una propiedad idiomática basto discutible. Desde luego, más acentuadamente en casos —allí bien notorios— en los que se atiene el modo operante —por hablar así— a la idea literalmente entendida, de lo "no figurativo", de difícil plasmación, desde luego, en lo escultórico.

Lo abstracto, en cuanto que liberta de toda sujeción a lo real, en lo que tiene de segura línea y entendido en lo que posee de recóndita fijeza inalterable a través de todas las figuraciones distintas, parece ser —en términos generales— la común aspiración de

los once. Pero sentido, sobre todo como inmediata manera clara de liberación, de evasión del naturalismo rigoroso al que se abandona tratándose con las mismas trabas que el empleo.

Más a menos dentro de un concepto abstracto del arte aplicado a todas aquellas obras de estos artistas abstractos eran como gritos —, de gozo, de brío, de desespero?— grávidos de un infinito deseo de libertad. Nada aún quizás, aún lo más logrado, como las esculturas de Antigua y de Agustín Cárdenas y las pinturas de Jorge y Bermúdez, de Guido Llinás y de Consuegra —que permita afirmar un logro definitivo: pero todo acusando, una "señal del tiempo", como una gran muestra noble y valiente de un arte contemporáneo que se hace no sólo en nuestro tiempo, sino "con" nuestro tiempo; por tanto, una expresión de los once que marca en un momento, alza una voz, expresa la genuina conciencia del arte joven y nuevo, la realidad, en fin —se quiera o no— de un estado colectivo de una conciencia joven en busca de una nueva libertad.

Cuando se piensa, pues, en aquella ya lejana exposición se la puede ver no sólo vigente y presente, sino, por eso mismo, como una "data", como una inequívoca afirmación de "un momento" cubano, de una conciencia artística que revela la existencia de una juventud preocupada de vivir, como ella entiende, "con" su tiempo. Y al mismo tiempo, como un índice que ha de hervir para entender en el futuro por los historiadores —meteorológico del tiempo— lo que "sucedía" en Cuba el año 1953 cuando once jóvenes artistas en coro no acordado, acordaron una expresión de anhelos.

ALUSIONES EN ELUSION

Creemos se entenderá nuestra sinceridad cuando, después de todo esto, soslayemos una reseña crítica e incluso un breve análisis de la exposición de los once en La Rampa. No tendremos en esto caso tanto cómo nos interesaba a nosotros justificar la razón de esta

evocación que, retrasada en la cronología del almanaque no lo es sin duda, si nos atenemos a algo más que a las hojas del calendario.

Por consiguiente, nos abstendremos de una labor de que nos creemos excusados. Pero no sería justo, en este capítulo de recordación, silenciar los nombres de los once artistas que de modo tan gallardo y hasta podríamos decir tan valeroso, dejaron clavado en el camino un hito tan significativo. Cualesquiera sean las sendas proyecciones que les impriman a su arte, ninguno de ellos olvidará sin duda esta hazaña colectiva que, en cierto modo, es tanto como arte, historia. (Y no olvidemos que la función crítica no puede ser verdaderamente tal, si no es en recusación con la historia).

Cuatro fueron los escultores: Francisco Antigua, José Antonio, Francisco Cárdenas y Tomás Oliva. Siete los pintores: René Ávila, José Y. Bermúdez, Hugo Consuegra, Fayad Jamís, Guido Llinás, Antonio Vidal y Viredo.

Las muchas controversias que suscitaron, entre lo valientes las obras expuestas, son otra prueba, con un plus de resaca y una vana gallardía de espumas, de la inmediata eficacia ahora fija ya, como duradera, en el sentido que hemos querido señalar, de esa exposición en la que, además, había, y hay que recordarlo, obras de tan perfecta seguridad y tan bien logrado propósito como las de Antigua, muy dentro de su tiempo sin abandono de la personal conciencia con que afirma sobre la libertad estética, la de la propia convicción; las del escultor Cárdenas, muy en eminencia aparente de saltar la linde hacia una enquematática estilización, muy adentrada en la zona de lo abstracto en la que ahora incide sin haber abandonado todo el equipaje que llevó hasta sus fronteras; y las de los pintores Bermúdez, de quien ya se habló aquí largamente, Consuegra, de quien también no hace mucho se trató en nuestra sección diaria de INFORMACION, y las de Consuegra y Vidal.

INICIO EN FINAL

Y esto es todo.

Y esto —la Exposición de los Once en La Rampa es, por no sujetarnos a una data determinada y vencida, una data histórica. Y al mismo tiempo, una afirmación que haríamos mal todos —los conformes y los inconformes— en no tomar muy en cuenta. El futuro es una grávidez de incógnitas. Avanzar hacia él ha de ser un modo de ir dejando plantadas en la ruta las columnas que señalan el itinerario.

Téngase en cuenta además que del arte abstracto podría decirse, con más precisión y mirando "en abstracto" todo el panorama artístico, lo que de la poesía dijo el amado, el admirable, el gran poeta Maragall, el de la palabra viva: "apenas ha comenzado y está llena de virtudes desconocidas".

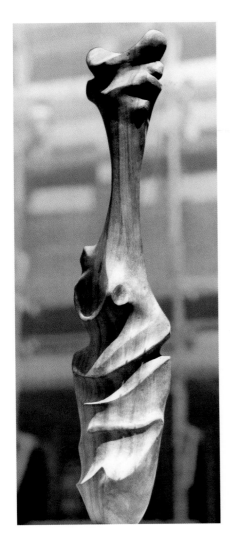

FIGURE 26 (opposite)
Rafael Marquina, "A propósito de la exposición de Los Once," *Información* (Havana), June 14, 1953, p. 28. Clockwise from top left: René Ávila; Antonio Vidal; José Antonio Díaz Peláez; Francisco Antigua; Guido Llinás; Hugo Consuegra; José Ygnacio Bermúdez; and Fayad Jamís (center).

FIGURE 27 (above)
Tomás Oliva, *Flauta-fémur,* c. 1953. Wood. Location unknown.

"eleven" (the exhibition "could have consisted of any number of artists from that generation that moved in the same circles and held similar interests and aspirations"), and the group's constituents varied from one exhibition to the next.[61] Still, the artists who showed at La Rampa made up the given "once": the painters Ávila, José Y. Bermúdez, Consuegra, Viredo Espinosa (1928–2012), Jamís, Llinás, and Antonio Vidal, and the sculptors Antigua, Cárdenas, José Antonio Díaz Peláez (1924–1988), and Oliva. The catalogue illustrated one work by each of the eleven, as did *Noticias de Arte* and the newspapers, giving the onceños broad exposure (fig. 26). The work as a whole manifested varying degrees of abstraction; inasmuch as the exhibition has been painted as a watershed moment in the history of Cuban abstraction, the group united less around aesthetic than generational solidarity. (Indeed, the success of Los Once was not then, nor would later be judged mainly on visual credentials alone.) The exhibition demonstrated the group's professionalism (for example, paintings were framed for the first time), and critics responded positively to the improved quality of the works on display.[62] Early stylistic tendencies within the motley, and only to varying degrees "abstract," group were already apparent—per Dulzaides Noda, the "Carreñismo" of Viredo Espinosa and "Lam-ism" of Jamís, the Calvinism of Díaz Peláez and necrophilia of Oliva, the geometry of Llinás and sobriety of Cárdenas.[63]

The group's sculptors concerned themselves still less with the pursuit of nonobjectivity and expressionism than the painters, and their work progressed in semi-abstract, humanist terms, sometimes inflected with a "literary, or surrealist 'halo,'" to the chagrin of some.[64] A somatic impulse loosely connects the eight sculptures in the exhibition, whose allusive range spanned spectral fauna, archetypal women, and macabre part-bodies. Antigua sent a classic reclining woman, a recurrent motif in his work, as well as the abstracted *Metamorfosis*, whose bulbous body stands in contrast to the concavities of Oliva's fetishistic *Flauta-Fémur*, in which the visible grain of the wood suggests the calcifications of bone, chiseled in sinuous grooves (fig. 27). The sculpture nominally alludes to the Paleolithic "bone flutes" thought to be the earliest musical instruments. Cárdenas, too, found source material in the ancient world, evoking the Aztec deity Oxomoco in a sculpture of the same name; its negative space, articulated through several small apertures, already looks ahead to the modeling of space seen in monumental works in marble. Díaz Peláez exhibited an elongated, hollowed-out owl that anticipated, in a similar parsing of positive and negative space, the greater attenuations and angularity of his sculpture by the end of the decade, grown leaner during his time in New York. Far from a priori creations, the sculptural abstraction of the onceños had clear Surrealist derivations—not unlike the early work of Jackson Pollock—but so too did some of the paintings on view, which were less gestural at this point than tentatively geometric.

Los Once exhibited nineteen paintings at La Rampa, showing an eager disposition toward nonrepresentational forms but typically retaining descriptive elements and titles. Viredo sent a single work depicting a stylized Santería ceremony (*Toque de Bembé*). Bermúdez showed an early tendency toward geometric patterning, layering shapes with offsetting curves and angles; this collage-like approach is refined in later paintings, which introduce a tactile surface quality and deeper emotional register. Jamís sent three paintings similarly lyrical in kind, with suggestively atmospheric titles (*Habitantes nocturnos, Tarde lunada*); the organic quality of this early work later gave way to heavier impasto and more existential gesture. Like his *Pintura*, discussed earlier, Llinas' *Abstracción* stands out for its restraint and spatial balance, the opposing blocks of color compressing space from the upper-left to the lower-right corners. Ávila and Vidal also turned to geometry as a structuring device, though with mixed results; Vidal sacrificed clarity for lyricism, *Noticias de Arte* remarked, and Ávila struggled to contain "coloristic anarchy."[65] More compelling was the linear, architectonic sensibility of Consuegra's paintings, some of which retained a vestigial naturalism alongside encroaching geometries. In a way reminiscent of Barnett Newman's drawings from the 1940s, these works tapped a germinal, evolutionary metaphor that evoked a return to (creative) origins and raised the question of self- and group-definition (compare Newman's "first man was an artist").[66] In this sense, the identification of abstraction as a vehicle of originality, by Consuegra and others, went hand in hand with cubanista cycles of national revolution and renewal.[67]

In retrospect, the visual provenance of the works shown at *Once pintores y escultores* mattered less than the generational identity that the exhibition affirmed. By the same token, the mixed critical fortunes of the onceños over the following two years cannot be pinned strictly to abstraction per se, though the artwork and the politics of the group would have seemed at times, and to contemporary viewers, virtually identical. The conjunction of the onceños with *cubanía rebelde* was in place from the beginning, broached by Texidor in more plaintive language than had appeared in his review of the Salon. Existential in feeling, his catalogue introduction registered the constraints of the one-year-old Batista state: "This group of young painters and sculptors has taken up an eternal and impassioned struggle—one of finding meaning in the world, in life, and in the spirit, and above all of expressing themselves with the freedom that art alone can offer . . . which allows them to be one with their time and with the future."[68] Describing the exhibition as a powerful affirmation of the abstractionist trend, Texidor asked for a temporary stay of questions regarding technique and achievement, appealing instead to the group's spirit of "invention, adventure, and daring: in sum, of creation."[69] His words had wide resonance: Marquina cited them as the perfect "synthesis of the transcendence and artistic validity" to which the onceños aspired, and *Noticias de Arte* praised the exhibition as "one more page in this heroic history of modern art in Cuba," the direct descendent of the vanguardia tradition begun by Víctor Manuel.[70] Likely written by Carreño,

distancing himself more and more from Havana School aesthetics as he turned toward abstraction in his own practice, the latter review further consecrated the onceños as a third generation, evoking their historical birthright and circumscribing their role within a heroicizing, cubanista narrative of regeneration.[71]

Los Once doubtless benefited by association with their vanguardia inheritance, internalizing its received politico-cultural mythos even as, in classic vanguardist fashion, they proclaimed their rupture with the visual tradition of the modern movement before them. This generationalist mentality—"a revolutionary viewpoint of change alongside a traditionalist memory of the past"—gave gravitas to the young artists' self-conscious iconoclasm.[72] Their invective touched upon not only artworld targets but also the Cuban public, whose alleged attitude of *"estar en la cerca"* (sitting on the fence) frustrated the revolutionary animus of the onceños. The shock value of abstraction was part and parcel of its appeal, Martínez later explained: "Within the context of the backward painting that existed in Cuba at the time, to do abstract painting was a revolution in itself. . . . It was decided that Cuban painting would have to be destroyed, in a manner of speaking, because it had always been backward. . . . We decided we had to be up-to-date, to discover a new vision of our country. We were tired of the palms and the fruits, of the idyllic vision. We decided we had to take a different direction. We had to look at this continent, not at Europe. We decided to use North American abstraction as our form, because in Cuba there was no tradition, there was nothing to explore."[73] More than a means to *épater le bourgeois* at home, abstraction also signaled the group's aspirational Americanist synchronicity, its orientation away from Europe and from the perceived sterility of its own vanguardia past. Often latecomers to vanguard movements in the history of art, Cuban artists, Martínez acknowledged, had long made the mistake repeated by Víctor Manuel in 1927 when he returned from Paris with *Gitana tropical*, a painting whose marked traces of Gauguin seemed undesirably retardataire at a moment better defined by "the Fauves, German Expressionism, Picasso, Juan Gris and Braque."[74] "I wasn't interested in being a bad Juan Gris or a poor Pablo Picasso," Corratgé reiterated, a resolution that led him to "experiment with the forms of abstract art."[75] Los Once likewise vowed not to look backward, and in turning instead to gesture painting they latched onto the sweeping American zeitgeist of the postwar period, which was meanwhile (and with Batista's blessing) penetrating virtually every sphere of habanero life.[76]

Martínez and Llinás held the keenest americanista line among the onceños, a position affirmed by their artwork, which came closest to American "action painting," and by their consistently expressed interests and influences. Like Llinás, Martínez became acquainted with the New York School firsthand, in his case over the course of an academic year (1952–53) spent at the Art Institute of Chicago. "The students were divided between those who defended Abstract Expressionism and those who attacked it," Martínez recalled, crediting a classmate for having "clarified and dispelled [his] many doubts."[77] Highlights from his year abroad included the major Fernand Léger

retrospective in Chicago and encounters with Auguste Rodin, Paul Klee, and Georges Seurat's *A Sunday on La Grande Jatte* (1884); on his return to Havana, he visited New York for the first time.[78] Martínez was absent on the occasion of Los Once's debut, not returning to Havana until September or October of 1953, and his official admittance to the group was delayed until Bermúdez left for the United States, at the invitation of Gómez Sicre to work at the Visual Arts Section of the Pan-American Union, a couple of months later (the timing necessary, Llinás explained, to retain the numerical integrity of the group).[79] While Llinás and Martínez had become converted by the new American painting during their travels abroad, the American imprint reached those artists who remained in Cuba in a meaningful way through the print medium. The artist-run *Noticias de Arte* favored the New York School with regular coverage. In addition, the onceños cited the American imprint *Art News* for its wide local circulation at the time, and its iconic spreads—notably, "Pollock Paints a Picture" (May 1951), "The American Action Painters" (December 1952)—conveyed in terms both visual and philosophical the furor building around gestural abstraction.[80] Harold Rosenberg's invocation of the canvas as "an arena in which to act," fraught with tension and "inseparable from the biography of the artist," doubtless appeared as much an imperative in Havana as it did in New York.[81] Even for artists like Antonio Vidal, who never traveled further than Guantánamo, the hegemony of the new American school and its brand of abstraction were everywhere reinforced at second hand, aided no doubt by the omnipresence of American culture—cars, capitalism, celebrities—across the island.[82]

Notwithstanding the predominance and nearer proximity of the New York School, some of the onceños tacitly acknowledged (if somewhat latterly) the continued, contemporary presence of European abstraction over the 1950s. Consuegra, in particular, has emphasized the relevance of the European tradition, dismissing the notion that the onceños were "Yankee offspring." While conceding the "pictorial supremacy" of North American expressionism, he claimed that Europe remained the more important cultural nexus for his generation, citing its influential philosophy (existentialism), film (neorealism), and music (neoclassicism).[83] Consuegra's revisionist gesture toward Europe reflects a later ambivalence toward the United States, hardened over decades of Cold War antagonism, and privileges certain of his own sources over the prevailing americanista orientation of the time. An acknowledgment of European influence would have appeared behindhand, if not altogether impolitic to most of the onceños in 1953, no more so than in the buildup to the *II Bienal Hispanoamericana*. But inasmuch as the Catalan painter Antoni Tàpies (1923–2012) and postwar French *art informel*, for instance, were known in Cuba, the quality and ubiquity of American abstraction remained—for Los Once as a group—without equal during the 1950s. While the heyday of the onceños had passed by the time that Dolores (Loló) Soldevilla (1901–1971) returned to Havana with a School of Paris portfolio in hand, the Constructivist horizons that she opened had greater impact on the concretos than they ever had previously on the onceños.

LOS ONCE: 1953

The onceños organized six dedicated group shows in Cuba over the two years follow-ing their eponymous exhibition, though not (and never) again as the "original" eleven. Administrative responsibilities fell to Consuegra, Llinás, Martínez, Oliva, and Antonio Vidal (and for a time, Cárdenas), who negotiated and arranged the exhibitions and framed the group's identity.[84] In most cases, no record remains of the artworks exhibited; much of the work itself remains undocumented and may not survive. Consuegra, for instance, claimed to have destroyed twenty of the twenty-eight paintings that he made in 1953, "so intense were [his] inner conflict and dissatisfaction."[85] The debate over the val-ues of abstraction and the generational status of Los Once vis-à-vis the vanguardia did not change meaningfully in these early years, but the onceños remained purposefully in the public eye as they built their practices. Two exhibitions followed *Once pintores y escul-tores* in 1953—first alongside the historical vanguardia and then, in perhaps their most ambitious showing, at the Lyceum—and marked early milestones in the group's history.

No doubt chastened by the news of Moncada, intergenerational tempers from the year's opening Salon seemed to subside over the summer, just around the time of an early showing of solidarity across vanguardia lines. The exhibition *Pintura, escultura, cerámica* opened on July 18 at the Retiro Odontológico, a commercial center designed by Antonio Quintana in a functionalist modern style with a Corbusien *brise-soleil* on two sides. "A shot of modernity into an area [Vedado] that was rapidly becoming the hub of Havana life," the building was well suited to bring together the elder-generation vanguardia and the onceños in a gesture of unanimity. A ground-floor mural by Mariano Rodríguez, *El dolor humano*, imparted a measure of gravity to the space, its attenuated bodies strung out against an angularly abstract, apocalyptic landscape. Rodríguez was one of forty-five artists spanning twenty-eight years of Cuban art selected by Gladys Lauderman for the show, which included almost all of Los Once (excepting only Llinás) as well as two paint-ings by Zilia Sánchez. Lauderman appealed for generational coexistence in her introduc-tion to the exhibition; and abstraction, in the work of the onceños and others, may itself have seemed a unifying medium, lately (if fleetingly) fashionable to artists of the Havana School.[86] Dulzaides Noda faulted the exhibition on numerous counts but made a blanket exception for the onceños, anticipating his more enthusiastic support over the coming months.[87]

Llinás rejoined the group for its next exhibition, *Los Once*, which opened on November 19 at the venerable Lyceum, since 1928 the institutional haven of the vanguar-dia. Martínez exhibited for the first time as an official member of the group, permanently replacing Bermúdez who had left for the United States; Jamís was absent, reducing the group's number to ten. Following earlier debuts at La Rampa and at Nuestro Tiempo, newer spaces emblematic of their generation, the group's year-end exhibition at the Lyceum crowned their arrival as heirs to the vanguardia mandate. Some younger art-ists had held solo shows at the Lyceum—for example, Agustín Fernández (1928–2006)

in 1951; Rolando López Dirube (1928–1997) in 1951 and 1952; Martínez in 1952; Consuegra, Bermúdez, and Zilia Sánchez in 1953—but the group show conferred clear generational prestige.[88] Tellingly, Martí's oft-repeated phrase—"a revolution of forms is a revolution of essentials"—served as the leitmotif of *Los Once*, definitively positing abstraction as a medium of revolution. Lauderman and Dulzaides Noda remarked upon the rapid maturation of the onceños as a self-made avant-garde, praising their enterprise and historical awareness.[89]

Cárdenas and Consuegra stood out to both critics for the maturity and plastic expressiveness of their work, which took markedly different paths to abstraction. Consuegra's early paintings display an architectonic clarity and austerity less agitated in feeling than much of his later work, as seen in a surviving example from 1953 (fig. 28). Against a subtle palette of taupe and ocher, dark, nondirectional lines and watery drippings of paint suggest the flatness of the surface, modulated through the recessive layering of close tonalities and floating, semi-transparent rectangles of color. The Constructivist feeling of Consuegra's early practice was first noticed by Texidor, who cited the essential precedent of Joaquín Torres-García, but the philosophy of Constructive Universalism—which proposed an ancient American origin for abstract art—found little truck among the onceños.[90] Cárdenas diverged from Constructivist and Expressionist models, instead plumbing a vestigial Surrealism through biomorphic and sexualized bodies that accessed West African and pre-Columbian archetypes by way

FIGURE 28

Hugo Consuegra, *Untitled*, 1953. Oil on canvas. 30½ × 41 in. (77.5 × 104.1 cm). Dr. and Mrs. Juan C. Erro.

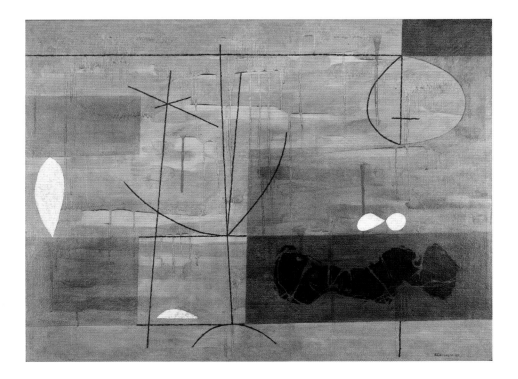

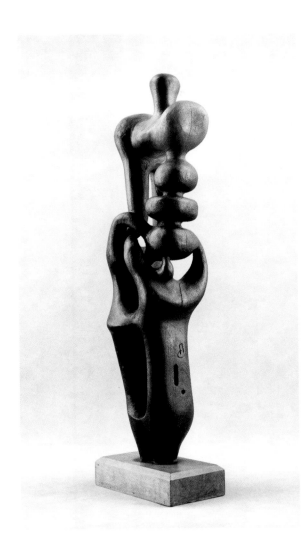

FIGURE 29
Agustín Cárdenas, *Sculpture cubaine*, 1954. Charred wood. 22¾ in. (58 cm).

of the modernist triumvirate of Henry Moore (1898–1986), Constantin Brancusi (1876–1957), and Jean Arp (1886–1966), all known through reproductions. His early wood sculptures, four of which he sent to the Lyceum, explore the plasticity of material and representation through open volumes, abstracted but not (ever) nonrepresentational. The hyper-elongated figure of *Sculpture cubaine*, for example, swells suggestively, its parts adjoined through interlocking forms at its center; its wooden armature offsets rounded, bulbous shapes with carved-out hollows running the length of its interior (fig. 29). A descendant of slaves from Senegal and the Congo, Cárdenas was one of two onceños of African descent (the other was Llinás), and their early prominence within the group marks important points of differentiation—class, race—between the third-generation vanguardia and its predecessors. The equal-opportunity origins of Los Once, which permitted visual diversity within abstraction among an equally motley constituency, presented both a strength and a weakness to the group's cohesiveness and sense of fraternity over time.

A full year passed before the onceños—reduced in number to seven—mounted their next group show. In the interim, their attention turned toward the *II Bienal Hispanoamericana*, which tested the agency of abstraction and the power of its witness to the transatlantic politics of the decade. Already in their transition from "23 y medio" to Los Once, the "under-30s" had ventured abstract art as a revolutionary gambit. The visual shock of abstraction represented a decisive break with the tropicalist and essentializing tropes that had canonically defined "lo cubano"—no more so than in its North American extraction, which marked an ideological, as well as an aesthetic break with the vernacular modernism of the Havana School. Emboldened by the generational vanguardismo of the moment, with its rallying martiano cry, the onceños and their supporters began posthaste to leverage abstraction—in theory as much as in practice—as a cubanista response to Batista's coup d'état. Fully invested as a third-generation vanguardia by the time of the watershed exhibition *Once pintores y escultores*, the onceños could dare command their practice as a medium of public and political engagement by the close of 1953. A new, radicalized paradigm for modern Cuban art, abstraction stood poised to confront dictatorship at home and abroad.

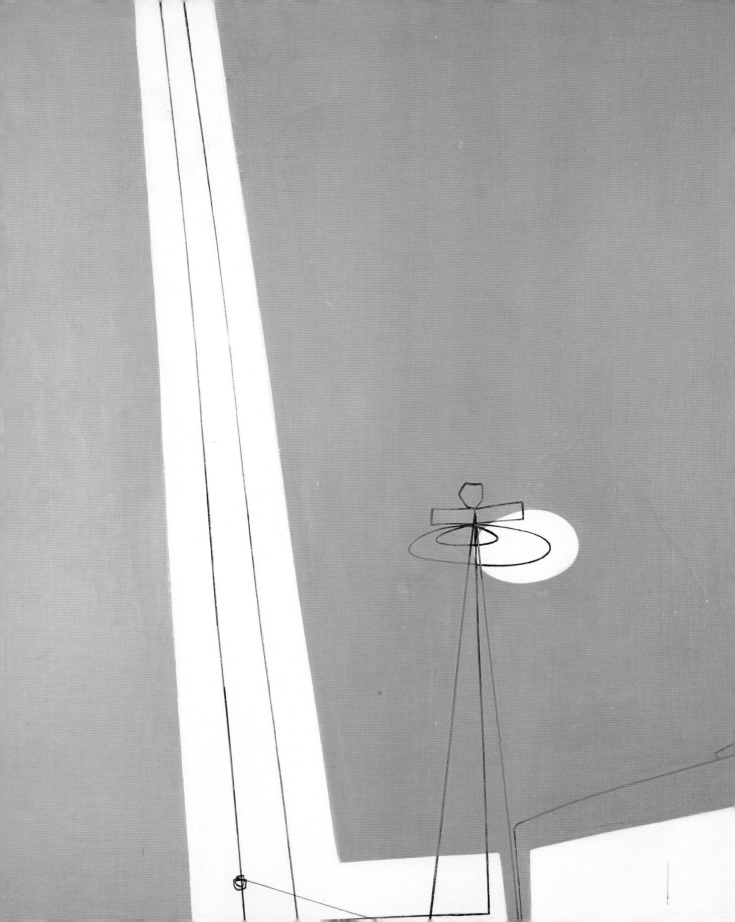

3 Anti-Bienal, Bienal, and the Dissolution of Los Once

By the end of 1953 and their eponymous exhibition at the Lyceum, Los Once appeared fully vested as a third-generation vanguardia, flush with recent critical success and increasingly adept in their promotion of abstract art. The martiano overtones of their exhibitions—to wit, their adoption of Martí's classic phrase, "a revolution of forms is a revolution of essentials"—already conferred an ideological imprint to their practice of abstract art at the level of form. Over the next year, the onceños began to parlay abstraction as praxis, repeatedly instantiating their artwork in the world as a medium of protest and political eyewitness. "The social revolution was being made by what we were doing with the work after it was finished," Raúl Martínez emphasized. "There was not unity, but a duality which our work reflected: on one hand an aesthetic search for form; but on another level, our daily attitude was that we gave battle with our work."[1] The battleground of 1954 centered on the *II Bienal Hispanoamericana*, which arrived in May from franquista Spain, ostensibly to conclude a year-long commemoration of the birth of José Martí, beloved as the "Apostle of Cuban Independence." In the buildup to the Bienal, the onceños participated with other vanguardia artists in a months-long *anti-bienalista* protest, beginning as early as October in the press and culminating with a counter-exhibition at the University of Havana in May (fig. 30). The occasion of the Bienal forced Los Once's hand, pinning abstraction's fortunes to political action and, by the following year's end, compelling the group to define itself in ideological—not artistic—terms.

The function, rather than the form, of abstraction consumed the onceños as they directed their energies against the Batista regime, and their activism brought to light questions about the power of art as a means of political transformation. "We supported with our presence all activities against the tyranny," Martínez later recalled. "We believe[d] that art is for art's sake, but what one does *with* the art is a problem of individual conscience, and that is already political."[2] More to the purpose than the political "content" of abstraction, as Martínez recognized, was its transitive value, in other words its capability to act within the world in which it circulated. In its most ambitious charge, abstract art possessed the extraordinary potential to intervene in relations of power (its forcework), regardless of its direct engagement in politics or success therein. Seen from a longer perspective, the artworks of the onceños stood testament to the historical process

Detail of fig. 41

INDIGNO PARA CUBA
que Franco rinda homenaje a Martí

No concurrirán a la "Bienal" los pintores cubanos

FIGURE 30

"Indigno para Cuba que Franco rinda homenaje a Martí," *Tiempo*, October 31, 1953.

unfolding around them, and the simple fact of their presence became as significant over time as the event of the Bienal itself. Between the Anti-Bienal and the Bienal, the onceños repeatedly tested the relationship between the transformative work of art and radical political change. In real time, their strategies—international networking, broadsheet publications, protest-exhibitions—produced an uneven outcome, bottoming out a year later with the dissolution of the group. Los Once struggled to regain their momentum and autonomy in the aftermath of the Bienal, shaken by artful overtures from the Batista state and an initially rocky resumption of their exhibition program in late 1954. Their disbandment was a move made partly for posterity, an act to repossess abstraction from those who would depoliticize its aesthetics; as a practical matter, it conceded the group's growing balkanization and transatlantic dispersal. Although the core onceños reconstituted themselves as "Los Cinco," the decision to formally dissolve as Los Once signaled a tactical shift—retrenchment, internationalization, survival—by many of their generation over the remainder of the decade. As the last major venture of the original group, the Anti-Bienal/Bienal dyad marks a critical moment at which to appraise abstraction, its continued *martiano* and *cubanista* resonances, and its status vis-à-vis the historical *vanguardia*.

ANTI-BIENAL

The exhibition *Homenaje a José Martí: Exposición de plástica cubana contemporánea*, known colloquially as the Anti-Bienal, opened with great fanfare on January 28, 1954, at Havana's Lyceum (fig. 31). "The visual arts could not be absent from this commemoration," the catalogue's introduction stated, "particularly when certain activities are being sponsored that go against the most essential principles of the *ética martiana*."[3] The unnamed activity was, of course, the *II Bienal Hispanoamericana*, originally slated to inaugurate the Palacio de Bellas Artes, the new site of the Museo Nacional, on the same day (January 28, Martí's birthday). The cordiality between the Francisco Franco and Batista dictatorships appeared, to the forty-two participating artists among others, an indignity to the republican legacy of Martí, and the centenary connotations of the Bienal struck a particularly bitter note. The cultural vanguardia lodged its opening round of protests in late 1953 with the publication of a broadside, "*Ultraja la Memoria de Martí: La Bienal*

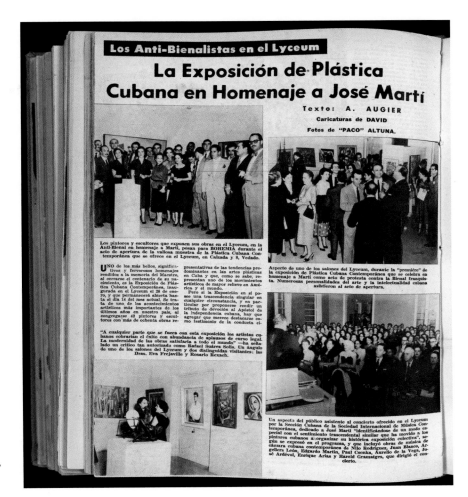

Hispanoamericana" [The Hispanoamerican Biennial Insults the Memory of Martí] (fig. 32). Among its passages was a widely circulated and reprinted article, first published in the magazine *Bohemia*, that declared the Bienal a "Falangist exhibition" and enumerated its neocolonial pretentions, citing the third point of the Falangist Manifesto (1934): "We have a will to empire. We affirm that Spain's historical destiny implies an empire.... With respect to the countries of Spanish America, we strive for the unification of culture, of economic interests, and of power. Spain considers that her position as spiritual axis of the Hispanic world gives her preeminent place in common enterprises."[4] Referencing the sixteenth-century conquistador Pánfilo de Narváez and the totalitarian reign of Adolf Hitler, *Bohemia* reminded its readers of Spain's early recognition of the Batista regime and warned of an encroaching franquista sphere of influence (the "yoke and arrows"). The flagrant juxtaposition of Franco and Martí provided a natural rallying point for the left-leaning vanguardia, and the impending Bienal gave the artists a clear political platform.

Ultraja la Memoria de Martí la Bienal Hispanoamericana

BOLETIN Núm. 1

Con el objeto de mantener informado al pueblo de Cuba sobre la actitud que asume un grupo de artistas plásticos cubanos ,opuestos a la celebración en La Habana de la II Bienal Hispanoamericana como homenaje a José Martí en el Centenario de su nacimiento, se reunen aquí diversos documentos que debe conocer la opinión pública, ya que dicha Bienal constituye un ultraje a la memoria del Apóstol de nuestras libertades al estar organizada por el gobierno de la España actual, producto de esas fuerzas destructivas de la humanidad que son el nazismo y el fascismo, encubriendo la referida exposición un acto de penetración falangista en suelo de América.

Es, además, incongruente que se utilice fondos públicos para costear un acto de tal naturaleza, inspirado por un régimen que en todo momento ha sido repudiado por el pueblo de Cuba y que es la negación absoluta de los conceptos martianos.

Se hace constar aquí que la impugnación de la Bienal Hispanoamericana no es un movimiento para defender determinadas tendencias estéticas, sino que se trata de una repulsa general por parte de todos los artistas cubanos firmantes del manifiesto, sin distinción de escuelas o credos artísticos; que los pintores, escultores, caricaturistas, intelectuales y profesionales que han protestado y secundado respectivamente, actúan con el único propósito de defender la cultura y la dignidad humana, frente a la amenaza franquista, y que basados en los más fieles preceptos de José Martí, repiten con el Apóstol: "El verdadero hombre no mira de qué lado se vive mejor, sino de qué lado se está el deber."

Origen de la Bienal Franquista

Se reproduce a continuación parte de un interesante artículo publicado por la revista "Bohemia" —noviembre 8, 1953—en el que describe hechos y factores que dan origen a la Bienal Hispanoamericana como un instrumento de penetración franquista en América, y comienza hablando sobre el punto 3 de la Falange Española, la cual declara con insolencia simpar que:

—"Tenemos voluntad de imperio. Afirmamos que la plenitud histórica de España es el imperio... Respecto de los países de Hispanoamérica, tendemos a la unificación de la cultura, del interés económico y del poder. España alega su condición de eje espiritual del mundo hispánico como título de preeminencia en las empresas universales.

Tal era la vehemente prosa que traducía, en los tiempos dorados del totalitarismo, la ambición de los espadones reaccionarios, que ya ensayaban sus fuerzas para agredir por la espalda a la República Española. Tras ella estaba la mano del general Wilhelm Von Faupel, designado por Hitler, en 1934, para dirigir el Instituto Iberoamericano de Berlín. La orientación de aquella época hacia la reconquista del imperio—que, por supuesto, sólo podría realizarse a la sombra de la hegemonía nazi—incluía a las antiguas colonias de América y Filipinas como partes del "mundo hispánico" sobre el que Madrid volvería a ejercer su coyunda.

El vehículo directo de esa política fué el Consejo de Hispanidad, instituido oficialmente, por decreto del gobierno franquista, el 7 de noviembre de 1940. Los dos primeros artículos de su parte dispositiva son elocuentes:

—Con el fin de que ayude a cumplir la obligación que se tiene de velar por el bien y los intereses de nuestro espíritu en las más nobles de las que un organismo asesor, dependiente del ministerio de Asuntos Exteriores, que se denominará Consejo de Hispanidad, y será rector de aquella política, destinada a asegurar la continuación y eficacia de las ideas y las obras del genio español.

—Serán del cuidado de este Consejo—decía el artículo 2—todas las actividades que tiendan a la unificación de la cultura y los intereses económicos y de poder relacionados con el mundo hispánico.

Devotos quijotescos de un pasado que jamás podría retornar, los falangistas hacían referencia en el preámbulo a la obra de expansión española en el mundo, "como ordenó la Reina Católica en su día". Desgraciadamente para ellos, la suerte de las armas las fué infiel. La que soñaron ser metrópoli de un imperio resucitado quedó convertida en refugio vergonzante de los nazis prófugos de la justicia aliada. Y entre los virajes que la nueva situación internacional impuso a

OPINIONES DE UN MARTIANO

Gonzalo de Quesada y Miranda, hijo del discípulo predilecto de Martí, Director de las Obras Completas del Apóstol y Director del Seminario Martiano de la Universidad de La Habana, en sin duda una de las voces más autorizadas en todo lo relativo al gran cubano. En unas declaraciones a la revista "Bohemia" —noviembre 22, 1953—dice:

"El proyecto de clausurar la celebración del Centenario de Martí con la Bienal Hispanoamericana, prohijada por el gobierno de Franco con dinero cubano, me parece completamente fuera de toda lógica y en pugna con la recta interpretación del pensamiento martiano."

Protesta de los Artistas Plásticos de Cuba

A la Comisión Nacional del Centenario de José Martí:

De acuerdo con informaciones publicadas sobre la celebración de la II Bienal Hispanoamericana por la Comisión Nacional del Centenario de José Martí, a celebrarse en La Habana, los artistas abajo firmantes, nos dirigimos a ese organismo para hacerle las siguientes manifestaciones:

PRIMERO: Que nos parece absurdo que uno de los festejos del Centenario de José Martí sea la celebración en La Habana de la Segunda Bienal Hispanoamericana, dado que dicha exposición está estructurada por un país extranjero, por tratarse de una continuación de la Primera Bienal celebrada en Madrid y la cual fué convocada por el Gobierno Español.

SEGUNDO: Que resulta incongruente que el Estado cubano financie esta Bienal, para la cual ya se ha destinado un elevado presupuesto.

TERCERO: Que teniendo en cuenta que lo que se celebra es el Homenaje al Apóstol Martí en su Centenario y que el Estado cuenta con los fondos correspondientes para tal evento, lo indicado, lo lógico, es que sea la propia Nación cubana la que organice y convoque a una EXPOSICION MARTIANA INTERNACIONAL DE ARTE y no a una Bienal Hispanoamericana que está auspiciada por un gobierno extranjero.

CUARTO: Que reafirmados en nuestras patrióticas convicciones y en la del pueblo cubano, pedimos a la Comisión Nacional del Centenario de José Martí el cumplimiento de esta justa demanda. En caso de no celebrarse nuestra propuesta EXPOSICION MARTIANA INTERNACIONAL DE ARTE, nos abstendremos de concurrir a la Segunda Bienal Hispanoamericana.

Firman: Amelia Peláez, Cundo Bermúdez, Mario Carreño, René Portocarrero, Julio Girona, Raúl Milián, Jorge Arche, Mariano Rodríguez, Manuel Roldán Capaz, Alfredo Lozano, Agustín Fernández, Romero Arciaga, Sandu Darie, Raúl Martínez, Felipe Orlando, Marta Arjona, Pablo Porras, Fayad Jamis, Hugo Consuegra, René Avila, Guido Llinás, Luis Martínez Pedro, Marcelo Pogolotti, José Mijares, Eugenio Rodríguez, Jesús Casagran, Francisco Antigua, Antonio Vidal, Agustín Cárdenas, Zilia Sánchez, Viredo, Lucía Alvarez, Manuel Couceiro, María Miyares, Tapia Ruano, José I. Bermúdez, Jorge Camacho, Enrique Moret, Luis Alonso, Domingo Ravenet, Víctor Manuel, María Elena Jubrías, Palko Lukacs y otros.

Falange Española figuró la sustitución del hombre, según indicreto, el Consejo de Hispanidad, por el Instituto de Cultura Hispánica.

Apenas se reanudaron las enseñanzas normales en el "caudillo", el ICH y su filial de Cuba, denominado Instituto Cultural Hispanocubano, no desaprovecharon la oportunidad de penetrar en el escenario isleño. Y dió la casualidad de que coincidieron tales esfuerzos en el tiempo con el Centenario de Martí. De este modo resultó que los fondos de la Comisión de Actos y Ediciones del Centenario del Apóstol nutrieron el primer simulacro cultural del franquismo en suelo cubano: la costosa a intrascendente exposición de grabados españoles y de copias de Goya en el Castillo de la Fuerza.

Como éste, los demás actos y exposiciones efectuadas hasta ahora por el organismo falangista fueron financiados con dinero cubano a causa de la gran crisis que divisa padecida por España, aunque el absurdo ideológico de ver al concurrir a una Bienal que intriga totalitarias mayor que el contrasentido económico.

Ya se había celebrado en Madrid la primera exposición bienal de arte hispanoamericano, a través del cual proyectaban los falangistas atraerse a núcleos artísticos valiosos de Latinoamérica, asociándolos, más o menos directamente, a la esfera de influencia del Yugo y la Flecha. Esto sucedió de fines de 1951 a principios de 1952. Pero el empeño se vió rodeado por el vacío. Las clases cultas de Europa y América hicieron caso omiso. De ahí que se decidiera sacar de España a la Bienal y llevarla al antiguo escenario de las depredaciones de Pánfilo de Narváez.

La tramitación del atrevido plan se hizo por la vía diplomática, donde el embajador Antonio Iraizoz olvidaba su pasado de Gran Maestro de la Masonería cubana, yendo de bracete con el canciller franquista Martín Artajo.

De nada valieron las objeciones y protestas alzadas en la Comisión de Actos y Ediciones del Centenario de Martí. No sólo Emeterio Santovenia y José M. Pérez Cabrera, sino el mismo director de Cultura, José López Isa, manifestaron:

—Señores, nos parece un disparate patrocinar esa exposición de arte como clausura del año centenario del Centenario, porque los contribuyentes a los fondos de la Comisión protestarán, con razón, de que se empleen sus aportaciones para algo ajeno y hasta opuesto al espíritu de Martí.

Pero el proyecto, en definitiva, quedó aprobado. Gran parte de lo que el pueblo entregó, con sacrificio ejemplar, para el monumento al Apóstol y las fiestas del Centenario, debía distraerse en el aparato de propaganda montado en Madrid por los enemigos públicos de la democracia.

Según el cálculo oficial, la II Bienal de Arte Hispanoamericano se inaugurará en La Habana en una fecha increíble: la del propio 28 de enero, natalicio del Apóstol. Era motivo de duelo para las libertades cubanas."

LOS ARTISTAS SE DEFINEN

Por GLADYS LAUDERMAN

Los tiempos que vivimos imponen las definiciones. Hoy se es uno a otra o una cosa con firmeza, porque estar entre ambos extremos es casi no existir. Y así ha pasado en estos vaivenes absurdos del mundo contemporáneo en América que ha tocado definirse a los artistas plásticos. Es decir, a los pintores y escultores. Pero esta afirmación—que después de todo es lo que significa definirse—no ha sido, como se de suponer, apreciar los rumbos estéticos de uno a hacer distinciones sobre teorías postuladas, sino algo mucho más hondo por atañer a los valores permanentes del ser humano iguales para todos, creadores o no.

Los artistas cubanos, ante la inminencia de un evento internacional organizado por una nación extranjera con el concurso de la nuestra, se han apresurado a manifestar sus opiniones que con sumamente esperanzadoras para los que hemos leído y aún más para aquellos que conocemos la trascendencia de sus implicaciones. Es altamente satisfactorio que los afanes estéticos no hayan hecho sino enriquecer en ellos los valores eternos de la libertad y la dignidad humana defendidos en su propia vida por nuestro Apóstol. Ellos hacen suyas sus palabras inolvidables: "¡La justicia primero, y el arte después!" Y con él piensan que no es un hombre cabal aquel "... que en tiempos sin decoro se entretiene en las finezas de la imaginación, en las elegancias de la mente!" Dice aún Martí palabras más definitivas en el artículo sobre Verreschagin: "Cuando no se disfruta de la libertad, la única excusa del arte y su único derecho para existir es ponerse al servicio de ella. ¡Todo el fuego, hasta el arte, para alimentar la hoguera!"

Los artistas no han olvidado las pautas que marca la vida José Martí nos legara, y fieles a ellas han proclamado con gran sinceridad—no hay nada mejor que manifestar la verdad abiertamente—, sin estruendos ni algazaras inútiles, que no concurrirán a la II Bienal Hispanoamericana, como no lo hicieron a la primera por estar organizada por un gobierno cuyas esencias repudian y que, en este caso, condenan de un modo público por constituir un festejo conmemorativo de un hombre cuya vida y cuya obra es la negación rotunda de los principios que sustentan los rectores de ese país.

En Cuba hemos olvidado tanto las enseñanzas martianas que es hermoso saber que los pintores y los escultores se acuerdan de ellas en momentos de urgencias definitorias y de defensa de ideologías veneradas. Es también hermoso ver que los que siempre andan discordes se aunan para pronunciamientos de esa honrada humana, mientras otros se ponen de acuerdo en pormenores y se despreocupan de estas actitudes de corosas por ser eternas protestas dignísimas del hombre. Hoy no hablamos de tendencias, de orientaciones estéticas, o de presencias más o menos decorosas en nuestro medio. No es necesario. Otros aspectos se discuten. Cuba a través de sus más destacados representantes del arte no concurre a una Bienal que no puede invocar al espíritu martiano. Cuba ha sido, aunque los firmantes sean un pequeño grupo, fiel al Apóstol. A ellos me uno.

(Tomado del periódico "El País", La Habana.)

Adhesión de Intelectuales, Artistas y Profesionales de Cuba

A la Comisión Nacional del Centenario de José Martí:

Enterados por la prensa del manifiesto que más representativo de la plástica cubana actual, hubo de dirigirle a esa Comisión con motivo de la celebración en la ciudad de La Habana de la II Bienal Hispanoamericana para cerrar los festejos del Centenario de la más fiel tradición martiana.

Coincidiendo con esos pintores y escultores en que es absurdo que se pretenda rendir homenaje al Apóstol con dicha Bienal Hispanoamericana, por cuanto se trata de una continuación de la I Bienal celebrada en Madrid y en la cual Cuba sólo aporta la cuantía y la gran parte del costo de esa exposición, sin contenido martiano, apoyamos la proposición de esos artistas de que sea una EXPOSICION MARTIANA INTERNACIONAL DE ARTE convocada por Cuba, la que se le rinda como homenaje en su centenario, identificándonos también con su civica determinación de no asistir a esa Bienal Hispanoamericana.

Firmado: Gladys Laudeman, José Ardévol, Alicia Alonso, Fernando Alonso, José Lezama Lima, Salvador Bueno, María Teresa Freyre, Luis Amado Blanco, Conrado W. Massaguer, Harold Gramatges, Vicentina Antuña, Félix Pita Rodríguez, Aurelio de la Vega, Juan David, Eva Frejaville, Alberto Bolet, Francisco Carone, Edgardo Martín, Julia Rodríguez Tomeu, José M. Valdés Rodríguez, Marta Frayde, Nicolás Quintana, Raúl Roa, Rosa Oliva, Mario Romañach, Argeliers León, Carlos Mestre, Ricardo Porro, Mario Parajón, José F. Expósito Fernández, Antonio Rubio, Francisco Sierra, Antonio Quintana, Carlos Vidal, Silverio Bosch, Nilo Rodríguez, J. Pino Zitro, Juan Blanco, Néstor Almendros, Blanca Bahamonde, E. Collado, J. M. Rodríguez Cruz y otros.

Nota: Se han recibido otros manifiestos de diversas repúblicas hispanoamericanas, que no reproducimos por falta de espacio, pero se publicarán en el Boletín No. 2.

De México

A la Prensa Cubana:

Los abajo firmantes, pintores mexicanos y residentes de México, estamos interesados en hacer saber a través de la prensa cubana que no participaremos de ninguna manera voluntaria en la Bienal Hispánica que va a celebrarse en La Habana.

De la misma manera que no permitiríamos la inclusión de nuestras obras en la I Bienal, sostenemos nuestra posición de no coparticipar en eventos preparados por la dictadura franquista.

Nuestra actitud nada tiene que ver con el pueblo de Cuba al cual respetamos. Sólo queremos significar que, aunque cambie de localidad los actos de propaganda del gobierno de Franco cuenta con nuestra repulsa total.

Firman: Rufino Tamayo, Carlos Mérida, Alberto Gironella, Carlos Orozco Romero, José Luis Cuevas, Raúl Anguiano, Enrique Echeverría, Machila Armida, Fernando Belván, Enrique Climent, Alfonso Michel, José Bartolí, Vlady, Francisco Tortosa, Arturo Souto, Antonio Rodríguez Luna, José González Camarena, Ramón Gaya, Héctor Xavier.

De Guatemala

Carta abierta al pueblo de Cuba:

Enterados de que el gobierno de Franco pretende efectuar un homenaje a José Martí en tierra cubana, celebrando en la II Exposición Bienal de Arte en La Habana, los artistas guatemaltecos que suscriben, desean dejar constancia, por medio de la prensa de Cuba de lo siguiente:

a) Que no estamos dispuestos a prestar obras nuestras con destino a actos de propaganda franquista, sea en Madrid, en Cuba o en cualquier otra parte.

b) Que en un ultraje a la memoria de Martí, un homenaje rendido por un tirano como Franco.

c) Que deseamos exhibir nuestra obra en Cuba, pero sólo bajo el patrocinio de instituciones cubanas legítimas.

d) Que todos los firmantes son ciudadanos democráticos y artistas independientes, que toman esta decisión en razón de conciencia y, en momento alguno, cumplen con ninguna consigna de partido político de ninguna clase.

e) Que nos solidarizamos con los buenos artistas cubanos que ya han repudiado el turbio proyecto de Franco. Con un saludo al pueblo cubano y nuestra adhesión a sus pintores y escultores:

Rodolfo Galeotti Torres, Roberto González Goyri, Rolando Palma, Víctor Manuel Aragón, Roberto Ossaye, Arturo Martínez, Dagoberto Vázquez, Juan de Dios González.

De Colombia

Al pueblo cubano:

Un grupo de pintores colombianos independientes, desea manifestar a la opinión pública en Cuba que, bajo ninguna circunstancia está dispuesto a participar en la Exposición Bienal que organiza el Gobierno de Franco en La Habana.

Nos sería muy grato exhibir en Cuba en otra ocasión, bajo un patrocinio más honorable y no bajo una burda propaganda de un régimen fascista.

Aprovechamos la oportunidad para saludar a los artistas libres de Cuba y de todas las naciones latinoamericanas que se han negado igualmente a figurar en ese lamentable evento con que el falangismo se "propone manchar la memoria de José Martí.

Firman: Alipio Jaramillo, Marco Ospina, Jorge Elías Triana, Eduardo Ramírez Villamizar, Ignacio Gómez Jaramillo, Enrique Grau, León Cano y Jorge Moreno Clavijo.

DECLARACION DE INTELECTUALES Y ARTISTAS DE SANTIAGO DE CUBA

En vibrante manifiesto hecho público el pasado 16 de noviembre los intelectuales y artistas residentes en Santiago de Cuba se oponen patrióticamente a la celebración de la II Bienal franquista de Arte. El documento histórico es:

"Apoyamos, pues, la justa protesta de los artistas plásticos de nuestro país y nos unimos a ellos fervientemente en la demanda de que sea, convocada por el Estado cubano, a través de la Comisión Nacional del Centenario, se celebre en nuestra patria una "Exposición Martiana Internacional de Arte", a la que concurran artistas de todas las naciones en tributo universal de admiración y respeto a José Martí en el Primer Centenario de su nacimiento.

Firman este importante documento:

M. Ferrer Cuevas, Presidente del Consejo Territorial de Veteranos; Francisco Ibarra, Secretario del Comité Pro Tumba Digna del Apóstol; José Medina, Presidente del Club Rotario; Rafael M. Arcilagos, Director de la Biblioteca Municipal; Felipe Salcines, Rector de la Universidad de Oriente; Emiliano Ramos, Pedro E. Cañas Abril, M. Pujals, M. Céspedes, Baudilio Castellanos, Max Figueroa, Edmundo López, Hilda Orosa, Rafael Grillo, José Antonio Portuondo, Manuel Alvarez, Justo Nícola, Leonardo Griñán Peralta, Angel Díez, Juan de Moya, profesores de la Universidad de Oriente; Dulce María Serret, Directora del Conservatorio Provincial de Música; Antonio Ferrer Cabello, Director de la Escuela de Artes Plásticas; Mario Perdigó, René Valdés, Gloria García, J. M. Carbonell, profesores de la Escuela de Artes Plásticas; Enrique Gay, escultor y pintor.

OFENSA A NUESTROS PROCERES

"El Museo Nacional, que albergará las reliquias de los libertadores, no debe inaugurarse con la Bienal organizada por Franco; sería ofender la memoria de nuestros próceres..."

GLADYS LAUDERMAN
Presidente de la Asociación de Críticos de Arte
(De la revista "Bohemia", noviembre 22, 1953.)

Rotundo Fracaso de la Bienal Franquista

BOLETIN No. 2 • LA HABANA, JUNIO 1954

RESUMEN

Bienal y Antibienal

ERA ya larga y estaba llena de peripecias la contienda entre los auspiciadores de la II Bienal Hispanoamericana y sus opositores. Desde que la propaganda franquista anunció a nombre del gobierno y platillos su celebración y mencionó como su organizador al Instituto de Cultura Hispánica —dependiente de la Cancillería peninsular— brotó la repulsa en muchos círculos culturales de la Isla.

Una circunstancia nacional hizo más repetente la iniciativa. A la concomitancia falangista del suceso se unió el hecho—ofensivo para los cubanos—de que se pretendía clausurar la II Bienal dentro de los actos del Centenario de Martí, el 28 de enero último.

Indignados, los representativos de la plástica vernácula hicieron declaraciones terminantes. Síntesis del documento:

—Nos parece absurda la inclusión de esta exposición en los festejos del Centenario del Apóstol, dado que ha sido estructurada por un gobierno extranjero. Lo indicado es que sea la propia nación cubana la que organice y convoque una exposición martiana internacional de arte y no la Bienal auspiciada por el gobierno español. Reafirmando en nuestras patrióticas convicciones y en la del pueblo cubano pedimos a las autoridades la atención a esta justa demanda. En caso de no celebrarse lo que proponemos, nos abstendremos de concurrir a la II Bienal Hispanoamericana.

Firmaban esos valiosos creadores del patio: Carreño, Amelia Peláez, Cundo Bermúdez, Portocarrero, Mariano, Mijares, Martínez Pedro, Arche, Lozano, Orlando, Víctor Manuel, Girona, Pogolotti... Y no fué dicha reclamación la única que recibiera la Comisión del Centenario. A ella se unió el escrito de los críticos de arte, musicólogos, caricaturistas, escritores y profesores aplaudiendo la decisión de los artistas y adhiriéndose a la proposición de una exposición martiana. Sus argumentos eran idénticos y se cifraban en la violenta oposición entre el espíritu de la Bienal y el del Apóstol.

A esta ofensiva general respondió burdamente la Comisión del Centenario, a través de un equipo de propaganda formado en el hoy extinto ministerio de Información, con insistentes notas de prensa subrayando los premios que se ofrecían a los artistas concurrentes a la II Bienal. Parecían estimar que el cebo metálico era capaz de romper la Resistencia.

Tan seguro estaban, que la fecha inicial del 28 de enero fué fijada para el acto, lo que tomaron los cubanos como un desafío. El director del Instituto de Cultura Hispánica, Alfredo Sánchez Bella, llegó a La Habana en compañía de otros funcionarios franquistas para supervisar e impulsar los preparativos y reforzar los contactos con artistas del continente.

Los artistas e intelectuales isleños no perdieron tiempo en lamentar la conducta reprochable de la Comisión del Centenario. Frente a la Bienal franquista, que funcionaba como un ultraje al espíritu del Apóstol, organizaron como un desagravio la Antibienal. La pulcra y acogedora casona del Lyceum, siempre fecunda en iniciativas culturales, fué escogida como escenario de la trascendental exposición de plást...a cubana contemporánea, abierta el mismo 28 de enero. Sin embargo, los que esperaban la competencia de los salones simultáneos estaban equivocados: el silencio y la oscuridad predominaban en el lujoso Palacio de Bellas Artes. Sin que se ofreciera explicación alguna del aplazamiento, la Bienal franquista no había podido inaugurarse en los festejos del Centenario.

Los motivos de la frustración no eran sólo nacionales, sino también continentales. Los principales centros de creación estética en la América Latina se adhirieron a la postura insurgente de sus colegas cubanos.

Consecuencia inmediata: no pudieron exhibirse muestras calificadas del arte criollo. Por ejemplo, los dos grandes escultores pictóricas de México—sin cuya presencia no puede hablarse de la plástica latinoamericana—hicieron constar su repudio.

Los "arrepuristas" Rufino Tamayo, Carlos Mérida, Orozco Romero, Anguiano, Rodríguez Luna, Orozco Camarena y Gironella recordaron que no habían permitido la inclusión de sus obras en la I Bienal y expresaron la postura intransigente de su administrarán en la II.

—Nuestra actitud—puntualizaron—nada tiene que ver con el pueblo de España, al cual respetamos. Sólo queremos significar que, aunque cambien de localidad, las maniobras de propaganda del gobierno de Franco cuentan con nuestra repulsa plena.

El mensaje de los pintores y escultores argentinos era del mismo tenor. Lo calzaban las firmas de Solari, Castagnino, Urruchúa, Biscione, Giustozzi, Ibarra, Vigo, Devoto y transmitía "el más cálido apoyo a los artistas cubanos que luchan contra la II Bienal".

De Colombia llegaban envíos análogos con las firmas de Jaramillo, Ospina, Triana, Ramírez Villamizar, Grau Araujo, Leon Cano, Moreno Clavijo; de Guatemala venía la repulsa de Galeotti Torres, González Goyri, Palma, Aragón, Onsaya; de Uruguay, la de Armando González, Anhelo Hernández, el grupo plástico El Taller... Los artistas hispanoamericanos radicados en París, encabezados por Picasso, designaban el llamado de la II Bienal como "una invitación a colaborar con el franquismo".

Ese rechazo general hizo fracasar la segunda aventura de la Bienal falangista, una vez en tierras de América. La intentona quedaba frustrada. Y sino dió lugar al inevitable pleito de las responsabilidades. En lugar de atribuirlo, como era evidente, a la repugnancia que inspira en el exterior toda empresa ligada al franquismo, las autoridades hispanas se echaron mutuamente la culpa. Mientras el director Sánchez Bello, del IdeCH—entonces turista en La Habana—la hacía recaer en el escaso apoyo prestado por el marqués de Vellisca, éste le atribuía a la interferencia de su rival y reclamaba el manejo absoluto de la organización para sacar a la Bienal del atascadero.

En la Isla, determinadas autoridades emprendieron la poco airosa tarea de sustituir a los falangistas, intentando levantar la Bienal a toda costa. Transcurrido el Centenario martiano, les pareció que había mejor ambiente. Procedieron, sin embargo, con cautela. Cierta providencia se urdió la estrategema de celebrar la exposición al margen de poder hispanoamericano, para que no se contaba con aportes del continente—junto con el Salón Nacional de Cuba, cuyos créditos se habían evaporado en los tres años anteriores.

Creyeron así conquistar a los artistas rebeldes del patio, pero estaba claro que el salón vernáculo, aunque apareciera independiente de la Bienal, integraría en definitiva la sección cubana de ella. Insinuantes, los mediadores destacaban que no existía la incompatibilidad entre...

DE PICASSO

Los pintores y escultores cubanos que recientemente expresaron su oposición a la II Bienal Hispanoamericana recibieron un extraordinario respaldo artístico y moral, quizá el mayor: la adhesión de Pablo Picasso, el más famoso y discutido pintor de la época actual, y de una docena de artistas españoles residentes en París.

La espontánea declaración de los pintores—Picasso, Antonio Clavé, Peinado, Baltasar Lobo, Manuel Angeles Ortiz, Viéns, Ceballos, Riba, Rovira, De la Serna, Pizano Pelayo y otros—contenía en un cable dirigido a los artistas cubanos, da a la actitud del firme propósito pictórico cubano una resonancia mundial, prescindiendo de manera absoluta de los matices políticos y las particulares expresiones plásticas de las escuelas.

De Argentina

Estimados colegas cubanos:

Saludamos vuestra honrosa actitud frente a la Bienal de La Habana que está inspirada y realizada por lo más reacio y caduco de las fuerzas dirigentes de la España de Franco, elementos que tuvieron la osadía de vender a manos extranjeras su propio suelo patrio y la libertad de su pueblo. Tiene la Bienal de parte de los Artistas Plásticos Argentinos, la más repudiada censura, y para los Artistas Cubanos que luchan contra la Bienal, el más cálido apoyo, haciéndonos el firme propósito de esclarecer a nuestros colegas en este sentido.

Con vosotros hermanos Plásticos de América Latina marchamos unidos y confiados en que nuestra Cultura la defenderemos con el mismo valor y hombría con que lo hicieron nuestros progresistas antepasados.

Firman: H. Solari, A. Devoto, Vicente P. Carice, J. C. Castagnino, Demetrio Urruchúa, Abrahan Vigo, C. Adler, J. A. Gnecco, Julio Giustozzi, Ricardo Tinelli, Juan Ibarra, E. Pons, Ana Briez, F. Gesuddi, Elsa Leff, J. Rodríguez, C. Biscione, E. Orioli, Enrique Policastro, Mauro Glorioso, D. Z. de De Marinis, Anselmo Piccoli, Elida Castro, Helio Casol.

AGRADECIMIENTO

Los artistas plásticos cubanos firmantes del manifiesto contra la Bienal franquista, expresan por este medio el más profundo agradecimiento a todos los artistas, intelectuales y organizaciones de Cuba y del extranjero que se han adherido a esta cívica protesta, manteniendo alerta las conciencias libres de América y defendiendo la cultura y la dignidad humana contra la amenaza franquista.

las celebraciones martianas y que sólo se trataba de un evento artístico internacional más.

Esto no hizo variar la actitud de los remisos. Entendían que el pleito histórico con el franquismo no estaba ligado a fechas o nombres aislados, por ilustres que fueran, sino con el propio destino de Cuba, irrevocablemente democrático. La Antibienal del Lyceum habanero, que obtuvo el éxito de crítica más resonante de los últimos tiempos, se trasladó con igual repercusión a Santiago de Cuba y Camagüey.

Los alternativos de la contienda no habían cesado. Los organizadores de la II Bienal fijaron una nueva fecha: la del 18 de mayo, tomando ciertas precauciones. El marqués de Vellisca por eso se reforzar el apoyo español para comprobar la por Isfalba de latinoamericanos y exigió que el inoportuno Sánchez Bella no se atreviera por La Habana.

Inmediatamente entró en acción la Antibienal, esta vez auspiciada por la FEU. En la noche del lunes 17, ganándose 24 horas al evento franquista, el Primer Festival Universitario de Arte comenzó sus realizaciones en los salones de la Escuela de Derecho. El director de cultura de la FEU, Luis de la Cuesta, tradujo en conceptos enérgicos...

—Se está celebrando, al caluroso por inaugurar de Bellas Artes, la II Bienal de Arte Hispanoamericano. Los dictadores de la península y los de la Isla, cual si no hubiéramos sentido un 20 de mayo, se unen a agasajos y a contrapelo del pueblo para la misma empresa. Nosotros, los que sabemos que arte y dictadura son términos tan contradictorios como democracia y tiranía, sólo vemos en la Bienal la piqueta y la caricatura de quienes son incapaces de sentir y expresar el alma de los pueblos y se contentan con el cliché oficial de la usurpación.

El artista de a primera línea aceptan con el formidable despliegue artístico, que seria clausurado el 4 de junio, pero no estaban solos. La Sociedad Universitaria de Bellas Artes contribuyó con su exhibición en la música y una audición comentada de Falla bajo la dirección de Harold Gramatges; el Departamento de Cinematografía del Alma Máter, bajo la dirección de José Manuel Valdés-Rodríguez, participaría con un excelente programa de películas y el Teatro Universitario con la representación de La Zapatera Prodigiosa.

(De "Bohemia", mayo 23, 1954)

Protesta del Pintor Español Oscar Domínguez

El Dr. José López Isa, Director de Cultura del Ministerio de Educación y Presidente de la Comisión Organizadora de la II Bienal Franquista, recibió del pintor español Oscar Domínguez, residente en París, la carta que a continuación reproducimos:

"Por solidaridad y completamente de acuerdo con mis amigos los pintores cubanos, mexicanos, españoles, etc., que protestan de la II Bienal en Cuba, suplico a los señores organizadores, le remitan a mi amigo Mario Carreño, pintor residente en París, los tres cuadros enviados desde París.

Cuando yo pasé por la Biblioteca Española aquí para retirarlos, me dijeron que los cuadros estaban ya en ruta para La Habana.

Esperando ser atendido les saluda su S. S.

(Fdo.) OSCAR DOMINGUEZ

De Mexico

Hace dos años la I Bienal franquista tuvo en Madrid el más estrepitoso fracaso y por ello hoy tratan de introducir en La Habana, con la complicidad de otros, subrepticiamente, tal exposición para que sirva de publicidad al dictador español.

"Lo que origina nuestra protesta es lo siguiente: "Que el falangismo nos crea pueblos tan ignorantes que podamos ser engañados con esta farsa y para que ello aun nos invite a participar en tal organización fascista, que tiene la propaganda del régimen de Franco, de la cual es parte esta II Bienal, está dirigida a ocultar que en este mismo año los últimos restos de la independencia de España fueron vendidos a los Estados Unidos al concederles bases y soldados a cambio de millones de dólares que servirían para enriquecer a los jerarcas fascistas y fortalecer la opresión del pueblo español, que vive en la miseria más tremenda y privado de todas sus libertades.

"Que debido a las persecuciones del terror fascista, los artistas e intelectuales españoles más representativos viven desde hace muchos años en el destierro. *Nuestra solidaridad con ellos y con todo el pueblo español sería más que suficiente para que denunciáramos, como lo hacemos, la farsa de la llamada II Bienal Hispanoamericana.*

"Nadie ignora los miles de españoles desterrados y los miles que sufren en las cárceles de España por el único delito de luchar por la libertad de su patria. Las bienales de Franco y toda su propaganda que hacen sus organismos no logran que todos los hombres y mujeres que aun aman la democracia, pueden ser engañados por esta propaganda que tiende, principalmente, a mimar nuestro amor a la paz para atrasarnos a una guerra imperialista llevando como caudillo a Francisco Franco, en nombre de lo que ellos bastardeamente han llamado "hispanidad".

Encabezan las firmas: Eli de Gortari, Prof de la Facultad de Filosofía y Letras; Leopoldo Méndez, grabador; Diego de Rivera, Xavier Guerrero, Clara Porset, pintores; Ruth Rivera, arquitecto; Oscar Fría, pintor; David Alfaro Siqueiros, Olga Costa, José Chávez Morado, pintores; Adolfo Valencia, escritor teatral; Susana Nevo, Armando Rosales V., Arturo Estrada, pintores; Antonio Ramírez, Héctor Cruz Lorenzo Guerrero, Guillermo Monroy, Gustavo Gutiérrez y Angel, jóvenes pintores. Y otros.

De Matanzas

LOS intelectuales, escritores, artistas y representativos de la ciudad de Matanzas declaran lo que sigue:

Consideramos que con su desacierto más de la Comisión Cubana del Centenario de Martí prestarse para la organización de un acto de burda propaganda franquista como lo es la proyectada II Bienal Hispanoamericana, evento político que mancilla la memoria del Apóstol y los postulados de justicia, paz, libertad y democracia.

La II Bienal Hispanoamericana no es honrosa para Martí ni es manifestación artística: la cultura y el arte españoles están en el exilio político, y nos caracterizan ya se han negado públicamente a prestar su concurso a tan oscuro consorcio.

Firman: Dr. Luis Rodríguez Rivero, Juan J. Sicre, Elena de Arenas y Ruibal, Dr. Mario E. Dihígo y Llanos, Dr. Antonio Font Tió, Dra. Consuelo Miranda Mirabel, Dr. José Nodarse, Dr. José L. Rey-Barreau, Isreal M. Möltner y Rendón, Dr. Rodolfo Labourdette, Mario Argenter Sierra, Dr. Jesús López Luis, Dr. Angel Gómez Freyre, Dr. Jorge Salazar Silvestre, Dr. Manuel Labra Fernández, Dr. José A. Tresserra y Pujadas, Juan Esturd Heidrych, Aída López Suárez, Dr. Luis Socarrás, Dr. Américo Alvarado Stvillié, Orlando Carvajal, Dr. Miguel A. Beato, Rafael Alfonso Morales, Gloria Teijeiro, Rafael Somavilla.

De Chile

Ante este evento, los artistas plásticos que suscriben, declaran:

Que el Gobierno Nacionalista español, invitante, surgió como una negación de la libertad, el progreso, la cultura y el arte, y que este hecho lo desautoriza moralmente para propiciar un torneo de la naturaleza del indicado.

Que el actual gobierno, dirigido por el General Franco, ha infringido las más elementales leyes de humanidad y es responsable de la muerte de representativas personalidades del mundo hispánico, tales como García Lorca, y el poeta Miguel Hernández y Antonio Machado, muerto en el destierro.

Que mantiene alejados de la patria a miles de eminentes artistas, escritores, catedráticos y políticos, entre los que se cuentan Picasso, Casals, Juan Larrea, Rafael Alberti, Américo Castro, José Bergamín y numerosos otros, y que ante esos hechos, que repugnan a sus conciencias, no pueden menos de sumarse a la dicha Bienal, invitando a todos los artistas a unirse en torno a ese repudio, no concurriendo a dicha Exposición y rogando a aquéllos que hayan sido sorprendidos en su error, la retiren sus obras de la Exposición. —Firmados— Lily Garafulic, Carlos Sotomayor, Gregorio de la Fuente, Ana Huelbada, Jaime Catalán, Gustavo Poblete, Juan Egenau, Julio Antonio Vázquez, Camilo Mori (Premio Nacional de Arte), Mireya Lafuente, Julio Escames, Emilio Pieva, Sergio Mallol, Lucy Lortch, Germán Montero, Roser Bru, Waldo Vila, Gracia Barrios, José Balmes, Bindis, Emilio Canepa."

Con ocasión de la II Bienal Hispanoamericana de Cuba agregamos nuestros nombres a protesta de los artistas chilenos.— Nemesio Antúnez, Roberto Matta Echauren, José Venturelli.

Santiago de Chile, mayo, 1954.

DE URUGUAY

El Grupo Plástico "El Taller", del Uruguay, repudia la llamada "II Bienal Hispanoamericana de Arte" por considerar que es un intento de penetración del franquismo en el campo de la cultura en América y un insulto a la preclara figura de Martí, gran luchador por la libertad.

Fracaso de la II Bienal

UN rotundo fracaso ha constituido la celebración en La Habana de la II Bienal Hispanoamericana franquista que ha sido repudiada, no sólo por los artistas e intelectuales más representativos de Cuba, sino por todos los del continente hispanoamericano. En nuestro "Boletín No. 1" dimos a conocer las protestas de los artistas plásticos de México, Guatemala y Colombia, así como el manifiesto de los cubanos que encabezaron esta heroica lucha contra la penetración nazi-franquista en suelo americano, que a través de la "mascarada bienalista" intentan realizar los agentes del dictador Franco y de su secuela falangista el "Instituto de Cultura Hispánica", los cuales se han encontrado con la más enérgica oposición por parte de los innumerables artistas e intelectuales latinoamericanos que han alzado su protesta contra los planes propagandísticos de los franquistas, los que desde a Federico García Lorca y a Miguel Hernández, los que enangrentaron el suelo de España con metralla de los alemanes nazis y la "Guardia Mora" del "Caudillo", piseándose así la soberanía de la República Española elegida democráticamente, los que mantienen en el exilio a lo más valioso de la intelectualidad española, como Pablo Casals, Rafael Alberti, Pablo Picasso, Juan Ramón Jiménez, Margarita Xirgu y otras personalidades.

Doblemente ha fracasado la cacareada "Bienal" franquista, primero por la repulsa y el vacío que ha encontrado en América, y segundo por la baja calidad artística de las obras expuestas, pues salvo contadas excepciones la exposición en general es de una lamentable pobreza estética que denuncia elocuentemente su procedencia, ya que, repetimos y aseguramos, lo mejor del arte hispanoamericano no está allí presente. Se puede hablar en serio de una "Bienal" que pretende ser hispanoamericana si en ella no figuran obras de Picasso, de Miró, de Diego Rivera, de Orozco, de Tamayo, de Siqueiros, de Portinari, de Castagnino, de Matta y de otras valiosas firmas que se negaron a concurrir a esa "mascarada", sin contar con la ausencia en la misma de lo más valioso de la plástica cubana, como Amelia Peláez, Cundo Bermúdez, Martínez Pedro, Mario Carreño, Lam, Portocarrero, Mariano, Lozano, Mijares, Felipe Orlando y otros.

Ante el inminente fracaso, los organizadores de la Bienal apelaron a innumerables ardides para atraer a los artistas, pero todos fracasaron lastimosamente. Ofrecieron premios y recompensas fabulosas, fama internacional a los menos conocidos, etc., pero nada les rindió resultado. En vista de lo cual recurrieron a lo inaudito: "echarle mano a los muertos ilustres", a aquellos que no podían protestar, y allí están mismo acerca la fuerza a esa burla artística, las obras de Romañach, Menocal, Ponce de León y el español Gargallo.

Si los muertos hablaran escucharíamos las protestas de esos maestros contra el escarnio de que han sido objeto. ¿Qué nos diría el gran Ponce de esa "mascarada", el mismo Romañach o el escultor español Gargallo, cuya obra expuesta fué adquirida por la República Española? Vergonzosa es la participación de los que han colaborado en este agravio que se ha manchado la memoria de los ilustres fallecidos. Por la fuerza también han exhibido muchos artistas de Santo Domingo, Perú, Venezuela, Nicaragua, etc., cuyos regímenes dictatoriales han contribuido con "envíos oficiales", sin contar con la voluntad de los artistas o escultores representados. A varios españoles exiliados en París, entre ellos el pintor Oscar Domínguez, le llevaron sin consultarle tres cuadros para exponerlos en la Bienal, motivando la protesta que reproducimos en otra parte de este Boletín.

Al lado de la heroica y digna actitud de los plásticos cubanos, de la acción ejemplar de los artistas que en su lucha han solidarizado con la cultura antibienalista, despreciando las "jugosos premios" y la supuesta "fama" ofrecidos por los franquistas, contrasta de la manera más grotesca, la condición de otros cubanos que voluntariamente han vendido su conciencias y dignidad por "un plato de lentejas", al concurrir a esa bienal franquista, cuyo espíritu encarna la representación de la barbarie nazi-fascista, al mismo espíritu que calificó de "arte degenerado" la producción de los artistas contemporáneos, que persiguió y asesinó a innumerables artistas no hace mucho tiempo, en Berlín, en toda Europa, sino también en Madrid y en las demás capitales europeas por donde campearon los hitlerianos. Sólo los ciegos, los inconscientes o los sinvergüenzas no ven o no quieren ver, la identificación del franquismo con el hitlerismo, así tampoco quieren ver el juego político que los franquistas tratan de hacer con la "bienal hispanoamericana", intentando con ese "apa-cicua" las conciencias libres de América, "dorar la píldora" con eventos "artísticos" para que los intelectuales americanos se olviden de sus crímenes y sus barbaries cometidos contra la democracia hispana.

Lamentable es también la actitud innoble de esos "críticos" que agazapados, algunos de ellos, bajo la coraza del "Diario de la Marina", periódico filofalangista, se han dedicado a enlodar la digna posición de los artistas que se han pronunciado contra la Bienal, a un mismo tiempo de alabar rastreramente las obras expuesta en la misma, obras que salvo contadas excepciones, repetimos, no merecen el más mínimo elogio. Los acomodaticios "glosadores" como Francisco Ichaso, Jorge Mañach, Rafael Suárez Solís y Gastón Baquero, que han mantenido siempre, como vulgarmente se dice: "la en cerca", o sea "a la orden del mejor postor"; prontamente se inclinaron a favor del "Instituto de Cultura Hispánica" o mejor dicho, del "plato de lentejas", pisoteando así la razón y la dignidad humana, valientemente defendida por los antibienalistas.

De nada ha servido a los organizadores del engendro bienalista contar con toda la maquinaria propagandística de la prensa, radio y televisión reaccionaria, con el poder de "los de arriba", ni el robarle al pueblo cubano los dineros destinados a honrar a José Martí para así poder celebrar la Bienal franquista (que intentaban inaugurar como homenaje al Apóstol, a lo que tuvieron que aplazarla por la protesta de los artistas cívicos de América). Nada ha podido salvar a esa "carnavalada artística" del más estruendoso de todos los fracasos.

The vanguardia moved quickly against the Bienal, releasing a formal protest and marshaling statements of support from international peers, the texts of which they distributed widely in two bulletins, the previously mentioned *Ultraja la memoria de Martí* and *Rotundo Fracaso de la Bienal Franquista* [The Categorical Failure of the Francoist Biennial], the latter released post hoc in June 1954 (fig. 33). Undersigned by over forty artists spanning the historical vanguardia (nearly half of them onceños, official or otherwise), "Protesta de los artistas plásticos de Cuba" (Protest of Cuba's Visual Artists) registered four complaints. The signatories declared first the absurdity of marking Martí's centenary with an exhibition organized by Spain, faulting secondly the steep expense of the Bienal (reportedly at a cost to Cuba of $100,000). The artists proposed in place of the Bienal an *exposición martiana internacional de arte*, to be convened locally; the statement closed with a threat to boycott the Bienal should the National Centenary Commission not move forward with the proffered exposición martiana. Alongside editorials by the local press (*Bohemia* twice; Gladys Lauderman for *El País*), the bulletins' printed statements of solidarity were circulated across the island and the Americas. Mexican artists noted their own refusal to participate in the first Bienal (Madrid, 1951), an action that cut across aesthetic and ideological lines. (Still, their support for the boycott came in separate dispatches: first from Rufino Tamayo, Carlos Mérida, and José Luis Cuevas, among others; and second from Diego Rivera, David Alfaro Siqueiros, Leopoldo Méndez, and others.) The Guatemalans and Colombians similarly pledged their support, expressing a desire to show their work in Cuba as soon as legitimate institutions had been restored to power. The Argentines and the Chileans condemned the Franco regime; El Taller [Torres-García] of Montevideo repudiated the Bienal on all counts. A particularly prized cable came from Pablo Picasso, who wrote on behalf of Spanish artists in Paris; one of them, the Surrealist Oscar Domínguez, separately requested that the three paintings of his that had unintentionally been shipped for the Bienal be instead consigned to Mario Carreño upon their arrival in Cuba.[5] A riposte to the Falangist enterprise, the display of inter-American fellowship stirred by the Bienal was a resounding coup for Cuba's protesting artists. Furor over the Bienal imparted a serious, contemporary tenor to a vernacular modernism still better known abroad for palm trees than politics, and in a way it made good on the vanguardia's courtship of international attention at the decade's start.

The first bulletin carefully noted that the protest was not "a movement to defend particular aesthetic trends," a position echoed in the introduction to the Anti-Bienal (the realized exposición martiana) and in press coverage favorable to the movement. "Here, one can see distinct trends and generational groupings within Cuban art," Carreño offered, "artists from different schools and of varying ages gathered at will to pay homage to Martí."[6] Still the vanguardia overwhelmingly dominated the Anti-Bienal, and the absence of the academics was noted by the minorista Jorge Mañach (1898–1961). "It's nothing short of a war to the death," he opined of the old fight between the "moderns" and the "academics," and he chastised the vanguardia for exacting retribution for their

FIGURE 34

Juan Tapia Ruano, *Cuarteto*, 1953. Oil on canvas. Dimensions unknown. Location unknown.

FIGURE 35

Domingo Ravenet, *Azul*, 1953. Molten iron rods. 31.9 x 22.8 x 12.2 in. (81 x 58 x 31 cm). Dirección Municipal de Patrimonio, Municipio Plaza, Havana.

exclusion from a book, *La pintura y la escultura en Cuba* (1953), recently published by the long-serving director of San Alejandro, Esteban Valderrama (1892–1964).[7] Mañach also remarked upon the Anti-Bienal's preponderance of art that "represents nothing," a hackneyed knock on abstraction and a statement of the obvious: abstract art, highlighted by the de facto predominance of the onceños, was the insignia of the protest, appearing nowhere less conspicuously than on the catalogue's color-blocked cover. Between the signed protest and the Anti-Bienal exhibitors, the third-generation vanguardia was indeed well represented.[8] Notably, the exhibition marked the inclusion of Juan Tapia Ruano (1914–1980), slightly senior to the onceños but a participant in three later group shows; he had only recently begun to paint, following his earlier study of architecture. Abstract from the outset, his paintings conveyed an architectonic sensibility, measured in balanced (often, bilateral) proportions and "transparencies of color" modulated in clean, elongated shapes (fig. 34).[9] More appreciably, the abstract turn of the elder-generation vanguardia was in full effect, seen in elegant submissions from Cundo Bermúdez, Carreño, Julio Girona, Alfredo Lozano, Luis Martínez Pedro, and Domingo Ravenet, among others. Ravenet showed his metal sculpture *Azul*, one of a number of linear, open metal works exhibited at La Rampa a year earlier (fig. 35).[10] Like

the contemporary *Mástil* and *Abanicos, Azul* is an exercise in "drawing in space," its three-dimensional lattice of rods spiraling upward from two points; its Constructivist transparency and geometry prefigure the tabletop mobiles that Loló Soldevilla developed later in the decade. A single drawing by Enrique Moret (1910–1985), who fought in the Spanish Republican Army before immigrating to Cuba in 1942, made literal reference to the franquista regime. Graziella Pogolotti deemed the Anti-Bienal one of the decade's two most important exhibitions by virtue of the art shown, politics aside (the other exhibition, *Homenaje a Guy Pérez Cisneros*, opened at the Lyceum two years later).[11]

No doubt a defining moment for Havana's historical vanguardia, the Anti-Bienal provided the greatest affirmation to date of abstraction as a martiano practice, cosigned by stalwarts of cultural vanguardismo across generational lines. Musicians, led by the founders of Nuestro Tiempo (Harold Gramatges, Juan Blanco, Nilo Rodríguez), gave a performance at the opening of the Anti-Bienal in a show of support.[12] Over forty writers and other intellectuals, among them Lezama Lima, Eva Frejaville, Alicia Alonso, Ricardo Porro (1925–2014), Nicolás Quintana, and the Spanish cinematographer Néstor Almendros (1930–1992)—in Cuba with his father, a Republican Loyalist—signed a statement backing the exposición martiano and against the Bienal. At an institutional level, the venue of the Lyceum plumped up the vanguardist origins of the Anti-Bienal, swiftly enfolding it within the trajectory of modern Cuban art. Writing for the twenty-five-year anniversary issue of the in-house *Revista Lyceum*, Luis de Soto (1893–1955) included the Anti-Bienal among the Lyceum's milestone exhibitions, confidently wagering on its historical legacy just days after it opened.[13] The Lyceum had paid tribute to Martí over the course of the previous year with dedicated conferences, seminars, and educational initiatives, activities all feeding the martiano temper incited by Moncada and its marshaling of the cubanista canon.[14] The 26th of July Manifesto, an elaboration of Castro's speech in self-defense, repeatedly invoked Martí as the movement's intellectual author, and its call for activism—"in a tradition of *lucha*, heroism and commitment, on which Cuba Libre would be based"—pressed deeply, as intended, on the cultural field.[15] There is "no republic without culture," the manifesto declared, explicitly enlisting the youngest generation—"the contribution and presence of the reserves of youth who are anxious for new horizons in the chronic frustration of the Republic"—in the realization of the "unfulfilled ideals of the Cuban nation."[16] The alliance of the Lyceum with the anti-bienalistas ultimately marked a new mobilization of Cuba's vanguardia tradition, which in the name of Martí appended its generational might to the generación del centenario.

In a crucial way, the Anti-Bienal functioned as a political manifesto for the vanguardia, instrumentalizing core cubanista beliefs against a clearly defined and material threat: the Bienal, a thinly veiled proxy for Falangist Spain abetted by the Batista state. To be sure, the onceños had advanced abstraction as an expression of Cuba Libre already for a year, since the National Salon of 1953. But the Bienal provided them with an unimpeachable pretext to promote their work as a political enterprise, supported by a

complement of cubanista codes—culturalism, activism, generationalism, international-ism, revolutionism, and so forth—and a compelling martiano mythology. In a departure from the more insular nationalism of past generations, the anti-bienalistas stood in solidarity with artists across Latin America against franquista Spain, a readymade target (and one less ambivalent, at the time, than the United States). The youthful leadership of the onceños (the "under-30s") harked back to the dissident student movement of 1923, led by the charismatic Julio Antonio Mella (1903–1929) and the Federation of University Students (Federación Estudiantil Universitaria [FEU]). Mella's "Universidad Popular José Martí," a school for workers, had earlier radicalized the martiano myth, plausibly recasting it from Cuba Libre to "*Nuestra América Libre*" and positioning Martí's message as popular, hemispheric, and anti-imperialist.[17] Founded in 1922 to stamp out corruption in the university, the FEU had later expanded its reach to the political arena, namely in opposition to the Machadato and its coziness with the United States. At a philosophical level, the anti-bienalistas claimed a moral imperative, pitting apostolic (martiano) honor against the corruption of the Batistato; in taking "action" they positioned themselves within a history of heroic lucha against (neo-)colonialism and well-worn domestic choteo, a self-deprecating cynicism about the nation. "Our position was firm and this obligated us to confront the other artists," Martínez reflected, particularly those who adopted "an attitude called *estar en la cerca*, which meant that one should not participate on one side or the other, one should not be committed. It appeared to us that this idea was not good for the country, nor was it good for painting, and we fought against it."[18] Exhibitions were the most powerful actions that artists could take, and the Anti-Bienal made plain the alignment of cultural vanguardismo with revolution—as per the classic martiano maxim, "to be cultured is the only way to be free" (*ser culto es el único modo de ser libre*). Teltingly, the fallout from the Anti-Bienal was not aesthetic (abstraction was not attacked per se) but rather political in kind. The weekly *Marcha* reported that both Cuba's Ministry of Education and the Spanish Embassy in Havana took retaliatory action against the anti-bienalistas, withdrawing scholarships and jobs. Tomás Oliva, absent from the Lyceum due to travels abroad, was briefly jailed upon his return to Cuba for his association with Republican groups in Spain.[19]

The Anti-Bienal marked the ultimate validation of abstraction as a martiano medium, politically mobile and implicitly revolutionary, and its socially transforma-tive potential was sounded out across the island over the following three months. As a moving manifesto, the exposición martiana traveled to three cities—Santiago de Cuba, Camagüey, and Havana again—in an emphatic reinstantiation of artwork (and exhi-bitions) as a means of protest. The first venue was the Universidad de Oriente and the Galería de Artes Plásticas "José Joaquín Tejada" in Santiago de Cuba, at the far eastern end of the island. The cubanista connotations of Oriente were deeply rooted: from Martí's death at Dos Ríos to the assault at Moncada (and in two years' time, Castro's staging in the Sierra Maestra), the province evoked a rural and organic patria in clear

contrast to the perceived decadence and corruption of *batistiana* Havana.[20] As a discursive production, the installation of the Anti-Bienal in Oriente laid claim to a symbolic geography through the fact of the artworks' physical presence. Portable and instantly iconic, the artworks connected the anti-bienalistas to an originary site of revolution and *martiano* renewal; with each successive audience, they reenacted the first protest at the Lyceum, reinstantiating its revolutionary, vanguardist, and inter-American appeal. By mid-March, the Anti-Bienal opened at the Lyceum in Camagüey, near the center of the island.[21] "The attitude of the modern artist is in line with the reality of life, restless, torn, convulsive," Rosa Martínez remarked in her review of the exhibition there, stoking classic *cubanista* anxieties. "The serenity of living, the peacefulness of dreaming, has all but disappeared. . . . The world of today is the best explanation of the art of today."[22]

Flush with momentum sustained from Oriente to Camagüey, the anti-bienalistas returned to Havana to enact a final protest at the University of Havana, planned to coincide with the opening of the Bienal. Organized by the FEU with assistance from

Hugo Consuegra, at the time an architecture student at the University, the *Primer festival universitario de arte* (fig. 36) opened fifty-two years to the day after Cuba had achieved formal independence from the United States (May 20, 1902).[23] Thirty-nine artists, about half of them drawn from the third-generation *vanguardia*, exhibited; the program also included three films (*Visita a Picasso*; *Pablo Casals*; Roberto Rossellini's *Alemania, año cero*) with suggestively Catalan and anti-fascist messages. Critics fell silent under threat of the Batistato, but the catalogue essays from the academic community were explicit in their condemnation of the Bienal and defended the university as a bastion of resistance and democracy. "Art and Dictatorship are terms as contradictory as Democracy and Tyranny," FEU president Luis de la Cuesta inveighed in his introduction to the catalogue. "Far from a celebration," he cautioned, the *Primer festival universitario* "should be, in everything that it stands for, a mirror of the anxieties and the vitality of faith, of faith grounded in the supreme values of culture and in the future destiny of democracy in our country."[24] Carrying on the *martiano* tradition of student dissidence, the FEU had continued to declaim against state corruption since the time of Mella (a martyr, in the wake of his assassination in Mexico in 1929) and the Machadato. In April 1952, the FEU staged a public funeral for Cuba's Constitution of 1940, burying the text on the grounds of the university; in March 1954, amid the Anti-Bienal's progression across the island, students paraded in a truck before the Capitolio, brandishing slogans against Batista and the sham elections called for November.[25] Apropos to the university setting, the anti-bienalista catalogue emphasized the youth of the *onceños* at the forefront of the resistance and reached out in spirit to student movements around the world,

"in Tehran and in Barcelona, in Guatemala and in Cuba."[26] The persistent international reach of the anti-bienalistas, from the earliest broadside to the FEU, corroborated the now-familiar ethical reproach to the Batistato and its betrayal of the martiano centenary, as José Antonio Portuondo (1911–96) restated in the catalogue.[27]

More remarkably, Portuondo also argued at length for the transformative character of abstract art, writing of the "double insurgency"—ethics and aesthetics—and privileging the latter, which he described in the terms of scientific revolution. In distinction from the Lyceum catalogue, which took an inclusive approach to style, Portuondo keyed the aesthetics of revolution to (geometric) abstraction. At a time when Soviet socialist realism had depreciated the currency of realism tout court, he wrote of "young artists, disgusted with the circumstances in which they live, [who] refuse to regard [their reality] with physical faculties that would imply the ordinary appearance of things." Against the illusionism of painting as an Albertian "window onto the world," he proposed new coordinates of physics and geometry ("magical escape routes," as it were, for artists "imprisoned by the crisis of their historical circumstances.") From the "thermonuclear" crucible of destruction, he envisioned art that could "express the same restlessness and desire to escape . . . the same determination to reorder the chaos of the present day" as contemporary science.[28] The techno-futurism of his entreaty, with references to Alfred North Whitehead and Albert Einstein, argued for abstraction as revolutionary in form, its structure the embodiment of a new reality. Among the exhibiting artists whose work most engaged geometric abstraction were Carreño, José M. Mijares, and José Y. Bermúdez. (Sandú Darié, whose affiliation with the Madí artists in Buenos Aires brought his practice into closer alignment than any of the vanguardistas with science and technology, had shown at the Lyceum but was absent from the FEU exhibition.) Portuondo's scientific paradigm was in any event less a precise description of current practices than a utopian (and cubanista) projection for the mostly young artists assembled. More meaningful was the fact of the exhibition itself: in the near term, it served as an impressive proving ground for the onceños, for whom the correlation of abstract art and anti-bienalista agitation affirmed the revolutionary forcework of their group practice.

If, as Martínez understood, the social revolution were to be effected by tangible, real-world interventions—that is, exhibitions as outreach and manifesto—the protracted course of the Anti-Bienal and its final instantiation at the university represented the apogee of Los Once's work. Staged just over a mile away from the Bienal, the *Primer festival universitario de arte* rounded off a visual geography—stretching between Havana and Oriente—that symbolically linked the assault on Moncada, the increasingly theatrical university demonstrations, and the third-generation vanguardia. Taking the shape of social praxis yet remaining autonomous (one-off and ephemeral), the Anti-Bienal acted through a *transitive modality of relation*, in Krzysztof Ziarek's coinage, within a generational and cubanista network of revolution. As a relational and reorienting inflection in power, art gains maximal import "not in its political engagement or its subversion

of aesthetic forms," Ziarek explains, but rather in the radicality of its transformative potential, or forcework.[29] Moreover, art's ability to "transvers[e] the workings of power without either becoming a party to power or being rendered powerless by power's domination" gives it the extraordinary capacity to intervene in relations of power.[30] Ziarek elaborates his argument for art's forcework through two claims tied to the political process of democracy: first, the event of transformation must transpire and have bearing in the world; and second, in order to transcend the purview of art alone, it must be continually reactivated and reaffirmed through corresponding social and political transformation.[31] The Anti-Bienal, instantiated four times with unequivocal martiano and antidictatorial animus, instantly politicized abstraction (a revolution of forms) and established it within a matrix of cubanista activity across the island. Acting in concert with the student movement and the cultural vanguardia, the anti-bienalistas worked situationally to pry open the power structure of the Batista regime, shifting the transitive balance of power (however incrementally) against dictatorship. Their cause was not that of abstraction per se, but their reiteration of abstract art through their exhibition practice (including, but not limited to the Anti-Bienal) marked the artworks in turn as collective sites of analysis, layered with these accumulations of time and place.

In a meaningful way, the whole of the anti-bienalista catalogue exceeded the sum of its parts, and arguably the fact of its coalescence mattered more than any individual work on display. The artworks varied in quality and execution; nearly all were realized in 1952–54 (the exceptions were token contributions from a few of the elder-generation vanguardia). To suggest that the immediate political contingencies of the Batistato informed the process of art-making at a structural level seems obvious; the obduracy of abstraction, its opacity and self-referentiality, invites plausible analysis of this kind. Yet no single artwork came to define the Anti-Bienal—its Lyceum cover featured a Mondrian-esque design—and a more compelling argument can be made for locating its forcework within the totality of the group enterprise. Insofar as the Anti-Bienal functioned as a tableau vivant, reliant on a critical mass of participants and reenacted across the island, it may also be understood as an artwork per se—a seventy-piece installation performed as a prolonged, vanguardia stunt. In at least some cases, the works were intended from their inception for inclusion in the Anti-Bienal (more certainly the works dated 1954, and likely many from 1953), and thus the circumstances of their display— related to, but separate from the political environment—insinuated themselves into the creation of the whole. This emphasis on the "where" of the Anti-Bienal, understood in terms both of geography and of posterity, privileged praxis: the conception of the exhibition (as traveling manifesto) ultimately mattered as much as its content (abstract art). Its narrative was not revolution—it could not have been, for there was no consensus about what revolution entailed—and yet it nevertheless encoded, in its discursive and superbly cubanista form, the fractious politics and circumstances out of which it was made.

II BIENAL HISPANOAMERICANA

In defiance of the anti-bienalista campaign, Batista presided over the opening of the *II Bienal Hispanoamericana* at Havana's Museo-Palacio Nacional de Bellas Artes on May 18 after almost four months of postponements.[32] An anticlimax in the wake of the Anti-Bienal, which had in the meanwhile soldiered on across the island, the Bienal opened with over two thousand works from eighteen countries. The administration dismissed the protesters ("a furious sectarian passion") and declared that the works "didn't respond to any political current."[33] Still, the counterpresence of the Anti-Bienal had long become a nuisance, and the government position was elaborated at length in *Charlas de la segunda Bienal*, released in April by Fernando de la Presa, a writer representing franquista Spain at the Instituto Cubano de Cultura Hispánica. The book acknowledged the absence of certain Spaniards (above all, the "communist" Picasso) and some of the anti-bienalistas, singling out Wifredo Lam, René Portocarrero, Carreño, Rodríguez, and Víctor Manuel. De la Presa implied that some artists had sent second-rate work to the Anti-Bienal and accused them of propaganda mongering, of "seeking out [political] allegiances external to the arts."[34] Even as the Bienal boasted of its plurality of form and content, de la Presa needled Víctor Manuel for dabbling in abstraction and slipped in the hackneyed line about abstract art as an excuse for a lack of talent.[35] But in an irony that could hardly have been lost on the bienalistas and anti-bienalistas alike, the *I Bienal Hispanoamericana*, held in Madrid, had all but consecrated *informalismo* as the official art of the franquista regime.[36]

Alfredo Sánchez Bella (1916–1999), Director of Spain's Instituto de Cultura Hispánica between 1948 and 1956, organized three Hispanoamerican Biennials during the 1950s: Madrid (1951), which occasioned corresponding Contra-Bienales in Paris, Caracas, and Mexico City; Havana (1954); and Barcelona (1955). A fourth Bienal was initially planned for Caracas (1957–58) but was foiled by the fall of Marcos Pérez Jiménez (1914–2001); an attempted revival in Quito (1959–61), meant to coincide with a meeting of the Organization of American States, was similarly scuttled.[37] Franco opened the inaugural Madrid Bienal on October 12, 1951, a public holiday (the *día de Hispanidad*) in honor of the arrival of Christopher Columbus in the Americas. As a referendum on contemporary Spanish art, the *I Bienal* marked the first recognition of the postwar generation by the Franco regime, ending the academic spell of the prior decade. In a way akin to the martiano rendering of abstraction in Cuba, the *I Bienal* legitimized abstraction within the *españolista* canon: "Every formally innovative artist does far more to enrich and consolidate the art of the past than the false traditionalism of the academics."[38] Julián Díaz Sánchez has remarked that, at the time, modern art could only have meant abstraction, and the *I Bienal* celebrated many of the contemporary informalistas, among them Antoni Tàpies, Manolo Millares, Manuel Mampaso, Julio Ramis, Joan-Josep Tharrats, and Modest Cuixart.[39] Among the Cuban artists who exhibited in Madrid were Wifredo Arcay (b. 1925), later one of Los Diez, the "honorary" onceño Servando Cabrera Moreno,

and Roberto Diago. The *I Bienal* was met with three Contra-Bienales. In Caracas, the Taller Libre de Arte collaborated with the Ateneo de Caracas to sponsor a *"Semana de Cultura"* (October 12–20) designed to reclaim the historical legacy of October 12 in more integrationist terms.[40] Later in Paris, the Galerie Henri Tronche opened the *Exposition Hispano-Américaine* (November 30–December 22, 1951), which included the Spanish School (fifteen artists, including Picasso, Oscar Domínguez, and Antoni Clavé) as well as works by Lam, Carlos Mérida (Guatemala), Antonio Berni (Argentina), Carmelo Arden Quin (Argentina), Cândido Portinari (Brazil), and Joaquín Torres-García (post-humously, Uruguay).[41] Diego Rivera and David Alfaro Siqueiros exhibited in Paris and also in Mexico City, which mounted the *Primera exposición conjunta de artistas plásticos mexicanos y españoles residentes en México* on February 12, 1952. The Mexican artists had earlier released a manifesto (October 3, 1951) declaiming fascism and the fraudulence of the franquista regime and its Bienal; Spanish artists exiled in Mexico condemned the Bienal in a separate statement ("Declaración de los pintores españoles republicanos residentes en México sobre la I Bienal Hispanoamericana," October 13, 1951). More than ninety artists from Spain and Mexico ultimately participated in the Contra-Bienal, among them Rufino Tamayo, Pablo O'Higgins, María Izquierdo, Leopoldo Méndez, José Renau, and Vicente Rojo. The *exposición conjunta* nevertheless marked an uneasy, and short-lived ideological compromise between the *"artepuristas"* (Tamayo) and the social realists (Rivera and Siqueiros); the absence of exiled artists Remedios Varo, José Horna, Cristóbal Ruiz, Enrique Climent, and others reflected misgivings on the Spanish side as well.[42]

Despite the clamoring of the anti-bienalistas across town, the *II Bienal* opened with the support of many of Cuba's academic artists and, as a batistiana inducement, in conjunction with the *VII National Salon*.[43] Incentivized financially by the Batista regime, which also tacked on mini-retrospectives of Armando Menocal (1863–1942), Leopoldo Romañach (1862–1951), and the vanguardia artist Fidelio Ponce de León, the Salon awarded prizes to Teodoro Ramos Blanco (1902–1972) in sculpture, Carmelo González in engraving, and Mirta Cerra (1904–1986) in painting. Though senior to the onceños, and best considered alongside Amelia Peláez and the eldest-generation vanguardia, Cerra was grouped (anomalously) among the "under-30s" at the start of the decade on the basis of her recent turn toward abstraction. A series of maritime paintings from the 1950s marked the culmination of her post-Cubist experimentation, advanced through the course of transatlantic travel between Europe and New York in the 1930s and 1940s.[44] In *Ships*, a characteristic work from this period, the chromatic atmosphere of light-reflective sails is rendered through variations in texture and brushstroke, yielding a richly faceted surface of ochers, browns, and yellows (fig. 37). Notable among the other Cuban artists who participated in the Salon were Ernesto González Jerez (1922–1996), Orlando Hernández Yanes (b. 1926), María Pepa Lamarque (1893–1975), Carlos Sobrino (1909–1980), and Esteban Valderrama.[45] De la Presa acknowledged the inferior quality

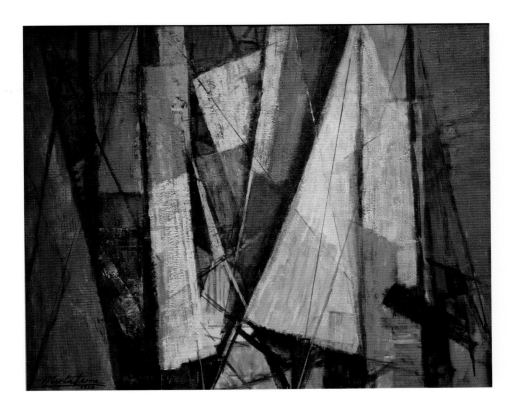

of the Cuban delegation at the *II Bienal* in a letter soliciting Cuba's participation in the *III Bienal* the following year (published by Carreño, to whom it was addressed, in the magazine *Carteles*). The absence of the Havana School—de la Presa singled out Peláez, Lam, Portocarrero, and Mijares—did not go unnoticed in 1954.[46] As in Madrid, the Mexicans were absent (as were Mexico's Spanish exiles) from the *II Bienal*, but a number of the so-called second *escuela de España* in Paris—including some who had participated in the Contra-Bienal in 1951—sent work: Pedro Flores (awarded the City of Havana Grand Prize), Ginés Liébana, Emilio Grau Sala, and Xavier Oriach. Their inclusion was noted in the daily press, which mocked their "disobedience to Moscow," but the franquista allure of eighty prizes worth more than two million pesetas was self-evident.[47] More than three thousand five hundred works were shown between the Bienal and National Salon, which remained on view through September. An edited, anthological version of the *II Bienal* subsequently went on tour to Santo Domingo, Caracas, Colombia (Bucaramanga, Medellín, Cali, Tunja, and Bogotá), Panamá, São Paulo, Quito, Lima, and Santiago de Chile. Cuba sent a small delegation (18 artists, 32 works) to the *III Bienal*, which opened in September 1955; none of the vanguardia artists participated, but notable among the exhibitors were Sobrino, Daniel Serra-Badué (1914–1996), and Florencio Gelabert (1904–1995).[48]

LOS ONCE: 1954

Los Once slowly regrouped in the wake of the *II Bienal* and Anti-Bienal, and on November 27, 1954, they opened their first collective show in a year at Havana's Círculo de Bellas Artes. Consuegra considered it the group's most ambitious exhibition, with the greatest number of artworks and the best overall organization.[49] In a sign of the tightening leadership under the "quintuplets"—Llinás, Consuegra, Antonio Vidal, Oliva, and Martínez—Viredo was expelled from the group on the eve of the exhibition's opening for having brought still-wet canvases, hurriedly painted the night before (his work "shined by its absence," one reviewer allowed).[50] José Antonio Díaz Peláez and Oliva, recently departed for Europe, would not return until the following May.[51] Los Once thus showed as seven (Francisco Antigua, Agustín Cárdenas, Consuegra, Fayad Jamís, Llinás, Martínez, Antonio Vidal) at the moment of their foray into the city's academic stronghold. The symbolism of "exhibiting the extreme vanguardia in the sanctuary of the rearguard" was not lost on the onceños, who also saw in the venue's central location—"between the Capitolio and Las Antillas"—an opportunity to reach audiences beyond the Vedado elite.[52] In a similar vein, Rafael Marquina applauded the "attitude of coexistence, tolerance, and solidarity between artists" conveyed by the unlikely pairing of the onceños and the academy (fig. 38); Pogolotti declared the lineup of abstract paintings a salutary provocation to a lately slumbering institution.[53] With the exception of Antigua, the exhibiting onceños were all nonfigurative by this time, and mostly favorable reviews (for example, by Carreño and Antonio Hernández Travieso) emphasized the maturation of individual practices—Consuegra and Martínez, particularly—and the welcoming of abstraction into the national fold.[54] In an essay accompanying the exhibition, the Surrealist poet José Baragaño (1932–1962) referenced "reconstruction" in an uncertain time ("a world of glass or of fear"), and he invested the onceños with creative agency that he found wanting in earlier Cuban art (he explicitly excepted Lam, in attendance at the opening).[55] A promising restart to Los Once's group practice, the exhibition continued the naturalization of abstract art, whose once notorious shock value began to pale in the face of academic and wider cultural acceptance.

A few days before their exhibition at the Círculo de Bellas Artes closed, the onceños opened a smaller show of works on paper in Camagüey, *Los Once: dibujos y acuarelas* (December 12–17). Thirteen artists participated, Julio Matilla and Manuel Vidal for the first time since *15 pintores y escultores jóvenes* at the start of 1953. A noted colorist, Matilla often textured his paintings, repeatedly plying pictorial questions—intervals between soft-edged shapes, vibrations of line and color, passages of tone and space—with a collagist's sensibility (fig. 39). Though working well within Los Once's mantle of lyrical abstraction, Matilla tracked separately from the group after this, his last exhibition with the onceños. Held under the auspices of the Orden Caballero de la Luz, a Masonic society, the exhibition was organized by "los nuevos," a local group of artists supportive of the nonobjective tendencies—the *pintura-pintura*—of the onceños. In their brief catalogue

FIGURE 38 (opposite)
Rafael Marquina, "Notas a la exposición de 'Los Once' que esta vez fueron siete," *Información* (Havana), December 19, 1954, p. F8. Clockwise from top left: Hugo Consuegra; Guido Llinás; Francisco Antigua; Antonio Vidal; Fayad Jamís; Agustín Cárdenas; Raúl Martínez; and Henri Rousseau (center).

"Nocturno", óleo de Hugo Consuegra.

CORREO SEMANAL DE LAS LETRAS Y DE LAS ARTES

NOTAS A LA EXPOSICION DE "LOS ONCE" QUE ESTA VEZ FUERON SIETE

Objetivo abstracto.- Hugo Consuegra.- Agustín Cárdenas.- Raúl Martínez.- Francisco Antigua.- Nota en excusa

Por RAFAEL MARQUINA
(De la Redacción de INFORMACION)

OBJETIVO ABSTRACTO

Por esta vez tómese el rábano por las hojas. Todo concurre a caer, con cierto deleite del gusto e incitación de la mente, en esta tentación. Los "signos" descifran "condensan"—cábala de paradoja. Se inicia —y es gran ventura— con el buen gesto del veterano Círculo de Bellas Artes que ha condecorado su efectivo decanato longevo con acogimiento de ese grupo de "Los Once", hoy por hoy representante genuino de ciertas tendencias artísticas en pugna con las que parecía privaban, con pertinacia demasiado hermética, en aquella institución.

No por otra cosa que por lo que significaba de buena actitud de convivencia y tolerancia y solidaridad entre artistas, en una gran lección de buena política artística, conviene y es grato subrayar esta posición y rendirle, en público tributo, aplauso sincero.

Pero en "Los Once" hay, además, como ligando en una razón viva las razones once, una trabajada antinomia que acaso sea para el tiempo y en el tiempo su interés mayor. Un cierto anhelo —consciente o no, más o menos claro y dominante en los sendos casos— de arribar, por los caminos del llamado arte abstracto a una concreta plasmación de lo concreto; de entrar por la puerta de lo no figurativo en el mundo mágico de lo objetivo.

Este abstracto concreto —si llega a concretar lo abstracto— en quizá el mayor afán —y habrá de ser el mejor logro— de esa inquietud, a veces alucinada lucha en que se halla —definiendo o delirando— el arte plástico más reciente y más atormentado en su gozo creador. Es, por tanto, buena credencial muy límpida en sus intentos la que puede presentar el grupo de "Los Once" en su justificada pre-tensión de ser contado en la gran contienda.

La paradoja que alienta y vive en esta ansia de sus integrantes es, en fin de cuentas —y con el vigor y la valía exigibles— lo que define y nutre la nobleza de los actuales intentos nuevos.

Por todo ello, el interés de esta última Exposición de los 11 se reafirma, sobre el valor que pueden acreditar cada uno de los expositores, por la significación misma de su comparecencia afirmativa.

Lo abstracto llega a ser en cada uno de ellos un objetivo muy concreto. Y esta antinomia es o debe ser para el hombre contemporáneo una revelación aclaradora. Por esta vez, además, los ONCE no son más que Siete, pero en este mismo inconcreto error de lo concreto parece el grupo, con un guiño pícaro sonreír de su propia facecia, afirmándose en su in-pintor, en suma, que sabe lo que quiere —porque quiere lo que sabe— y que está en madurez apta para crearlo.

No importa ni detiene el ímpetu definidor en este caso lo que, en el futuro —cuyo secreto guarda la Esfinge— pueda hacer Hugo Consuegra. No puede detener el rotundo juicio de hoy lo que el artista pueda hacer mañana. Lo que afirma en él precisamente seguridades para el calificador es precisamente eso "concreto" que hay en su arte abstracto. Esa manera de darle una contundencia de equilibrio sólido. Por donde quiera que vaya más tarde en su elección de caminos, este gran don, ya ahora en ejercicio creador muy afirmado, es su gran significación y su certificado de aptitud para admisión en el tiempo histórico.

AGUSTIN CARDENAS

Habida cuenta de todas las mayores y más numerosas razones

Oleo de Raúl Martínez, "Fuga número 1".

de complicación que alzan su dificultad en este arte, lo que en relación con la pintura se ha insinuado ahora respecto a Consuegra, puede ser dicho también del escultor Agustín Cárdenas.

Su reciente exposición individual acreditó, con persuasiva brillantez, su alta valía. No sólo es un escultor, sino que se a a plenitud de conciencia, con claro propósito de serio "con su tiempo", en ayuda y en obediencia a su tiempo. (Y acaso ¡ay! con certidumbre de sacrificio de facilidades).

No podemos detenernos a examinar con alguna detención lo de más— que permiten asegurar en la obra de Agustín Cárdenas una plena realidad de arte logrado: un perfecto y claro y definido concepto de lo escultórico. Y sobre eso, en evidencia de gracia, una facultad técnica asombrosa. Lo que Cárdenas consigue, es, vive y "se aguanta". Todo el dictamen coaccionante de las tres dimensiones se mantienen en vuelo de armonía, en primor de creación propia, con riqueza de certeros modos. Y en sus obras, el espacio y la luz conjugan su presencia, en un mutuo traspaso que es su gran prodigio de no confundirse en la materia.

Hay sobra en el cabal entendimiento sustentador y creativo. Y todo se halla como sujeto a un entendimiento de lo permanente. La materia está allí como asegurada en su categoría de materia. De: si inmaterial en su condición maciza.

RAUL MARTINEZ

Dentro quizá —¿quién se atreve a asegurar nada?— de los más mos cardinales propósitos —más o menos claros y conscientes— de Hugo Consuegra, este otro pintor, condensador de esperanzas y afirmación de valores, Raúl Martínez, parece caminar por otros senderos. Luminoso en su tanteo, desde luego. Pero con algunos terraplenes.

No se puede ignorar, frente a la pintura de Raúl Martínez, una inmediata sensación de buen arte, si se puede dejar de ver la portentosa facultad de que está dotado y que maneja y ejercita con singular brío y muy advertido de lo que exige, en un orden de creación libérrima, la sumisión a lo humano. Podrá quizá parecer es-

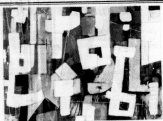

Un óleo de Guido Llinás que figuró en la Exposición de los 11.

Un cuadro famoso del "Aduanero", Rousseau.

to un poco fuera de lugar, tratándose de lo que se ha dado en llamar arte abstracto. Pero, precisamente por no tenerlo en cuenta cuando de arte abstracto se habla, se han cometido tantas injusticias al hablar de los artistas que lo cultivan y han perpetrado y perpetran tantos y tan escandalosos errores muchos artistas que pretenden cultivarlo.

Lo que hasta ahora, en una constancia de labor muy madurada de inteligencia, ha hecho y ha avanzado Raúl Martínez —cuyo nombre no puede caer en olvido cuando se habla de pintura de hoy en Cuba— acredita en su arte la plena conciencia de conceptos y valores muy sentido en su significación.

Y, sobre todo, con nitidez suasoria, una fiel obediencia tanto a cánones incaducables (que todo artista, los razone o no, mantiene vivos en la esencia misma de su sentirse artista) los imperativos anhelos de nuestros tiempos, en una conciencia lúcida de crisis exigente de renovación; en el afanosa búsqueda de un camino hacia la luz.

Raúl Martínez, en el arte pic-

Una acuarela, "Noche transparente", de Fayad Jamis.

tórico, es, a veces en audacia de geometría soñada, un creador más que un intérprete. Y por ese camino ha de hallar sin duda sus mejores aciertos. Quizá precisamente porque en él se acechan —y tendrá que vencerlos— los mayores peligros.

FRANCISCO ANTIGUA

Ya hace algún tiempo señalamos desde aquí la valía indiscutible de este escultor, situado desde sus inicios en el sendero de las renovaciones. Por lo pronto, hay en él, con una marcada excelencia, lo que, en términos gramaticos un poco abstrusos, podríamos llamar "entendimiento de la materia". Nos referimos, al concretarnos, al "material" sobre el que trabaja. Punto, hoy día, de capital importancia.

Antigua, sobre el concepto de lo escultórico, cuenta con el don de lo técnico. Y este buen bagaje lo utiliza con audacia pero con pericia. Empieza por entender perfectamente, ante el material inerte, frente a la materia informe, cuál es la creación artística que le conviene. No yerra en su primera necesidad a satisfacer. Y se diría que el inicial acierto conduce ya su mano hasta el final retoque.

Lo que, aparte las pruebas evidentes en sus esculturas, permite

"Figura", escultura en madera, de Antigua.

—reforzando el elogio— asegurar la excelencia, presente y potencial, de Francisco Antigua, escultor, es lo que sus obras proclaman excelente: su concepto de la escultura. Y no podemos hoy extendernos en considerar lo que esto vale y lo mucho que este se halla ausente en muchos de los escultores que pretenden serlo a pesar de esta causa de imposibilidad.

FAYAD JAMIS

Caso curioso y deleitoso. Lirismo que rima geometrías libres. Una gran originalidad nutrida, en el fondo de su manantial secreto por reminiscencias que vienen de campos no visitados y responden, en eco que crea palabra nueva, de resonancias vagas. ¿Tan distinto, tan opuesto —todas las distancias guardadas— a Odilon Redón y a Rousseau, por ejemplo?, no se halla, no se advierte viva en una niebla grávida de luces rosadas, una correspondencia —en sueño y en misterio— entre el arte de este joven artista y el de aquellos maestros?).

Lo que Fayad Jamis, en sus acuarelas, en sus dibujos, en sus óleos nos ofrece, en riqueza de imaginaciones, en fantasías, en el fondo, la nueva luz de una inquietud antigua; la creación de lo pretérito alzada en vivencia de ineditez. La alucinación puesta

en la realidad. El sueño que es vida. Su "Noche transparente" le define por entero.

NOTA DE EXCUSA

No es posible, por hoy, seguir el hilo de estas alusiones y mucho menos llegar hasta el ovillo. Nos quedan aún por aludir algunos de los otros artistas que comparecieron esta vez, en representación de Los Once en el Círculo de Bellas Artes. Que se nos perdone esta imposibilidad, tan involuntaria. Otro día podremos, con el favor de Dios, remediarla con toda buena voluntad.

Pero sepan Los Once, los que nombrados y los que no hemos podido citar; los que expusieron en Bellas Artes y los que se abstuvieron, que cuentan con nuestra simpatía. Y que, con toda sinceridad, recomendamos al ciudadano interesado —y hasta al indiferente— que los acompañen con su interés y con su ayuda. Así sea.

Pintura de Antonio Vidal. (De la Exposición de los 11).

HUGO CONSUEGRA

Por razón, ante todo, de hallarse en él más manifiestas, con vigor cada vez más acrecido en acierto, estas razones quizá no razonables, cedemos primer lugar a Hugo Consuegra, pintor de una seria tenacidad en la convicción. Y desde luego, obseso en un afán de concretar en colorido, espacio y contenido, lo abstracto —mejor dicho, no lo figurativo— en perfecta, mensurable, contornada y casi palpable geometría asible, maciza, casi sólida. Lo que Hugo Consuegra, maestro ya en su arte, consigue es, en el debate de las discrepancias actuales, un argumento de gran valor. Ante sus óleos, ellos mismos se bastan para sí mismos. No han menester apoyaturas ni exigen interpretaciones. De la abstracción, como dándole sentido, lo propiamente abstracto concreta su figura. Un concreto afán muy concreto.

Agustín Cárdenas, "Composición horizontal", yeso directo.

note, the "nuevos" affirmed Los Once's generational status within Cuba's vanguardia and
placed them, admiringly, within an international trajectory of modernism starting with
the Impressionists.[56] A small exhibition, its interest fell mostly to the promotional side:
Los Once deliberately showed outside of Havana (four of eight exhibitions before the
group's disbandment in 1955 were held elsewhere in Cuba), and the appearance of groups
like the "nuevos" in Camagüey hints at the spread of abstraction across the island.

In their final exhibition of the year, numerous onceños joined artists from all ranks
of the vanguardia on December 21 to inaugurate the permanent gallery of the Sociedad
Cultural Nuestro Tiempo. "The *Galería Nuestro Tiempo* will be our true Museum of
Painting and Sculpture," Lauderman declared in the frontispiece of the catalogue, in clear
defiance of the Museo-Palacio Nacional de Bellas Artes (fig. 40).[57] Since 1951, Nuestro
Tiempo had hosted temporary exhibitions of many of the third-generation vanguardia,
not least the first gathering of the onceños in *15 pintores y escultores*. Its new retrospec-
tive focus, which meant to historicize modern Cuban art from Víctor Manuel to Los
Once, was engendered by the permanent installation of the batistiana museum, which
included (to their chagrin) many iconic works by the vanguardia. The works exhibited
at the Galería Nuestro Tiempo couldn't compete with those across town—they were "not
among the best produced by the artists," later historians have allowed—but their con-
gregation in Vedado marked another incarnation of the protest-exhibition, shades of the
Anti-Bienal a year after it had begun.[58]

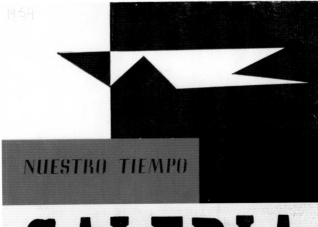

Nuestro medio artístico se resiente de muchas insuficiencias. Y una de ellas es que no teníamos ningún lugar que exhibiera permanentemente un conjunto cabal de las creaciones de los pintores y escultores cubanos. A esa necesidad responden los integrantes de NUESTRO TIEMPO, que han realizado una labor tenaz por despertar la inquietud pública hacia toda manifestación estética, abriendo esta exhibición.

La Galería que se inaugura viene a cumplir la misión divulgadora que todo país debe hacer de sus obras estéticas; y por ser iniciativa privada de una institución cultural y por adelantarse a medidas oficiales que debieron prever esta necesidad, adquiere una significación especial: la Galería NUESTRO TIEMPO será nuestro verdadero Museo de Pintura y Escultura. Y a ella tendremos que acudir si queremos apreciar la evolución del arte cubano. Nuestros artistas, a partir de Víctor Manuel, incluyendo toda la llamada Escuela de La Habana, hasta el grupo de Los Once, colgarán sus obras en las paredes de esta Asociación. Esto es un indicio inequívoco de la calidad y la diversidad estética de lo que contemplaremos. A través de estos cuadros y estas esculturas, observaremos en cada caso, peculiaridades de estilo que diferencian a artistas que se sienten atraídos hacia comunes caminos de expresión, como los que pintan en el no-objetivismo o los que gustan de la abstracción objetiva, sin olvidar los decorativos y los que dentro de la tradición trataron de simplificar y renovar la pintura. El colorido brillante y deslumbrante del arte cubano se verá surgir esplendente en las obras, ya sea una u otra la forma expresiva en que se manifiesten sus autores. Si NUESTRO TIEMPO no hubiera efectuado ya tareas elogiables, la Galería Permanente de Pintura y Escultura bastaría para asegurarle el reconocimiento de haber realizado una labor fecunda por la cultura del país.

Los artistas cubanos, comprendiendo la significación que tiene esta Galería para el arte que ellos han creado, han brindado con gran entusiasmo sus obras para integrarla. La Galería será, así, una experiencia de colaboración entre todos, creadores y divulgadores.

GLADYS LAUDERMAN.

PINTURAS		ESCULTURAS
F. I. Acevedo	Fayad Jamís	Francisco Antigua
Jorge Arche	Wilfredo Lam	Agustín Cárdenas
René Avila	Palko Lukacs	Roberto Estopiñán
Luis Alonso	Guido Llinás	Rita Longa
Cundo Bermúdez	Mariano	Alfredo Lozano
Servando Cabrera Moreno	Raúl Martínez	Enrique Moret
Jorge Camacho	Amelia Peláez	Tomás Oliva
Mario Carreño	Zilia Sánchez	Pablo Porras
Hugo Consuegra	Juan Tapia Ruano	Domingo Ravenet
Manuel Couceiro	Víctor Manuel	Eugenio Rodríguez
Sandú Darie	Antonio Vidal	**DIBUJOS**
Agustín Fernández	Viredo	Adigio
		Rigol

A veteran of the anti-bienalista protest at the University of Havana and an earlier exponent of abstraction, Portuondo wrote an expansive review of the Galería Nuestro Tiempo, meditating at length on the significance of Los Once as the endpoint of the vanguardia trajectory. He first acknowledged the preeminence of the onceños and their embodiment of "the fullest and most complete path toward nonobjectivity," singling out Cabrera Moreno, Jorge Camacho (1934–2011), Consuegra, Jamís, Llinás, Martínez, Zilia Sánchez, and Tapia Ruano. But then he shifted course, warning that abstraction risked becoming a "new academicism," a facile and formulaic style that carelessly repeated itself in works already indiscernible by title (a jibe at the ubiquitous "untitled") and very nearly by the hand of the artist as well. "The monotonous tone of some recent exhibitions suggests to us that the danger of a new academicism is graver than that which preceded it," he continued, "because it comes with pretensions of great modernity and operates in an environment of snobs and nouveaux riches who only want to cover the blankness of their new-built walls with something that neither compromises them nor implies an aesthetic attitude, of which they are incapable, and that can rather be subsumed within the innocuousness of mere wallpaper."[59] An echo of Harold Rosenberg's famous warning about "apocalyptic wallpaper" and the entrenchment of the commonplace—published in *Art News* in 1952 and almost certainly known in Havana—his words cautioned the onceños against the easy temptations, financial and otherwise, of plying an essentially corporate art.[60] He called finally for social realism in the name of the nation (*la existencia nacional*), rebuking the onceños for their real-world detachment and raising, somewhat disingenuously, concerns over "the relationship between this development in contemporary Cuban art and the historical development of our nation over the past thirty years." Portuondo struck at Los Once from the left, challenging their political bona fides at a suddenly vulnerable

time: the onceños suffered personal and economic repercussions from the Anti-Bienal, and as abstraction had gained newfound respectability (no less than at the Círculo de Bellas Artes) it threatened to be coopted and subdued by the very entity against which it had fought for almost two years.[61]

If Portuondo touched a sensitive nerve, the need for collective stocktaking had already suggested itself to the onceños by the fall of 1954 as they began to reconvene as a group. A short essay, "Exposición de Los 11," appeared in *Espacio*, a journal published by students of the University of Havana's School of Architecture, and came to be perceived as a de facto group manifesto (Consuegra believed it had greater resonance abroad, through its circulation by José Gómez Sicre, than in Cuba).[62] Originally written by Consuegra as a personal, rather than official assessment of Los Once's trajectory, the essay conveys equal parts hope and disenchantment as it describes the group's plight. He relates the group's coming-of-age in existential terms: self-made men forced by circumstance to grow up quickly, the onceños had preemptively "twisted the lion's tail," striking out against the Batistato with no experience behind them. Those who might have guided them—implicitly, the elder-generation vanguardia—stood pat, compromised by the extremes of "love-hate entanglements" gone sour over long nights of café con leche. Neither the mountain nor Mohammed moved, Consuegra finally reflected, and, left to themselves, Los Once drew strength (and admittedly, prophylaxis) in their group identity. In an unexpected turn, given the general reticence on issues of race in regard to the onceños, he goes on to link martiano identity ("there exists in each of us a marvelous force that is the synthesis of America") through "the lattice of races that cross our land." (Consuegra naturally cites Lam as the torchbearer in this; however, Cárdenas and Llinás may have been the more meaningful references, along with Jamís, who was of Cuban-Lebanese-Mexican heritage.) "There is no denying that we have become a vehicle of hope and unrest," the essay concludes. "All we needed was a Truth to fight for, and in the end we began to glimpse it. In the meantime, we kept running . . . and the lion behind."[63] The retrospective cast to Consuegra's "manifesto" suggests an ending—of a stage in Los Once's work, if not yet of the group itself—and his frustration and sense of aporia are plainly palpable. The batistiana "lion" proved relentless in regard to the onceños, and the strains of their felt isolation surfaced in the next year.

LOS ONCE: 1955

The onceños exhibited four times together over the first half of 1955, twice in larger group settings and twice more by themselves. "Our intention was to exhibit as frequently as possible," Consuegra explained, "wherever we had the opportunity, wherever we could provoke opposition and politics."[64] Yet the capacity of abstract art to provoke per se was diminishing, both as Portuondo had observed and no less by the aesthetics of urban modernization in Havana. In a real way, what political animus the onceños had

by the start of their third year derived from their anti-bienalista past rather than from the artwork itself. As they adapted to their new acceptance by the vanguardia and even the academy, they became ripe targets for their adversaries: Dulzaides Noda accused Los Once of capitulating to the monetary temptations of the conservative Academy; Batista courted their silence with promised prizes. What had once been a natural union between their brand of abstraction and their anti-batistiana agitations began to break down for reasons both internal and external.

In February, Los Once decided to submit work to the *XXXVI Salon of the Círculo de Bellas Artes*, the site of their group exhibition two months earlier. The onceños were only five on this occasion: Llinás, Consuegra, Cárdenas, Antigua, and Martínez. As a cultural institution, the Círculo de Bellas Artes had waned in importance as the vanguardia rose, and their annual Salons of the 1950s lacked the bellwether status of the revived National Salons. The onceños had not previously participated in the Círculo's salon, and their motives appeared doubtful. Dulzaides Noda smelled a rat, chiding the group for what seemed a blatant pursuit of prizes (Llinás, Consuegra, and Cárdenas all received awards) and for work that "left much to be desired." An erstwhile "embryo of heroes amid the moral decay suffered at all levels of the country," the onceños stood accused as traitors of contemporary Cuban art, their earlier "sacrificial fervor" and "aesthetic militancy" called into question.[65] Marquina declaimed against some organizational changes in the Salon that led to a more open submission procedure; his unsubtle targets were the onceños, whose works were deemed "inadmissible."[66] Consuegra later defended the group's participation, noting the overriding interest of exhibiting at any cost, but in retrospect it appears a case of poor judgment.[67]

The onceños reconvened as a group at the Galería de Artes Plásticas in Santiago de Cuba, where *Exposiciones de los "Once"* opened on March 6. Vidal, Jamís, and Oliva joined the five who had submitted work to the Salon, and the group stood at eight. In contrast to the politicoethical stridency that characterized earlier commentaries, Baragaño's brief introductory text drew more obliquely on "*lo real maravilloso*" (the marvelous real), gleaned through exposure to the Cuban writer and musicologist Alejo Carpentier (1904–1980). Baragaño rendered lo maravilloso as a means of both altering and revealing "*lo real inmediato*," blurring the spaces of "magic" (abstraction, set in metaphysical terms) and reality (the "opacity of the present").[68] A member of the "Generation of the 50s," a group of poets who coalesced around the journal *Ciclón*, Baragaño became involved with Los Once through a personal friendship with Llinás and through Jamís, arguably better known at the time as a poet. His early intimations of the magical real failed to gain traction, but their interpretive possibilities—as a means of calibrating local and international identities of Latin American (Cuban) art, following Carpentier, or in regard to the utopian mythos of cubanía—suggest a fertile, though mostly unrealized, ground of abstraction.[69]

Los Once's lone European gambit was foiled by what seems to have been a misunderstanding between the artists—Consuegra, Llinás, Martínez, and Zilia Sánchez—and

the Cuban journalist Ángel Huete, who organized an exhibition of their work in Madrid in March 1955.[70] A selection of drawings and watercolors apparently intended for a conference on the history of Cuban art was instead exhibited at the Instituto de Cultura Hispánica, a Francoist venue under the direction of Sánchez Bella, the much-loathed instigator of the *II Bienal Hispanoamericana*.[71] Consuegra omits this show from Los Once's exhibition history, but the artists were repeatedly identified as members of the group, and Huete's words closely reprised the arguments of the onceños themselves.[72] Although Oliva had earlier exhibited in Madrid and at the *Salon des Réalités Nouvelles* in Paris, the onceños—unlike the concretos—never established a European profile, staying, whether by choice or by circumstance, within the Americas.[73]

Among the *"quinceños"* included in the first of Los Once's group exhibitions at Nuestro Tiempo, Zilia Sánchez struck an idiosyncratic path through the 1950s, engaging geometry apart from the concretos in ways more organic and self-reflexive. An alumna of San Alejandro, Sánchez held her first solo exhibition at the Lyceum in 1953, debuting paintings in which profiled, graphic lines geometricize space against a soft-edged, painterly ground.[74] Reminiscent of Mark Rothko's semiabstract early drawings, Sánchez's works from this period convey a free-form abstraction—a geometry "found," so to speak, within the natural world and the human body. Sánchez traveled a peripatetic circuit both within abstraction, ranging from the convulsive, informel materiality of artists like Tàpies to the syntactical asceticism of post-Minimalism, and across the Atlantic, traveling first on a fellowship to Spain (1957) before moving to New York and, in the early 1970s, settling permanently in Puerto Rico. Her *Afrocubanos* series bridges the linear exuberance of her earliest abstractions with the muted, flat space that characterizes the reliefs of later years (fig. 41). Taut and animate, two ink lines—described in later works as "tattoos"—simulate the shape of the white space, plunging dramatically down the canvas; the line at left doubles back on itself as it migrates upward, circling a pattern, and then drops down, growing faint as it exits right. A diasporic allegory that anticipates Sánchez's own émigré experience, the line inscribes the movement and displacement of a people; her geometry is fundamentally human, not

concrete. An outlying onceño, her position approximating that of Carmen Herrera with respect to the concretos, Sánchez nevertheless shared in the group's generational identity and, in her way, embodied its diversity.

In May, Nuestro Tiempo held an exhibition in tribute to the Cuban art historian and professor Luis de Soto Sagarra (1893–1955), a loyal supporter of the vanguardia and its americanista horizons. A strong showing by the third-generation vanguardia included many of the onceños: René Ávila, Cabrera Moreno, Jorge Camacho, Agustín Cárdenas, Consuegra, Estopiñán, Agustín Fernández, Llinás, López Dirube, Martínez, Oliva, Rodríguez, Zilia Sánchez, Tapia Ruano, Antonio Vidal. Another instance of vanguardia solidarity across generations, the exhibition continued the collaborative mentality in place since the Anti-Bienal campaign and nurtured by the Galería Nuestro Tiempo. Tensions surfaced a month later, however, as Los Once fought for their generational identity amid increasing internal dissension and outside pressures.[75]

Los Once's eighth group exhibition opened on June 13 at the Galería Habana, directed by Gertrudis Ludtke, the wife of Martínez Pedro, and located in the vestibule of Arte-Cinema La Rampa in Vedado. Twelve artists participated: Antigua, Ávila, Cabrera Moreno, Cárdenas, Consuegra, Díaz Peláez, Llinás, Martínez, Oliva, Zilia Sánchez, Tapia Ruano, and Antonio Vidal. Consuegra later commented that the works exhibited carried minor aesthetic interest, but controversy set in over a short statement by Martínez that accompanied the exhibition (fig. 42). "Until very recently one could not truly speak of the existence of a genuine movement of painters and sculptors in the visual arts," Martínez began, "a movement that responded fully and with force to the needs of a sweeping and spirited art, in contrast with Cuban painting that is still called new, but which has been around for many years." Taking direct aim at the Havana School, he continued, "It is true that isolated figures existed, but they failed to form a real generation, becoming absorbed into the preceding movement. Those who show their work here today already form a school, that of the new Cuban painting that has arrived to claim its rightful place."[76] As fighting words, they elicited a strong reaction—from Carreño, who wrote to Gómez Sicre of the impertinence of the *niños*, and from the critic Suárez y Solis, who reprinted the entirety of Martínez's text in his write-up of the exhibition, dubiously titled "Painters and sculptors also turn out literature."[77] Consuegra professed that neither Martínez nor the rest of the onceños anticipated the reaction that his words would have, though this seems disingenuous.[78] At face value, Martínez's insistence on Los Once's authenticity and ascendance within the vanguardia tradition harked back to the familiar, early arguments for the onceños as a third-generation vanguardia, invested with a cubanista mandate carried out through their practice of abstract art (that is, against the "palm trees and idyllic vision"). Received alternatively as an ad hominem attack, his rhetoric repudiated the long-standing personal friendships and patronage that had spanned generational lines and united the vanguardia in common purpose against the academy and in support of modernism. More subversively, as Freudian disavowal of filial recognition, the words dared

GALERIA HABANA

● ARTE-CINEMA LA RAMPA ● CALLE O y 23 ● VEDADO

Hasta hace muy poco no podía hablarse con propiedad de la existencia de un verdadero movimiento de pintores y escultores en nuestra plástica. Un movimiento que respondiera cabalmente y con fuerza a las necesidades de un arte amplio y espontáneo en contraste con la pintura cubana todavía llamada nueva y que cuenta ya con muchos años. Es cierto que existían figuras aisladas de pintores y escultores, pero éstos no llegaron a formar nunca una verdadera generación, siendo absorbidos por el movimiento anterior. Los que aquí hoy muestran sus trabajos forman ya una escuela, la de la nueva pintura cubana que viene a tomar la posición que legítimamente les pertenece. Y vienen a realizar esa labor con una conciencia y un concepto artístico que le hacen luchar abiertamente en contra del arte académico; el viejo arte de las fórmulas y las reglas, y todo aquel que aún siendo nuevo se complace en el desarrollo de las mismas formas ya establecidas. Nuestro arte joven toma la forma, desprovista ya de falsos lirismos literarios y la renueva como sólo la vitalidad de lo fresco que sale a la lucha logra hacerlo.

Crear no es más que dar expresión a un símbolo. El símbolo es suma y divisor de todos los lenguajes artísticos, ya figurativo, ya como ahora dominado por la más libre abstracción que deja en libertad al hombre de crear su propia realidad fuera de la que nos parece conocida. Tal es lo que hace Klee con su intimismo y tal lo que ofrece Mondrian en su simbolismo plástico, depurado por un amplio razonamiento intelectivo.

El símbolo de la pintura y escultura que aquí se exhiben, es en su más amplia naturaleza abstracto y obedece a un principio de depuración individual bajo el cual el producto final presenta las características propias de una postura particular, pero todas agrupadas bajo el mismo común denominador. No es la teoría la que importa en el dominio de las artes, es la obra consumada. Los conceptos intelectuales sirven para fijarla y encauzarla pero nunca servirán para crear con ella formas significativas y valederas, formas que vivan fuera del tiempo y del espacio en que fueran creadas. La obra de arte es un espontáneo lenguaje al que sólo pueden darle calor y vida los que saben. Los que aquí exponen sus obras, han demostrado ya, que están en el conocimiento, y que siguen bien encaminados.

Sólo el tiempo y la labor personal de cada uno de ellos, nos dirá al final si el símbolo ha consumado y si lo expresado trasciende el simple plano superficial para colocarse alegremente a la par de todo buen arte.

RAUL MARTINEZ

Pintura

RENE AVILA
Pintura
(Oleo)

HUGO CONSUEGRA
Capitán del Futuro
(Oleo)

SERVANDO CABRERA
El Papalote
(Gouache)
De la Noche
(Gouache)

GUIDO LLINAS
Pintura
(Oleo)

RAUL MARTINEZ
Pintura **1 y 2**
(Oleo)

ZILIA SANCHEZ
Composición
(Oleo)

JUAN TAPIA-RUANO
Ventana Roja
(Oleo)
Oleo en Azul

ANTONIO VIDAL
Pintura **1 y 2**
(Oleo)

Escultura

FRANCISCO ANTIGUA
Maternidad (Sabicú)
Figura
(Jucaro)

JOSE ANTONIO
Figura **1 y 2**
(Peral)

AGUSTIN CARDENAS
Composición vertical
(Madera)

TOMAS OLIVA
Escultura **1 y 2**

FIGURE 42
Raúl Martínez, [*Los Once*], exh. brochure. Galería Habana, 1955.

to expunge an entire generation of artists—arguably, Cuba's most celebrated—thereby diminishing the pressure (the "anxiety") of their influence. Martínez's motivations are unclear, but the need to recoup a generational identity could not have seemed more urgent than at the time of the exhibition. A week before its opening, Los Once had elected to dissolve itself, and the uncertainty surrounding the group's legacy—both on behalf of abstraction and against the Batistato—undoubtedly fueled the temper of his text.

THE DISSOLUTION OF LOS ONCE

The reasons behind Los Once's disbandment have been guarded by the group's members and by later historians, at first under tacit threat of persecution and perhaps later out of a sense of deference or elective amnesia. In recent years, however, Consuegra, Martínez, and, to a lesser extent, Pedro de Oraá have published similar accounts of a political intrigue that began in the buildup to the Anti-Bienal and Bienal, intensified over the following year, and ended in a late-night session at Martínez's apartment, where the decision was ultimately made to dissolve the group. On June 6, Los Once published a short statement signed by nine members—Antigua, Ávila, Cárdenas, Consuegra, Díaz Peláez, Llinás, Martínez, Oliva, and Antonio Vidal—declaring their amicable intention to part ways. They carefully noted that their decision indicated "no change in aesthetic principle or belief," but rather supported "individual freedom of action."[79] Suárez Solis wondered publicly about two missing signatures, but only the absence of Jamís is notable; of the founding members, Viredo had been expelled and José Y. Bermúdez long ago replaced by Martínez.[80] The seeds of discontent had in any event been sown a year earlier in the clamor around the franquista Bienal, and the strains of the batistiana war of attrition against Los Once finally took their toll.

Carreño's role in breaking up the onceños is debatable, but he has shouldered much of the blame in latter-day recountings of the group's end. At issue are his political maneuverings in 1954–55, beginning with the Anti-Bienal and its near derailment by a proposed exhibition of Cuban art in Caracas, organized by Gómez Sicre, to which he promised and then reluctantly retracted work. While the Venezuelan show never materialized, the history of its negotiations provides a revealing backstory to the Anti-Bienal, which was unfolding across the island at the same time. In the chronology set out by Martínez, the first development following the announcement of the Bienal was the decision by the Lyceum to organize an exhibition in homage to Martí. "We knew that this was an excuse to protest all of the Latin American dictatorships," Martínez explained, "but when José Gómez Sicre, representative of the Pan-American Union in Washington, made an appearance in Havana, the tenor of everything changed."[81] Gómez Sicre was organizing an exhibition of Cuban art to travel to Venezuela, whose flush, oil-driven economy promised a lucrative market for the vanguardia. A number of artists reportedly agreed in principle to the project.[82] True to their political stake, the onceños immediately denounced the exhibition, asking in mock disbelief, "Perhaps there wasn't a dictator such as Pérez Jiménez? How could we be so opportunistic?" Martínez recalled that many artists "defended themselves by saying that 'art is art and has nothing to do with politics,'" but he rejoined, "Wouldn't they sell paintings in Caracas?"[83]

Carreño ultimately backed away from the exhibition for a complicated set of reasons related to his role in staging the Anti-Bienal and the hypocrisy of simultaneously protesting two dictators (Franco, Batista) and supporting another (Pérez Jiménez). In a long and ingratiating letter posted to Gómez Sicre on March 26, 1954, Carreño explained

the complexity of his situation in Havana. In the midst of the Anti-Bienal and an influential "contra-Caracas" manifesto published in *Bohemia*, the elder-generation vanguardia, led by Mariano Rodríguez and Alfredo Lozano, had come to oppose the Caracas show on political grounds. With support from Lauderman and the Lyceum, they waged a radio and television campaign against Carreño (and by association, he insinuated, against Gómez Sicre) that ended with an "ultimatum": unless the works were withdrawn from Caracas, the artists would release a "manifesto," to be signed by all of the anti-bienalistas, stating their opposition to the show (and to Carreño, by name). A face-saving measure, Carreño's capitulation preserved the political gesture of Havana's Anti-Bienal and extricated a number of vanguardia artists from a personally compromising association. Yet he acknowledged his frustrations on a personal level; his role in the Anti-Bienal had preempted his ability to show in Caracas, and he resented both the lost opportunity and his unwitting role as the fall guy for the foiled exhibition.[84]

In the wake of the Anti-Bienal, Carreño accepted a new role as Artistic Director of the National Institute of Culture (INC), acting as Batista's cultural emissary within the visual arts. (To his chagrin, he was also viewed locally as a proxy for Gómez Sicre and officialdom generally.[85]) In one of his first acts as Director, Carreño gathered a number of artists at the Lyceum to explain the Institute's cultural program. He "tried to separate the worlds of culture and politics," Consuegra recalled, "indicating that he had the authority to award prizes, commissions, and jobs to those intellectuals who decided to 'collaborate' with the government."[86] Among his proposed initiatives was the "1% Art in Public Places" program, in which the Ministry of Public Works would allocate a percentage of its budget for new buildings to artists. The program had obvious appeal, Martínez acknowledged, but Carreño drove a hard bargain. In exchange for lucrative state purchases and fellowships, the artists would offer their silence: no demonstrations, no protest-exhibitions, no political commentary that could be seen as detrimental to the state.[87] Los Once mistrusted Carreño's promises ("quixotic projects") and declared they would neither stand still nor be silenced; according to Martínez, they left the meeting to jeers and epithets that only "reaffirmed [their] civic attitude."[88] The carrot-and-stick approach plainly targeted the onceños, who as young artists were most affected by grants and travel awards, and within a year the financial and professional costs of resistance took their toll.

The tipping point came when Cárdenas informed the group that he had accepted a government prize, a disclosure that precipitated a chain of late-night meetings and wrangled debates. "We made him understand that the fellowship was nothing other than a maneuver by Carreño to divide the group and shut us down politically, given that we would lose our moral ground were he to accept the award," Martínez later wrote. "Agustín defended himself with arguments that we understood very well; he referred to the artistic realities he faced and his future as a sculptor."[89] During a heated meeting at Martínez's apartment, the ideological differences between the remaining onceños

became clear: "Los Cinco" were charged as communist sympathizers, and Cárdenas stood accused of betrayal and ethical failure.[90] Cárdenas would not be dissuaded from accepting the fellowship, and the decision was made unanimously that night to disband the group. (Aware of another pending offer from Carreño, Llinás and others preferred to dismantle the group themselves rather than suffer defections one by one.) Los Cinco would resume the fight for a "better world" underground, Llinás pledged, no matter the political jeopardy or expected economic hardship.[91] Carreño may not have delivered all of the promised fellowships, as Martínez charged, but Cárdenas and Jamís left for Paris by the end of the year. In a way maddening to Los Cinco, to whom his shrewdness seemed self-serving and Machiavellian—Consuegra reluctantly described him as a Judas figure—Carreño had achieved his goal.[92]

The full truth of Los Once's disbandment could not have been aired publicly at the time—hence the clipped, politic statement released by the group—and in the intervening years there has been little interest, within or outside of Cuba, to reconstruct the course of events.[93] Yet inasmuch as Carreño's overtures hastened the group's dissolution, Los Once were already vulnerable by 1955: abstraction threatened to become yet another "academicism," removed of its shock value and, arguably, some of its political agency, and the group had struggled to regain momentum following its year-long hiatus. The Anti-Bienal had imprinted abstraction as martiano and cubanista, but the degree to which that political charge remained in effect (and could be continually renewed) appeared uncertain. The onceños had privileged the situational forcework of abstraction in exhibition-manifestos, but in the anticlimactic months following the Anti-Bienal they faced the difficulties of sustaining a united, ideological front indefinitely. Los Once's ostensible missteps—for example, at the Círculo de Bellas Artes, with Martínez's gallery text—suggested a crisis of identity in the making before Carreño's intervention.

The artists pledged to not exhibit again as "Los Once," but they did in varying configurations show together eight more times, culminating with their valedictory exhibition, *Expresionismo abstracto*, in January 1963. Consuegra and others consider the group's later exhibitions—occasionally as Los Cinco (though not consistently as five) and other times with various "honorary" members—within the extended history of Los Once. Smaller in scale and less polemical, these shows lacked the cumulative force and near cult status of the group's earlier exhibitions; their significance lies mostly in their fact and, to a lesser extent, their inter-American breadth. Without question, the two-year period between the group's debut as fifteen, in February 1953, and its disbandment in June 1955 comprised its most critical period of activity and influence. Acting in a climate of contingency, Los Once embraced the new circumstances of the batistiana regime as the substrate of their practice, allowing politics to dictate the process and manifestation of their artwork and instantiating abstraction within a generationalist and, ultimately, cubanista mandate.

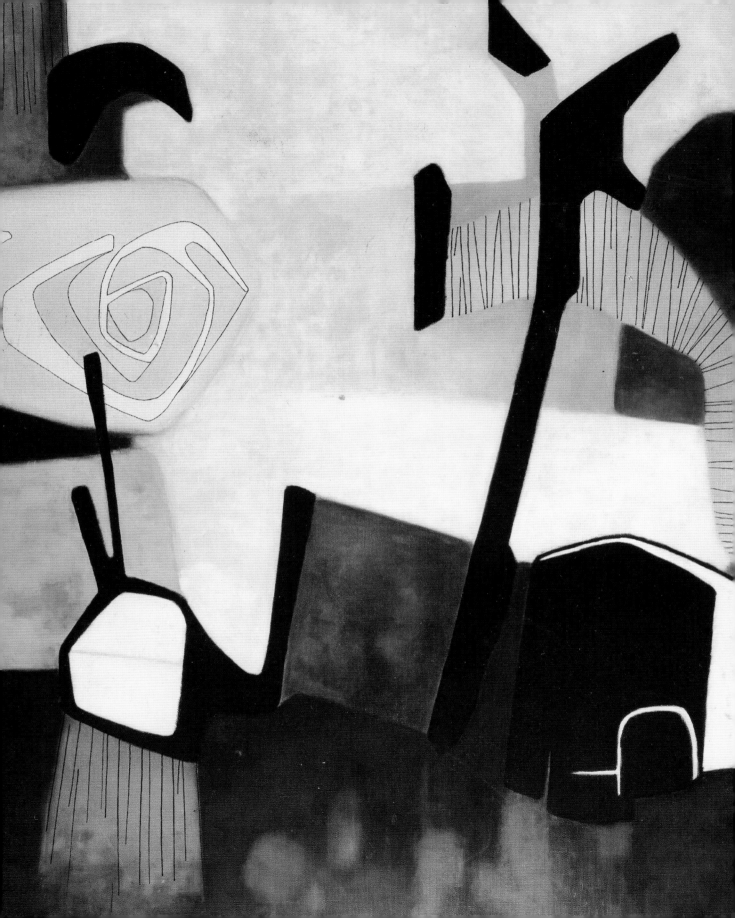

4 The Offices of Abstraction

"Havana Grows and Modernizes," a striking, black-and-white photo essay, graces the third issue of the *Revista del Instituto Nacional de Cultura*, the eponymous journal of the INC (fig. 43). A panoramic spread in three parts—"A Modern City," "The Visual Arts," and "Urbanism and Planning"—the essay shows off a metropolis built for the future, "a beautiful and functional city" at the leading edge of urban design and postwar utopian projection. "The contrast between yesterday and today could not be more emphatic," the text declares, punctuated by high-contrast images that distill the city into lines and planes; aerial shots of the wide, seaside horizons of the Malecón serve as foils to the sinuous curves of Vedado's high-rises, dramatically foreshortened in hard, tropical light (fig. 44).[1] The clean, streamlined designs of Havana's built environment bracket a display of geometric paintings by Mario Carreño and Luis Martínez Pedro (and a stylized abstraction of the city by René Portocarrero) presented as examples of "new aesthetic currents within modern Cuban art now enjoying international prestige" (fig. 45).[2] That abstraction had become institutionally paradigmatic of modern Cuban art by mid-decade was in turn remarkable, given the recent fracas over Los Once and the anti-bienalistas, and telling of the semantic plasticity of abstract art in the late 1950s, its evolving associations with the elder-generation vanguardia, and its increasingly international outlook.

As the dramatic arc of Los Once drew to a close, Havana's cultural field shifted in answer to the consolidation of the arts under Batista, on the one hand responding to the modernizing transformations of the city and, on the other, continuing to rail against its miscarriage of democratic process. Abstraction was in some ways a red herring: its earlier polemics began to fade as the onceños dispersed, and it soon became ubiquitous in public commissions and in international exhibitions of Cuban art. Yet insofar as abstraction appeared politically neutralized, its moral ground—its inscription of cubanista values of freedom and revolution—took on increasingly Manichaean proportions for the minority within the vanguardia who publicly kept up the fight. No less than "the internal liberty of the free man" was endangered by a looming "Grand Inquisitor of Culture," Virgilio Piñera cautioned, insisting that there could be "no morality of culture as distinguished from the political" and that "the cultural values of a nation do not have a morality officially defined—not even Christian, nor revolutionary, nor orthodox. . . .

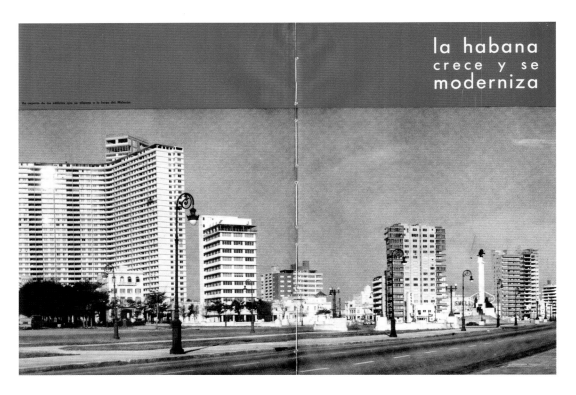

la habana crece y se moderniza

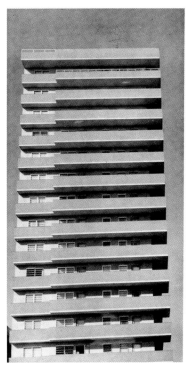

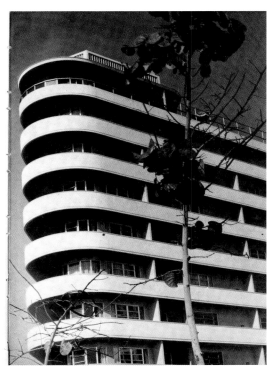

una ciudad moderna

Toda ciudad tiene un estilo en el cual se concreta el modo de vivir de su población, sus costumbres y la época. A La Habana colonial, de vida reposada y prócer, sucede La Habana moderna, agitada, ansiosa de progreso. El contraste entre el ayer y el hoy no puede ser más rotundo, y, sin embargo, se percibe claramente entre ambas el espíritu creador que anima nuestra capital desde la época de su fundación hasta el presente. Ese espíritu es el que da a La Habana su carácter a través del tiempo. En esta Habana moderna que todos hemos visto crecer, es donde más elocuentemente se manifiesta, acaso, el impulso creador del cubano. Dentro de las normas nuevas del arte arquitectónico, que son comunes a todas las grandes urbes de hoy, se destacan los rasgos peculiares de nuestra sensibilidad artística. He aquí una ciudad que, sin romper sus lazos con el pasado avanza resueltamente con el futuro.

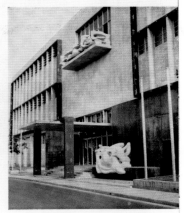

las

artes plásticas

también se han renovado
el movimiento de arte moderno
en nuestro país tiene sus comienzos en 1927
cuando algunos artistas cubanos
regresaron de Europa trayendo en sus obras
trazos de las nuevas corrientes estéticas
actualmente
el movimiento de plástica cubana
moderna goza de reconocido prestigio internacional.

Fachada principal del Palacio de Bellas Artes, sede del Museo Nacional y del Instituto Nacional de Cultura. Las sobrias y modernas líneas de este edificio, son una muestra del avance arquitectónico de la capital habanera.

"La Ciudad", óleo de René Portocarrero que pertenece a la Sala Permanente de Artes Plásticas del I.N.C.

28

FIGURE 45
"Las artes plásticas," *Revista del Instituto Nacional de Cultura* 1, no. 3–4 (June–September 1956): 28. Painting is by René Portocarrero.

The day on which the artist has to live according to an 'official morality' and adjust his creation to the dictations of an 'official culture,' art and culture will suffer."[3] Yet whatever the prognostic value of his warnings, the second half of the decade witnessed undeniable successes within the arts and, with respect to the vanguardia, no less than the apotheosis of abstraction as a stylistic interface of the Batista state. However much to the chagrin of the onceños, cultural life flourished during the Batistato due in no small part to the path that they blazed in 1952–53, and the utopian imaginary of abstraction—seen from architecture and urban planning to the concurrently developing vein of concretism—took on new forms and dimensions. If abstraction had jumped the shark by the end of 1955, the last years of vanguardia activity nevertheless left a rich legacy of artwork and exhibitions, returning in unexpected ways to the cubanista mandate of its youngest generation.

Abstraction wore changing and multiple identities during the twilight of the republic, and this chapter illuminates the ongoing practices of the onceños and the vanguardia at large within a wide matrix of cultural activity in Cuba and abroad. Under the auspices of the INC, the state exhibited the national collection for the first time at the Palacio de Bellas Artes in 1955, positing an early, and soon canonical narrative of Cuba's art history. The historicizing inaugural installation culminated with abstraction, whose geometric tendencies resonated both in the modernist design of the museum itself and, in an aspirational way, in the contemporaneous "patterning" of the city under proposed urban and architectural developments. Indeed, abstraction was writ large across Havana, from the renderings of a modular Plan Piloto to the spate of public murals commissioned from vanguardia artists for new residences and buildings. The widespread acceptance of abstract art and accompanying critical détente came, not surprisingly, at the price of abstraction's radical politics, tied indelibly to Los Once. Though officially disbanded, the core group of Los Cinco led a protest of the *VIII National Salon* (1956) with an "Anti-Salon"—a self-conscious repetition of the Anti-Bienal—but otherwise shifted their efforts abroad, seeking new audiences principally in the United States and in Venezuela. Their external locus paralleled the long-awaited international recognition of the vanguardia, and the numerous, intergenerational traveling exhibitions of the 1950s

ushered in a new era of Cuban art, detached from the tropicalista stereotypes of old. The competing regional claims on Cuba—North American, Pan-American, Latin American—cast abstraction in complicated and, at times, contradictory roles, and the americanista identity of the movement remained as amorphous as its revolutionary cause.

THE NATIONAL INSTITUTE OF CULTURE

The establishment of the INC in 1954 signaled a new effort to consolidate the state's jurisdiction over the arts and to render its visual patrimony into a national history. Headed by Guillermo de Zéndegui (1901–1998), a writer and man about town, the INC reflected the conservative disposition of Cuba's older intellectual guard; to naysayers, its advisory board appeared an amateurish and servile consortium of cultural elitists.[4] In their sociology of Havana, Segre, Coyula, and Scarpaci describe the Institute's "prophetic association of elitism, superficiality, and uncouthness with the arts" through a telltale joke that "circulated sotto voce among the upper class: The imaginary setting goes like this: a nervous Batista seeks advice from his brand-new director of the National Institute of Culture about an upcoming special exhibit of the Mona Lisa. Looking for an easy way out, the ill-trained Zéndegui tells the president to pause in front of the painting, take two steps back from the work, and exclaim admiringly: 'Such a face! What an expression!' [*¡Qué cara! ¡Qué gesto!*]. The next day when the exhibit opens, Batista follows Zéndegui's advice but confuses the word 'face' (*cara*) with 'hell' (*carajo*) and exclaims: 'What the hell is this?' [*¿Qué carajo es esto?*]"[5] Yet whatever Batista's philistinism, he did not engage a public culture war, preferring to deal behind the scenes (as with Los Once). Predictably, the INC drew the ire of the onceños and their cohort, who faulted its conservatism, condescension, and cronyism. Piñera had withering words for the "political *croniqueurs*" and "writers of the encomiastic glosses" who served the INC, speaking out against its "climate of absolute conformity to the orthodox ideas that its director embodies" and rejection of "whatever minority figure might be polemical or combative on account of the newness of his ideas." The INC's exclusion of the onceños was a moot point (they remained in open defiance of Batista); its elevation of "a good academic [Juan José Sicre (1898–1974)] that follows from the sidelines all the new and creative development in that art" rankled, nevertheless.[6] In a more global sense, these kinds of petty complaints—outmoded aesthetics, alleged handouts, desultory (and worse, imported) exhibitions—provided fraught fodder for questions about the role of the state in the formation of a national culture.[7]

A likely target, the INC served as a lightning rod for criticism of the Batistato, couched in suggestively cubanista phrasings of artistic freedom as a proxy for the pursuit of Cuba Libre. Piñera opined the reality "that in these moments not only society pursues and hems in the artist; also the State and the official organs direct anti-intellectual vendettas," declaring further: "The legitimate end of all true State culture is to propitiate and jealously guard the artist so that thus he can create a new work which

would be a sincere and unequivocal reflection of his own convictions—that is, the internal liberty of the free man—whether they adjust or not to that which some believe is the 'official morality.' In this free interchange of ideas and in this living splendor of the creative imagination, the true culture of a nation is being forged."[8] The rhetorical equation of artistic and human freedoms underpinned the crux of cultural vanguardismo during this time, advanced by Piñera and the literary "Generation of the 50s" that emerged around the journal *Ciclón*. Less and less a question of formal aesthetics than of political freedom, opposition to the INC turned in increasingly totalizing dimensions: pitched philosophically, it took on the utopian projections of cubanía; at a more mundane level, it exposed the corruption of the "official" culture. Among the INC's most notorious episodes was its failed overture to the Ballet Alicia Alonso, founded by Cuba's preeminent prima ballerina in 1948. In 1956, Zéndegui offered a monthly pension ($500) in perpetuity in return for Alonso's silence and public acknowledgement of the INC's patronage. She refused and shut down her company; denounced as a communist agent as part of a public smear campaign, she left Cuba the following year.[9] Alonso's falling-out with the Batistato paralleled the crooked negotiations between Carreño and the onceños a year earlier, and her defection—at a far greater political cost to the state—further weakened the Institute's credibility.

In regard to the visual arts, the INC's most enduring legacy was the first permanent installation of the Museo Nacional at the Palacio de Bellas Artes on July 22, 1955 (fig. 46). Likened rather extravagantly by Rafael Marquina to Florence's Uffizi Gallery, the Palacio

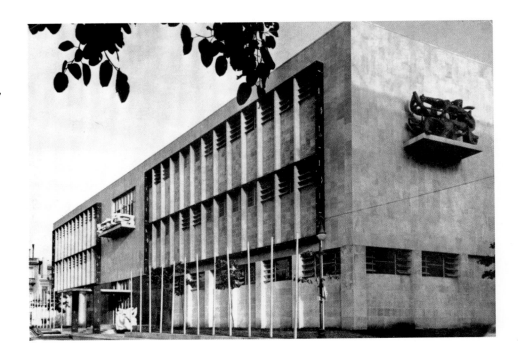

FIGURE 46
Palacio de Bellas Artes. Reproduced from *Sala permanente de artes plásticas de Cuba* (Havana: Palacio de Bellas Artes, Instituto de Cultura Nacional, 1955).

de Bellas Artes was celebrated as a national symbol and a jewel of the modernizing city: "In the City, a Palace; in the Palace, a Gallery. A fine precept for the ideal architecture of a city, with or without a plan of urbanization. Give a city a 'gallery' and the urban plan will follow in stone and in the soul, which is what matters."[10] Marquina's tacit reference to the concurrently developing *Junta Nacional Planificación* (National Planning Board), assembled in January of that year and tasked with the urban development of Havana (see below), underscored the importance of the museum—and by extension, its historicization of modern Cuban art—within the construction of the city's civic identity. The building fulfilled a commitment made on the occasion of the first National Salon twenty years earlier to dedicate an official space to the exhibition of works acquired by the state through the Salons.[11] Founded in 1913, Cuba's Museo Nacional had previously occupied a series of small, ill-suited venues, and the modernist redesign of a site in Old Havana (formerly, the arcaded nineteenth-century Colón market) by Alfonso Rodríguez Pichardo (1918–1980) provided an ideal setting for the collection.[12] An example of contemporary interests in the integration of the arts and architecture, the building incorporates passages of light and air throughout, from the Corbusien brise-soleil on the exterior to the open plan extending through a ground-floor portico and interior courtyard and along a long ramp leading to the galleries. Among the elder-generation vanguardia sculptors who contributed to the facade and interior vestibule were Enrique Caravia, Rita Longa (1912–2000), Alfredo Lozano, Ernesto Navarro (1904–1975), Eugenio Rodríguez, Juan José Sicre, and Mateo Torriente (1910–1966). The first published, partial guide to the collection listed 265 paintings on view; organized into ten galleries, the historical installation integrated the museum's holdings—in large part, donated works from early modern Cuban and European schools—with loans from private collections.[13] Of keener interest was the permanent installation of the modern galleries (omitted from this first guide and published separately), which dominated contemporary discourse.

The museological inscription of Cuban art effectively canonized the vanguardia, whose works were publicly presented within a progressive narrative of nation-building and modernism for the first time. Many of the prize-winning Salon entries had been scattered among various, unauthorized hands over the years, and the installation reunited the works under a historicizing, national rubric.[14] "Our aspiration," the accompanying catalogue concluded, "is embodied in the effort to enrich this artistic patrimony and to give a defining and instructive meaning to its exhibition."[15] Assurances on this count—for example, "Cuban art can compete with the best of our continent," per the Peruvian artist and writer Felipe Cossío del Pomar—were highly valued and well publicized.[16] As the Institute's artistic director, Carreño took curatorial responsibility for the installation of the Sala Permanente, and his stylistic codification of the vanguardia—synthesized in the "Historical Diagram of the Visual Arts in Cuba," displayed in the vestibule of the modern galleries—imparted a clear genealogy to the past fifty years of Cuban art (fig. 47). With an admiring nod to the diagram famously published by Alfred H. Barr, Jr., in the exhibition

FIGURE 47
"Historical Diagram of the Visual Arts in Cuba." Reproduced from *Sala permanente de artes plásticas de Cuba* (Havana: Palacio de Bellas Artes, Instituto de Cultura Nacional, 1955).

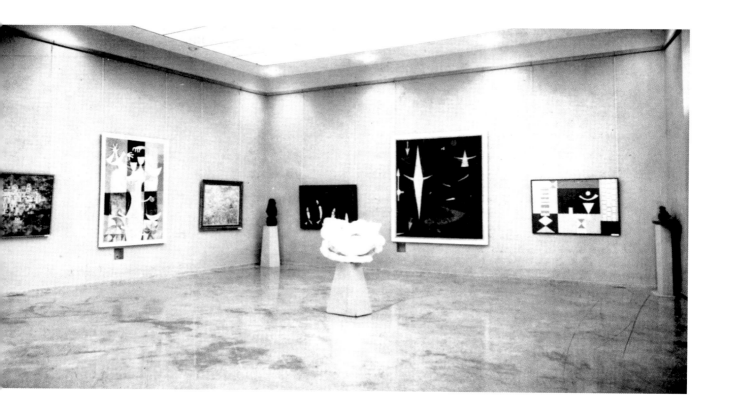

and catalogue *Cubism and Abstract Art* (New York: Museum of Modern Art, 1936), Carreño
mapped the coevolution of Cuban painting, sculpture, and engraving in a didactic flow-
chart. Carreño knew Barr through José Gómez Sicre and their earlier collaboration on
the exhibition *Modern Cuban Painters*, organized by the Museum of Modern Art in 1944.
The historicist linearity of his adapted diagram positions the return of Víctor Manuel
to Cuba in 1927 along a foundational axis that connects the Academia San Alejandro,
through the late Leopoldo Romañach (1862–1951), to three strands of modern painting: the
academics (for example, Caravia, Carmelo González, Carlos Sobrino); the first-generation
vanguardia (Eduardo Abela, Roberto Diago, Antonio Gattorno, Wifredo Lam, Amelia
Peláez, Fidelio Ponce de León); and the Havana School (Cundo Bermúdez, Mario Carreño,
Luis Martínez Pedro, Felipe Orlando, Mariano Rodríguez). Anthological by design, the
Sala Permanente was inclusive—Carreño was careful to emphasize the catholicity of the
inaugural installation, noting its "variety of styles and aesthetic precepts"—but its teleo-
logical progression privileged the vanguardia, whose works predominated.[17]

The unabating presence of abstraction, ubiquitous and thus tacitly condoned, sug-
gested a temporary détente: so long as the onceños (excepting Agustín Cárdenas) were
kept out, abstraction was assimilable within the national canon. Writing on behalf of the
INC, Guillermo de Torre (1900–1971), the Spanish critic and member of the Generation

of '27, named "systematic abstraction" one of two risks to contemporary art—the other, the strident "hyperboles" of the Mexican school—but allowed that the artworks might be absolved by their "fidelity to the spirit of the age and deeply American flavor."[18] However tepid the INC's endorsement, Carreño nevertheless positioned stylized, mostly geometric abstraction as the culmination of modern Cuban art. The ubiquity of abstraction is indicated in an early, and frequently reproduced installation photograph, which shows works by Cundo Bermúdez, Carreño, Portocarrero, Lam, and Eugenio Rodríguez (fig. 48). Their grouping reflects the widespread period phenomenon of abstraction; sanitized of anti-bienalista dissidence and its problematic associations with Los Once, abstraction was effectively repossessed by a multigenerational vanguardia as a state style. A remarkable turnabout from the slash-and-burn tactics of the onceños just three years earlier, this consecration of abstract art whitewashed its origins (no less the outsider status of its earlier protagonists, who did not move in the same social circles as the INC's board).

Cárdenas, among the few onceños to remain in Carreño's good graces, was rewarded with a joint exhibition with Rafael Soriano at the Palacio de Bellas Artes in 1955. His debut the following year in Paris, alongside Fayad Jamís, at the Left Bank gallery À l'Étoile scellée marked not only a mutually serendipitous initiation within the late Surrealist circle still led by André Breton, but also the beginnings of a more existential self-discovery vis-à-vis his encounter with African culture (fig. 49).[19] The long, silhouetted hollows of his iconic wooden totems, reproduced in the Institute's

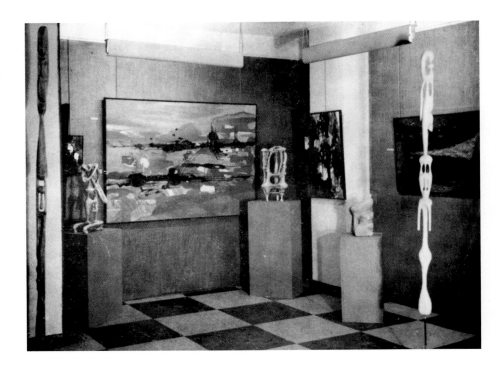

FIGURE 49
Works by Agustín Cárdenas and Fayad Jamís at À l'Étoile scellée (Paris). Reproduced from *Revista del Instituto Nacional de Cultura* 1, no. 3–4 (June–September 1956): 58.

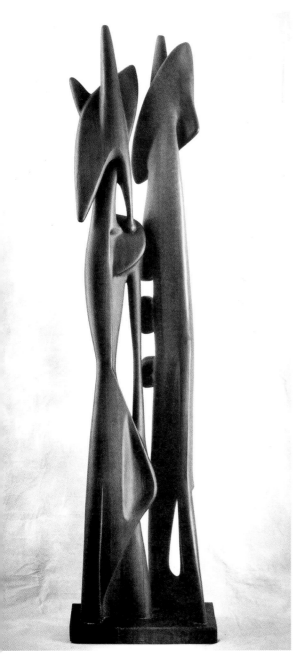

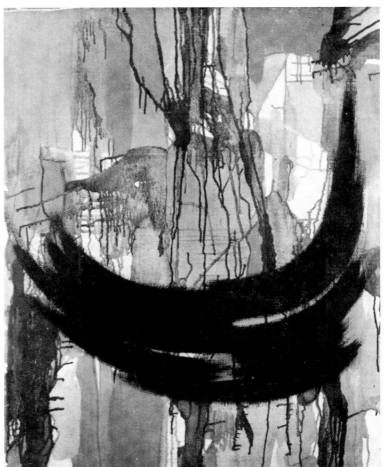

journal, enkindle the space surrounding them, their bodies a distillation of divinity and of awakened, pan-African belonging. For Cárdenas, the coupling of Surrealism and Africa in the wake of Sartre's *Black Orpheus* (1948) and his poetics of *Négritude* engendered a powerful plastic response, allusive and morphological, with regard to Cuba. Rising metrically through seductive, intertwining forms, the monumentalized figures of *Couple antillais* embody the vitalist, plastic drama of (Afro-Cuban) blackness and creation, themes persistently engaged in his work (fig. 50). Mexican-born and of Lebanese descent, Jamís was a published poet as well as a painter, known for the gestural and telluric drama of his abstractions (in "the colors of anarchy," in the words of Surrealist historian José Pierre). Squiggly veins of paint stream down the surface of a painting exhibited at À l'Étoile scellée, interrupted by dark, scythe-like swaths of paint (fig. 51); its improvisational, fugue-like energy characterized his painting from the Paris years (1954–59), which developed in the context of European *art informel* (and, by extension, Surrealist automatism). Christened "the

FIGURE 50
Agustín Cárdenas. *Couple antillais*, 1957. Wood. 90½ in. (230 cm).

FIGURE 51
Fayad Jamís, *Untitled*, c. 1956. Oil on canvas. Location unknown.

black pearl and the ruby" by Pierre, Cárdenas and Jamís—like Lam before them—found a reception abroad that far eclipsed the initial response in Cuba to their work. Such plaudits abroad, proudly reported by the INC, conferred elevated status in Havana, which warmly welcomed both artists after the Revolution (Jamís immediately, and Cárdenas for the first time in 1967 at the Salon de Mai, organized by Lam).[20]

Among the publicists of Cubans abroad was the quarterly *Revista del Instituto Nacional de Cultura*, a little-remembered grace note in the INC's history that resumed the work of the earlier, artist-run magazine *Noticias de Arte*, remarking upon cultural events

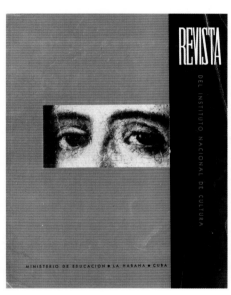

and serving as a general forum for Cuban art (fig. 52). The official organ of the Institute, the *Revista del INC* was published three times between December 1955 and June 1956; its modern graphics, tipped-in plates, and high-quality photography suggest Carreño's hand in its design and production. In characteristically florid language, Zéndegui introduced the magazine in terms that recall those applied to the Institute itself: "This journal," he proclaimed, "will contribute to the rediscovery of Cuba, so explored and so plundered, and yet so little known." Zéndegui pledged that the *Revista del INC* would rectify these historical slights and omissions, declaring the magazine the "result of a purpose: the first and foremost part of an emerging but serious cultural policy that considers, among other urgent national questions, the need to offer the world a taste of what we do and a better showcase of our skills and potential."[21] Acknowledging the country's mixed renown as a paradise of rum and rumba, Zéndegui, like the onceños before him, advocated a move away from tropicalista carica- ture, situating modern Cuban art rather within and for an international context. The journal published niche features ("The Newspaper in Cuba, from 1794 to 1902," "The Speleological Society of Cuba") and contemporary news briefs, but its content was dictated primarily by the national collection, introduced through vir- tual walk-throughs of the galleries. More global in its taste than the modernist *Noticias de Arte*, the *Revista del INC* called attention to lesser-known works from the colonial era and attempted, through the breadth of its coverage and studiously didactic tone, to articulate a canon of Cuban art in line with the collection on display at the national museum.[22] Notwithstanding its occasional puffery—for instance, tracing the history of the "Cuban book" to Babylonian tablets and a thirteenth-century book of hours, as Nuestro Tiempo chided—and its short run, the magazine provided a rare, photographic record of the ear- liest institutional display of the vanguardia and the kind of critical scaffolding erected around it.[23] The undeniable presence of abstraction, once contentious and spurned by the Salons, partly vindicated Los Once's early vision of a cosmopolitan and americanista medium. In an ironic turn, that vision succeeded, though in a far different circumstance— after the surprise of the Batista coup and their near-immediate politicization of abstrac- tion, in response—than the onceños could have foreseen.

FIGURE 52
Cover, *Revista del Instituto Nacional de Cultura* 1, no. 2 (March 1956).

THE SPACES AND OFFICES OF ABSTRACTION

The increasingly civic identity of abstraction carried over from the Palacio de Bellas Artes into Havana's urban environment, at the same time undergoing intense spatial and sociological scrutiny as part of official planning projects. As Timothy Hyde has argued, the city of Havana itself came to be visualized as an abstraction in the mid-1950s, under the urbanizing (and wholly utopian) rubric of the Junta Nacional Planificación de Cuba (JNP), established in January 1955, and its commission of the *Plan Piloto de la Habana*.[24] The JNP authorized Town Planning Associates, a CIAM-influenced firm cofounded in 1941 by Josep Lluís Sert and Paul Wiener (1895–1967), to work with local architect and Minister of Public Works Nicolás Arroyo (1917–2008) on the Havana Plan (fig. 53), set out in three stages: preliminary research; the *Plan Piloto* (pilot plan), a schematic rendering; and the *Plan Regulador* (master plan), with specific structural and regulatory recommendations.[25] To be determined were not only the city's limits and land-use distributions—

FIGURE 53

Paul Wiener et al., The Central Area of the City. Reproduced from *Plan piloto de la Habana: directivas generales, diseños preliminares, soluciones tipo* (New York: Wittenborn Art Books, 1959), 31.

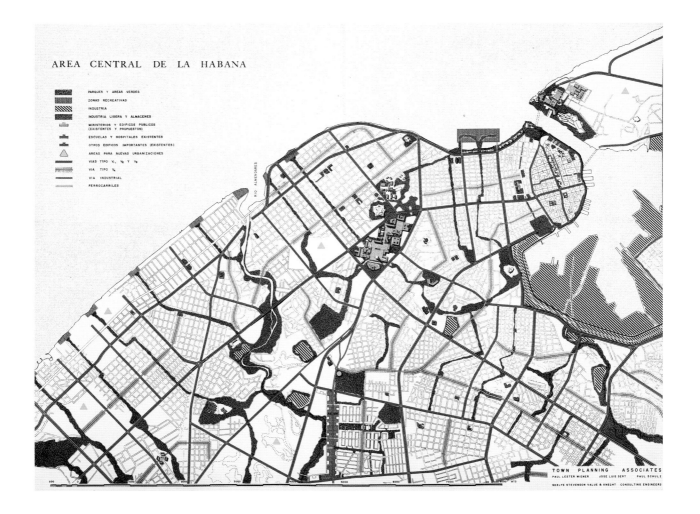

a response to the sprawling *repartos* (subdivisions) that had developed outward from central Havana—but also the kinds of design criteria, from roadways to buildings, that would foster harmonies of order and circulation ("servants and instruments of the new desires and intentions," per Jorge Mañach).[26] The word "pattern" became a leitmotif of Sert and Wiener's work, acknowledging both the familiar—"patterns of old experience" (Mañach)—and the "very interesting and new pattern for the city" (Sert); the conjunction of aesthetic, functional, and normative modeling underlay the Havana Plan from its inception.[27]

At the core of this conceptual "patterning" of the city was the Modulor, a Corbusien proportion introduced in 1948 to synthesize the geometry of the human body with metric and English units, which Sert adapted to the Havana Plan. The Modulor, a platonic order defined by its creator as "a harmonious measure to the human scale, universally applicable to architecture and mechanics," was in practice mathematically flawed and applied irregularly to accommodate local variations (it was neither strictly objective nor universal).[28] As a design heuristic, however, the Modulor provided Sert with a social construct—"a new measure related to man and to the social structure of the community"—that appears in his Havana Plan in varying scales from window to wall, patio to *cuadra* (apartment block) (fig. 54).[29] This standardized visual patterning, extending from modular, component parts, had an earlier source in Sert and Wiener's plan for Quinta Palatino (1954), a neighborhood development with several cuadras that served as a prototype for the new repartos. Its use of perforated walls exemplified the social design of the Plan Piloto: scaled to the height of Modulor Man's raised arm, the walls integrated private and public spaces, serving as a perceptual partition and, functionally, as a filter of tropical light and air. Sert described the Modulor "as a symbol and a promise," and its aspirational projection of social order shared in the utopian outlook that had defined Cuban vanguardismo since the beginning of the decade. His belief in both the universality of the modular system and its local history—"geometry is rooted in the Americas as far as we can trace the history of this continent"—neatly sums up the utopia of the Havana Plan and its spatial abstraction.[30] In applying the Modulor's proportions to the Plan Piloto, Sert envisaged Havana as an international metropolis, in a way realizing its erstwhile ambition to become the "New York of the Caribbean" and redefine an American sphere of influence. (By the mid-1950s, a more of-the-moment comparison may have been to Caracas, where Carlos Raúl Villanueva [1900–1975] was nearing the completion of Ciudad Universitaria, or to Brasília, just beginning to take shape under the direction of Oscar Niemeyer, Lúcio Costa, and Roberto Burle Marx). As in Caracas and Brasília (and in Sert's master plan for Bogotá and other "new city" projects in Brazil, Peru, and Venezuela), the ontological tension between the Modulor's universal, emancipatory formalism—corollary to the "American-type painting" proselytized by Clement Greenberg in New York—and the integrative (that is, nonautonomous) arts environment of Havana was left unresolved.[31]

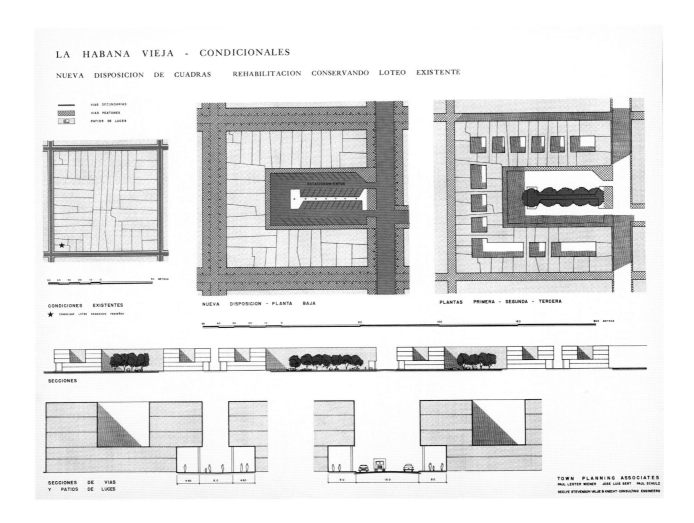

LA HABANA VIEJA - CONDICIONALES

NUEVA DISPOSICION DE CUADRAS REHABILITACION CONSERVANDO LOTEO EXISTENTE

FIGURE 54

Paul Wiener et al., Proposed Design Controls for Old Havana. Reproduced from *Plan piloto de la Habana: directivas generales, diseños preliminares, soluciones tipo* (New York: Wittenborn Art Books, 1959), 45.

The sublimations of Sert and Wiener's plan papered over the grim, politico-economic realities of Havana under the Batista regime, hardly unaffected by the financial motives of the administration but plausibly, as Hyde has argued, driven more by civics than by business. For Hyde, the Plan Piloto was ultimately "both an instrument of complicity, insofar as it would have accommodated and even assisted the unmitigated financial speculation of the period, and an instrument of regulation, in that it would have defined and delineated much of the physical outcome of that speculation in advance."[32] While the Plan Piloto remained an abstraction—a scaled-back version was completed in 1957 but not realized—its philosophical influence on Havana's de facto built environment was farther-reaching.

In its projected patterning of the city, the Plan Piloto rendered the city through a social design perfected on geometry, one in line with the proliferation of graphic,

stylized abstraction—recall the photo-spread, "Havana Grows and Modernizes"—as quasi-official art. Geometric abstraction was not only a civic but, increasingly, also a corporate style, and the diffusion of International-style architecture and abstraction alike spread across public and private buildings from central Havana to Vedado and Miramar. The salient point, in regard to the artistic vanguardia, was the supply of new commissions and, with them, the experimental space in which to test out different models of arts integration (the latter, long a hobbyhorse of Hugo Consuegra and Arquitectos Unidos). The 1950s witnessed a limited reprise of muralism, carried over from 1930s-era experiments in nation building, as well as a number of site-specific commissions that further reiterated the all-over abstraction of the city, rendered not only in spatial but also in visual terms. The overlay of geometry as a socially constructive design was notably mirrored in the contemporary disposition toward concrete art, but the civic origins of aesthetic integration and cubanidad also reflected a parallel trajectory within American avant-gardism and the continued, local presence of social realism.

Muralism had first developed in Cuba around the time of the historical vanguardia, with whom it shared a concern to articulate "lo cubano" in modern art.[33] "The influence of Mexican muralism was felt in Cuba for the first time by 1930," according to the artist Orlando Suárez (1926–1986), and the movement's orientation toward the Mexican school not only countered the francophilia of the Generation of 1927, but also established a link to the most visible and innovative (Latin) American avant-garde of the decade.[34] David Alfaro Siqueiros visited Havana in 1943, painting a mural in the home of Carreño (soon after dismantled), but the movement struggled to gain traction even with the support of the Batista presidency (1940–44).[35] The Second Republic sought to "repeat the post-1902 process of institutionalising its avowed nationalism," Antoni Kapcia has observed, noting that "this was especially the case under Batista after 1940, when he explicitly sought to emulate the Mexican nation-building exercise under José Vasconcelos by creating a range of new cultural bodies and encouraging the study of history, even chairing the inaugural session of the 1943 Segundo Congreso Nacional de Historia."[36] Batista's cultivation of cultural nationalism produced uneven results in the 1950s, seen in the mixed reception of the INC and ironically, in retrospect, in its association with "international" abstraction. Still the revival of public works, coming even at the cost of the artists' silence, marked a peculiar, if imperfectly cubanista intervention within the public sphere. For artists like Suárez and Carmelo González, the Mexican model remained a touchstone throughout the 1950s, sustained by regular travel to study firsthand the techniques of "Los Tres Grandes"—Diego Rivera, Siqueiros, and José Clemente Orozco.[37] No doubt, too, the applied "Integración Plástica" of Mexico's Ciudad Universitaria (Universidad Nacional Autónoma de México), designed by architects Mario Pani (1911–1993) and Enrique del Moral (1906–1987) and completed in 1954, served as a contemporary point of reference.[38] Monumental murals by Juan O'Gorman (1905–1982), Siqueiros, and Rivera, among others, honored Mexico's cultural patrimony

FIGURE 55

"Anticipo a 'El México de Diego,'"
Nuestro Tiempo 4, no. 15 (May–
February 1957): 1.

and national history from pre-Hispanic times to the postrevolutionary present, embodied in the ideals of public education. In particular, the sensibility of Siqueiros' contribution, a dynamic example of his hybrid "esculto-pintura" subtitled "Por una cultura nacional neohumanista de profundidad universal" [For a national, neohumanist culture of universal depth], tacked suggestively with the contemporary discourse in Havana. News of Rivera's return to Mexico, following treatment for cancer in the Soviet Union, graced the cover of *Nuestro Tiempo* in 1957, illustrated with details of hands—in stocks, with a knife, of prisoners and slaves—from his murals at the New Worker's School in New York (fig. 55).[39] The dramatic foreshortening, stylized realism, and didactic message of postrevolutionary murals such as *Martí de la libertad, justicia y amor* and *Conceptos martianos sobre economía y comercio* are characteristic of local adaptations of the Mexican model. But for the historical vanguardia (including a few onceños, working under the radar), the medium of mural painting offered an extraordinary opportunity to test out ideas of aesthetic integration and the shape of utopian praxis.

The murals commissioned for the Esso Standard Oil Company building were an early indicator of the new prominence of public art and the possibilities opened therein to the vanguardia. To inaugurate its new building in Vedado, the Esso Company invited seven Cuban artists, chosen in consultation with the Ministry of Education, to contribute a mural to each of the building's floors (fig. 56). Their selections reflected a conservative position, even for the time: four of the historical vanguardia (Wifredo Lam, Amelia Peláez, René Portocarrero, and Carlos Enríquez) and three academics (Jorge Rigol [1910–1991], Carmelo González, and Enrique Moret). Gastón Baquero criticized the selection as anachronistic, suggesting that what had constituted a "revolutionary position" in 1928 or 1930 no longer sufficed; in particular, he faulted Enríquez, whose mural was an ill-conceived adaptation of a painting, and the imitative "*mexicanada*" of Rigol.[40] Certainly, the Mexican-sourced social realism of the 1920s and 1930s seemed mannered in mid-century Havana (and incongruous on the walls of a U.S. oil company). More prognosticative of the decade to come was the contribution of Lam, the only mural to engage the architectural space of the building and a clear departure from the decorative and didactic pictorialism of the other works. The all-over effect of *Fresque*, which spanned the wall from floor to ceiling, "fulfill[ed] the essential role of a mural," Mañach

FIGURE 56

"La ESSO estrena el mural cubano," *Gente* 3, no. 8 (February 25, 1951): 17. Clockwise from top left: Carlos Enríquez; Carmelo González; Amelia Peláez; Wifredo Lam; René Portocarrero; Jorge Rigol.

wrote approvingly, "which is to complement the architecture, to deepen and broaden its severe space, to open walls as if to reveal a fourth dimension."[41] The innovation of Lam's design lay in its activation of the full space of the room from the doorway in the center of the wall to the triangular plane at the bottom of the composition, which insinuates a passage beyond the two dimensions of the wall. Oversized, disembodied renderings of Lam's iconic *femme cheval*, the horse-headed female avatars of the Santería cult, hover menacingly in the shallow space of the painting, their flying arrows aimed steadily at the doorway and, thus, at those who crossed its threshold. *Fresque* adapted the cinematic experience and visual impact of the Mexican prototype through a modernist formal

vocabulary—flattened geometric shapes, reduced palette, synthesized abstraction. Lam's mural for the Esso building anticipated his greater acclaim in Cuba over the next decade, a period that saw his work experiment more with formal reduction as he turned his critical interest toward his relationship to Cuba.[42]

Lam's reconnection with Cuba brought him back within the orbit of the vanguardia, and his example of international and activist avant-gardism—cubanista avant la lettre—staked out an important position in the decade's debates over abstraction and "national" art. Although he established a permanent residence in Paris in 1952, Lam maintained his home in the Havana suburb of Marianao, using it as a base for travel to Mexico and Venezuela; his comings and goings—sometimes in the company of Guido Lollabrigida, an actor and the brother of the Italian actress—were covered with great fanfare by the local press. Inasmuch as his celebrity stature estranged him from many of the Havana School who resented his success and still begrudged his absence from the major Cuban show at New York's Museum of Modern Art (1944), his personal distance from the elder-generation vanguardia may have brought him closer to the onceños, whom he served as an informal mentor. Lam was more publicly reticent on the political question than the onceños, but his cynicism came across in a 1954 interview with Carlos Franquí (1921–2010), a left-wing journalist and later liaison between Lam and the Castro government. "I believe my paintings reflect our life," Lam explained, "our complexes and the idiosyncrasies of our people . . . the lack of integration between our economic situation and our psychology . . . the cacophony that characterizes our common condition. . . . There is no equivalent for the well-known phrase '*no hay problemas*' in my paintings. There are, yes, problems in them."[43] Lam's work became "more syncretized and internationalized" over the course of the 1950s, Lowery Stokes Sims has suggested, characterized by a schematic, spare angularity and use of geometric pattern; the "secularization" of Afro-Cuban content and an occasional, trenchant title—*We Are Waiting* (1958), *La Sierra Maestra* (1959)—hint at his discontentment with the Batista regime.[44] The visual distillations carried over to two architectural murals of mid-decade, one at the Centro Médico in Vedado (fig. 57) and the other for the Botanical Garden in Caracas, designed by Villanueva. Executed in black-and-white tiles imported from Italy, the Havana mural's rhomboid and triangle shapes command the space of the double-story vestibule, the aggression of sharply tapering points directing compositional energy from corner to corner, the negative space as charged as the black forms. Also seen in *Umbral* (1950) and *Pasos miméticos, II* (1951), the familiarly elongated lozenge shapes at center summon rich, and wide-ranging iconographic traditions: the four-pointed orbit of the soul in West and Central African culture; the classical elements (fire, air, earth, water); the symbology of both Abakuá (*ñáñigo*) and European Masonic traditions.[45] Yet simplified here within an angular geometry of black and white, Lam's mural resists easy allusion, its universality as easily allied to the purely formal properties of the triangle—doubled, inverted, insinuated—in space. Indeed, Sims has remarked that the Caracas and Havana murals are

FIGURE 57
Wifredo Lam, *Mural*, 1955.
Ceramic tiles. Centro Médico,
Vedado, Havana.

exceptional within Lam's work for their distance from Afro-Cuban iconography, and his adoption of a geometric idiom in Havana should be seen as intentional and responsive to the city's changing urban and artistic culture.[46] At the corner of Calle N and the major east-west artery La Rampa, the mural was positioned at the hub of the modernizing city, only a block away from both the Hotel Capri (1957) and the Hotel Habana Hilton (1958).

Designed by Welton Becket and Associates with the Cuban firm Arroyo and Menéndez, the Habana Hilton stood at the epicenter of the city's modernizing movement when it opened in March 1958: the tallest hotel in Latin America, it became an instant landmark, spreading across a city block beneath low-rise, cantilevered roof structures at its base and ascending to twenty-seven stories. Works were commissioned from Lam, Rodríguez, and Portocarrero for various interior spaces, but the most iconic was Peláez's Venetian glass mosaic-tile mural, which stretches across the building's southwest facade (see fig. 97). Like Lam and others, Peláez experimented with a greater degree of abstraction in her work during the 1950s. Earlier murals, in addition to the Esso commission, include *San Juan Bosco* (1956), at the Casa Salesiana "Rosa Pérez Velasco" in Santa Clara, and the ceramic-tile *Abstracción* (fig. 58), installed at the former Tribunal de Cuentas in the Plaza Cívica José Martí (now the Plaza de la Revolución). The sinuous linearity of *Abstracción*, stretched across a lower-level structure attached to the main building, introduces a perceptual interplay between its flat-pattern, post-Cubist design and the building's Corbusien brise-soleil, whose interlocking, horizontal rows articulate its facade. But in the florid lyricism and undulating color of *Las frutas cubanas*, Peláez arrived at the apotheosis of modern Cuban art. The hibiscus, a leitmotif in her work, is deconstructed within a rhythmic pattern of thick lines and kinetic color, rendering an overall effect of

FIGURE 58

Amelia Peláez, *Abstracción*
(mural), 1953. Ceramic tiles.
11.5 × 65.6 ft. (3.5 × 20 m).
Tribunal de Cuentas (now,
Ministerio del Interior),
Havana.

color set in continuous motion; the flicker of light across the original surface imparted a shimmering optical effect, transforming the stained-glass vitrales of colonial-era Havana into a modernist mirage. A virtual billboard for the patterned city of Sert and Wiener's design, Peláez's mural inscribed abstraction into the heart of modern Havana, merging the whole of the preceding vanguardia tradition with the totalizing vision of tropical utopia.

If the Esso building and the Habana Hilton bookended the epiphenomenon of modern muralism, the conceptual "patterning" of the city through abstraction cut across different media and encompassed both private and public spaces in the intervening years. Notable examples from the elder-generation vanguardia include Ravenet's *Colonial*, in the Focsa building, and Rodríguez's *Boomerang*, installed in the Centro Médico (in a different lobby than the Lam mural). The third-generation vanguardia had fewer opportunities, on account of politics and seniority, but a handful of younger artists were able to experiment with abstraction on a large scale. Fernández's inside-outside mural for the Colegio Nacional de Arquitectos, for example, insinuates a darker bloom than Peláez's luminous tropicalia, its distended, proto-Surrealist forms unfurling across a grid of square tiles (fig. 59). Moving mostly in different circles than the onceños, Fernández exhibited in New York in the later 1950s (Duveen-Graham Gallery, October 17–November 5, 1955; Condon Riley Gallery, November 24–December 13, 1959); a promising early painting, *Still Life and Landscape* (1956), entered the collection of the Museum of Modern Art.

Rolando López Dirube, like Fernández of Los Once's generation but independent of the group, worked in a quasi-Constructivist mode of abstraction shaped by his training as an architect. Following study in New York at the Art Students League and the Brooklyn Museum School (1950–51), he applied himself to murals and site-specific

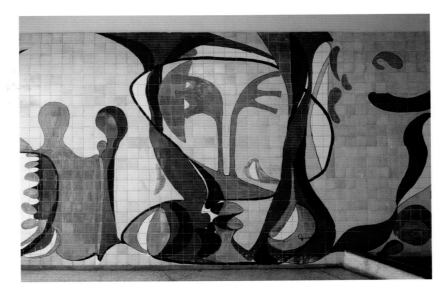

FIGURE 59

Agustín Fernández, *Mural* (detail),
1957. Ceramic tiles. 45 ft. (13.7 m).
Colegio de Arquitectos e
Ingenieros, Havana.

FIGURE 60

Rolando López Dirube, "Escultura
en la terraza de una residencia,"
c. 1950s. Reinforced concrete.
42.7 × 4.9 ft. (13 × 1.5 m).
Architects Sabater, Salmán &
Sánchez.

sculptures.[47] Notable commissions include the Hotel Habana Riviera (1957), where he designed a metal-and-stone mural just off the lobby and a bilevel sculpture around a spiral staircase; Ciudad Deportiva (1958), to which he contributed eight murals on the subject of sports, rendered through Cubist-Futurist figures; and the monochrome sculpture at the entrance to the Instituto de Cardiología y Cirugía Cardiovascular in Vedado, among his most minimal works. For a private residence, he installed a sculpture of rein-

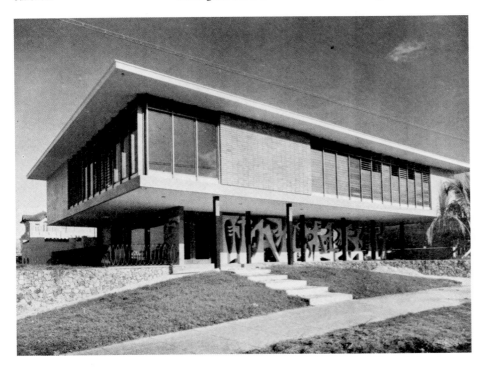

forced concrete on a ground-level terrace, the biomorphic forms appearing almost as modernist caryatids, their dynamic, Picassian shapes breaking the geometry of the flat roof and regularly spaced piloti (fig. 60). From the athlete to the playful biomorph, López Dirube's iconography underscored the humanism of his practice, articulated in his vision to "procure for man a proper standard by which to live his life"—words that recall Modular Man and the human scale of the Plan Piloto.[48] He spoke at the time of his desire to

"*cotidianizar*," or habituate, a form of integration shaped by "environmental, cultural, and economic factors, technical expertise and the joint initiative and sensibility of the architect and artist-collaborator."[49] A catchword in contemporary urban and architectural discourse, "integration" was also a profoundly *cubanista* conceit and one expanded upon by Consuegra, in particular, toward the end of the decade.

Sidelined from public works projects and past the point of losing their proprietary (anti-batistiana) hold on abstraction, the *onceños* could only look on as geometric abstraction became, mutatis mutandis, the corporate style of the Batista regime. Of necessity, Los Cinco considered arts integration mostly at the level of theory, rather than of practice, but in one case they were afforded the opportunity to design an "integrated" space of their own. At the restaurant La Roca in Vedado, just blocks from the Habana Hilton, mural paintings by Guido Llinás and Raúl Martínez and sculptures by Tomás Oliva represented what Consuegra deemed "the first large-scale experiment" of its kind in 1957.[50] A site-specific mise-en-scène, the commission (no longer extant) provided a testing ground for the use of technology in the service of "a form of expression . . . that gives the measure of our time."[51] La Roca was ultimately a one-off project, but in the moment it gave Los Cinco some small purchase within the modern mural movement and a footprint in Vedado. It was not meant to be polemical, in the spirit of their exhibitions; exploratory in nature, the project pitched itself to the future, channeling the constructive capacity of abstraction to build a kind of techno-humanist utopia (or, an ultimate integration of art and life).

SALON, ANTI-SALON

While the rise of muralism represented a new, public paradigm for abstraction, survey exhibitions continued to provide a referendum on Cuban modernism and the mainstreaming of abstract art. Two major shows held at the beginning and end of 1956—a tribute exhibition to Guy Pérez Cisneros and the *VIII National Salon*—further demonstrated the ascendance of abstract art across the board, in a way mirroring contemporary directions in architecture and urbanization. (A third exhibition that year, *Pintura de hoy: vanguardia de la escuela de París*, introduced international concretism to Havana for the first time.) A certain parallelism exists between 1954 and 1956: in both years, a memorial exhibition (Martí, Guy Pérez Cisneros) inclusive of all three vanguardia generations was followed by a state-sanctioned survey (Bienal, Salon), met swiftly by a protest-exhibition. *Plus ça change?* Abstraction appeared a moot argument in the immediate wake of Los Once's disbandment, but the artists and the state labored through essentially the same motions in 1956.

Exposición homenaje en memoria de Guy Pérez Cisneros opened at the Lyceum on January 12 with works by fifty-five painters and sculptors representing a broad spectrum of modern Cuban art. A diplomat and respected art writer, Pérez Cisneros had been a

prominent advocate for the historical *vanguardia* in the 1940s; his *Pintura y escultura en 1943* and posthumously published doctoral dissertation, *Características de la evolución de la pintura en Cuba*, were among the first attempts to periodize the development of Cuban art.[52] The brief catalogue introduction described the exhibition as an "imaginary 'salon,'" built around the canon of artists he had supported over the past thirteen years.[53] A better synopsis of current art than the year-end Salon, the exhibition provided a meaningful forum for the ostracized *onceños*, who were well represented: Francisco Antigua; Servando Cabrera Moreno; Cárdenas; Consuegra; José Antonio Díaz Peláez; Llinás; Martínez; Oliva; Zilia Sánchez; Juan Tapia Ruano; Antonio Vidal. From the rhythmic, rippling effect of Amelia Peláez's *Mujer con abanico*, whose pattern unfurls from the eponymous woman at the center to the canvas edge, to the floating, translucent layers of Martínez's *Azul blanco* (fig. 61) that percolate in the shallow space of the painting, the ubiquity of abstraction was all but a given. Adela Jaume noted "an almost complete abandonment of representational art" and warned of the exhibition's "disconcerting uniformity"; Marquina slipped in an oblique dig at the "outmoded propensity for abstract art."[54] The latter was otherwise at pains to emphasize the plurality of the exhibition, though his commentary oscillates between satisfaction in the reassuring familiarity of the show and misgivings about its predictive value.[55]

While the stridency of the *onceños* was subdued on the occasion of the Pérez Cisneros memorial, it was plainly back to politics as usual by the end of the year. The

VIII National Salon opened on November 28 at the Palacio de Bellas Artes; the Anti-Salon or the "Salon Across the Street" (officially, the *Exposición de pintura y escultura contemporánea*) opened one month later.[56] The embarrassing counter-exhibition aside, the Salon was beset by internal problems, from the much-maligned decision to eliminate the drawing and engraving categories to inveterate charges of partiality and middling artistic quality. The jury of Rita Longa, Alan McNabb, and Eduardo Abela (the latter honored with an individual exhibition of forty-one works within the Salon) awarded the top prizes to Portocarrero and Roberto Estopiñán, distributing others among many of the abstractionists (Antigua, rewarded for his breach with the onceños; Jorge Camacho; López Dirube; José M. Mijares). The predominance of abstraction was thoroughly unremarkable by this time and registered little on the critical radar. The reviews alluded instead to the politicking behind the exhibition, with veiled reference to the absence of the boycotting artists and the sham cultural governance of the regime. "The first thing one notices in the *VIII Salon* is the conspicuous absence of certain outstanding personalities of our classical and modern painting," Ramón Loy observed, "artists whose participation would have been a positive contribution to the exhibition."[57] Marquina was among the apologists for the Salon, shifting the blame to the absentee artists and admonishing their unwillingness to accept an opportunity to rectify prior wrongs.[58] Loló de la Torriente took a long view of the Salon and encouraged her readers, "hate Zéndegui or not," to celebrate Cuba's national patrimony as their own and to remember that the works of art were not only independent of the state, but all but sure to outlast Batista's tenure as well. In due course, she concluded, the public would be able to admire how, "in such difficult moments, in an epoch so unsettled and in moments of so much rivalry and intrigue," Cuban artists nevertheless carried on, "working, without present reward, for the future."[59] For the beleaguered onceños, the future was already the present, and they rallied in protest of the Salon at the Cuban Association of the Congress for Cultural Freedom (Asociación Cubana del Congreso por la Libertad de la Cultura), a venue literally across the street from the Palacio de Bellas Artes.[60]

Organized by Manuel Couceiro (1923–1981), a veteran of the Anti-Bienal and a member of the underground 26th of July Movement, the Anti-Salon opened on December 21. Taking its cue from the Anti-Bienal in 1954, the Anti-Salon publicly denounced the failures of the *VIII Salon* and the INC to cultivate the arts and to create an economic environment hospitable to working artists. The signatories of the accusatory "Declaration of Principles" included the onceños José Y. Bermúdez, Cabrera Moreno, Consuegra, Díaz Peláez, Llinás, Martínez, Julio Matilla, Oliva, Tapia Ruano, Antonio Vidal, and Manuel Vidal. Víctor Manuel and Marcelo Pogolotti alone of the first-generation vanguardia added their names; their allegiance with their younger peers against the regime was a public blow to the INC and a certain coup for the onceños.[61] Mimeographed copies of their "Declaration" were distributed at the Anti-Salon, and the full text was distributed with the January 1956 issue of *Nuestro Tiempo*, one of fewer and

fewer independent print outlets. The litany of grievances aired against the state mostly targeted the nature of jury prizes at the Salon, calling out their arbitrariness, scarcity, and overall inefficiency in serving the country's artists. Needless to say, the majority of the protesting artists stood little chance of receiving a Salon prize on account of their political pasts, a point raised by their naysayers. But all caviling aside, the call for greater transparency, better programming, and a clearer national vision was a shrewd riposte to the Salon.

Although no record remains of the works shown at the Anti-Salon, the composition of the exhibiting artists suggests that gestural abstraction figured prominently. The catalogue cover was dominated by a jagged blot of dripped and splattered paint—a deliberate reinforcement of the alliance between gestural abstraction and oppositional politics and in clear contrast to the geometric modularity of "official" culture. The Anti-Salon regrouped nearly all of the original *once* and, in much the same way as the Anti-Bienal before it, reprised the exhibition-as-manifesto mentality that had girded the group since its beginnings.[62] The protest resonated hardly at all in the mainstream media, under de facto censorship, and elicited nothing of the local or international response that had elevated the Anti-Bienal to a cause célèbre. And yet the fact of the Anti-Salon—its very possibility and implausible execution—confirmed the forcework of the Anti-Bienal, backing up its transformative potential through the repetition of its original action. In this regard, the platform provided by the Congress was not only geographically desirable, on Calle Zulueta, but also politically astute. Constituted in West Berlin in 1950, the Congress for Cultural Freedom was an anticommunist operation active across the Western world with significant support, as was later revealed, from the CIA. The Havana outpost opened in August 1955 through the efforts of Julián Gorkin, a veteran leader of the Spanish Marxist party (POUM), and the Peruvian literary historian Luis Alberto Sánchez; the local board included, among others, President José Manuel Cortina, an elder statesman known for his work on the 1940 Constitution of Cuba; First Vice President Jorge Mañach; and Rosario Rexach, director of the Lyceum.[63] The Cuban Congress struggled to launch a program in the wake of the Anti-Salon on account of the increasingly repressive political environment triggered by an abortive attack on the Presidential Palace in March 1957, and it paused operations in early 1957 as many of its board went into exile (Mañach, among others). The onceños likewise kept a low profile over the last two years of the Batista regime. Their last public statement in Cuba, the Anti-Salon signaled both the group's dogged resistance to dictatorship and, more subtly, its recognition of the inter-American and transatlantic crosscurrents in which its work traveled.

VANGUARDIA GAMBITS AND ABSTRACTION ABROAD

The politics of inter-American cultural diplomacy ramped up during the Second World War, casting a persistent shadow on the relationship between Cuba and the United States projecting well into the 1950s. Cuba had entered the war on the side of the Allied forces in 1941, and amid broad promotion of Pan-American solidarity there arose unprecedented opportunities for artistic exchange. The Pan-American Union lent promotional support to the 1939 New York World's Fair, for example, showing a twenty-by-thirty-foot "Illuminated Map of the Pan American Republics" in its pavilion—highlighting steamship lines and natural resources—while also playing up each country's tourist interests (for example, Brazilian coffee, Argentine and Chilean wine).[64] In much the same way that the vogue for Mexico had characterized the 1920s and 1930s, cultural curiosity about Cuba began in earnest by the time of the fair, where the Cuban Village attracted notoriety for "scandalous" dances (the outlawed *ñañigo*) and the "Miss Nude of 1939" contest, much to the chagrin of Cuban officials left with little recourse against the American promoter Harry Dash.[65] A more auspicious cultural introduction was provided by forty works chosen from vanguardia artists including Longa and Ramos Blanco, which were simultaneously on display at the Riverside Museum (New York), as part of the *Latin American Exhibition of Fine and Applied Art* (June 2–September 17, 1939). Subsequent forays of Cuban art abroad were facilitated by the Inter-American Office at the National Gallery of Art and the personal efforts of Gómez Sicre at the Pan-American Union. As Royal Cortissoz noted in his review of the landmark exhibition *Modern Cuban Painters*, which opened at New York's Museum of Modern Art on March 17, 1944, "The good-neighbor policy which means so much in the domain of statesmanship means something also in the field of art."[66] Organized by Alfred H. Barr, Jr. and Gómez Sicre, *Modern Cuban Painters* broke the ice for the vanguardia, and its endorsement of that generation—thirteen artists, including Diago, Enríquez, Rodríguez, Martínez Pedro, Peláez, Ponce de León, Portocarrero, and Víctor Manuel—was (and remains) a point of national pride.[67] The expressive modernity of Cuban art was set in deliberate counterpoint to the socialist undertones of Mexican muralism, at the time the best-known art movement in Latin America (and since Diego Rivera's 1931 retrospective, well supported at MoMA). "There is little obvious regional and nationalistic feeling," Barr wrote in the catalogue, noting that "the Cuban painters are too much concerned with painting as a personal art of form and color to surrender their individuality to a collective enterprise with political implications."[68] The exhibition was accompanied by the publication of Gómez Sicre's *Pintura cubana de hoy*, the first survey text of Cuba's modern movement, and following its seven-week run in New York it went on tour for two years throughout the United States.[69]

The timing of the exhibition, held at a moment when the war had begun to turn in the Allies' favor, naturally raised questions about the museum's continuing interests in Latin American art. In internal correspondence about the exhibition, Barr stressed his concern to continue inter-American cultural interchange after the war, albeit through

more modest and less paternalistic means. "The Latin Americans are no fools and have looked forward cynically to the gradual collapse of the Good Neighbor Policy, at least on the cultural level," Barr acknowledged, and while he appears to have envisioned a more active role for private institutions, in the Cuban case subsequent promotional efforts were largely coordinated under the auspices of the U.S. government.[70] Exchange exhibitions of Latin American art were officially encouraged as a channel of cultural diplomacy over the following decade. Hector de Ayala, Cuba's ambassador in Paris, was explicit (and aspiring) on this count, imagining Cuban art—"a decisive factor in the mutual understanding of peoples and in the formation of a true universal conscience"—coming to the major European capitals.[71] Before the end of the decade, exhibitions of Cuban art were officially mounted for the first time in Port-au-Prince (1945), Moscow (1945), Mexico City (1946), Buenos Aires (1946), and Stockholm (1949).[72] The artworks exhibited were drawn from both Cuba's vanguardia and academic schools and, *pace* Barr, mostly typical examples of the vernacular and florid tropicalismo that characterized the Havana School.

While MoMA and the United States retained an active, though covert hand in the promulgation of modern art across the Americas, the museum did not prominently feature Latin American art again in New York over the next decade and a half, as Barr had anticipated.[73] The slack was taken up by the Visual Arts Section of the Organization of American States in Washington, D.C., whose exhibition program featured Cuban artists on twenty-one occasions between 1945 and 1959.[74] Overseen by Gómez Sicre, named Chief of the Visual Arts Section in 1948, the exhibitions afforded meaningful opportunities in the United States; during his tenure, a stop in Washington and a show at the OAS became de rigueur for artists traveling from Latin America to New York and Europe. Solo exhibitions featured a range of second- and third-generation vanguardia artists: *Felipe Orlando* (1947); *Cundo Bermúdez* (1948); *Luis Martínez Pedro* (1951); *Roberto Diago* (1953); *Agustín Fernández* (1954); *Hugo Consuegra* (1956); *René Portocarrero and Raúl Milián* (1956); *Jorge Camacho* (1958); and *Servando Cabrera Moreno* (1959).[75] Notable among the group shows is *7 Cuban Painters: [Cundo] Bermúdez, Carreño, Diago, Martínez-Pedro, Orlando, Peláez, Portocarrero* (August 15–September 20, 1952), which opened at Boston's Institute of Contemporary Art and, like *Modern Cuban Painters*, traveled the country for two years. Gómez Sicre's brief introductory text declared these artists "concerned with expressing themselves in modern idiom, tending toward abstraction"; Leslie Judd Portner singled out Carreño's work for having "become more international, both in concept and in technique," noting that "his now wholly abstract compositions . . . seem to show little or nothing of Cuban influence."[76] While the exhibition just preceded the tidal wave of abstraction in Havana (and the firestorm around Los Once), its critical reception indicated the contemporary disposition toward abstract art, removed of nationalist sentimentality and assimilable within a new, Pan-American canon of modern art forming under the auspices of the OAS and MoMA.

The political nature of Gómez Sicre's position at the OAS and his "Cold Warrior" mentality during the 1950s are inseparable from his promotion of "international" modernism, a lingua franca at the time for hemispheric values of freedom and democracy. While his foundational, historiographical contributions to the field remain under-recognized, Gómez Sicre was among the first to champion "Latin American art" in broadly regional, rather than national terms, bringing aesthetics into line with concurrent development initiatives of the OAS, from the Good Neighbor Policy (1933–45) to the Alliance for Progress (1961–64).[77] His privileging of lyrical and geometric abstraction, set against the supposed "communism" of Mexican muralism and socialist realism, consecrated a new, inter-American generation that encompassed such artists as Carlos Cruz-Diez (Venezuela, b. 1923), Alejandro Obregón (Colombia, 1920–1992), Tomie Ohtake (Japan/Brazil, 1913–2015), María Luisa Pacheco (Bolivia, 1919–1982), Jesús Rafael Soto (Venezuela, 1923–2005), and Fernando de Szyszlo (Peru, b. 1925). Unsurprisingly, Gómez Sicre encouraged the "internationalization" of Cuban art, both in style and through exhibition practices, and his continued influence (and interest) in Cuba—through the person of Carreño and others—enhanced the vanguardia's exposure abroad. Martínez Pedro and Darié figured prominently, for example, in the "Cuba" section of the OAS gallery installed in Caracas on the occasion of Tenth Inter-American Conference (fig. 62), a meeting notable for its declaration that "international communism, by its anti-democratic nature and its interventionist tendency, is incompatible with the

FIGURE 62

Photo of Cuba installation, Tenth Inter-American Conference, Caracas (1954).

concept of American freedom."[78] The conference transpired against the backdrop of Carlos Raúl Villanueva's Ciudad Universitaria, a modernist paean to arts integration and its Constructivist utopia, whose just-completed Plaza Cubierta (Covered Plaza) served as the setting for the conference. Concurrent satellite exhibitions sponsored by the Museo de Bellas Artes de Caracas and New York's Museum of Modern Art reinforced the rhetorical elisions between abstraction and Cold War liberalism, epitomized by Alejandro Otero's progressively geometric *Cafeteras* series and *Six American Painters*, led by Jackson Pollock's classic drip painting *Number One* (1948).[79]

Gómez Sicre's support for Cuban artists extended beyond the OAS, and he served as a conduit between artists

and private galleries and, similarly, between the INC and U.S. institutions.[80] The group show *Cuban Tempos*, for example, a collaboration between Zéndegui, Gómez Sicre, and the American Federation of Arts, exhibited work by a number of third-generation artists—among them, Consuegra, José Y. Bermúdez, and Martínez—in venues across the United States.[81] (This promotional tour evokes, at a small scale, the earlier, interwar attention paid to Mexico under the Good Neighbor Policy and the cultural diffusion of Pan-Americanism from Washington, D.C., to California.) The inclusion of the onceños in an exhibition with ties to the INC may have rankled the artists, but Consuegra passes over any such tension in his memoir, remarking only on the delicacy of Gómez Sicre's situation at the Pan-American Union and the deteriorating political state of affairs.[82] *Awakening*, among his most clarified, restrained canvases from this period, graced the catalogue's cover (fig. 63). Against a familiar, tonal ground of free-form shapes, carefully

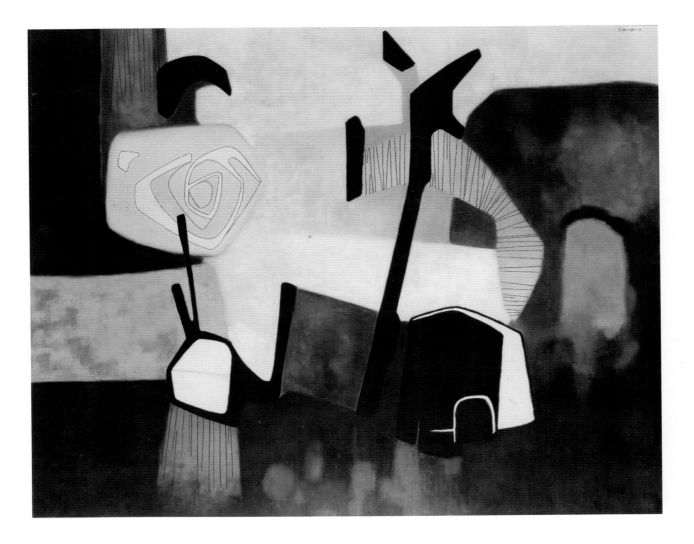

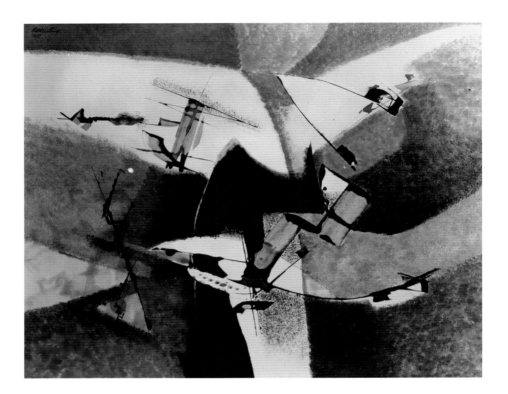

delineated forms emerge in space, their opacity crisply cohering the image in a subtle, suggestively rotational design. Martínez exhibited a small work characterized by a similar compositional structure: the blurry, patternized ink wash shows off the dexterity of a calligraphic black line that flows ragged and restive across the surface (fig. 64). In a similar vein, the seventeen-member Cuban delegation to the International Exhibition of the Caribbean, held in March 1956 at the Museum of Fine Arts, Houston, included four onceños—José Y. Bermúdez, Cárdenas, Consuegra, and Martínez—alongside artists from the elder vanguardia generations.[83] A student of Diago in 1952–53 but otherwise self-taught, Bermúdez had left the onceños in 1953 to work with Gómez Sicre in Washington, from where he continued his practice. Like others of the onceños abroad, from Díaz Peláez in New York to Cárdenas and Jamís in Paris, his work took a clear Surrealist route toward nonobjective forms, as Dore Ashton remarked in the *New York Times*, with references to witchcraft and mythology.[84] The textured surface and pieced-together forms of *Pastiche* are indicative of Bermúdez's contemporary collages and assemblages (fig. 65). Sedimentary layers of fiery, ruddy shapes press upward against a dark gray horizon, which bears down with both impasto and thinned streams of paint. That telluric sensibility—of the land erupting in no less than the colors of the Revolution—calls to mind contemporary work by Consuegra (for example, *Entrada en la tierra* [1958]) and Antonio Vidal.

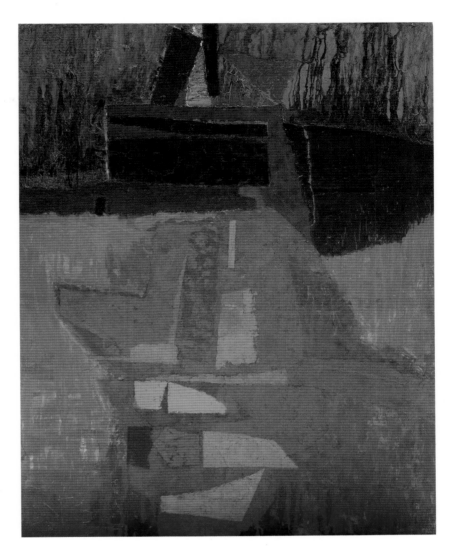

FIGURE 65

José Ygnacio Bermúdez, *Pastiche*, 1959. Oil on canvas. 57⅜ × 45 in. (148.3 × 114.3 cm). Private collection, Coral Gables, Fla.

For both the elder-generation vanguardia and the onceños, private galleries played an important role in keeping modern Cuban art almost continually in the public eye and, moreover, in dispelling the outmoded stereotypes of the tropical vernacular. The most reliable outlets by the latter half of the 1950s were in the United States (to a lesser extent, in Venezuela and western Europe).[85] Two uptown galleries in New York—Galería Sudamericana (866 Lexington Avenue) and Roland de Aenlle (59 West 53rd Street)—were particularly favorable to Cuban and Latin American artists during the 1950s, but they were by no means the only ones. Galería Sudamericana, owned by the Chilean writer and wartime journalist Armando Zegrí (1899–1972), faithfully supported Latin American artists throughout the decade; among its Cuban protégés granted solo shows were Mirta Cerra (1955), Carmen Herrera (1956), Enrique Riverón (1957), and Emilio Sanchez (1958).[86] Roland de Aenlle also championed Cuba's abstractionists, giving exhibitions

to Consuegra (1957), José Y. Bermúdez (1958), Díaz Peláez (1959), and Orlando (1957, 1960). The international aesthetic that characterized official exhibitions carried over to the galleries, which exhibited abstraction across generational lines. Cubans had "shaken off their 'regional' tendencies and are joining the international movement toward abstraction with distinctive work," Dore Ashton wrote of a group exhibition in 1956.[87] Stuart Preston voiced similar sentiments a few months later, in words that could hardly have been more validating to the vanguardia (and too, the INC): "Modern Cuban painting, as represented in the well selected small exhibition at Galería Sudamericana . . . seems to be much like modern painting the world over. In other words, it is largely abstraction of varying kinds and degrees. A general addiction to bold, bright color and unambiguous design is apparently the only bit of recognizable national flavor."[88] The exhibition in question was expressly planned to "popularize the work of Cuban painters in the United States," according to W. Scott, Chairman of Cubana Airlines, which cosponsored the show with the INC.[89] It followed on the heels of the Los Cinco's success at the same venue, a precedent cited by Zegrí no doubt to the chagrin of Zéndegui and the INC in preexhibition publicity.[90]

Even as the vanguardia began to establish a public and a market in the United States, artists turned a hopeful eye toward Europe and South America at the start of the 1950s. The watershed event was the exhibition *Art cubain contemporain*, which opened in February 1951 at the Musée National d'Art Moderne and marked the full-circle return of the vanguardia to Paris a quarter-century after the Generation of 1927 had begun to arrive. Hector de Ayala noted in his preface to the catalogue that Cuban art could boast a modern tradition fully commensurate with its Euro-American peers, and the selection committee concluded that Cuba's artists were indeed no longer "*criollos.*"[91] Organized by Loló Soldevilla, the exhibition included twenty-seven painters and sculptors drawn from the three vanguardia generations; although mostly historical in character, the exhibition drew praise for work by two up-and-coming geometric painters—Herrera and Wifredo Arcay—based in Paris.[92] Ayala later established a permanent gallery at the embassy to facilitate the circulation of Cuban art throughout Europe; the buildup of a repository of works (fifty-five, to start) was designed in part to expedite submissions to major fairs and exhibitions (*Salon des Indépendants*, *Salon d'Automne*, etc.).[93] Cuba's invitation to participate in the *XXVI Venice Biennale* (1952) marked another European milestone of this kind, although the installation failed to generate the same excitement as the debut of Mexico—represented by Rivera, Orozco, Siqueiros, and Rufino Tamayo—two years earlier. Cuba was not able to build its own national pavilion, and its submission—twenty-three characteristic works by fifteen vanguardia artists—was installed in a space appointed by the Biennale.[94] The artist who gained the most personally from the Venice Biennale was Martínez Pedro, who subsequently held solo exhibitions in Venice and Milan; he showed throughout West Germany and had greater European exposure than any other vanguardia figure at this time (excepting, perhaps, Lam and Cárdenas in Paris).[95]

In both Venice and São Paulo, where Cuba sent delegations coordinated by Gómez Sicre in 1951, 1953, and 1955, the curatorial selections privileged the vanguardia and, within that cohort, works that trended toward an "international" aesthetic.[96] "If there is a defining characteristic of Cuban art today, it is the absence of provincialism," Gómez Sicre remarked of the artists exhibited at the *II São Paulo Bienal*. "There is a constant echo of universal movements, a reverberation of solutions and directions from many places." He rejected the notion that Cubans wore international modernism "like a borrowed suit," and the progressive incorporation of younger artists—Estopiñán and López Dirube in 1953; Arcay in 1955; Cabrera Moreno, Camacho, and Fernández in 1957 (chosen by Zéndegui)—mirrored the curatorial program and permanent collection that he was simultaneously assembling at the OAS.[97] The origins of the Bienal, at the hand of the industrialist Francisco "Ciccillo" Matarazzo with the support of MoMA and Nelson A. Rockefeller, are of course inextricable from the hemispheric politics of the time, as generations of revisionist scholarship have made clear.[98] But without digressing into the Cold War history of U.S. interests in Latin America, suffice it to note here that the Bienal—the second of its kind, after Venice—marked a geopolitical power play within the history of modern art. The Bienal upended the canonical Euro-American paradigm, proposing in its place a southern axis running through the Americas and, with it, an alternative evolutionary narrative of the postwar international avant-garde. The early disposition toward geometric abstraction, telegraphed by the prizes awarded to the Swiss Constructivist Max Bill (1908–1994) and the Brazilian concretist Ivan Serpa (1923–1973) in 1951—and to Martínez Pedro, for *Jardín imaginario I* at the *II Bienal*—dovetailed with the contemporary aesthetics of modernization and utopia, which colored development not only in Havana, but from São Paulo to Caracas, Bogotá, Buenos Aires, and beyond.[99] For the Cuban vanguardia, the opening of an avant-garde network to the south provided a useful counterpoint to the long-dominant North American horizon. Not coincidentally, Gómez Sicre drew parallels between Cuba's Generation of 1927 and Brazil's "Semana de Arte Moderna" (Week of Modern Art) in 1922 in his accompanying text to the Cuban entry to the *I Bienal*.[100] His mindfulness to constantly locate Cuba within inter-American artistic networks proved most beneficial to Los Diez, half of whom sent work to São Paulo in the 1950s, but even the erstwhile onceños—excluded from the Bienal until the selection of Llinás, Martínez, and Sánchez in 1959—profited indirectly through Cuba's expanded exposure to inter-American networks.[101]

Cuban abstraction, promoted as the "North American style," traveled to Caracas through the dealer and critic Florencio García Cisneros (1924–1999), who organized exhibitions at his own Galería Sardio and at the Asociación Venezolana de Periodistas (AVP) toward the end of the decade.[102] Lam, not surprisingly, preceded the Cuban abstractos in Caracas: through the Venezuelan writer Miguel Otero Silva, whom he met in Havana in 1950, he had come to know Carlos Raúl Villanueva and Alfredo Boulton in Paris. His retrospective at the Museo de Bellas Artes (Caracas, May 8–22, 1955) and mural at

Villanueva's Ciudad Universitaria were widely acclaimed and set the table, in a way, for the Cuban abstractos that followed.[103] Although Lam declared his disaffection with the School of Paris to a Caracas newspaper—"abstract art is a dead end"—his mural stands out for its unusual degree of abstraction and decorative aspect, both of which suited the aesthetic program of Ciudad Universitaria, shaped by international abstraction (in works by Alexander Calder, Victor Vasarely, Jean Arp, Alejandro Otero, and others).[104] The Constructivist stage in Caracas was set by Villanueva's poetics of arts integration, which anticipated a generation of kinetic and optical experiments by artists including Jesús Rafael Soto, Carlos Cruz-Diez, and Gego (Gertrud Goldschmidt) that materialized in the wake of the decade-long military dictatorship (1948–58). In 1957, Cisneros facili-tated a pilot exhibition of Cuban art at the Palacio de Bellas Artes in Caracas of mostly blue-chip vanguardia artists, and its critical success encouraged him to initiate a regular exchange of exhibitions to take advantage of the anticipated "artistic boom" in both countries.[105] Cuban abstraction found ephemeral footing at the same moment, appearing at the Galería Sardio—deemed by the local paper "the headquarters of *abstractismo*' in Caracas"—with two exhibitions in succession: a solo show of works by Pedro de Oraá and a show of twenty-seven works by the onceños, *Pintura abstracta cubana en Venezuela* (July 10–August 1, 1957).[106] Whatever their earlier misgivings about exhibiting under the Pérez Jiménez dictatorship, the exhibition stressed the "fraternity between the lands of Simón Bolívar and José Martí" and the "artistic freedom" therein implied.[107] José A. Baragaño declared it possible, on this occasion, to "bury at last the corpse of all of the old Cuban painting and sculpture (excepting Lam)," characterizing the onceños as ever ready ("at the barricades") to defend their hard-won position.[108] Severo Sarduy, among the most incisive young intellectuals to write on art in the 1960s, further declared the group "the vital center of Cuban abstract painting" and "its most fervent jewel."[109] García Cisneros plumbed the Havana-Caracas connection again the following year, opening an intergenerational group show at the AVP of the Cuban vanguardia—including works by Cabrera Moreno, Jamís, Matilla, and Sánchez—and, in Havana, showing the "primi-tive" Venezuelan painter Feliciano Carvallo at Galería Color-Luz and operating his own space, Galería Cubana, in Vedado.[110] The opening of an alternative "American" window in Caracas allowed the vanguardia exposure to new audiences at a time when exhibi-tions of any kind had become increasingly scarce in Havana; in retrospect, the chance to tap into the explosion of geometric abstraction in 1960s Venezuela was a regrettably missed opportunity.

LOS CINCO

Amid the ascendance of Cuban abstraction, the onceños had meanwhile regrouped in the fall of 1955, beginning with a small exhibition in Camagüey and their debut in the United States as Los Cinco. Held at the Lyceum, one of the sites of the Anti-Bienal, the

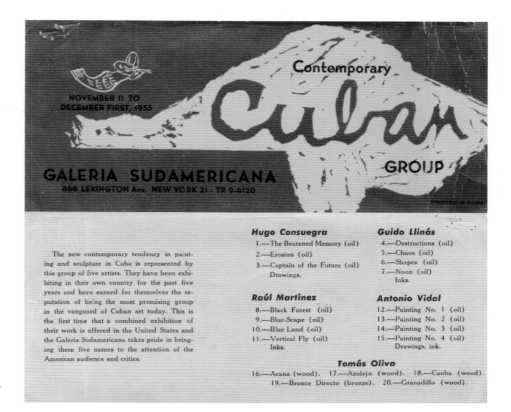

FIGURE 66

Contemporary Cuban Group, November 11–December 1. Exh. brochure, Galería Sudamericana, New York, 1955.

The following text appears within the brochure image:

Contemporary Cuban Group

NOVEMBER 11 TO DECEMBER FIRST, 1955

GALERIA SUDAMERICANA
866 LEXINGTON Ave. NEW YORK 21 - TR 9-4120

PRINTED IN CUBA

The new contemporary tendency in painting and sculpture in Cuba is represented by this group of five artists. They have been exhibiting in their own country for the past five years and have earned for themselves the reputation of being the most promising group in the vanguard of Cuban art today. This is the first time that a combined exhibition of their work is offered in the United States and the Galeria Sudamericana takes pride in bringing these five names to the attention of the American audience and critics.

Hugo Consuegra
1.—The Beatened Memory (oil)
2.—Erosion (oil)
3.—Captain of the Future (oil)
Drawings.

Raúl Martínez
8.—Black Forest (oil)
9.—Blue-Scape (oil)
10.—Blue Land (oil)
11.—Vertical Fly (oil)
Inks.

Guido Llinás
4.—Destructions (oil)
5.—Chaos (oil)
6.—Shapes (oil)
7.—Noon (oil)
Inks.

Antonio Vidal
12.—Painting No. 1 (oil)
13.—Painting No. 2 (oil)
14.—Painting No. 3 (oil)
15.—Painting No. 4 (oil)
Drawings, ink.

Tomás Oliva
16.—Acana (wood). 17.—Azulejo (wood). 18.—Caoba (wood).
19.—Bronce Directo (bronze). 20.—Granadillo (wood).

group's ninth exhibition included eight artists, Cárdenas among them.[111] The catalogue brochure excerpted a lesser-known text by the medievalist and architectural historian Paul Frankl (1878–1962), a curious choice but for its entreaty to the modern artist: "Art of today must be created today. It must express the life about us."[112] The onceños had paid dearly for their fealty to an activist "art of today," and as personae non gratae in Havana they looked abroad for their next incarnation as Los Cinco. Excepting the misstep earlier that year in Madrid, the group's exhibition at Galería Sudamericana brought them squarely into the orbit of inter-American abstraction. *Contemporary Cuban Group* (fig. 66) opened in November 1955 with twenty works by Los Cinco, promoted as "the most promising group in the vanguard of Cuban art today."[113] The press release characterized the onceños as a "militant group" but glossed the political question, noting only that the group had exhibited "all over Cuba with the purpose of clearly demonstrating their reaction to what they called the 'local colorists of the modern Cuban academism.'"[114] The exhibition attracted notice from two of the city's most respectable critics, who predictably emphasized the cosmopolitan character of the work. Dore Ashton explained that the group "set out to incorporate in abstract terms their experience with contemporary art outside Cuba," praising the "strong design" and "clear, flat colors" of Llinás and naming his the "most decisive work in the show."[115] Carlyle Burrows found Martínez the most "accomplished" of the group and gave credit to his early training in Chicago ("it is

America's recent abstract trend that he has perhaps taken most inspiration from").[116] The auspicious reviews counted among the "most important of our career," Consuegra later acknowledged, not least for the weight they carried back at home.[117] Hernández Travieso offered a mea culpa ("no one is a prophet in his own country") and, citing the New York press, allowed that the onceños had "won a bit of glory for our country" despite the withholding of state exhibitions and grants.[118] His editorial waded more broadly into the generational identity of the onceños, staking their youth as a measure of innovation and progress in a way reminiscent of the cubanista styling of the "generación del centenario." His allusion to the moral leadership of Cuba's youth—"Cuba has progressed politically and socially whenever young people have influenced the progress of delicate national offices"—tacitly reiterated the generational associations between the cultural and the political "under-30s."[119]

FIGURE 67

Collages, Esculturas, abril 20 a mayo 1. Havana: Lyceum, 1956.

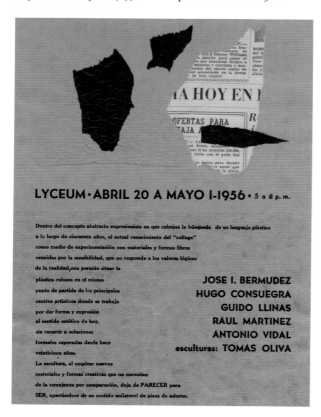

Los Cinco reunited the next year back in Havana, exhibiting a selection of collages and sculptures under the umbrella of "Abstract Expressionism" at the still-friendly Lyceum (fig. 67).[120] Their focus on collage as an experimental medium sought, again, to strike synchrony with international art currents; points of reference likely ranged from Hans Hofmann to the contemporary work of younger artists such as Robert Rauschenberg (1925–2008). The layered textures of collage inflected contemporary and later paintings by Antonio Vidal, in particular, as his work began to shed some of its earlier rectilinearity, the color building its surface from the inside out (fig. 68). That pictorial illusion of shallow depth, rendered here in the overlay of dark blue and black paint and through the visible traces of process and color, characterized much of his mature work. Vidal accrued (and seemingly, sought) fewer individual honors during the 1950s than other onceños, assuming a role less polemical than steadily supportive. The exhibition also included José Y. Bermúdez, who had not shown as part of the group since their eponymous exhibition at La Rampa in 1953, though he participated with them in various other shows in the intervening years. The show registered not at all in the local press—a casualty of the group's political stigma—and no exhibition list has survived. Among this group, Llinás was most invested in the medium of collage; contemporary examples display an all-over patterning of sundry newspaper headlines, tickets, and catalogue covers that commingle biographical

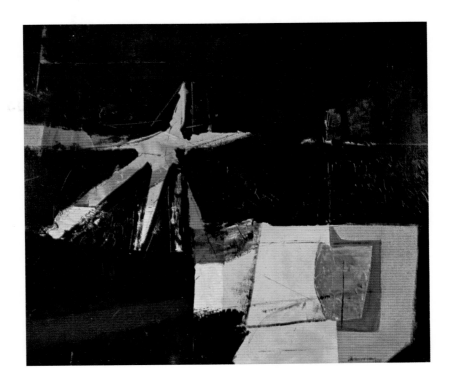

FIGURE 68

Antonio Vidal, *Untitled*, 1956. Oil.
24 × 30 in. (61 × 71 cm). Location
unknown.

elements (particularly as relate to transatlantic travel) and contemporary history. In the
wake of the show in Caracas just over a year later, Los Cinco did not exhibit again as a
group for almost two years, a hiatus that Consuegra attributed to the departure of Llinás,
still the group's de facto leader, for Europe.[121] Some of the group's members found trac-
tion with the Galería Color-Luz; many reassembled for the exhibition *Pintura y escultura
contemporánea* (July 1–August 29, 1958), held at Havana's Centro de Arte Cubano and
among the last exhibitions of prerevolutionary Cuba.[122]

Amid the group's temporary disbandment, many of the onceños pursued oppor-
tunities in Cuba and abroad with some success, beginning to define individual identities
and in some cases staging their first solo exhibitions. Díaz Peláez found early success
in New York, arriving in 1957 and immediately drawing the notice of Alfred H. Barr, Jr.,
who advised Nelson A. Rockefeller on the purchase of *Form in Space*, one of a series of
"floating sculptures" suspended from the ceiling and often positioned in canny dialogue
with the architecture of the gallery (fig. 69). Made from sabicu wood, a reddish tropical
hardwood, the carved form extends laterally, releasing energy in opposing directions
from its hollowed, pelvic-like center. Julia González Fornés, Díaz Peláez's wife at the
time, recalls the early influences of Henry Moore and Louise Nevelson and the impact
of the Antoni Gaudí retrospective at the Museum of Modern Art (1957–58). "[José]
Antonio can never deny his most non-naturalistic shapes some strangely oblique human
suggestion," Stuart Preston wrote in the *New York Times* of his solo debut at Roland de
Aenlle two years later, remarking on the "sensuous neo-baroque animating force in his

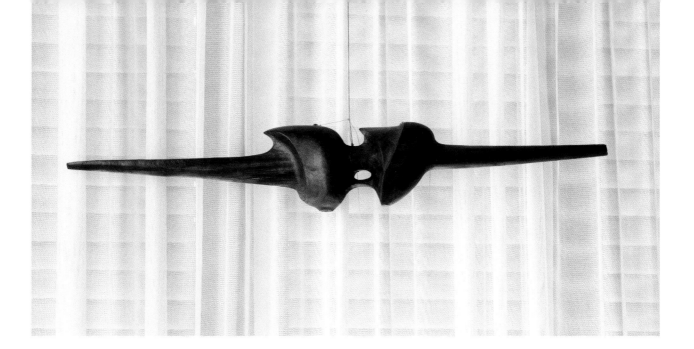

work" and drawing comparisons to "a streamlined Gaudí."[123] Consuegra pursued the
most active exhibition schedule of the dispersed onceños, likely through the promotion
of Gómez Sicre, who introduced him as "one of the most outstanding and definite per-
sonalities in the group of 'The Eleven;'" of the original onceños he alone was awarded a
solo exhibition at the Pan-American Union (May 1956).[124] The "most ambitious" painting
of his second one-man exhibition (Roland de Aenlle, November 18–December 7, 1958),
according to the reviewer for *Arts* magazine, was the suggestively titled *Sierra Maestra*,
but *Poetry against Itself* was deemed the finer achievement: "the raw, discreet shapes are
frozen in a fastidious suspense, yet an excitement is curiously absent, as if he had reached
a vision without the pain attendant on it."[125]

That sense of anticlimactic suspension is an apt characterization of the work of
Los Cinco through the remainder of the Batista regime. Shut out of official Cuban chan-
nels and linked in the public's eye to the revolutionary zeitgeist (however tenuous the
connections were in fact), the onceños remained in a kind of holding pattern, exhibiting
in smaller venues in Cuba and abroad.[126] The "honorary" onceño Julio Matilla opened
a solo show at the AVP in 1957 and, in 1956, exhibited with Oliva at Havana's Sala Teatro
Prado, a private venue run by the Spanish-born director and actress Adela Escartín (1913–
2010). Zilia Sánchez held solo exhibitions in Madrid (Clam Gallery, 1957) and at Havana's
Las Máscaras gallery (1957), where she also worked on scenography. Oliva and Llinás
opened a joint exhibition at the Lyceum in 1957, presenting increasingly mature manifes-
tations of autographic gesture (fig. 70). Working at a larger scale and, distinctively among
the onceños, in metal, Oliva placed welded iron sculptures directly onto the floor; linear
and lyrical, their open structures rise up as modern totems, drawn asymmetrically in
space. Llinás showed a range of expressionist techniques, in some cases introducing the

FIGURE 70

Installation photo, *Tomás Oliva: Esculturas; Guido Llinás: Pinturas* [September 19–25]. Lyceum, Havana, 1957.

"accident" of dripped and splattered paint within an underlying, geometric scaffolding. The self-referential ethos of "action painting" more demonstrably inflects other works, such as *Composition* (fig. 71); inverting the convention of black marks on white ground, the surface builds in thin layers of tempera, interleaving bright touches of red and blue within the dense, all-over field of thrusting, seemingly spontaneous brush-strokes. For Llinás and the generation of artists still hovering around the "under-30" mark, the progression to solo shows and independent identities marked a professional coming of age. More complicated were the cultural politics of gestural abstraction by the late 1950s and the significance of its imprint in the Latin American "third world."

To the degree that the onceños increasingly sought validation in the United States and exhibited internationally through channels of the Pan-American Union, their allegiance in the Cold War ideological divide was closely watched by the end of the decade. As discussed in chapter 1, the rise of Cuban universalism in the 1940s had drawn productively on a broadly conceived americanismo as a means of shedding outmoded European influence, and Los Once likewise pitched their adoption of North American forms as an expression of cultural and artistic revolution. In the wake of the Batista coup, the onceños had instantly leveraged their practice of gesture painting as a means of political resistance—in their case, against a right-wing totalitarian state reluctantly supported by the United States—and the question of their americanista loyalties lingered over the second half of the decade. The distinction between "nuestra América," defined by Martí as a Latin American rejoinder to U.S. imperialism, and the unctuous Americanism of the Batista state, seen as a virtual U.S. satellite, grew sharper as the anti-Americanism of the revolutionary movement became clear. At issue, for later historians, has been the political valence of abstraction itself: if Abstract Expressionism were put to ideological use as an instrument of Cold War propaganda, as Serge Guilbaut and others have suggested, did it still retain any of the original countercultural and anarchistic values of the artists themselves?[127] More pertinently, did the practice of gestural abstraction brand the young Cuban and Latin American abstractionists as complicit in U.S. imperialism or mark them as shrewd critics, cannily appropriating the language of abstraction to advance the cause of national self-determination? The full international reach and political use value of Abstract Expressionism fall somewhat to the periphery of the situation in Cuba, but

the intentionality behind Los Once's practice of abstraction in this regard is germane
to the group's position at the end of the decade.

Abstraction's political corollaries were not immediately apparent at the turn of
the decade, and the ideological implications of Los Once's practice within the Latin
American theater have attracted serious historical interest only in recent years. Expand-
ing on the writings of Marta Traba, David Craven has most persistently argued for a
revisionist account of Abstract Expressionism, which in his analysis became a form of
"anti-imperialist art" through its cooptation by the young Cuban and Latin American
vanguard of the later 1950s and 1960s. "What made Abstract Expressionism so compel-
ling in ideological as well as visual terms," Craven explains, "was how its language of
negativity, its role as abstract 'social protest' against mainstream U.S. culture of the Cold
War period were valued deeply by many artists and intellectuals not only from Cuba and
Nicaragua, but also from other countries like Argentina, Colombia, and Peru."[128] Craven
draws connections between the work of the core onceños and contemporaries such as
the Nicaraguan Armando Morales (1927–2011), Peruvian Fernando de Szyszlo (b. 1925),
and Argentine César Paternosto (b. 1931), among others, linking their practices through
a common thread of dissent and Marxist negation. The implication that the practice
of gesture painting registered as a collective Pan-American backlash against the tide of
Western capitalism is intriguing but circumstantial, particularly so with regard to the
Cuban situation. The aspirational onceños prized the validation of the American market

and critical press, and Craven's attribution of anti-Americanism is to a large extent determined by the subsequent rise of revolutionary activity, in Cuba and elsewhere, in the 1960s. Cuba did not shy away from the overtures of Gómez Sicre and the Pan-American Union through the 1950s, and to all appearances the onceños moved in closer step with U.S. interests than with those of their Latin American peers.[129]

If Los Once did feel stirrings of Latin American solidarity in the waning years of the decade, not until the profound cultural shock of the Revolution did their practice of gestural abstraction and its attendant political values come to face a new day of reckoning. The Revolution deeply altered the political geography of the Americas, and the rhetoric of liberation and anti-imperialism overshadowed the Western idea of modern nationhood that had at least notionally governed the Cuban republic since 1902. "With its vanguard action," the Mexican writer Carlos Fuentes declared in 1961, "the Cuban Revolution has opened a path so that in the future our countries may overcome the unilateral pressure that the United States exercises through the Panamerican system."[130] Fuentes later revised his opinion of the Revolution, but at that time his words reflected the new tenor of the Latin American vanguard, emboldened in its commitment to the cause of emancipation in the Americas and elsewhere in the developing world. The complexion of Cuba's artistic and literary vanguardia changed in accordance with the country's new political views, and the onceños found themselves disappointed at best with their role in the postrevolutionary world. The future of abstraction was a moot point already by the early 1960s, foiled both by the ambiguity of its political loyalties and, in more practical terms, by the defection of many of the principal onceños. The ensuing ostracization of the onceños somewhat refutes Craven's arguments for the anti-imperialist orientation of Abstract Expressionism in the Americas, but there exist other, more ontological reasons for abstraction's diminished revolutionary role.

Abstraction was not ever the exclusive province of the onceños, as this chapter has elaborated, and its myriad expressions—in Cuba and abroad, from concrete geometries to gesture painting, in public works and in political protest—illuminate the complexity of the status it held in the later 1950s. While the polemics of Los Cinco cast abstraction in stark ideological terms, taking the crusade of the original onceños across the Americas and to Europe, the Batista regime co-opted abstraction for its own purposes, from the Modulor at the heart of the visionary Plan Piloto to the support it showered upon geometric abstraction. The decade-long dalliance between the elder vanguardia generations and abstraction of various kinds further cemented the currency of abstraction in Cuba, as did the prominence of abstraction in national delegations sent to exhibitions across Europe and the Americas. By all appearances, the decade represented the apogee of abstraction in Cuba and, with it, the consummation of the modern movement that had begun with the Generation of 1927, witnessed the rise of the Havana School, and (grudgingly) celebrated the cosmopolitan vision of the youngest vanguardia as they ascended to the world's stage.

5 Cuba's Concretos and the Constructivist Turn

"What is concrete art?" Mario Carreño raised the question as a lead-in to a short, art-historical lesson prompted by a recent show of works by Sandú Darié and Luis Martínez Pedro that advertised itself as Havana's "first concrete exhibition" in 1955 (fig. 72). With deference to Darié, whom he named the "prophet of 'concretismo' in Cuba," Carreño sketched a history of concrete art from the Bauhaus to postwar centers in New York, Ulm, and Buenos Aires. First introduced in a manifesto by the Dutch artist Theo van Doesburg (1883–1931) published in the magazine *Art Concret* (1930), the term refers to nonfigurative art intended to be perfectly autonomous, that is, with no basis in observed reality and without symbolic meaning. Favoring mathematical, mechanical construction and conceived through line, color, and plane, concrete art found purchase within the Paris-based group Abstraction-Création and, in the postwar period, with Max Bill, who facilitated the movement's spread to South America. Writing to the Cuban public, Carreño was careful to distinguish concretism from "abstraction . . . , much less the so-called 'Abstract Expressionism' with which it is often confused," and his emphasis on the "new reality" of concretism, free from external or individual conceits (quoting Van Doesburg), intentionally separated the concretos from the erstwhile onceños.[1] Amid the latter's well-publicized travails, Carreño and others acted quickly to recast the narrative that had fixated on abstract art as incendiary and, moreover, proprietary to Los Once. The parallel trajectory of the concretos, who came increasingly into the public eye through Carreño and the INC from mid-decade onward, took an intellectual course, pitching nonfigurative art first as a Leonardian *cosa mentale* set apart from the chaos of the contemporary moment and, later, as a medium of social intervention and transformation.

This second gestation of Cuban abstraction had multiple points of origin that, not unlike its gestural counterpart, extended from Paris to New York and Buenos Aires. In Cuba, the early adopters of concretism were Darié (beginning by 1950), Carreño, and Martínez Pedro—the triumvirate behind *Noticias de Arte* and, in the case of the latter two, among the most celebrated exponents of the Havana School. New stimulation came at mid-decade with the return of Loló Soldevilla from Paris and the emergence of younger artists around Galería Color-Luz, which maintained a steady slate of exhibitions

Detail of fig. 73

FIGURE 72
Installation photo, *Martínez
Pedro, Sandú Darié, abril 25 a
mayo 10*. Universidad de la
Habana, Pabellón de Ciencias
Sociales, Escuela de Arquitectura
y Planificación, 1955.

between 1957 and 1961. The tenacious existence of the gallery during these years became itself a symbol of cultural resistance for the vanguardia artists who remained in Cuba (concrete or not). Serving a similar function as Las Antillas had for the onceños at the start of the decade, Galería Color-Luz nurtured the group Los Diez Pintores Concretos, who belatedly claimed their place within the vanguardia in 1959. Compared to Los Once, the concretos proved more politically circumspect, declining to confront the Batistato directly whether through exhibition-manifestos or mass-produced broadsides; such outright defiance was no longer possible, at any rate, as the departures of many artists and intellectuals—among them, Guido Llinás and Carreño—implied. The cerebral mold of Los Diez has been frequently written off as apolitical and, for a long while, uncomfortably cosmopolitan; no doubt, concretism has suffered guilt by association with the Batista regime, and its inherent cubanidad has barely, if at all, been recognized. Yet considered within a more strictly delimited horizon of possibility, the work of Los Diez may also be understood as idealist and teleological in kind: cubanista in its turn to concretism as a utopian tabula rasa, it functioned as a Constructivist medium through

which to engender a new world. In separating out the rise and reception of the concretos from that of the onceños and others, this chapter argues for the historicity of Cuban Constructivism and its significance within the generational vanguardia project that it shepherded over the waning years of the decade.

CONCRETE BEGINNINGS

The wartime arrival of Darié in 1941 and the return of Carreño a decade later, following eight years abroad, mark the earliest points of origin for concretism as a discrete movement in Havana. Although geometric abstraction had occasionally surfaced in work by the elder-generation vanguardia, the conjunction of Darié's development by 1950 and Carreño's exposure to artistic currents in New York laid the groundwork for the establishment of Havana as an emerging node within international concretism. Darié's work underwent a critical transformation between 1949 and 1951, shedding the emotive poetics of earlier drawings as his orbit expanded to New York and Buenos Aires. His first solo exhibition, which traveled from the Lyceum to New York's Carlebach Gallery in 1949, consisted of what Stuart Preston, writing for the *New York Times*, described as "mists of rainbow color . . . seen through zig-zag bars of black" and applied through scratches and spatterings of paint.[2] The press release issued by the gallery described the twenty-four *Compositions* as "poetic explorations in the selective light of imagination and the tension of a non-objective world—lyrically expressed," adding a notation that "these purely individual views of modern art are possible only under a democratic system."[3] By the time of his second exhibition at the Lyceum a year later, his *Estructuras pictóricas* already anticipated his concrete turn. "I wanted to evoke a new pictorial structuralism," Darié explained, and his brief catalogue references to "aesthetic formalism" and "time-space sensation" suggest his attentiveness to the Constructivist tradition.[4] Behind Darié's transformation were two key developments: his epistolary (self-)insertion within the Madí movement and his continuing exposure, in New York, to Neo-Plasticism.

The sole Cuban member of the Madí movement, based in Buenos Aires and led by Gyula Kosice, Carmelo Arden Quin (1913–2010), and Rhod Rothfuss (1920–1969), Darié established Havana as a satellite of Madí activity in the 1950s. He first became aware of the Madí movement at the time of the Carlebach exhibition through his acquaintance there with the Greek American artist Jean Xceron (1890–1967), a transatlantic figure associated with the group Abstraction-Création in Paris and later, in New York, with the American Abstract Artists. Writing from Havana on November 26, 1949, Darié introduced himself to Kosice, explaining the connection through Xceron and inquiring about Madí publications and other activities.[5] "The existence of Madinemsor is brilliant," he wrote in early 1950 upon receipt of the second issue of the journal *Arte Madí Universal*. "It is the concern of a group of men who arrive at the same conclusions in the plastic arts, amid the divided aesthetic of our times."[6] Darié contributed a "Pensamiento

Madista" [Madist Thought] to the fifth issue of *Arte Madí Universal* (October 1951) in which he praised the group's "Constructivist, which is to say ethical and progressively activist—*madista*—ideals."[7] The tension between the metaphysical ("poetry = creation") and the physical, a persistent theme throughout his work, runs throughout his essay in spite of its change in title (from the original "Madist Spirituality," at the behest of Kosice): "The conception of madista spirituality will bring modern rationalism and materialism to light, subjecting plastic and creative intelligence to a severe discipline, which sets it apart from confused imaginations. . . . Possessing a cosmic consciousness, the paintings are manifest in universal space and time, discovering endlessly inventive creation. They demonstrate the importance of the conscious [mind] for plastic life."[8] The correspondence between Darié and Kosice during the 1950s touches upon subjects ranging from aesthetic theory to mundane matters of publishable photography and printing fees, shedding light on the early nexus of activity around geometric abstraction in Havana and on Darié's advancing practice. Darié facilitated exchange between the madistas in Buenos Aires and his colleagues in Havana, from the time of *Noticias de Arte* in 1952–53 through the early 1960s. His continued participation in group exhibitions—at least two of Darié's *Pinturas transformables Madí* traveled and were exhibited in Madí contexts early in the decade, beginning with the July 1953 exhibition at the Ateneo del Chaco—suggests ongoing dialogue and mutual awareness.[9] Comprising five wooden rectangles affixed at their midpoints, *Pintura transformable Madí* dispenses with the traditional "frame" of painting in a classic Madí gesture, instead orienting its composition spatially around the movement of color and shape (fig. 73). Stabilized by the all-black piece attached to the wall, the movable pieces challenge the static two-dimensionality of conventional painting; installed in a conventionally white-walled gallery, the perceptual effect is one of free-floating color in space.

While the madista connection exposed Darié to the techno- and cosmic futurity of concretism, his simultaneous experience of historical Constructivism in New York provided a continental counterpoint informed by expatriated members of the Bauhaus and the School of Paris. In 1951 he participated in a group show at Rose Fried Gallery, *Some Areas of Search—1913–1951*, in which his spiritual-humanist leanings found better company. "Generally speaking, the aim here is to prove the relationship between geometry and metaphysics," Preston wrote in his review: "'A triangle has a spiritual value of its own,' said Kandinsky. An attempt to get to the bottom of these new, exciting and troubling problems of space is evident in all the work on view, from that by [Piet] Mondrian, [Robert] Delaunay and [Georges] Vantongerloo, the forerunners, to that by [Josef] Albers, [Fritz] Glarner, [Mary] Dill and Darié, the painters who are developing this search according to their own lights."[10] The reference to the triangle was particularly apt for Darié, who took that "form-shape" as the basis for his early *Estructuras pictóricas*, constructed by the division of a rectangle and activated by orthogonal rhythms extending, he explained, in continuous space to infinity.[11] "Exhibitions function to drive ideas,"

Darié wrote on the occasion of his solo show at the Lyceum in 1950, and he presented
these triangular *Estructuras pictóricas* as the consummate (Hegelian) "will to form," the
"spiritual and constructive manifestation" of the age.[12] Further reflections on the poet-
ics of space drew upon an unlikely intellectual medley—the Comte de Lautréamont,
Hermann Hesse, and John Dewey as well as Mondrian and Constantin Brancusi—whose
idealist aesthetics served as a counter to more pragmatic, madista interests. Spiritual
affinities remained latent in Darié's work through most of the 1950s as he privileged the
more outwardly social and progressive aspects of concretism, but the contemporary
associations with Neo-Plasticism paid intellectual dividends as well, particularly in con-
cert with the mid-decade connections between Havana and Paris.[13]

 Darié's immersion in Constructivist aesthetics dovetailed with the heralded
return of Carreño to Havana in late 1951 and the recent turn in his own work toward
geometric abstraction. Carreño had remained in New York in the wake of *Modern Cuban
Painters* (Museum of Modern Art, New York, 1944), taking a studio on Bleecker Street in
Greenwich Village and continuing his work as an artist, curator, and teacher.[14] In 1947–48
and again in 1950–51, he taught "oil painting, drawing, and composition" at the New
School for Social Research under the departmental direction of the Ecuadoran Camilo
Egas (1889–1962); members of the faculty during his tenure included Berenice Abbott,
Rudolf Arnheim, Stuart Davis, Meyer Schapiro, and Adja Yunkers (the latter featured

in *Noticias de Arte*).[15] He exhibited at the Pan-American Union and at Perls Gallery in New York; José Gómez Sicre's monograph, published through the PAU, came out in 1947.[16] Carreño left for Chile in 1948, returning to New York the following year to "something quite different than what I had left behind," he later remarked. His citation of Josef Albers, Mondrian, and László Moholy-Nagy as the dominant figures of abstract art—in a pointed oversight of the New York School—supported the recent direction of his own work: "My humble '*guajiros*' [peasants] followed the geometric trend. Everything led to the square."[17] The gradual geometricization of Carreño's work met with puzzlement and some misgivings upon his arrival in Havana, and he reached out to the cultured public, with the backing of Octavio de la Suarée, with a convert's zeal. "Abstract painting, misunderstood today, will be the classic and traditional painting of tomorrow," a headline promised, and from the beginning Carreño argued for the universality of Cuba's vernacular, rendered not in literal, descriptive terms but rather through the poetry of light and color.[18] Among his signal, transitional works from this period is *Cielos del sur*, in which warm, verdant tones of dark green, ocher, black, and ivory outline a gridded, nocturnal horizon (fig. 74). Recalling a similarly cosmic sensibility in the contemporary work of the Mexican colorist Rufino Tamayo, whose work Carreño knew from New York, *Cielos del sur* juxtaposes the constellations of the night sky, alight with multicolor stars, with three figures whose simplified forms—triangles, crescent moon—distill the Afro-Cuban iconography seen in his earlier work (see fig. 18). Such sublimation of the Cuban landscape, under the universalizing cover of the (southern) skies, epitomized the beginnings of the concrete project in Cuba, which projected geometry—Carreño's teleological "square"—within the cubanista mindset. Carreño gave a series of lectures on the "evolution of contemporary painting" at San Alejandro in early 1952, offering a narrative in fifteen parts beginning with neoclassicism and concluding with the "abstract-symbolists: Paul Klee, Joan Miró, Hans Arp."[19] His pedagogical bent carried over to his published texts, which ranged from the cerebral (for example, "El factor moral en la pintura abstracta," in the May 1953 issue of *Noticias de Arte*) to his regular column in the weekly magazine *Carteles*, "Artes plásticas en el mundo," in which he struck a genial, conversational tone. The concretos benefited from their patient courtship of the public, trading as they did on the goodwill built up over the preceding decades and their elevated stature within social and cultural circles. (The upstart onceños, notwithstanding the greater socioeconomic contingencies they faced, mistakenly assumed an audience for their brand of abstraction and, no less, its self-evident appeal.)

In addition to Darié and Carreño, Rafael Soriano and José M. Mijares stood out among the early adopters of geometric abstraction, each guided by the example of Roberto Diago. Slightly younger than the second-generation vanguardia but self-consciously senior to the onceños, they occupied a median position; their path to abstraction came out of the prewar School of Paris (vis-à-vis Cuba's first-generation vanguardia) rather than the vernacular color of the School of Havana. Among the future

members of Los Diez, Soriano was among the first to work in a geometric mode, but he did so from Matanzas, where he served as professor and then director of the School of Fine Arts until 1955. His pathway into abstraction led from flat-pattern, curvilinear silhouettes (not unlike contemporary work by the Argentine Emilio Pettoruti) in the late 1940s to purist geometry by 1950. In *Flor a contraluz* (fig. 75) and its pendant painting, *Músicos tocando un órgano* (1949), Soriano probed the sensory essences of his subjects, in one case stylizing sound and in the other amplifying the found symmetry of the flower's form, unfurling it chromatically, layer by layer, through resonant tones of vermilion and dark burgundy. In much the same way as Darié, before Kosice's dissuasion, Soriano plumbed the spiritual in images that sought to convey "the truth of our interior world, the reality of our psychic world."[20] Less intellectualized than intuitive and oneiric, his geometric painting ranks among the earliest and autochthonous nonfigurative abstraction in Cuba, developing out of post-Cubist faceting into dynamic color fields. In such works as *Composición* (fig. 76), Soriano folds planes of color, effectively flattening and triangulating two-dimensional space along a diagonal axis. Subtle tinting and shading define the nested triangles of pigment; Gómez Sicre

credited the early mentorship of Fidelio Ponce de León with instruction in "the art of tonal painting." His conduit to current trends, however, was Diago, his former classmate and, in the early 1950s, fellow teacher in Matanzas.[21] More worldly than Soriano, with exhibitions already in Europe and in the United States, Diago gradually shed the organic forms still present in *Figure* (see fig. 21). Reminiscent of Barnett Newman's drawings of the late 1940s, works like *Untitled* survey the topology of the paint surface, shifting bands of color toward and against the edge of the canvas and using value contrasts to calibrate intervals of space and movement (fig. 77). Textural variations on the surface (cross-hatching, stippling) and visible brushstrokes characteristically impart an expressionist tactility to the geometric shapes, adapting graphic techniques—Diago's draftsmanship, particularly with the woodcut, was first-rate—to modernist abstraction. His death in Madrid in early 1955, plausibly by suicide, cut short a promising career—notably, of the first Afro-Cuban artist to broach concrete abstraction. A newspaper account of

FIGURE 76
Rafael Soriano, *Composición*,
1959. Oil on canvas. 28⅕ ×
39½ in. (71.6 × 100.3 cm).
The Brillembourg Capriles
Collection.

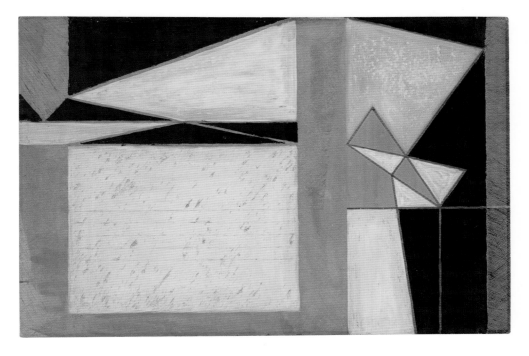

FIGURE 77
Roberto Diago, *Untitled*, n.d.
Oil, gouache, and ink on
board. 20 × 30 in. (50.8 ×
76.2 cm). Location unknown.

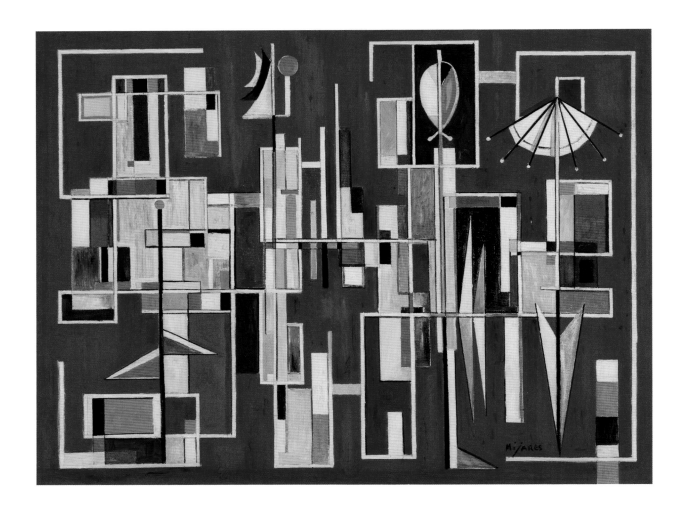

FIGURE 78

José M. Mijares, *Lo concreto en rojo*, 1954. Oil on wood. 26¾ × 35 in. (67.9 × 88.9 cm). Private collection.

the police investigation hinted at the indignities of racism (indeed, there was little racial diversity amongst the abstractos as a group, Llinás and Agustín Cárdenas excepted).[22]

Mijares studied at San Alejandro at the same time as Diago but acknowledged the greater influences of Ponce de León and Amelia Peláez, who offered free classes at her home, as he worked his way through Cubism to concrete art. Progressively abstract, and declared "concrete" as early as 1953, his paintings assimilated easily within the vanguardia lineage, their strongly outlined dissections of color and tonal harmonies comparable, early on, to work by Mirta Cerra. Mijares won prizes at the National Salon in 1950 and 1951 and exhibited at the São Paulo Bienal in 1953.[23] By mid-decade, his work began to condense the baroque touch of Peláez's painted vitrales, rendering prismatic color within intricately delineated grids. To an even greater degree than his *Orígenes* cover from the same year (see fig. 3), *Lo concreto en rojo* patternizes panes of color, vitalizing the Neo-Plastic purity of plane, line, and color through kaleidoscopic asymmetry and a near-continuous, framing line that travels in right angles, circumscribing the corners of compositional space (fig. 78). The structure remains open, its penetrability implied

by the conspicuously few, nonrectilinear shapes: the arrow-like triangles pointing downward in the lower right-hand corner; the schematic fish at the top, encased in a shaded rectangle; the opposing right triangles that anchor a black line running down the painting's left-hand side. Like Soriano and others, Mijares came to abstraction first as a progression out of post-Cubist faceting, rendering traditional subjects—landscapes and port scenes, portraits of women and, often, clowns—through increasingly flattened and geometricized means. Not until 1956, following Soldevilla's return from France, did his work free itself from these origins in observed reality and, as such, embrace the concretist dictum of pure, ideal forms evolved from abstract thought.

In a general way, the concretos were late-blooming and idiosyncratic in their turn toward geometry, and they worked more independently than the onceños, who leveraged their generational fellowship more opportunistically, between 1952 and 1955, into a movement. The lone bridge figure between the future concretos and "los 23 y medio" was Salvador Corratgé, included in Los Once's first exhibition (*15 pintores y escultores jóvenes*) and later a member of Los Diez. Frustrated with the teaching at San Alejandro, he relied on the mentorship of Texidor and Diago ("all that I could learn about abstraction I learned from Roberto Diago"), gleaned from the elder artist's weekend visits from Matanzas to Havana.[24] Like Martínez Pedro, he worked commercially as a designer during the intervening years as he found his way within geometric abstraction.

MARTÍNEZ PEDRO: "NO ENTRE QUIEN NO SEA GEÓMETRA"

Incised on the door to Martínez Pedro's studio, these words—in effect, "only geometers allowed"—declared the new ethos of geometry that had become manifest in his work by the early 1950s.[25] Known best for the expressive plasticity of his drawings, mostly of vernacular subjects, in the 1940s, he recast himself through the medium of geometry over the following decade. His concrete turn was anticipated at the start of the decade by Jorge Romero Brest, who wrote in the vanguardist Argentine journal *Ver y estimar* of his belief that Martínez Pedro was the "revelation of Cuban painting" at the São Paulo Bienal (1951), on his way toward a "new universalism, neither that of Picasso nor of Cuba."[26] Gómez Sicre similarly declared his work "free and in the field of abstract expression" on the occasion of his exhibition at the Pan-American Union.[27] The lyrical and ethnographic localisms (for example, *cuartos fambá, ñañiguismo*) present in his work in 1951 gave way to more purely cerebral conceits in two years' time, no doubt informed by his close relationship with Darié and Carreño. What set Martínez Pedro apart from the other concretos, and made his geometric evolution all the more remarkable, was his concurrent, decade-long work for the advertising agency OTPLA (Organización Técnica Publicitaria Latinoamericana), which he cofounded in 1948. His hand in commercial advertising, which played to clichéd, tropicalista Cuban conventions, seemingly functioned as a counterpresence to his personal practice of painting, which evolved along a

contrarian, concrete path. That duality in his life and work—the day-to-day marketing of traditional emblems of cubanidad and the personal search for idealist universals—provided a uniquely sourced cubanista foundation behind his path to abstraction.

In May and June of 1953, Martínez Pedro showed a series of concrete paintings in Havana, first at the Miramar residence of the architect Miguel Gastón and later at the gallery La Rampa. (The *"primera exposición concreta"* of 1955 was in fact a misnomer, as it overlooked this earlier exhibition, which also carried the "concrete" appellation.) Built in 1952, the Gastón home accords architecturally with its seaside setting: the open design of the ground level and the large, rear-facing windows above refract the light and the water, framed by the square-shaped swimming pool and, further below, by the sea (fig. 79). As seen later in the Eugenio Leal House (see fig. 6), the adaptation of International Style architecture to the Antilles trucked with period discourse around arts integration, and the installation of Martínez Pedro's paintings was presented precisely in this context, by *Noticias de Arte*, as marking the first explicit identification of abstract painting and modern architecture on the island. Further to this integrationist end, the catalogue included

FIGURE 79

"Unos cuadros y una casa junto al mar," *Noticias de Arte* 1, no. 9 (June–July 1953): 8–9.

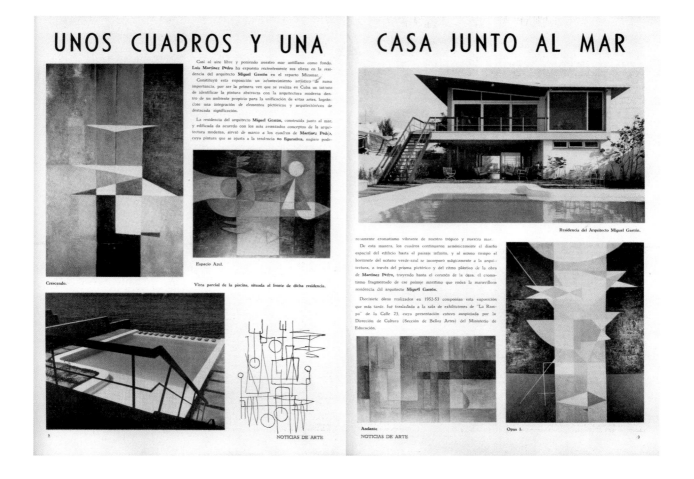

an instructive text by the modern architect and founder of the Bauhaus Walter Gropius (1883–1969), invited to Havana by Martínez Pedro, in which he underlined correspondences between the structures of music and abstract art. "As in painting," he began, "musical compositions consist of form and content. Their form is solely the work of the composer, who makes his musical ideas comprehensible through the use of counterpoint, a universally accepted system that divides the world of sound into intervals governed by fixed laws." Laws of counterpoint, harmony, and scale had historically informed the visual arts as well, Gropius explained, but recent lapses underscored the need for "the abstract painter of our time" to "use his creative powers to establish a new counterpoint of space—a new vision."[28]

The contrapuntal metaphor provided an insightful interpretive gloss to the seventeen paintings that Martínez Pedro exhibited, aided in some cases by such suggestive titles as *Andante*, *Crescendo*, and *Opus*. In *Crescendo* and *Opus I*, for example, compositional rhythm is built through the dialogue of colors across a central vertical plane, the visual intervals paced by offsetting bars of color. In the purely visual terms set out by these early concrete compositions, the import of musical structure is already clear: in their polyrhythmic spacing and tonal balance, the paintings innovate within and against traditional harmonies of color and form, conceptualizing new constructive possibilities. Reviews of the exhibition were magnanimous in their acceptance of concretism as a "cosa mentale," occupying an imaginary well apart from the "bitter drama" of reality. "Things are not what they are, but rather as we see them," Rafael Marquina observed—his review bears the fabled date of July 26—and he appealed to the imaginative (no less, the perceptual) receptivity of the viewer.[29] Luis Amado Blanco, writing on the day after news broke of the so-called Montreal Pact—a futile political alliance between the Auténtico and Ortodoxo parties intended to overthrow Batista and restore constitutional order—struck a similarly premonitory note. "One paints for tomorrow instead of for today," he proposed. "The message of the artist . . . appears somewhat confused in the agony, in the exhaustion of reconciling that which until yesterday seemed impossible."[30] His ruminations on the coexistence of an increasingly materialistic culture and an idealist art form—a disjunction epitomized in Martínez Pedro's body of work—were of a piece with the time. Moreover, the polarity between the real and the ideal gave the concretos a certain carte blanche; that is, their utopia appeared so far beyond reach that they could push the limits of Constructivist experiment and action with little fear of reprisal.

In December 1953, Darié, Carreño, and Martínez Pedro introduced Cuban concretism to a wider audience at the *II São Paulo Bienal*, whose anthology of international abstraction provided an early benchmark for their individual practices. Martínez Pedro exhibited nine paintings, the most of the twelve-person Cuban delegation, and was twice honored: with an acquisition prize for *Jardín imaginario I* and with the selection of *Espacio azul* by UNESCO as "the most outstanding example of abstract art" (the latter, an honor shared with the Brazilian Alfredo Volpi).[31] Reproductions of *Espacio*

azul were printed and readied for distribution to Member States through UNESCO's "Art Popularization Series" by early 1955, situating Martínez Pedro among a group of abstract artists that came to include, among others chosen from the Venice and São Paulo Biennials of the 1950s and 1960s, Karel Appel, Milton Dacosta, Roberto Matta, Ivan Serpa, Antoni Tàpies, Alberto Burri, and Jean-Paul Riopelle. Martínez Pedro again represented Cuba in São Paulo in 1955 and 1957, each time with concrete *Compositions*; his magisterial series, *Aguas territoriales*, was shown in 1963.[32]

Martínez Pedro followed up his success in São Paulo with an ambitious European itinerary that vindicated his—and no less, Cuba's—concrete position. In autumn of 1954, he traveled across Italy, France, Germany, and Switzerland, visiting the studios of artists including Victor Vasarely (1906–1997), Emilio Vedova (1919–2006), Robert Jacobsen (1912–1993), Fritz Winter (1905–1976), Gino Severini (1883–1966), Jean Dewasne (1921–1999), and André Bloc (1896–1966). In a published interview with Carreño upon his return to Havana in January 1955, Martínez Pedro remarked upon the elevated stature of Max Bill, credited as an instigator of Brazilian concretism in the wake of his prize at the first São Paulo Bienal (1951) and much celebrated, he reported, at the *Tenth Triennial of Milan Design*, held jointly with the International Congress of Industrial Design. "I can assure you," he advised Carreño, "that art is becoming more abstract not only in Paris, but throughout the world."[33] His words in support of concrete art, buttressed by first-hand accounts of European exemplars, paved the way for Havana's concretos. "The true artist of today attempts to order, rather than provoke, chaos," he declared (in veiled reference to the onceños, to be sure). "The concrete artist exceeds in re-creating that lost equilibrium in his works, in the attempt to express in stylistic terms his desire for order and peace, that peace for which the human spirit is so desperate."[34] Martínez Pedro was clear on the dead-end of Surrealism, comparing its false existentialism to literature, and spoke decisively in favor of the integration of the arts and architecture, a topic of increasing interest in Havana (and similarly broached by Hugo Consuegra and Rolando López Dirube, among others). In a counter to Cuba's traditionally francophile tendencies, Martínez Pedro's Italo-Germanic circuit laid the foundation for an unexpected series of solo exhibitions over the next few years. Carlo Cardazzo, a catalyst and patron of the postwar Italian avant-garde, showed him at both of his galleries, Galleria del Cavallino in Venice (August 1955; fig. 80) and Galleria del Naviglio

in Milan (January–February 1956).[35] The paintings exhibited bear close resemblance to those shown in Havana in 1953; free-floating forms migrate across vertical and horizontal registers and, as appreciated by Gropius, the musicality of their chromatic counterpoint manifested as well to the Italian critic Umbro Apollonio, whose text accompanied the catalogues for both shows. Martínez Pedro's work subsequently traveled across West Germany (Recklinghausen, Frankfurt, Bengsberg), giving Cuban concretism a second toehold in Europe and a credible connection to the Ulm School and, in line with Martínez Pedro's own practice, its interests in synthesizing art, design, and architecture.

PARIS INTERLUDE: SOLDEVILLA AND ARCAY

While Martínez Pedro cast a wide net within postwar Constructivism, Soldevilla and Wifredo Arcay found their early, foundational bearings in Paris, where they too immersed themselves within a milieu of geometric abstraction. Soldevilla embarked on her own, perspicacious path within abstraction in 1949 when she arrived in Paris to take a position as cultural attaché at the Cuban Embassy. Inasmuch as she kept close personal company with Latin American artists and intellectuals—recounted in her memoir *Ir, venir, volver a ir: crónicas (1952–1957)*, dedicated to José A. Baragaño—she studied and later exhibited within an international community of artists spanning different generations.[36] Soldevilla took classes in 1949 at the Académie de la Grande Chaumière under the Russian-born artist Ossip Zadkine (1890–1967), a principal of the School of Paris and early adept of sculpture drawn on Cubist geometries. She also worked between 1951 and 1953 at the Atelier d'art abstrait, founded by Jean Dewasne (1921–1999) and Edgard Pillet (1912–1996) in 1950 near the Grande Chaumière. Oriented around a collective approach to aesthetic research, the Atelier organized both *"visites-dialogues"* with elder-generation artists such as Auguste Herbin (1882–1960), Alberto Magnelli (1888–1971), and Vasarely and focused discussions around the work of the Atelier's younger students, among them Arcay, Yaacov Agam (b. 1928), and Pascual Navarro (1923–1985).[37] She received informal guidance from others, including Vasarely, Jacobsen, and Arp, likely facilitated through her association with the Atelier.[38] Through Pillet, Soldevilla would also have come into contact with Groupe Espace, founded by Bloc and Félix Del Marle (1889–1952) in 1951 around the promotion of collaborative, social values within geometric abstraction.[39] The group's advocacy of a synthesis between art and architecture and its public orientation suggests a precedent for the group Espacio, which Soldevilla founded in Havana in 1964.

Like Soldevilla, Arcay arrived in Paris in 1949, in his case on a grant to study painting, and he too developed his artistic identity under the auspices of the School of Paris. His career took a decisive turn following a propitious, early meeting with Bloc, the architect and sculptor well known as the cofounder (with Le Corbusier) of the avant-garde journal *L'architecture d'aujourd'hui*. Bloc offered him work as a print-maker and, despite initial misgivings—"I had left a really good job in Cuba as a silk screen printer . . .

and I wasn't going to fall right back into what I had just given up"—he took the job and a studio at Bloc's villa in Meudon, a suburb of Paris.[40] Meudon was home to a number of artists—Alberto Magnelli, Fernand Léger, Sonia Delaunay (1885–1979), Robert Delaunay (1885–1941), Jacques Villon (1875–1963)—and Bloc cultivated a community there into which Arcay was warmly received. His first album, *Art d'aujourd'hui: maîtres de l'art abstrait* (1953), included prints by sixteen artists whose work he had known only from books in Cuba, among them Kandinsky, Klee, and Mondrian.[41] Arcay's study of historical abstraction at first hand unquestionably inflected his own artistic practice, which already showed post-Cubist, flat-pattern geometries by the time of the exhibition *Art cubain contemporain* (1951), to which he contributed two paintings, and the *Salon des Réalités Nouvelles*, where he exhibited between 1952 and 1954. Arcay joined Groupe Espace in 1953, and in three years' time he gave up easel painting altogether in favor of mural painting, which he believed more responsive to the "artistic and sociological conditions of the day" and better equipped to express "new notions of space and time" through the synthesis of the arts, not least the integration of art and architecture.[42] In the 1950s he executed a number of murals in collaboration with the architect Jean Ginsberg (1905–1983), another member of Groupe Espace, which made manifest the expansion of interlocking geometries into modernist architectural space. Insistently horizontal, his sixteenth-arrondissement mural references the increasingly rationalized spaces and skyline of the city during postwar reconstruction: black bands with differing thicknesses change lanes across the design, navigating around the denser geometries of black and blue squares and rectangles at its center (fig. 81). "Arcay is the Paganini of the white space and the millimeter," Arp wrote on the occasion of Arcay's solo exhibition at the Galerie Denise René in 1962, where he exhibited various "propositions" and maquettes. "Arcay is the perfection of Cuba's Cubists."[43] Notwithstanding the anomaly of "Cuban Cubists"—with the partial exceptions of Peláez and Lam, Cubism found little historical traction in Havana—Arcay cut a singular, transatlantic identity as a pioneer of serigraphy in Paris and as the sole Cuban member of the internationalist and multidisciplinary Groupe Espace. With the exception of a solo exhibition at the Lyceum in 1954, Arcay was primarily known in Havana through Soldevilla, who promoted his work in a show of the School of Paris at the Palacio de Bellas Artes and later at Galería Color-Luz and through Los Diez. The extent to which his critical interests in the integration of the arts were known to Consuegra, López Dirube, and others in Cuba is difficult to ascertain, but the simultaneity of his practice in Paris marks him within the early, diasporic history of Cuban concretism.

The impact of Soldevilla's European venture on Havana's concretos is more readily discernible, given her instrumental role in consolidating the movement upon her return to Cuba. She was not a prolific artist in any medium—she worked in collage, painting, and sculpture—but as a dynamic hinge between the School of Paris and Havana's concretos, she brought new direction and an up-to-date critical apparatus to bear on a local artworld lacking coherence at mid-decade. Soldevilla's practice progressed

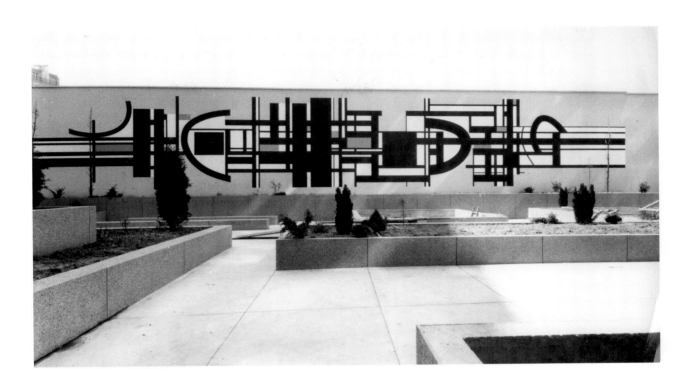

apace in Paris, and the work that she brought back to Cuba showed her facility with the Constructivist idiom and suggests the range of references upon which she drew. Herself an artistic latecomer, she quickly shed the heavy matière of her early sculpture (shown at the Lyceum in 1950) and the "wild poetry," per Zadkine, of earlier still-lifes and portraiture.[44] By 1952–53 she was working capably within the rationalist restraints of Constructivism, a progression seen clearly in a number of collages dedicated to luminaries of modernism—Arthur Rimbaud, Kazimir Malevich, Arp, Franz Kafka, even Darié—between 1954 and 1956. The additive aspect of Soldevilla's collages relates closely to her constructions in wood, which build upon the repetition of circular and rectangular forms in black and white. In a way reminiscent of Sophie Taeuber-Arp's polychrome *Rectangular Reliefs*, which she knew first from a magazine reproduction, and Sérgio de Camargo's white reliefs, Soldevilla's compositions analyze the relationship between positive, negative, and perspectival space through variations in color and shape. In an untitled relief from 1957, for example, the revolution of the circle is hypostatized multiple times against the square, presented as both flat, off-white ground and, in black, as a three-dimensional cube (fig. 82). In shallow, monochrome relief, two circular forms appear to rotate around the edge of a larger cylinder; the circle at right follows the circumference of the largest circle, itself nearly tangent to the smallest (fourth) circle, left unpainted and set directly onto the square ground. The optical convergences of the four, interrelated circles render the sculptural surface into a modular perceptual field, each

FIGURE 82

Loló Soldevilla, *Untitled
(Abstraction)*, 1957. Mixed media
on wood with wood components.
20¾ × 22 in. (52.7 × 55.9 cm).
Monica and Javier Mora
Collection.

cylindrical block projecting a different relationship between material, light, and shadow.
In a nod, perhaps, to Kazimir Malevich's iconoclastic *Black Square* (1915), the obduracy of
the black cube in the lower right-hand corner insists on the literality of the wood sup-
port, resisting the optical impulse toward dematerialization.

Among Soldevilla's most intriguing, and expressly optical works from the Paris
years are the *Relieves luminosos*, which she developed with the Spanish Kineticist Eusebio
Sempere (1923–1985), a student at Arcay's atelier in 1955 and an assistant at the Galerie
Denise René. The reliefs were first shown at Valencia's Club Universitaria in 1954 and
later exhibited in the *Salon des Réalités Nouvelles* in 1955 (and still later at the Museum of
Modern Art, at William Seitz's seminal period exhibition, *The Responsive Eye*, in 1965).[45]
Based on the geometries of the circle and the square and produced in black and white,

their boxes—here in an example by Sempere—projected light through reiterated grids, making mechanical the optical play of light and shadow (fig. 83).[46] In 1955, Soldevilla and Sempere published a "Manifesto," in which they drew an evolutionary history of light from Leonardo da Vinci through Caravaggio and laid out the material parameters and poetics of changing light and transparency effects.[47] They understood light as a means of "expanding the horizons of nonfigurative art," and Soldevilla's light reliefs suggest a logical progression beyond her earlier constructions in wood and metal.[48]

Also in Paris, between 1948 and 1954, was Carmen Herrera, a pioneer of Hard-Edge abstraction and an idiosyncratic figure within the history of Cuban concretism. Although Herrera may be considered a contemporary of the concretos, she was largely an invisible presence in Cuba during the 1950s, having first left in 1939; she settled permanently in New York in 1954. Herrera spent most of the 1940s in New York, where she attended the Art Students League (1943–45) and moved in the circles of the rising New York School, which included the Hard-Edge painter Leon Polk Smith (1906–1996) and the Abstract Expressionists Mark Rothko (1903–1970) and Barnett Newman (1905–1970), who became a close friend. Herrera's agitated *Habana Series*, painted in a moment of

FIGURE 83

Eusebio Sempere, *Relieve luminoso*, 1955. Mixed media (wood, plastic, metal, incandescent lights, two electric switches). 47 × 25¼ × 6 in. (119.8 × 64.3 × 15.4 cm). IVAM, Institut Valencià d' Art Modern, Generalitat.

FIGURE 84

Carmen Herrera, *Iberic*, 1951.
Acrylic on canvas on board. 40 in.
(101.6 cm) diameter.

self-described "rage" during a short stay in Cuba, marks an expressionist aberration in
a practice otherwise characterized by a cool, architectonic minimalism in step with the
leading-edge geometric abstraction shown at the *Salon des Réalités Nouvelles*, where she
exhibited between 1949 and 1952. Herrera experimented with shaped canvases during
this period, and the geometry of ovals and tondos imparts new tensions to the shapes
arranged across the canvas. Working against the traditional illusionism of the frame
(following Picasso and Braque and, more pertinently, artists like Smith working after
Mondrian), the red, orange, and black forms of *Iberic* (fig. 84) take cognizance of the
shape of the canvas whole, both rhyming with the circumference (circles, semicircles)
and contesting it (right angles). Herrera opened her first solo exhibition at Galería
Sudamericana in 1956 but struggled to establish herself, later recalling that Rose Fried,
a dealer known for her role in promoting abstract art in the United States, declined to
give her a show on account of her gender ("the men have families to support").[49] While
Herrera undoubtedly belongs within the diasporic history of Cuban abstraction, along
with Waldo Díaz-Balart (b. 1931), she was at best a fringe member of the generational
concretos and, as such, remains largely outside the cubanista narrative of Los Diez in
later 1950s Havana.

"LA PRIMERA EXPOSICIÓN CONCRETA"

While the Cuban presence in 1950s Paris remains little acknowledged, certainly relative to that of other artists from the Americas, the visibility of Soldevilla and Arcay abroad and the transatlantic exchange they initiated catalyzed the development of geometric abstraction back in Cuba. The slow buildup from Darié's Madí connection and Carreño's homecoming dovetailed with the momentum of Martínez Pedro (and soon, Soldevilla) returning from Europe and preaching the gospel of concrete art. By the time of Martínez Pedro and Darié's two-man exhibition at the University of Havana in April, deemed Cuba's "primera exposición concreta," the concretos were primed to capitalize on the confluence of factors working in their favor. First, the serial missteps of the onceños, beginning with the financially motivated decision to show at the Salon of the Círculo de Bellas Artes in February and ending with Raúl Martínez's ill-advised diatribe in June, had compounded the internal divisions within the group. With the dissolution of Los Once and the group's temporary retreat from the public eye, the concretos were able to tactically introduce concrete art in idealist and historicizing terms without the competing distraction of gesture painting and, no less, its own teleological vision. (However careful the concretos were to distance themselves from Los Once, they unquestionably benefited from the publicity, negative or otherwise, that the onceños brought to abstract art; the concretos' initial foregrounding of intellectual and aesthetic questions, rather than political ones, permitted them more latitude.) Furthermore, Carreño's position at the INC allowed him to introduce concretism at the Palacio de Bellas Artes—through exhibitions of the School of Paris (1956), for example, and a personal retrospective (1957)—and thus to accord it a national imprimatur as well as an international one. Finally, concretism slotted easily into the aspirational self-imaging of Cuba as a modern nation—the "New York (or, Paris) of the Caribbean"—with a visual culture to match. The conceptual patterning of the Plan Piloto for Havana and the strategic curatorial placement of Cuban art abroad are testament to the broad diffusion of geometric abstraction.

If Darié's *Estructuras pictóricas* had been seen as curiosities in 1950 and Martínez Pedro's exhibition at the home of Miguel Gastón had been viewed only by invitation, their exhibition at the University of Havana introduced concrete art to a public better conditioned to understand it (fig. 85). The exhibition included a number of Darié's *Estructuras transformables* and examples of his *"poesía óptica"*; Martínez Pedro showed a new series of geometric paintings and collages. In many ways two faces of the same coin, Darié and Martínez Pedro represented reciprocal tendencies within concretism over the decade spanning the mid-1950s through the mid-1960s, and their complementarity appeared already by the time of the 1955 exhibition. "In short," Marquina noted, "Luis Martínez Pedro immerses himself in painting; Sandú Darié breaks away from it. The fourth dimension preoccupies them both: for the former, in the fixity of stillness and, for the latter, in an obsession with movement."[50] Perceptual questions predominated as each artist probed the space and time of his medium—painting, collage, sculpture—through

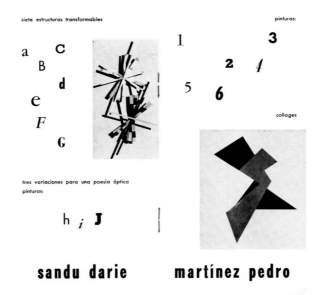

FIGURE 85

*Martínez Pedro, Sandú Darié,
abril 25 a mayo 10*, exh. brochure.
Universidad de la Habana,
Pabellón de Ciencias Sociales,
Escuela de Arquitectura y
Planificación, 1955.

different incursions within geometric forms. Darié continued to expand the range of his *Estructuras transformables*, multiplying nodes and connecting them into articulated structures (fig. 86). A moving dialogue between the square—the amorphous "negative" space framed between the two modules—and the circle, formed in the mind's eye through the rotational movement of wooden planks around two points, this structure not only breaks its frame, in madista terms, but also repositions the work itself directly on, and beyond, its framing edge.

For both Darié and Martínez Pedro, whose work became more and more reductive, the act of viewing appeared comparable to that of listening; and indeed music, as a measure of time and space, remained a persistent point of reference for each artist over the next decade. The plasticity of sound and its reliance on a listener lay at the center of their adaptations of concretism and, particularly, their educational outreach. Their publicity campaign, aided by a friendly press, included public lectures in which the artists ("evangelists") appealed directly to their audience to take an active role. "It's like seeing music," one overheard conversation begins, as partially transcribed in the newspaper:

"But you hear it?"
"When I like music I don't hear it, I see it."
"Where?"
"In the air."

The review concludes, "The spectator assumes half of the work. Where there is no viewer, there is no work."[51] Darié and Martínez Pedro's recourse to music as a heuristic device was, as a practical matter, a means of cultivating a skeptical audience mostly

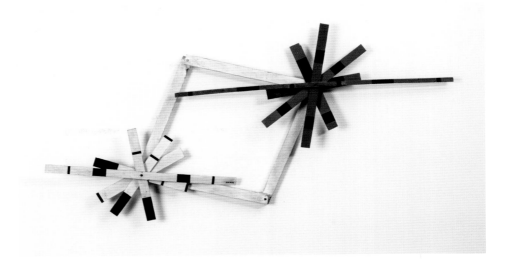

unfamiliar with nonfigurative art. Yet the temporal structure of music also inflected their work at a prior, ideational level that harked back to Mondrian's vision of pure painting: lines, forms, and colors held in dynamic and irreducible equilibrium. As early as 1922, in an essay on the feasibility of "Neo-Plastic music," Mondrian articulated the temporal structure of his painting, writing, "We look at a Neo-Plastic work and perceive successive relationships; after the first general impression our glances go from one plane to its oppositions, and from these back to the plane. In this way, avoiding traditional representation, we continually perceive new relationships which produce the total impression."[52] This dialectic of vision, in which the optical vibrations serve not only a pictorial purpose but also a fundamentally productive one ("the total impression"), has both a musical derivation and a deeply historicizing function. The musicality of such a cumulative act of viewing accords with the kind of compositional (contrapuntal) dynamics seen in Martínez Pedro's paintings from this period, in which the paces and rhythms of viewing are insinuated by their titles (*Andante, Allegro*). But to an even greater degree, Darié's paintings extended these internal dialectics outward, mediating as well the historical conditions of the artist's arrival in Cuba.

Darié fled Europe for Havana in 1941, after a year's service in the French Army as a volunteer, and he became a Cuban citizen in 1945. By the time of his first exhibition at the Lyceum in 1949, he had reinvented himself as an abstract artist, departing from the humoristic mood that had characterized his earlier work in Paris. The source of this change was almost certainly internal. The precepts of Neo-Plasticism and of abstraction generally were long familiar to him, gleaned from the fifteen years he spent in Paris; the visual culture of 1940s Cuba, characterized by the lush tropicalism of the Havana School, would not have obviously precipitated a turn toward concretism. Darié's compass-points

at the beginning of the 1950s stretched rather from Europe to New York and South America, and his concrete practice rendered the spatial and temporal ruptures of these transnational coordinates in (Neo-)Plastic terms. Harry Cooper has suggested that Mondrian's transatlantic paintings, repeatedly revised in New York (he arrived in 1940) and inscribed with double dates, "meditate on exile, offering an abstract iconography of its dialectics of rift and continuity."[53] Cooper considers the dialectics in Hegelian terms, explaining Mondrian's famous enthusiasm for piano boogie-woogie as an ultimate (that is, teleological) means of giving shape to his experience of dislocation; the "sonic boom," as it were, of jazz music provided the final strike to Neo-Plastic duality and opposition, allowing him to find his return to an original unity (in other words, a sublation of duality). Darié's work at mid-decade does not yet resolve, or sublate, the problems of repetition and rhythm, but it engages a similar dialectics of viewing (in time) and disjunction (as a measure of distance). In a more subtle way than the articulated sculptures, manipulable by a viewer, or the numerous paper collages that literalize cuts and textures, his major paintings from this period superimpose the temporality of viewing and the tactile conjunctions of space (fig. 87). Here, the optics of contrapuntal progression play out in the analysis of overlapping planes that push against the framing edges of the canvas. Varyingly scaled and upended, the red and black triangles swivel optically, almost accordion-like in space, vibrating against each other and to the black frame, displacing the formalist tension of the picture plane outward, by now self-consciously in madista terms, into the world.

For both Darié and Martínez Pedro, the syncretic impulse behind the historical Neo-Plastic vision—that is, visual harmony and unity as a cognate for society—translated as "a paradigm and an instrument, not an ideal," in the words of Romero Brest, quoted in the catalogue brochure of their joint exhibition.[54] Their aim was less to geometricize the city per se than to animate its spaces and, in that way, to penetrate the social and collective conscience of the nation—a utopian conceit, no doubt, but not a formalist one. Marquina, again among the keenest observers of Havana's artworld during this time, recognized the "pictorial conscience" of Martínez Pedro and the constant striving of Darié's structures to integrate aesthetic and social orders.[55] While Darié was a recognized madista by the mid-1950s, named in the *Dictionary of Abstract Painting* (1957) "the simplest and most level-headed of the Madí artists," in many ways the geometric movement in Cuba had more in common with the rival Argentine group, the Asociación Arte Concreto-Invención (1945–47).[56] Led by the artists Tomás Maldonado (based, beginning in 1954, at the Ulm School of Design alongside Max Bill), Alfredo Hlito, and Raúl Lozza, Arte Concreto-Invención sought to serve "the world's new sense of communion" through "concrete art [that] makes people relate directly to real things." The group stressed the artist's pedagogical role in society and outreach to the public—"down with all elite art, up with collective art," its manifesto proclaimed—and in that aspect their vision resonated more and more with the philosophical and didactic program of Cuba's concretos.[57]

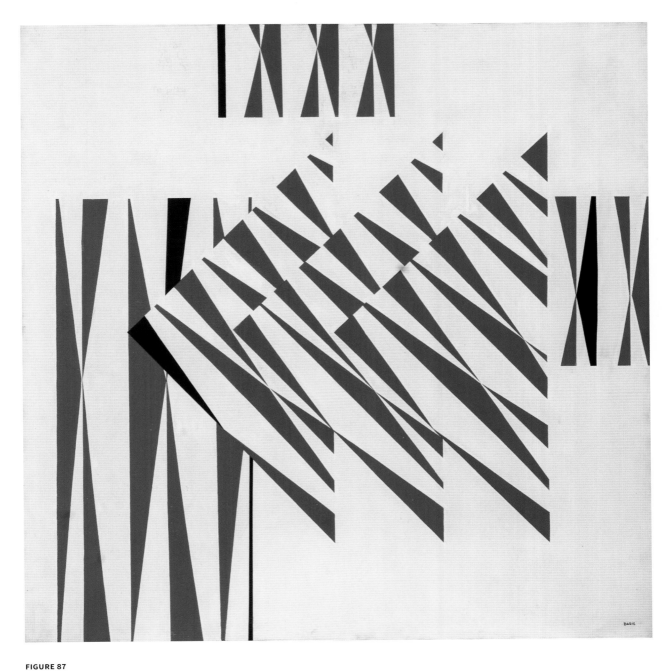

FIGURE 87
Sandú Darié, *Untitled*, c. 1950s.
Oil on canvas. 36½ × 36½ in.
(93 × 93 cm). Collection of John
Harald Orneberg.

CUBA CONCRETA

Soldevilla's return to Havana at the start of 1956 provided a decisive boost to Darié, Carreño, and Martínez Pedro, whose early, proselytizing efforts had carried Cuban concretism to this threshold moment. The concretos gained new validation with a major exhibition of postwar abstraction, *Pintura de hoy: Vanguardia de la escuela de París* (March 22–April 8), organized by Soldevilla with support from Carreño and the INC at the Palacio de Bellas Artes (fig. 88). Drawn from her personal collection, assembled in Paris, the exhibition included forty-six artists at the forefront of Hard-Edge, Op, and Kinetic art, among them, Arp, Bloc, Sonia Delaunay, Serge Poliakoff (1900–1969), Nicholas Schöffer (1912–1992), Michel Seuphor (1901–1999), Luis de Soto, and Vasarely, alongside Soldevilla herself and Arcay (the only Cubans). Carreño wrote a brief introduction to the catalogue, in which he again broached the question, "Is this art?" and declared perforce that abstraction reflected the "sui generis manifestations" of the modern mechanical age.[58] Like many of his other writings on abstraction, his text imparted an organic inevitability to the evolution of abstraction, drawing here upon Henri

FIGURE 88

Pintura de hoy: Vanguardia de la escuela de París, exh. brochure. Palacio de Bellas Artes, Havana, 1956.

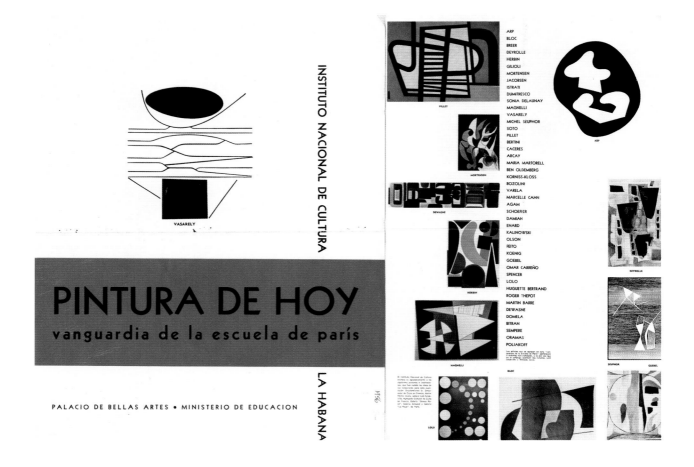

Focillon's formalist invocation of the "spirit of the age" to explain the surge of geometric abstraction. Unsurprisingly, the concretos took advantage of the exhibition as a teaching opportunity; Darié led a guided tour later recounted as no less than a full exegesis of abstraction and the historical avant-garde.[59] The consistent didactic attentions of the senior concretos played an important role in the development of both the public and a younger generation of artists, many of whom had known the European avant-garde only through limited reproductions. Severo Sarduy remarked, for instance, that Mijares entered his "concrete" phase "under the sign of Pillet and Vasarely," an introduction made indirectly by Soldevilla.[60] Indeed, Mijares' work shed its earlier, miniaturist detail by the end of the decade; simplified in both pattern and color, characteristically blocked in thick, black lines, his concrete painting posited (in a way like that of the Argentine artists) irregular shapes as formalist reinvention and, therein, revolution. At an institutional level and to the faltering INC, the concretos represented an internationally viable Cuban avant-garde—less dated than the Havana School and unthreatening politically—and with no viable alternative in sight, concretism faced few, if any, political challenges through the end of the Batistato. Resistance to Batista within the cultural field came from other disciplines, and concretism developed in the eye of the storm, as it were, outwardly agnostic and yet bound by the political situation of an increasingly terrorist state.

Carreño, in many ways the prime mover of the vanguardia since the late 1930s and the figure most responsible for the modern incandescence of Havana's artworld, also bore the brunt—personally and publicly—of the INC's failings. "You know better than anyone the ways of this blessed land," he wrote to Gómez Sicre in April 1957. "I hardly need to explain to you how things work, or rather how they don't work here. . . . The INC has suffered, and is suffering very difficult times."[61] Carreño left his position at the INC before the end of the year, accepting an invitation to teach in Chile, where he lived for the duration of his career (and took citizenship in 1969).[62] Notwithstanding his self-compromising position under Batista, his departure registered a blow to the vanguardia, who lost one of its cleverest and most talented members and a sympathetic voice within the INC. Not least among his legacies for Cuban concretism was a major retrospective of his nonfigurative work, *El mundo nuevo de los cuadros de Carreño, 1950–1957*, held at the Palacio de Bellas Artes months before he left.[63] "The evolution of his art is guided by our century's creative dialectic," Darié wrote in the exhibition catalogue, in words as easily applied to his own practice. "The viewer's gaze will pass optically from one form to another, discovering the rhythm of the picture, traversing its space-time."[64] The Constructivist cadence of these paintings, organized around totemic vertical shapes and leavening horizontal bars, unfolds in different arrangements—sometimes laterally, in a shallow optical field, and other times in vertical accretions that more tightly demarcate the space. Their temporality is both formal—for example, in the explicit musicality of *Sonatina* and *Symphony in Yellow*—and subtly emotional, registered in the localized cosmos that other titles address (*Equinox, Tropic of Cancer, Southern Skies* [see

fig. 74], *Summer*). A stirring swan song, the retrospective was declared "a decisive moment for abstract art" by Marquina; de la Presa's cubanista summation—"universal painting nationalized in Cuba"—plausibly endorsed the concrete generation tout court.[65] The exhibition traveled in September to Venezuela, where Carreño was lauded as Cuba's "best representative of non-figurative art."[66] Carreño made the decision to leave Havana shortly following his return from Venezuela, and he remained detached from the city's cultural politics of the next several years; for all his decade-long, vigorous defense of nonobjective painting, his work reversed course in the early 1960s as he revisited the iconography—women, still life, landscape—of his work from the 1940s, often adding oneiric and metaphysical overtones. As artist, administrator, and critic, he left a singular, if at times maddeningly inconsistent legacy for abstract art; while his activity between 1951 and 1957 has fallen largely by the historical wayside, he was a driving force behind the maturation of concretism by the decade's end.

While Carreño (following Lam) headlined Cuban inroads in Venezuela, others of the concretos also set their horizons abroad between 1956 and 1958, often in national contexts but also commercially. Darié and Martínez Pedro reprised their "primera exposición concreta" in Miami Beach, for example, installing works in offices and waiting rooms of the Washington Federal Savings and Loan Association.[67] As an integrationist intervention (to wit, toward the "habituation of the spectator"), the exhibition likely had limited reach. But its positing of works—three *Estructuras transformables* and four paintings—as "a sedative, a reason for living, a stimulation of the spirit" reinforced the social turn of concretism and its functionalist intent.[68] Darié traveled to Paris in 1957 for the *Salon des Réalités Nouvelles*, where he showed *Aleph I*, a lozenge-shaped canvas affixed to a dowel.[69] (He rarely titled works, and his use here of the first letter of the Hebrew alphabet as a symbolically alpha-numeric starting point cast subtly back to his past.) Soldevilla and de Oraá, her companion, traveled to Caracas for exhibitions in 1957: Soldevilla showed geometric paintings, Constructivist panels, and light-boxes at the Centro Profesional del Este in May, and de Oraá held his first solo exhibition at the Galería Sardio over the summer. The experience in Caracas was eye-opening for the Cuban concretos, de Oraá later recalled, citing in particular the ethical and aesthetic position of the Venezuelan avant-garde against Pérez Jiménez (eliding the local precedent of the onceños).[70] He neglects to mention Carlos Raúl Villanueva's Ciudad Universitaria, the Constructivist utopia of arts integration nearing completion by the late 1950s, though its impact seems undeniable. Villanueva's early associations with the Groupe Espace in Paris and his solicited contributions from the School of Paris—Arp, Bloc, Léger, Vasarely, among others—suggest commonalities with the Cuban concretos; the project's internationalism and humanist imaginary also find a parallel in the 1961 design of the Escuelas Nacionales de Arte, Cuba's National Art Schools. Ricardo Porro, the project's iconoclastic architect, worked with Villanueva on the Banco Obrero in Caracas (1958–60) before returning to Havana and embarking on the design of the schools.[71] But in a more

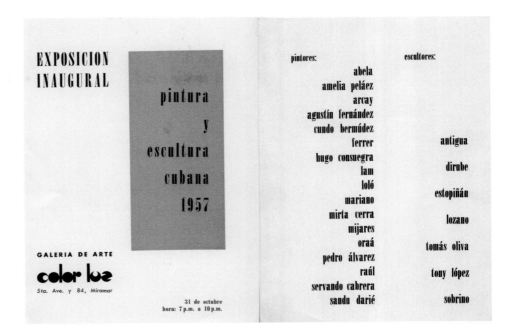

immediate sense, the months in Caracas led Soldevilla and de Oraá to conceive of a gallery of their own, which they opened in Havana in October.

Between 1957 and 1960, Galería Color-Luz served as an informal headquarters for the concretos and others of the vanguardia, functioning as a semi-permanent exhibition space and as an incubator for Los Diez (fig. 89). Founded by de Oraá and Soldevilla, the gallery opened on a residential block in Miramar on October 31, taking its name and insignia from the sculptural *"relieves luminosos"* (light-reliefs) that Soldevilla had continued to develop since her original collaboration with Sempere.[72] The gallery's inaugural exhibition featured works by all three vanguardia generations, including many of the onceños and the future "diez."[73] In his introduction to the gallery, Lezama Lima praised the evolution of painting that had "gone beyond its limits of discovery," entering into a new phase in which "the metaphysics in the air is resolved in the hypostatized geometry of the figure."[74] Over the next four years, the gallery supplemented a permanent exhibition of vanguardia artists with one or two special exhibitions each season that primarily served a didactic purpose (the gallery was not commercially successful) and drew considerably from Soldevilla's personal collection.[75] *Homenaje al pequeño cuadrado* (1957), a nod to Josef Albers' famous series *Homage to the Square*, and *El arte abstracto en europeo* (July 3–31, 1958), for example, presented paintings and prints not able to be included in the 1956 exhibition at the Palacio de Bellas Artes by artists including Agam, Jean Deyrolle (1911–1967), and Vasarely (fig. 90).[76] Another exhibition, *El* panneau *moderno en Cuba* (August 1–31, 1958), showcased the technical innovations of the contemporary

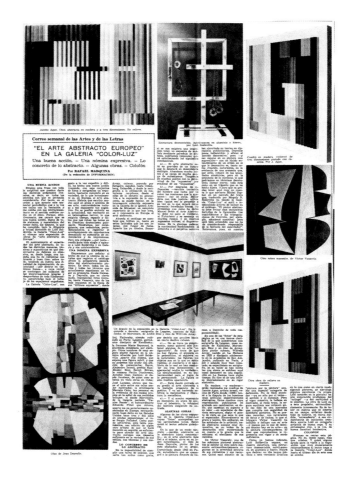

mural movement; the work and influence of Arcay, whom Darié saw in Paris in 1957 on the occasion of the *Salon des Réalités Nouvelles*, cannot be doubted.[77]

The gallery struggled over the question of whether to remain open in the last six months of 1958 amid the climate of asphyxiation that rent the island from the eastern provinces of Oriente, Las Villas, and Camagüey, under a state of "total warfare" by summer, to the heavily policed state of Havana.[78] Yet its steadfastness, at a time when others among the vanguardia chose silence as their form of protest, was meant fully as an act of resistance. "For us," de Oraá later explained, the gallery "signified a bastion from which to project an attitude of resistance and a program of action to protect, to the extent of our ability, the artistic values undermined on the one hand by the opportunism of the cultural apparatchiks and on the other, by the partisan dogmatism that failed to recognize those values."[79] The concretos lacked the journalistic platform that had propelled Los Once into the national and international spotlight, a casualty of the suspension of constitutional and civil rights in effect since the end of 1956. Yet their assiduous exhibition practice—now clearly, if covertly, in the shape of praxis—gave their artwork comparably cubanista purchase, in the same way that the prolonged protest of the Anti-Bienal

had invested the work of the onceños with political valence. The fact of the gallery's survival through 1958 and its commitment to the social values of concrete art constituted more than a symbolic resistance to the Batistato; it conferred the cubanista mantle of utopia, telos, and revolution onto the generation of Los Diez and, in that way, aligned concretism with a (still unknowable) postrevolutionary future. The coincidence of the gallery's final exhibition of the year, *La exposición aniversario: Pintura y escultura cubana 1958*, and the overthrow of Batista occasioned both a celebration and, in due course, the emergence of Los Diez.[80]

LOS DIEZ PINTORES CONCRETOS

"The formation and the launch of the group Diez Pintores Concretos in our midst was the result of [Galería Color-Luz]," de Oraá later stated, "and one of our greatest satisfactions."[81] The sole member of Los Diez to publish an account of the group's history, de Oraá is careful to underscore the intelligence and intentionality behind their alignment with international concretism ("we were not so naïve; we had quite a clear understanding of the subject and ample information").[82] The integrative, interdisciplinary initiatives of both the Grupo Madí and the Groupe Espace provided certain points of reference; de Oraá notes in particular the synchronicity of concretism in Spain after 1957 (for example, the group *Arte Normativo*, led by Jorge de Oteiza) among the contemporary, transatlantic waves of geometric abstraction.[83] Less homogenous than the onceños, both generationally and professionally, Los Diez included on one hand the established senior practitioners, Darié and Martínez Pedro, and on the other a mostly younger cohort who had arrived at abstraction through varied and sundry paths: Pedro Álvarez, Arcay, Corratgé, Alberto Menocal, Mijares, de Oraá, Soldevilla, and Soriano. Arcay, still resident in Paris, returned to Cuba a couple of times but mostly lent his support from abroad. José Rosabal (b. 1935) replaced Álvarez as one of the nominal "ten" at some point before 1961; Rosabal and Menocal, the youngest and most "extreme" of the group, broached proto-Minimalist forms.[84]

The history of Los Diez, comprising just three dedicated group exhibitions and two published volumes, forms a brief episode within the longer chronology of concretism, spanning Darié's first *Estructuras pictóricas* (1950) and the exhibition of Martínez Pedro's *Aguas territoriales* in 1963. Its temporality was no doubt a referendum on the intense political moment of 1959–61 and the escalating rhetoric around the character of revolutionary art. The group's debut exhibition, *10 pintores concretos exponen pinturas y dibujos*, opened in November 1959 at the gallery's new, smaller location in Vedado (the former premises of García Cisneros' Galería Cubana).[85] Los Diez exhibited next at the Biblioteca Pública "Ramón Guiteras" in Matanzas, in January 1960 (fig. 91), and later at the Galería de Artes Plásticas in Camagüey.[86] According to de Oraá, the concretos foreswore the publicity (and notoriety) of an extensive exhibition schedule to better focus on

10 PINTORES CONCRETOS

FIGURE 91

Cover, *10 Pintores Concretos, 9–16 de enero*, exh. brochure. Coordinación Provincial de Actividades Culturales, Ateneo y Amigos de la Cultura Cubana; Galería de Matanzas; Biblioteca Pública "Ramón Guiteras," Matanzas, 1960.

the art itself, a debatable decision that resulted in their marginalization within the artworld.[87] In the place of exhibitions, Los Diez channeled their activism through the print medium. They published two volumes of prints, both produced by Corratgé: *7 Pintores Concretos* (1960) and *A* (1961), in which each artist interpreted the letter "A" in support of the national literacy campaign begun that year.[88] The serigraphs from the latter edition were exhibited in the *Feria de arte cubano* that accompanied the First National Congress of Writers and Artists of Cuba (1961), and they marked the last formal activity of the group. Their limited visibility, if partly by choice undoubtedly also for want of opportunity, undercut the social extension of concretism as a real-world practice. But their vision, however much latterly refined by de Oraá in the intervening decades, speaks to the sense of possibility that took hold. The concretos may have ceded the revolutionary moment to others, but their articulation of collectivist art practice underlay the culmination of Cuban abstraction as it entered into public space.

The crux of the concrete proposition in Cuba centered on the integration of the artwork—authorless, collective, and participatory—into the social landscape. "This is concrete painting because each painting is a new reality," Darié affirmed, echoing de Oraá: "To insert oneself into the world is to be swept up in the social tide."[89] In a departure from Carreño's earlier intellectualizations (the artwork as a "cosa mentale"), Los Diez foregrounded the social reality of their work, railing against the "fallacy of the ivory tower" and affirming their practice as a transformative intervention into—not a reflection of, nor an escape from—the world.[90] They declared themselves for anonymity, sharing authorship with each other and the spectator; their works unfolded in real space and time, collapsing the distinctions of inside and outside, form and space. Stark binaries of black and white shape positive and negative space in Soldevilla's *Diagonal Silence*, dedicated later to Castro: atop mirroring (not symmetrical) rectangles, a gridded pattern of wooden circles and semicircles—black on white; white on black—surrounds two blank spaces, their optical "silence" a meditation on the symbiosis of presence and absence, dark and light (fig. 92). Less austere but worked similarly in black and white, de Oraá's paintings concretize the poetics of movement that had earlier animated a series of drawings made in Caracas. Closer in spirit to the emotional *geometría sensível* of South America than to European *art concret*, his organic forms reverberate slightly off-axis, shapes just touching (or not) across the opaque space of the picture's surface (fig. 93). The ultimate, "humanist dream of the integration of the arts appeared to find in this nascent moment its possibility of realization," de Oraá ruminated, echoing the earlier

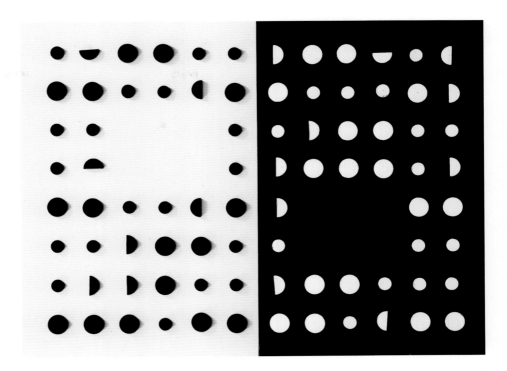

and ongoing propositions of Consuegra and others.[91] Still the concretos were overshadowed in the public discourse on arts integration, led by Consuegra and the architects Fernando Salinas (1930–1992) and Raúl González Romero, who began to rebuild the School of Architecture in September 1960.[92]

To a greater extent than even the revived onceños, Los Diez struggled to advance their social manifesto, and their dissolution in 1961 was a tacit acknowledgment of their peripheral and diminished place.[93] Although the group publicly and enthusiastically embraced the Revolution, perceived associations with the Batista regime shadowed many of its constituents (and arguably concretism itself), fairly or not. A few of the concretos attempted to engage the Revolution in a literal way, with limited success. Martínez Pedro exhibited five paintings from the "26th of July" series, described as "stark and severe geometrical compositions in black, red and gray, the colors of Fidel Castro," at the Gres Art Gallery (Washington, D.C.) in February 1959. He reportedly painted them behind closed doors, not showing them in an act of personal resistance to the Batista regime.[94] The newspaper headline, "Paintings are Pro-Castro," and Martínez Pedro's facile interpretive gloss—"This one is particularly dramatic. That is how things were in Cuba in December"—reduced the revolutionary content to description, omitting the functional role of the artwork emphasized by the others.[95] Mijares likewise worked within a somber palette (white, black, gray) during this time, conceivably in a nod to the 26th of July movement; his simultaneous abandonment of oil paints for a spray gun fell clearly within

FIGURE 93

Pedro de Oraá, *Untitled*, 1960. Plaka on cardboard. 23⅝ × 15¾ in. (60 × 40 cm). Private collection, London.

FIGURE 94

Salvador Corratgé, *Untitled*, 1964. Acrylic on canvas. 37½ × 35⅘ in. (95 × 91 cm).

the concrete playbook.[96] Los Diez eventually acknowledged the futility of their project, de Oraá notes with chagrin, citing the poorly conceived integration of art in public spaces and the official ambivalence surrounding the "necessity of art" at all.[97] The concretos conceded the public sphere in 1961, disbanding the group and closing Galería Color-Luz. Soriano and Mijares left for Miami in 1962 and 1968, respectively; de Oraá traveled to Bulgaria (1964–66); Soldevilla concentrated her attention on literary pursuits; Arcay remained in Paris; Corratgé accepted a diplomatic position at the Cuban Embassy in Prague (1963–67).[98] Abroad, Corratgé's painting shed the acute rectilinearity and smaller patterns that had characterized his works by the end of the 1950s, moving toward greater simplification of shape, line, and color. More approximate to Hard-Edge abstraction, these paintings indulge the experience of looking: color and shape are here one, the blue rectangle at right affirming the shape of the canvas and the sequence of curving, blue and black forms projecting outward beyond the painting's edges (fig. 94). The group's mass diffusion brought its decade-long project to a quiet anticlimax; it ended practically before it had begun. Yet the afterlife of concretism had already been written into its beginning, vis-à-vis the heuristic role of music in the work of its longest-standing adherents, Darié and Martínez Pedro.

CODA

While the cubanidad of concretism—no less, of abstract art of any kind—had its doubters through the 1950s, the introduction of concrete, or electroacoustic, music to Cuba in 1959 was assimilated from the beginning in national terms through the person of Alejo Carpentier (1904–1980), the writer and musicologist. A former minorista who spent much of his career in self-exile (in Paris between the wars; in Caracas beginning in 1945; and again in Paris from 1966), Carpentier drew upon music as a structuring device for a number of his novels, including *El reino de este mundo* [*The Kingdom of this World*, 1949], among the earliest incantations of "lo real maravilloso." As early as the 1920s, he invoked Stravinsky's groundbreaking, folk-experimental *The Rite of Spring* as "the ideal model for Cuban musical nationalism"; his symphonic novel, *Los pasos perdidos* [*The Lost Steps*, 1953], suggestively entwined autobiographical narrative and contrapuntal temporality.[99] In his landmark publication, *Music in Cuba* (1946), Carpentier analyzed the history of Cuban folk, popular, and classical music in migratory, transcultural terms, elucidating national character through productive regional and transatlantic encounters (for example, the emergence of *contradanza*, the importance of *Afrocubanismo*). Carpentier held weekly tertulias at his home upon his return to Havana, introducing a young generation of composers—namely, Juan Blanco, Leo Brouwer (b. 1939), and Carlos Fariñas (1934–2002)—to recordings and scores of concrete music, supplemented with his own ideas about folkloric tradition and cubanidad.[100] Their rapid apprehension of "*la música nueva*," as it became known, led them to explore open forms of composition and to experimentation with graphic scores, aleatoric composition, and electronic sound.[101] In 1961, Blanco created Cuba's first concrete composition, *Música para danza* [*Music for Dance*], a ballet in three movements, with an oscillator radio; the first public performance of concrete music came three years later, in the gardens of the Unión de Escritores y Artistas de Cuba (Union of Cuban Writers and Artists, UNEAC).[102] The convergence of concrete art and "la música nueva" marked a brilliant, cubanista moment during the 1960s, validating both the polyrhythmic musicality that had long characterized the work of the concretos and the teleological, syncretic impulse that marked the time of the nation. The passage from concrete to electronic and then to the combined form of "electroacoustic" music marked a break with the *cinquillo* and the *toque de claves*, both rhythmic patterns of Afro-Cuban music; in a way not unlike Los Diez, Blanco and his peers sought to rephrase "national" music in cubanista terms.[103] While the beginnings of concrete music in Cuba deserve closer study in their own right, as does the place of music in the work of Soriano, Corratgé, and Carreño, among others, the outstanding collaborations involved Darié and Martínez Pedro. For both artists, the textures and intervals of music had facilitated the structural rhythm of their work since the start of the 1950s, serving as a persistent, and resourceful, medium of engagement; their work with music in the 1960s marked a powerful coda to the visual history of Cuban concretism.

Darié experimented with a range of art forms in the 1960s, drawing out the plasticity of time and movement in sculpture, ballet, and film. *Cosmorama: electro-pintura en movimiento* [*Cosmorama: Electro-Painting in Motion*, 1964], directed by Enrique Pineda Barnet with music by Béla Bartók (1881–1945), Pierre Schaeffer (1910–1995), and Fariñas, introduced concrete music and mechanical movement to nonobjective forms (fig. 95). A "spatial poem," *Cosmorama* defined itself in its opening credits as an "experimental study of moving forms and structures with lights and color that generate images in formation."[104] Just under five minutes long, the film filters light and shadow through a series of geometric objects set in mechanical motion, the colors changing synaesthetically from shifting perspectives. This cinematic conflation of art and music—music made plastic; art rendered as sound—marked the apotheosis of Darié's concrete vision, capping the progression begun with his "optical poetry" a decade earlier.

Where his collages and *Estructuras transformables* had only invoked the fourth dimension, the "all-at-once-ness" of film, per Marshall McLuhan, set the acoustic in material terms, pitching visual and sound effects equally and simultaneously. I earlier described Darié's concrete practice as contrapuntal and dialectical, seeking resolution that could be at once formal (that is, pictorial unity) and personal, mediating his experience of exile. In *Cosmorama*, the cinematic technology of unity, in which sound and image are fused, is suggestively synchronic, a compression of past, present, and future. Its multimedia form corresponds suggestively to McLuhan's tetrad, a variation on Hegelian thesis-antithesis-synthesis that allows for a more fluid (that is, nonteleological) notion of time through four analytics: enhancement, retrieval, obsolescence, and reversal. "The tetrad illuminates the borderline between acoustic and visual space as an arena of spiraling repetition and replay," McLuhan and Powers wrote, "both of input and feedback, interlace and interface in the area of imploded circle of rebirth and metamorphosis."[105] As a recursive and plural space, *Cosmorama* engenders a dynamic, sensory equilibrium—a tetradic fusion not earlier attainable in Darié's two- and three-dimensional works (nor, from the post-1959 perspective, under the Batistato). Against the national transformation wrought by the Revolution, institutionalized and unmistakably radicalized by 1963, the film may also be seen as a distillation of Darié's own, consummately cubanista trajectory. "I am as Cuban as El Greco was Spanish," he stated in the early 1960s, and *Cosmorama*, his concrete tour de force and an ultimate period piece, brought to a sonic close not only a movement, but also the initial shock of exile and assimilation that had accompanied—and perhaps, stimulated—his Constructivist turn fifteen years earlier.[106] The concrete space-time of *Cosmorama* is simultaneously

visual and acoustic, pre- and post-revolutionary. Darié became "concrete," ergo he
became Cuban.

In contrast to Darié's multimedia self-realization, Martínez Pedro pushed concre-
tism to an ambiguous, allegorical end in his series, *Aguas territoriales*, first exhibited in
Havana in April 1963 and sent later that year to the *VII São Paulo Bienal* (fig. 96).[107] Tonal
monochromes, the paintings riff freely upon the strictures of Neo-Plasticism: primary
colors soften into gradations of blue (occasionally, of deep mauve); right angles become
elliptical curves. The optics of the surface, which juxtapose flatness against pulsing,

centrifugal movement, hypostatize the changing cultural geography of Cuba amid the first wave of mass migration. (An estimated 250,000 Cubans emigrated between 1959 and the end of 1962.[108]) Here, the vaunted universalism of concrete art is figured finally within the specific reality of early-1960s Cuba, whose territorial boundaries are distilled in the repeating circles and semicircles that reverberate, sonorously and chromatically, beyond the edges of the frame. Allegorical images, *Aguas territoriales* meditate on the political condition of the island itself, imaging Cuba's regional isolation through the flux of its surrounding waters; the paintings both demarcate Cuba's territorial space and point out its diasporic permeability. "The works of Luis Martínez Pedro are Cuban," Darié wrote in a classically cubanista phrasing, but "of universal vision."[109] Martínez Pedro's poetics are more literal and more catholic than Darié's; if the dislocations of Darié's optical poetry disclose a personal, transnational past, the ruptures of *Aguas territoriales* resonate as fissures within a national body.

The nature of that national embodiedness, elusive already in 1963, permeates *Aguas territoriales* through the synaesthetic simultaneity of sight and sound. That Martínez Pedro structured the series in musical terms is all but certain; notwithstanding his earlier citation of Gropius on music and his collaborations with Darié, the presentation of *Aguas territoriales* in serial form—a departure from his earlier practice—suggests a deeper engagement with the structures of contemporary music (and, in turn, with the series practice of modernist painting).[110] To follow McLuhan again, the "resonating interval" between the acoustic and the visual gives rise to the apprehension of new and continuously changing interfaces within each image (and here, across the series). In stimulating the common sensorium, *Aguas territoriales* privilege the phenomenological, free-associative experience of the viewer who encounters the work across space and time, infinitely shifting its calculus of relationships (between, for example, Cuba and Revolution, Cuba and concretism, Cuba and cubanía). This provisional durationality of the work is further enhanced and activated by its serial construction. The original installation of the paintings as a group, in Havana and in São Paulo, facilitated the perceptual extension of the sound-surface from one canvas to another, inducing an absorptive experience of movement (and, disjunction) through time. The composite effect, accentuated by surface and chromatic consonance across the series, creates a space of continual transformation, or chiasmus, between the visual structuring of the work (as modernist color-sound) and its allegories of distance and difference (as social history). The heterochronic surface as psyche yields myriad metaphors: the waters evoke "maritime wisdom" and "Antillean mythology" (Campoamor); the line functions as the artwork's "emotional transport," there "as a refuge" (de la Torriente); "as the universal sea penetrates our land, the mutations of our myths become fixed in time" (Lezama Lima).[111]

Tellingly, the series served as a point of origin for a musical composition of the same name. Carlos Fariñas dedicated his *Aguas territoriales* (1984) to Martínez Pedro, acknowledging their creative synergies and the tenacity of the concrete-maritime

metaphor.[112] Among the first Cuban composers to incorporate serialism, electroacoustic techniques, and the dodecaphonic scale into his practice, Fariñas based his piece on the sound of water itself, which he recorded and then processed, altering variables such as speed and frequency, into a final mixture of sixteen tracks. Fariñas' composition renewed the historical consciousness embedded within Martínez Pedro's original series, providing the connective tissue between concrete art—almost forgotten by the mid-1980s—and music.

<p style="text-align:center">❖ ❖ ❖</p>

Whither concretism? Concrete art, which arrived at once too early and too late in Cuba, was inevitably a failed project, its Constructivist vision unable to achieve the emancipatory, modernist transformation it preordained. "The epoch of the fifties was very beautiful, I think romantic for us," de Oraá remarked years later. "At times all we did was cross the desert, but in order to do that we not only had to see the mirages but also to invent them. I think that the latter was, for us, the essential point."[113] However fictional its utopia, concretism put forward the de facto beginnings of an ideational culture in Cuba, countering the ineptitude and dogmatism that elsewhere characterized the field with the Euclidean clarity of color and line. More than a formalist paradigm, Cuban concretism encompassed a historicizing dimension that drew liberally on cubanista belief, grafting its idealizing structures onto a spiraling national narrative poised on the brink of revolution. Its cosmopolitan ambit marked Havana as an outpost within the transatlantic circuit of postwar Constructivism, and its local impact stretched from contemporary architecture to the glancing geometric turn of many of the elder-generation vanguardia during the 1950s. Arguably, Los Diez represented the natural evolution of the Havana School and, as such, a more logical "third generation" than the onceños. Their advocacy for concretism as a progressive modernist practice, rather than as a rupture with the prior vanguardia past, marked a different point of insertion into the cubanista discourse, one more cerebral than polemical. Functional in a modernist-minded environment for over a decade, concretism persevered to the point at which its forms could no longer engender utopia, its legacy—as elsewhere in Latin America—a postmortem on vanguardia practice and the Cuban imaginary.

6 The Endgame of Abstraction

"And the flood began," Piñera wrote of the evening of December 31, 1958, as Batista fled Havana and the Revolution lay immanent in the air. "At the beginning, and in spite of the overwhelming impetus that it carried in itself, it seemed like a thread of water, quick and zigzagging, but which at the same time a child's foot could divert from its course." The enormity and euphoria of the Revolution's first moments reverberated across the city as it awaited the arrival of the *barbudos* amid "the air of liberty and, of course, the smell of the powder."[1] In the ecstatic early going, the horizon of possibility for the third-generation vanguardia dawned brightly, just as it had at the beginning of the decade. "When the Batista regime collapsed," Hugo Consuegra recalled, "my generation moved to fill the void, and for a brief moment, in elation, romanticism was in power."[2] For the onceños and their allies, who clamored expectantly for positions of authority and for validation within the new regime, the Revolution signaled not only the arrival of a new political order, but also the striking moment for the vanguardia to reimagine the cultural field in hard-won, cubanista terms.

Yet the process of aligning an increasingly radicalized political transformation with the generational zeitgeist of the youngest vanguardia, steeped in discourses of arts integration and abstraction, proved uneven and at times contradictory. As the writer Ambrosio Fornet (b. 1932) recounted, the situation was such that the revolutionary credentials of artists and intellectuals could be neither assured nor discounted by "a quartet of night-prowling tomcats who still confused jazz with imperialism and abstract art with the devil."[3] In the absence of explicitly stated cultural policy—"it was said in some circles that the best cultural policy was not to have one," Fornet acknowledged—the outward appearance of Cuban art changed only incrementally between 1959 and 1963.[4] But while the revolutionary government remained publicly coy until 1961, its socialist orientation was common knowledge to identifiably Marxist groups such as ICAIC and Nuestro Tiempo from the beginning. Well before the time of the historic Cultural Congress, held in Havana in 1968, the onus was decidedly on Cuba's intellectuals to prove their loyalty to the Revolution, even to the point of their commitment to the "armed struggle."[5]

Not surprisingly, the relationship between the third-generation vanguardia and the state fluctuated during this interim period, as artists gradually apprehended Cuba's

Detail of fig. 119

socialist direction and their role within revolutionary culture. The polemics over abstraction, though somewhat abated in the later years of the Batista regime, resurfaced almost immediately in 1959, becoming a red herring for broader arguments over cultural policy. Amid competing claims to "Cuban art," the ideological valence of abstraction wavered in the transitional climate of the 1960s, due to factors both internal (that is, cubanista) and external (socialist revolution). Piñera described the first days of reckoning as "half paradise, half hell," and his circumspection characterized the shifting critical stakes of the vanguardia.[6] This chapter assesses the post-history of the erstwhile "horizon of vanguards" as they took stock of Cuba's revolutionary climate and its cultural prerogatives. The place of print culture, in the prerevolutionary *Ciclón* and later in *Lunes de Revolución* and other channels, is privileged for its insight into vanguardia values of social action and commitment. The critical fortunes of abstract art are again assessed, beginning with the watershed National Salon of 1959 and concluding with the final activity of the onceños, who regrouped as Los Cinco three more times. Abstract art ceded its frontline political position by the early 1960s, and its legacy is considered finally in regard to its generational relationship to Cuba's historical vanguardia, the radicality of its forcework, and the nature of its complicity with the revolutionary process to which it was, indelibly, tied.

THE REVOLUTIONARY INTELLIGENTSIA

The complex, political history of the late batistiana regime and the underground dynamics of the 26th of July Movement are expansive subjects well-documented elsewhere, but suffice it to note that the cubanista codes consecrated at the Moncada barracks continued to shape revolutionary consciousness through the end of the decade.[7] The historic *Granma* landing, on the morning of December 2, 1956, marked the beginning of revolutionary war in Cuba, which lasted until the end of 1958. With a cargo of 82 guerrilla volunteers, the *Granma* ran aground at the southwestern tip of Oriente province, at the far eastern end of the island, two days after its scheduled landing. Its arrival had been timed to coincide with an uprising in Santiago, led by Frank País, a rising leader of the 26th of July Movement, as well as new attacks on the Moncada barracks; the delay left the revolutionaries exposed to a counterattack by government soldiers. The survivors regrouped in the hills of the Sierra Maestra and braced for prolonged guerrilla warfare. Periodic raids on local garrisons lent credibility to the camp, but the brunt of its work in the first year lay in reestablishing contacts with the urban network based in Havana (the *llano*) and in consolidating the support of rival factions.[8] Buoyed by the endorsement of the Ortodoxos and the Communist Party at the beginning of 1958, the rebel army (the *sierra*) opened new fronts in Oriente and, by the end of the summer, controlled the eastern end of the island. Aided by the capitulation of Batista's armed forces and a sense of their own historical providence, Castro's guerrilla forces moved their offensive

westward in the fall of 1958. The tide of public opinion turned overwhelmingly against Batista following what was seen as a fraudulent election in November, and the revolutionaries were initially hailed as a symbol of Cuba's deliverance from a decade of political corruption and tyranny. By the time that Che Guevara entered Havana, on January 1, 1959, the Revolution was understood not only as a liberation from Batista, but as an emancipation from a half-century of frustrated nation-building and a further evolution of the cubanista dream. In one of the iconic images of New Year's Day, Amelia Peláez's mural *Las frutas cubanas* (1957; fig. 97) frames the arrival of the armed revolutionaries at the Habana Hilton. Visually dividing the space between the crowning, modernist monument of Batista's Cuba, foreshortened into a geometric mirage, and the bearded troops that claimed the hotel as their provisional headquarters, the mural projects an arresting, iconic interface between the old and the new orders.

The psychology of the Revolution drew liberally upon the increasingly radicalized ideology of cubanía. Antoni Kapcia identifies a code of revolutionism that emerged within the cubanista canon in the 1950s, drawn on traditions "associated in the public mind with heroic rebellion against illegitimate or excessively authoritarian power" and on *eticidad*, which imparted a Manichaean morality to the culture of rebellion.[9] The pent-up frustration of Cuba's rebellions, from the time of Martí and against the Machadato, and their historical failures only strengthened the Revolution's appeal, Kapcia suggests, by underscoring the resilience of the country's radical spirit. The asphyxiating pattern of colonialism and neocolonialism, attended by a sense of choteo, a characteristically Cuban, contrarian humor, and associated accomodationism, exacerbated the collapse of the original cubanista mandate, traumatized anew by Batista's coup. The restitution of the martiano code pledged by the moncadistas cast a powerful image of historical inevitability and, eventually, invincibility to the sierra, one enhanced by the guerrillas' dogged survival and swaggering momentum. By 1958 the abjection of the Batista state all but precipitated the revolutionary outcome. Rampant acts of sabotage, carried out by both the llano and Batista's henchmen, beset Havana in the form of bombs and retaliatory executions, airport sabotage, arrests and permanent disappearances, and tactical kidnappings of American citizens throughout 1957–58.[10] The tense climate of martial law, punctuated by censorship and general curfews, kindled the revolutionary imperative, increasingly tantamount to that of Cuba Libre.

Kindred codes within the cubanista canon included culturalism and internationalism, which together with revolutionism underlay the conceptual synergy that had long engaged the vanguardia tradition. Over and above the material and political grails of agrarian reform and statist collectivity, cubanía encompassed a positivist faith in the intellectual vanguard and in the experience of education as liberation. Like the revolutionary code, Kapcia notes, culturalism accorded a political mandate to the intellectual and recognized the crucial role of the youngest generation in the patriotic struggle. "The good writer, at least, is as efficient for the Revolution as the soldier, the worker, or the

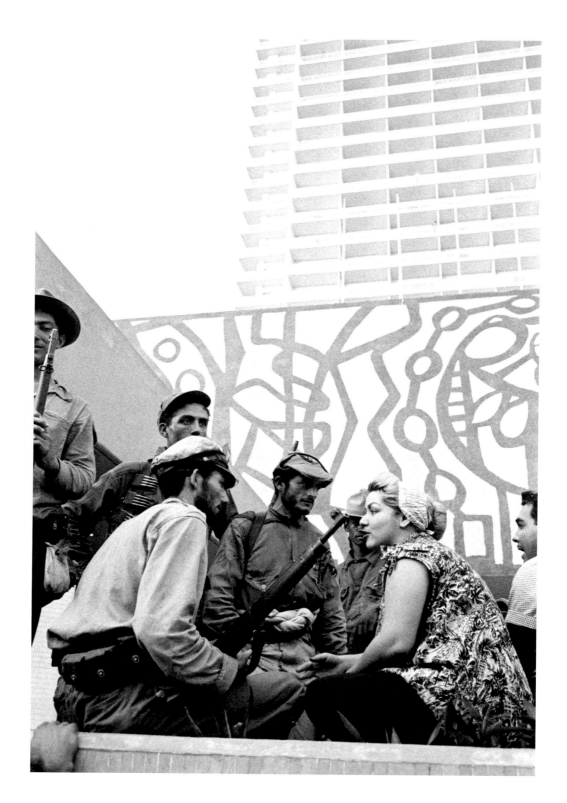

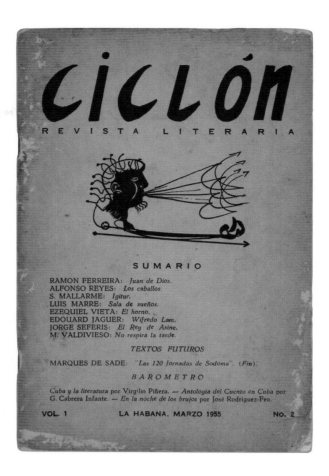

FIGURE 98

Cover, *Ciclón* 1, no. 2 (March 1955).

peasant," Piñera declaimed at the start of 1959. "Let it be known, once and for all."[11] The culturalist code validated the aspirational character of the young vanguardia, affirming the primacy of common cultural identity in cubanía rebelde and the political commitment of the radical intelligentsia.[12] Yet the philosophical abstraction of the cubanista mandate left open the question of how the intellectual vanguard should practically engage the revolutionary struggle. The rising intelligentsia moved swiftly to ally itself with the political ethos of the Revolution, and its militancy in the cultural arena played out prominently in two cultural journals that emerged in the mid-1950s: *Ciclón* (1955–59) and *Nuestro Tiempo* (1954–59). The politics of *Ciclón* proved more variable than the communist bearings of *Nuestro Tiempo*, which assumed a more frankly radical posture than its more literary peer. But both publications broke with the rarefied transcendentalism of the elder *Orígenes* group, whose incapacity to overcome the "sensation of ontological stupor, of living in a vacuum," as the poet Cintio Vitier described the last years of the republic, flew in the face of the praxis-minded avant-garde.[13]

Ciclón resolved to break free from the detached poetics of the *Orígenes* group and, however inflated its rhetorical brandishings, it provided an important outlet for the younger generation (fig. 98).[14] It emerged amid a bitter falling-out in 1953 between the

founding Origenistas, José Lezama Lima and José Rodríguez Feo, over the publication of an article by the Spanish poet Juan Ramón Jiménez on Vicente Aleixandre. The subsequent departure of Rodríguez Feo from the *Orígenes* camp, along with his financial backing, spelled the end of the journal, which published six more issues before folding in 1956. Rodríguez Feo launched *Ciclón* in January 1955 as a rejoinder to the ostensible neutrality and outmoded sensibility of *Orígenes*, and under the editorial leadership of Piñera the journal pledged to sweep aside the "dead weight" of its predecessor and its "vices of intellectual conformity."[15] Yet despite its determined rivalry with *Orígenes*, *Ciclón* did not depart appreciably from the former's belletristic model, even though its tastes proved more catholic and its critical voice somewhat less reverent. The journal attracted many of the radical avant-garde who later ranked prominently among Cuba's postrevolutionary generation, among them: Antón Arrufat (b. 1935); Roberto Branly (1930–2013); Rolando Escardó; Ambrosio Fornet; Rine Leal (1930–1996); Luis Marré (1929–2013); and Severo Sarduy. Its provision of an independent journalistic space afforded a measure of resistance against Zéndegui and the INC, and its fifteen-issue run provided continuity between *Orígenes* and its successors, *Lunes de Revolución* and *Casa de las Américas*.

Ciclón's critical vocation appeared at times equivocal, however, and its divergent tacks reflected the volatility of both the contemporary political situation and the dissident vanguardia. Piñera railed against Batista's ill-starred forays into the cultural field in November 1955, penning a strongly worded editorial in defense of political and artistic liberties. "The journal *Ciclón* considers it an ineluctable duty to pass judgment on cultural politics, whether of the state or private, which have to do with the situation of the artist in Cuban society," he began. "At a moment in which the life of the artist is becoming more precarious, not to say unsustainable, it is necessary to indicate the dangers which threaten his survival." His invective touched upon the cronyism and orthodoxy of Zéndegui and his cohorts, drawing a line in the sand between the pomposity of their "official culture" and the nation's "true culture," defended in moralizing, tacitly cubanista terms.[16] Yet *Ciclón* remained nonpartisan, and in mid-1957 Rodríguez Feo elected to suspend publication, adopting silence as a means of protest against the Batista regime. As he explained in a flyer-insert in the first (and only) issue published after the Revolution, the decision stemmed from an unwillingness to offer "*simple literatura*," felt to be an unfit response in the face of the wartime casualties.[17] (Martínez Pedro claimed that Cuba's artists similarly "produced nothing" in the waning days of the Batista regime, though this was far from a universal response.[18]) The shuttering of *Ciclón* was "later to be reproached by some revolutionaries," Judith A. Weiss has noted, "who felt that by closing down one of few intellectual publications Rodríguez Feo had in a sense capitulated, depriving the rebels of what might have been a source of international intellectual vindication."[19] The more divisive issue after the Revolution was that of neutrality, which Rodríguez Feo took up in his editorial, singling out Lezama Lima among others for collaborating with the dictatorship under the guise of the "neutrality of culture."[20]

FIGURE 99
Cover, *Nuestro Tiempo* 5, no. 29
(May–June 1959): 1.

In retrospect, the revolutionary import of *Ciclón* lay less in its advocacy of an explicit political program than in its cubanista projection. "If the journals represent any politics," Hassan has remarked of both *Orígenes* and *Ciclón*, "it is quasi-nationalist, striving to distinguish Cuba from the other nations of the Americas and at the same time to situate the island as the parodic center of a cosmopolitan hemisphere."[21]

For those nevertheless unsatisfied by the hedged, nonpartisan position of *Ciclón*, the Sociedad Cultural Nuestro Tiempo and its eponymous journal offered an alternative pole of action (fig. 99). Published bimonthly beginning in April 1954, *Nuestro Tiempo* sought to democratize art ("*traer el pueblo al arte*") and to promote Cuba's emerging generation of artists and writers.[22] Inhabiting the space vacated at the end of 1953 by *Noticias de Arte*, *Nuestro Tiempo* devoted regular sections to contemporary art, film, literature, theater, and music, filling a cultural niche elsewhere unserved. Less partisan in its coverage than Zéndegui's *Revista del Instituto Nacional de Cultura* and less highbrow than *Ciclón*, it provided a forum for dialogue on current cultural and political events. Breaking with the lingering Eurocentrism of *Ciclón*, *Nuestro Tiempo* adopted a more

assertively americanista purview, and its contributors counted among the more radical intellectuals of that time: poets Rafaela Chacón Nardi (1926–2001), Nicolás Guillén (1902–1989), and Roberto Fernández Retamar (b. 1930), who had been briefly connected to *Orígenes*; cineastes Alfredo Guevara (1925–2013), Sabá Cabrera Infante, and Gutiérrez Alea; and writers Guillermo Cabrera Infante (1929–2005) and Surama Ferrer (b. 1923). Beginning in September 1956, the journal profiled a contemporary artist in each issue (features ranged from the honorary onceño Servando Cabrera Moreno to Peláez); and arts coverage, often contributed by Graziella Pogolotti and sometimes related to the in-house Galería, was both consistent and inclusive of the third-generation vanguardia.

Nuestro Tiempo was later distinguished by the outspoken dissidence of its editorials, and the connections between its institutional home and the communist Partido Socialista Popular (PSP) increasingly shaded the journal's ideological bent. The Sociedad Cultural Nuestro Tiempo was reorganized in 1953, and its work came under the jurisdiction of the pertinent Party committee, led by former minorista Juan Marinello, writer Mirta Aguirre (1912–1980), and fidelista Carlos Rafael Rodríguez (1913–1997). As the de facto cultural arm of the PSP, the society began to parlay its cultural outreach programming into recruiting grounds for the Party. According to José Antonio González, "[T]he organization of the film club and the film cycles it mounted, the pamphlets and the magazine it produced, in reality masked clandestine and semiclandestine work by the Communist Party among the intellectuals, and organized opposition to the National Institute of Culture set up by the tyranny."[23] Batista allowed Nuestro Tiempo to remain open, even as its directors faced interrogations by state intelligence agencies (the Servicio de Inteligencia Militar; the Buró para la Represión de las Actividades Comunistas). The fact of its continued survival "had the effect of intensifying ideological confrontation in the domain of cultural activity," Michael Chanan has observed, and in that regard it was instrumental in fomenting a critical mass of revolutionary support.[24]

The journal served as the principal mouthpiece for Nuestro Tiempo, and its advocacy for the importance of culture as a revolutionary mechanism guided the young vanguardia. "Our work is performed within the boundaries of culture and art," a late editorial acknowledged, "but it can only be carried out—like any creative activity—under the absolute, total, unconditional, exclusive rule of freedom."[25] *Nuestro Tiempo* understood the arts as essential guardians of that freedom, and its pages instantiated the resistance of the revolutionary class and its political engagement. The journal railed against the Batista regime at every opportunity: disseminating the activities of the artists protesting the *II Bienal Hispanoamericana* (1, no. 1); publishing the correspondence between Alicia Alonso and Zéndegui, in which the ballerina refused the INC's bribery (3, no. 13); demanding the restoration of constitutional rights, suspended during martial law (5, no. 21). Adding its weight to an alliance of liberal institutions (the Conjunto de Instituciones Cubanas), Nuestro Tiempo called for Batista's resignation in mid-1957, triggering a round of police detentions and flights into exile.[26] A vital part of the llano, the

journal epitomized the culturalist program of cubanía, and its belligerence through the final months of the revolutionary struggle undoubtedly symbolized a "light in the darkness," as its editors later reflected.[27]

Nuestro Tiempo's communist orientation manifested more plainly in the aftermath of the Revolution, and as vitriol spilled over the ravages of the Batista state its cultural legacy fell under new, and telling scrutiny. "Five, ten, fifteen?" asked the journal's first editorial of 1959. "It may not be possible to make an exact estimate of the years lost to the development of our culture by the tyranny. Because our culture was traumatized during the tyranny."[28] The sweeping indictment of a generation of cultural progress did not augur well for Cuba's abstract artists, and the socialist turn of the Revolution brought revisionist scrutiny upon the arts produced under the Batistato. The remaining issues of the journal struck newly significant anti-imperialist notes—"La cubanía aniquilada por la enmienda Platt," "Imperialismo y cultura"—and the hard-line political values of the Revolution asserted increasing authority over the arts and culture. Many veterans of *Ciclón* and *Nuestro Tiempo* reemerged in a new literary supplement, *Lunes de Revolución*, which wielded considerable influence in Cuba and throughout the Americas during its brief, two-year run. A bellwether of cultural debate, *Lunes* found itself at the center of an early inflection point in the ideological trials of the revolutionary state and its arts administration.

CULTURAL RE(CON)NAISSANCE

The reality of the Revolution set in motion a series of escalating changes in the arts, and the new political climate both catalyzed the young vanguardia and, in short time, bred dissension among its ranks. Although the "arbitrary, inconsistent, and sometimes even anarchic operations of the Cuban cultural bureaucracy make it difficult to generalize about the degree to which official policy has infringed upon intellectuals' freedom of expression," as Linda S. Howe has remarked, cultural life was essentially formalized by the state and artistic freedoms curtailed.[29] The task of ideological transformation was assigned to the cultural field in the beginning, and artists were enlisted to spread the revolutionary program through didactic cultural and educational programs. The degree to which the Castro state emulated Bolshevik cultural policy during this period is debatable, but Cuba's awareness of contemporary Soviet practice cannot be doubted. "It is evident that a serious effort was made to introduce and if necessary impose a form of socialist-realist art on the Soviet model," David Kunzle has observed with regard to the critical period of 1960–62, noting the general encroachment of the Soviet sphere of influence.[30]

Cuba did produce some examples of socialist realist painting and, for a time, an ambitious mural program led by Orlando Suárez, a former assistant to the Mexican muralist David Alfaro Siqueiros. The most zealous practitioners of Soviet-style

aesthetics were longtime PSP members Carmelo González and Adigio Benítez (1924–2013); their work made inroads, appearing for instance in Cuba's delegations to the São Paul Bienal in 1961 and 1963, but still in a secondary position to that of the vanguardia artists. On the facade of a market in central Havana, a mural celebrating agrarian reform allegorized the suffering of the campesinos, portrayed at upper left: poor and unhygienic living conditions, exploitation by middlemen, reduced lifespan (fig. 100). The bounty of the harvest is embodied by the woman who sprawls suggestively, in a way that recalls the style of Carlos Enríquez, at the bottom of the image, her hair and right hand extending into virgin soil that fertilizes, through the fingertips of her other hand, the abundant vegetation. Murals also covered the multifamily dwellings built by the National Institute of Savings and Housing (Instituto Nacional de Ahorro y Viviendas; INAV), established in 1959 to finance construction designed to meet the estimated demand for thirty-two thousand new urban dwellings. In one example, the agency's revolutionary morality is narrated across one of its typical, four-storied constructions (fig. 101): INAV brought an end to an earlier practice of selling lottery tickets for its homes, replacing them with bonds redeemable with interest after five years, and the mural accordingly extolled the virtue of labor, not luck.[31] Yet at a moment when "the abstract murals of Lam [were] regarded as useless," as Sarduy acknowledged, the writing was on the wall for the onceños already by January 1959.[32] (Lam's inclusion later that year in *Documenta II*, organized in Kassel by Arnold Bode and Werner Haftmann under the banner "art has become abstract," is testament to the divergent postwar narratives around abstraction.[33]) "If Cuba had had a figure

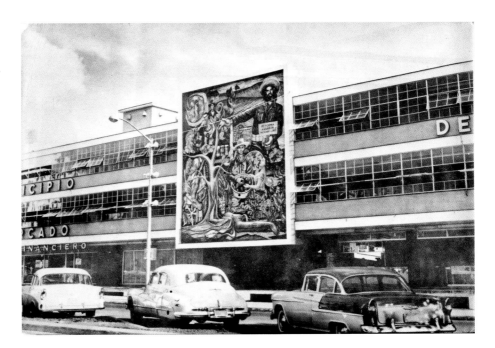

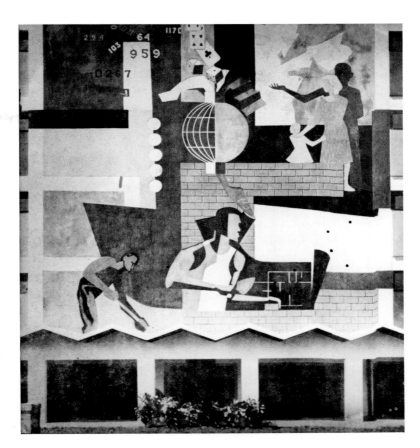

like Diego Rivera," Sarduy reckoned in retrospect, "it wouldn't have had a dictatorship." That moment of "Popular Painting, Objective Art" having already passed, however, he urged his readers to envisage a national art without "guajiros and palm trees," reminding them that in contemporary Cuba "the painters of the resistance [were] the abstractos."[34]

Although Castro and Guevara demurred on an aesthetic hard line, to critics on the outside—conspicuously, Gómez Sicre—the percolating discourse around "revolutionary art" nevertheless appeared ipso facto to cultivate an art of tacit compliance. Elder-guard communists Blas Roca (1908–1987) and Aníbal Escalante (1909–1977) reportedly lobbied Castro to ban abstract painting and promote Mexican-styled muralism, but it was Guevara, by all accounts well versed in Marxist theory, who laid caution to the "pontifical throne of realism-at-all-costs."[35] And while Khrushchev's "more-or-less public disputes with dissidents pursuing abstract or 'nihilist' art" undoubtedly raised the temperature on abstraction in Cuba, Castro was quick to defuse controversy, intoning that "our enemies are capitalism and imperialism, not abstract painting."[36] Still, certain of the onceños decamped to the realist position, embracing what Cabrera Moreno, among the first of the third-generation vanguardia to alter course, deemed the "new artistic orientation."[37] Yet even where his notional subject is the hyper-masculine campesino, his

virility now not only national (as per the vanguardia) but suggestively ideological, the visual narrative is both compositionally dynamic and monumentalizing, exemplified in the brandished machetes and torqued bodies of *Milicias Campesinas* (fig. 102). Set against the landscape in an electric palette of blues and greens, his outsized, eponymous subjects sit astride sinewy horses, their merged bodies splicing through pictorial space with a bravura that recalls Siqueiros and Orozco. Though far from the stereotyped academicism of Stalinist art, to detractors the simple appearance of "the usual paraphernalia—machetes, sickles, compressors, etc." put proof to "a mistaken instinct" allowed to fester in works designated for the Soviet bloc and China. "It is not important that Fidel or the Party does not demand that the artist follow a certain style or treat a certain theme," Gómez Sicre remonstrated. "The system, which suppresses the individual, castrates him. What remains after a time are sharp voices, obsequious gestures, that is to say, an art of the castrated."[38]

While socialist realism found limited traction, the Soviet model elsewhere proved useful to the revolutionary "apparatchiks" in mobilizing literacy and various other

propagandistic campaigns. The primary vehicles for mass media penetration of the country were films and the posters commissioned to advertise them, coordinated by the newly created Institute for the Cinematographic Art and Industry (ICAIC), installed just three months after the guerrillas arrived in Havana. "The cinema is the most powerful and suggestive medium of artistic expression and dissemination, and the most direct and extensive vehicle for education and the popularization of ideas," read the statement announcing the formation of ICAIC, and film took on new importance in the task of building revolutionary consciousness.[39] The populist "Cine Móvil," dispatched to schools, farms, and factories across the island and pitched toward the campesino masses, showed newsreels and didactic films alongside documentary-styled histories of the revolutionary process and the mobilization campaigns. To advertise these films as well as international imports, ICAIC launched a *"movimiento afichista,"* commissioning posters that, like early Soviet examples, became touchstones of graphic innovation and style. "The poster was invented by the Revolution," Raúl Martínez later remarked, and the explosion of the poster, with its stylized and imaginative typography and modern, ideogrammatic design, dovetailed with the pedagogic and cultural interests of the Revolution.[40]

Martínez turned away from abstraction in the early 1960s, repositioning himself in photography and graphic design and as one of the earliest practitioners of Pop art in Cuba. "When abstract painting had [no artistic solutions] to offer and many revolutionary schools became academic, it was up to the painters to start looking for those solutions again," he asserted in a published statement of 1965 (not coincidentally, the first year of the anti-homosexuality purges).[41] "I discovered that in Cuba there's a popular art, an anonymous art full of humor, irony, gaiety and naïveté. I saw a possibility in that."[42] Forced statement or not, his continued work on canvas, in mixed-media and Pop paintings, and in poster and graphic design for the Instituto del Libro was superb and, often, subversive. Among his most provocative works from this period were paintings that collaged his familiar, gestural forms within a proto-Pop, and occasionally pornographic landscape. His *Burro no. 1,* only ironically a "champion," was an unambiguous proxy for Castro, its suggestive "pin-the-tail-on-the-donkey" diagram and other cut-out images— clocks set to different times, an exaggerated claim for Cuban ham—a cynical assessment of revolutionary progress (fig. 103). The spelled-out "camp," at the center of the image, is still more suggestive. Plausibly an abbreviation of *"campeón"* or even of *"campesino,"* the letters also conjure the *campos de trabajo* (labor camps) to which thousands of homosexuals were later sent (1965–68) and, more allusively, the "Camp" sensibility articulated that year by Susan Sontag: "love of the unnatural: of artifice and exaggeration. . . . It is one way of seeing the world as an aesthetic phenomenon. . . . [T]o understand Being-as-Playing-a-Role."[43]

Much like Cabrera Moreno in later years, Martínez insinuated a homoerotic charge in his paintings of the 1960s and 1970s, leveling his critique both materially, on

FIGURE 103

Raúl Martínez, *Burro no. 1*, 1964.
Oil and collage on Masonite.
47 × 62⅘ in. (119 × 159.5 cm).
Colección Museo Nacional de
Bellas Artes de La Habana.

the canvas surface, and through the coded languages of synecdoche and sexual identity. In his poster for *Lucia*, the acclaimed film by Humberto Solás (1941–2008), Martínez drew upon a Pop-psychedelic idiom—a nod, perhaps, to the persecuted "hippies" sent to reeducation camps—to connect the three women who allegorize, in their period histories, the narrative of Cuban nationhood from independence to Revolution (fig. 104). Portraits of Martí and Guevara received similar treatment (*Repeticiones de Martí* [1966]; *Fénix* [1968]); repeated in motley fluorescence within allover, painted grids, his portraits elide fame and mortality (and martyrdom), remarking wryly, as Andy Warhol vis-à-vis the Mao Zedong portraits, on commodification and power. Such critical undertow reached its peak in *Isla 70* (1970), a huge group portrait that allegorizes the Committees for the Defense of the Revolution (CDR), a much-maligned, block-by-block neighborhood surveillance network established in 1960. In a lushly phallic setting, sexual innuendo—a cat, a same-sex couple, an ice-cream cone, an orchid—weaves through portraits of Party leadership (Castro, Guevara, and Cienfuegos alongside Martí,

FIGURE 104

Raúl Martínez, *Lucia*, 1968.
Silkscreen. 30.3 × 20.1 in. (77 ×
51 cm). Sam L. Slick Collection of
Latin American and Iberian
Posters, Center for Southwest
Research, University Libraries,
University of New Mexico.

Ho Chi Minh, and Lenin) and anonymous "everymen," including the artist's own lovers. Martínez, within a decade Cuba's most prominent Pop artist, arguably built the most successful postrevolutionary career of the onceños who remained in Cuba. If gesture painting had once, tactically, emblazoned his critique of the Batista regime (and indeed its excesses of Americanization), Pop later facilitated an apt, contemporary riposte to the communism of the following era. Among his few forays into concrete aesthetics was the comparatively restrained book jacket for Loló Soldevilla's *El farol* [The Lantern], which attempted to merge the formalism of concrete poetry with the novel's celebration of the Literacy Campaign of 1961 (fig. 105).

The mobilization of arts education proceeded less apace than the heavily publicized Literacy Campaign and Cine Móvil, but initiatives commenced on both popular and academic fronts. The *brigadistas* "Arístides Fernández," for example, brought art education to the countryside in the form of classroom lectures, accompanied by texts and slide projectors (fig. 106).[44] These brigades were named in honor of Fernández, a socially inclined figurative artist of the first-generation vanguardia, and organized in part by Rosario Novoa (1905–2002), an art historian and founder of the Department of Art History at the University of Havana. The success of this campaign is hard to gauge, but populist arts education and postgraduate university training of that kind were without local precedent. On the other hand, the rebuilding of the university's visual arts and

architecture program, following the chaos of 1959 ("professors expelled, professors exiled, inadequate classes . . . ") progressed in fits and starts between 1960 and 1963.[45] Guido Llinás, Raúl Martínez, Tomás Oliva, and Soldevilla took faculty positions in fine arts; Fernando Salinas, Raúl González Romero, and Consuegra reorganized the architectural program in August–September 1960, bringing back Ricardo Porro (from Venezuela) and his Italian colleagues Vittorio Garatti (b. 1927) and Roberto Gottardi (b. 1927). "The spirit in which one worked was very beautiful," Gottardi recalled of their collaborative start in late 1960. "In a certain sense, we had much freedom. . . . To found a new country, with a new people, was a great undertaking."[46] Yet however romanticized their beginnings— seen nowhere more clearly than in the design of the National Art Schools—the program suffered from partisanship in short time: Martínez was "dishonorably" discharged on account of his homosexuality; Soldevilla and Oliva were casualties of the FEU's "Battle against Intellectualism" (1966) and its anti-humanistic turn at the university; Porro and Llinás resigned in 1963, Consuegra in 1966.

Consuegra had continued to practice as an architect through the rise and fall of Los Once, and more than the other onceños he was attuned to the theoretical discourse around the integrated work of art. In "The Integration of the Arts," published during his short tenure at the postrevolutionary Ministry of Public Works, he presented his strongest arguments for integration as public policy, apropos to its realization "as a social function, as a fully socialist art" (fig. 107).[47] Artworks had lately lost sight of their "first and direct utility" to the general public, Consuegra observed, explaining this "crisis" as a problem of communication and social class, not of aesthetics or intelligibility. He faulted the mechanisms of the market—private collectors, galleries, even museums ("one cannot live in a museum")—for their abdication of responsibility to the people.[48] Integration, in his usage, implied not simply the "inclusion of a mural or sculpture in a building," but "a new form of art" altogether, one drawn on the homogenizing synthesis of painting,

FIGURE 107

Hugo Consuegra, "Artes plásticas: la forma de la verdad," *Boletín Interior de Obras Públicas* (August 30, 1959): 4–5.

sculpture, architecture, and engineering.[49] The maquettes accompanying his text showed a sculpture by Oliva intended for the National Theater (lower right) and two designs for hospital facilities. This democratizing function of art was predicated on its potential to act across society: "Art is nothing in itself," Consuegra declared; "it is not an isolated event."[50] What he described is akin to Krzysztof Ziarek's argument for art's forcework, or transformative potential, at "the instance in which the force field opened up by the artwork extends or radiates into the social context, reenacting the artistic release into the nonviolent 'strife' of daily differences and conflict, into a power-free relationality."[51] This understanding of artworks as not only inhabiting but also shaping patterns of everyday life (recall Rolando López Dirube's sense of *cotidianizar*) harked back, of course, to the defining moment of the Anti-Bienal and the mobilization of its manifesto across the island. For Consuegra and the youngest-generation vanguardia, the theory of arts integration had held out a beacon of possibility at a time, through the later 1950s, when the asphyxiations of "official culture" became more and more oppressive. Indeed, their utopian impulse, absorbed by the accelerating cubanista drive toward revolution was, arguably, at its most potent so long as it seemed unattainable.

The degree to which the intelligentsia could freely voice its ideas, particularly those critical of the government, was curtailed in the months following the Revolution, and division within the revolutionary camp precipitated a recalibration of cultural policy in mid-1961. The immediate trigger was the censorship of the film *P.M.*, but the beginnings of the crisis date to the first year of the Revolution and the retrenchment of the independent press. In a televised interview on April 2, 1959, Castro asserted the democratic values of the Revolution, acknowledging that "when one begins by closing a newspaper, no newspaper can feel secure; when one begins to persecute a man for his political ideas, nobody can feel secure."[52] However, a form of censorship had already been introduced that obligated print publications to append a notice to articles and news briefs whose views deviated from official policy. The newspapers *Información* and *Diario de la Marina* lost their challenge to the law on procedural grounds; *El Crisol, Excelsior,* and *El Mundo* were closed shortly thereafter on charges of collaboration with the former regime. On May 19, 1960, an armed mob stormed the offices of the *Diario* to prevent the publication of a letter signed by three hundred workers in support of the paper's management. The *Diario*'s symbolic burial that night, held at the University of Havana, was reported in the city's only remaining large, independent paper—*Prensa Libre*—whose deputy director gamely commented, "It is painful to see the burial of freedom of thought in a center of culture. . . . Because what was buried last night on the Hill [the University] was not a single newspaper. Symbolically the freedom to think and say what one thinks was buried."[53] *Prensa Libre* fell in a similar manner a few days later along with the weekly *Bohemia*, at the time the most widely circulated magazine in Latin America; what remained were *Hoy*, the paper of the PSP, and *Revolución*, the official newspaper. The government likewise assumed control of radio and television, consolidating the media under the United Front of Free Broadcasting Stations (FIDEL) and effectively limiting information to the government-controlled press and select publications from communist states.[54] The situation of artists and writers was similarly spelled in June 1961 over a course of charged meetings held at Havana's Biblioteca Nacional, an event touched off by the film *P.M.* and the defiant group around *Lunes de Revolución*.

A weekly literary supplement to the newspaper *Revolución*, *Lunes* "wanted to start a revolution in Cuban culture" and became in short time the outstanding public and intellectual forum of the revolutionary vanguardia.[55] Conceived by Carlos Franquí and overseen by the *cuentista* and film critic Guillermo Cabrera Infante and his assistant Pablo Armando Fernández (b. 1930), *Lunes* first appeared on March 23, 1959. "The Revolution has done away with all obstacles and has allowed the intellectual, the artist, and the writer to become part of the nation's life from which they were alienated," declared the magazine's first editorial. "We believe—and want—this paper to be the vehicle—or rather the road—to a desired return to ourselves. . . . We believe that literature—and art—of course, should approach reality more and to approach it more is, for us, also to approach the political, social, and economic phenomena of the society in which we live."[56] While

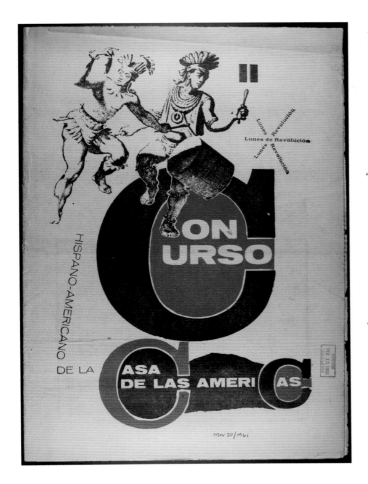

Lunes welcomed veterans of *Ciclón* and *Nuestro Tiempo* into its fold—the latter in spite of Franquí's lingering distrust of the PSP—the magazine attacked the anachronism and conservative worldview of elder cultural scions such as Lezama Lima and Jorge Mañach.[57] "The poetry that will emerge now in a new country cannot repeat the old Trocadéro slogans," the poet Heberto Padilla (1932–2000) declared. "The poet who expresses his anguish or happiness for the first time will have a responsibility; the gratuitous song must be opposed by a serious voice. To the uncontrollable rhetoric, a breath of fresh air."[58] Bridging cubanista projection and the postrevolutionary demand for social praxis, *Lunes* advanced an ambitious slate, pushing an activist agenda and giving space to many of the brightest minds of the "Boom" generation. *Lunes* published an international array of writers, including Jorge Luis Borges, Carlos Fuentes, Franz Kafka, Pablo Neruda, Nathalie Sarraute, and Jean-Paul Sartre; Marxist theory came from Castro and Guevara to Mao, Trotsky, and Lenin. Raúl Martínez eventually took over the magazine's design from Tony Évora, giving it a contemporary, almost psychedelic effect, and works by many of the abstractos appeared on its pages and its covers (notably, a front-and-back spread by Antonia Eiriz, no. 104–5).[59] A number of covers featured stylized renderings of the magazine's title or, simply, of the letter "R," in red and black inks and assorted fonts; others were topical, devoted, for example, to the Afro-Cuban fraternity Abakuá (no. 73) and to the death of Camilo Cienfuegos (no. 36). Often, the visuality of the text reinforced its (revolutionary) message, as on the cover of the March 20, 1961, issue (fig. 108), the alliterative Cs taking the shape of the island itself (the eastern end shaded, naturally, in red). At its peak, *Lunes* boasted a circulation of 250,000 and issues that swelled from six to over sixty pages; it was, according to intellectual historian William Luis, "the most significant and most widely read literary supplement in the history of Cuban and Latin American literary publications."[60]

The film *P.M.*, a fifteen-minute short made by the painter (and erstwhile onceño) Sabá Cabrera Infante, became the cause célèbre of the *Lunes* group when it was banned by ICAIC in May 1961, an act that precipitated the closure of the magazine and the communist shift of the cultural field. A paean to the ecstatic revelries of Havana's black and working-class nightlife shot in an experimental, "free cinema" style, *P.M.* was initially

broadcast on one of the two television channels controlled by *Revolución*. Following protocol, the filmmakers requested permission from ICAIC to show *P.M.* at one of the few private theaters left in Havana but were denied; the film was instead confiscated, on faltering charges of political and aesthetic irresponsibility to the Revolution. The film, and cinema generally, became a battleground between the *Lunes* group and ICAIC. Against charges of cultural Stalinism and dreadful socialist realism levied by Guillermo Cabrera Infante and his supporters, Guevara declared *P.M.* out of touch with social reality and its aficionados overawed by art for art's sake and avant-gardism in general ("a bit too exclusively preoccupied with beat poetry and the *nouveau roman*," a contemporary commentator noted).[61] The attack on *P.M.* was an implicit rebuke to *Lunes* and its editorial independence, and what had been planned as an informal tête-à-tête between Franquí and Castro to defuse the situation became, in effect, a public referendum. Held over three days (June 16, 23, and 30) at the Biblioteca Nacional and attended by nearly the entire intellectual and artistic community, the meetings debated the aesthetic merits of the film and the process by which it had been judged. Among Los Once, only Consuegra, Llinás, and Oliva were evidently invited to the meetings. "I said that the mission of the Revolution must be educational, inclusive rather than exclusive," Consuegra later wrote, "that the Revolution should tolerate all forms of expression, availing itself of all of those who would work for a common goal."[62] Castro pronounced his infamous "Words to the Intellectuals" at the last session, asserting the right of the government to dictate cultural production and effectively dividing the vanguardia along ideological lines.

Castro's intervention into the cultural arena marked a tipping point in the debate over intellectual freedom, and his closing speech carefully set out the terms of revolutionary culture and formalized the supervisory role of the state. His "Words to the Intellectuals" identified the question at hand as turning fundamentally on "the problem of freedom of artistic creation," and he moved quickly to assure his audience that the freedoms wrought by the Revolution would be defended. By general consensus, freedoms of form would be protected—"I believe there is no doubt as regards this point"— but on the more nebulous question of content he remained coy. To those apprehensive about the regulation of the arts, he reasoned that state supervision could only concern someone "who does not have confidence in his own art, who does not have confidence in his ability to create. . . . And it should be asked whether a true revolutionary, whether an artist or intellectual who feels the Revolution and who is sure that he is capable of serving the Revolution, has to face this problem, that is, if doubts may arise for the truly revolutionary writers and artists. I feel that the answer is negative, that doubt is left only to the writers and artists who, without being counter-revolutionaries, are not revolutionaries either." Likewise in defense of the Consejo Nacional de Cultura (CNC), the body created to superintend the cultural sector and headed by the communist old guard, Castro explained: "The existence of an authority in the cultural order does not mean that there is reason to be worried about that authority being abused. Who thinks that such

a cultural authority should not exist? By the same token one could think that the Police should not exist, that the State Power should not exist, and also that the State should not exist."[63] The overarching principles of his oration were condensed, at the last meeting, into the notorious formula—"within the Revolution, everything; outside the Revolution, nothing"—which reverberated quickly through the cultural sphere.

The upshot of Castro's speech was the elimination of opposition to the officially sanctioned interpretation of culture dictated by the CNC and reinforced through a new, Soviet-style professional-interests body, the Unión de Escritores y Artistas de Cuba (UNEAC). The censorship of *P.M.* was unsurprisingly upheld, and *Lunes* closed by the end of the year due to an alleged shortage of paper; its final issue, on November 6, paid defiant tribute to Picasso and modern art. Most of this group, including Franquí and Cabrera Infante, eventually left Cuba. Castro's "Words to the Intellectuals" served as the official prologue to the First National Congress of Writers and Artists of Cuba, convened on August 18–22, 1961, at the Hotel Habana Libre, during which time UNEAC was formally constituted. In his address, the Marxist ideologue José Antonio Portuondo urged the intellectuals to cultivate an "integrally formed national conscience," in effect to suppress their individual interests in deference to those of the state: "What is important is that the artist, creator, or critic assimilate, make into his own flesh and blood the experience of this new era in which we are living. That he deeply assimilate the new conception of reality, that he study and work; that he identify with his people, and that he express this new spirit in ways that cannot be given him ahead of time, like a set square, and that cannot be imposed on him by decree, but rather that he has to discover; he has to create art and literature."[64] Prominent support on the side of Portuondo and UNEAC president and poet Nicolás Guillén came from the promising writer Lisandro Otero (1932–2008), formerly of *Nuestro Tiempo*, and Juan Marinello. The Congress was accompanied by the *Feria de arte cubano*, which took over the Palacio de Bellas Artes and featured musical and theatrical performances, demonstrations and auctions, and the major retrospective *Exposición de pintura, grabado y cerámica*. Organized by Marta Arjona (1923–2006), Head of Cultural Activities at the CNC, and her deputies Orlando Hernández Yanes, Carmelo González, Enrique Moret, and Fayad Jamís, the exhibition included a stylistically and ideologically diverse group of artists from the colonial period through the youngest van-guardia generation, including Los Diez in their final group exhibition. Consuegra, Oliva, and Martínez Pedro made up the "modern" camp of the advisory group chosen by the Havana School and PSP stalwart Mariano Rodríguez, named president of UNEAC's Visual Arts department. González, Adigio Benítez and secretary Lesbia Vent Dumois (b. 1932) represented the "realist" side.

Despite nominal official statements to the contrary, the unionization of the art-world limited what remained of its autonomy. Artists were asked to publicly declare themselves Party members, and membership in UNEAC was expected of those who sought the sanction (and spoils) of the new regime.[65] In a letter to Mijares, Rodríguez

admonished his younger colleague's lack of commitment: "Comrade, we understand from our agent that you are not considered a member of this Section and, therefore, of UNEAC. . . . This organization, organ of the revolution, demands of its members a clear revolutionary position."[66] The state controlled most of the presses and publishing houses by 1965, and as the decade wore on less tolerance was shown toward works deemed unconventional and toward writers and artists who led "alternative" (that is, homosexual) lifestyles, some of whom were sent to the notorious UMAP (Unidades Militares de Ayuda a la Producción) camps for "reeducation."[67] Two journals published by UNEAC, *La Gaceta de Cuba* and *Unión*, immediately filled the lacuna left by the shuttering of *Lunes*; they were joined by *El Caimán Barbudo*, the literary supplement to the newspaper of the Unión de Jóvenes Comunistas (*Juventud Rebelde*), and the eponymous magazine published by Casa de las Américas. The *Gaceta* group generally hewed to a more orthodox political line; the staff of Casa de las Américas skewed slightly younger and less rigidly Marxist.

Casa de las Américas, the inter-American cultural clearinghouse founded in April 1959 by the guerrilla Haydée Santamaría (1923–1980), and its important literary magazine embodied the internationalist reach of the Revolution.[68] "Casa de las Américas celebrated the liberation struggles of the Third World, the heroic guerrilla, and the tradition of Latin American anti-imperialism epitomized by Martí," Jean Franco has observed. "It situated Latin America as an ally of other Third World nations in the struggle against imperialism. It represented a new cultural geography, one whose center had drastically shifted from Europe."[69] Casa de las Américas was the preeminent cultural think tank of the Revolution and later the site of ideological debates during the time of the Padilla affair (1971) and the subsequent *"quinquenio gris"* (1971–76), a period of repression and cultural Stalinization.[70] But earlier, under the editorial leadership of *Lunes* veteran Antón Arrufat, the journal sought to preserve a space for avant-gardist critique and published many of the younger members of the *Lunes* group, including Guillermo Cabrera Infante, Padilla, and Calvert Casey. Casa de las Américas sponsored the first postrevolutionary traveling exhibition of Cuban art, showcasing thirty-one artists and many of the third-generation vanguardia in Mexico City, Caracas, Montevideo, and São Paulo during the summer of 1960. Graziella Pogolotti, Adelaida de Juan, and Edmundo Desnoes, all prominent voices in the ongoing discussions over abstraction, provided most of the journal's art criticism.

Pogolotti also served as an advisor to the short-lived arts magazine, *Artes Plásticas* (1960–62), which followed in the footsteps of *Noticias de Arte* and the *Revista del Instituto Nacional de Cultura* (fig. 109).[71] Published under the auspices of the Ministry of Education, headed by Vicentina Antuña (1909–1992) and overseen by Marta Arjona, *Artes Plásticas* pledged in its first issue to "maintain a space dedicated to news that we hope will be rich and varied in the days ahead." Acknowledging a cultural impasse with the United States, the editors vouched for the cosmopolitanism of their mandate, in language that recalls that of *Noticias de Arte*: "We want to make the cultural activities of our country well-known; we aim to gather news of what happens in our America, because from her,

FIGURE 109

Cover, *Artes Plásticas* 1, no. 2 (1960).

more than from any other country, we have become isolated. And, finally, we will maintain our relationships with larger cultural networks."[72] News pieces from abroad ranged from a review of the *VIII Quadriennale* (1959–60) in Rome, for instance, to a reminiscence of an encounter with Jean Arp in Paris, written by Jamís. Yet shades of anti-imperialism were on the horizon as well, in the sketches of the caricaturist René de la Nuez (fig. 110). Interviewed by Jamís, he explained that even "caricature should be social," noting the danger—the "treachery"—of maintaining false illusions of island paradise: "Cuba," he declared, "is not Guatemala" (that is, vulnerable to a U.S.-backed coup d'état).

The magazine's final issue published the full text of Castro's "Words to the Intellectuals," set incongruously between photographs of abstract sculpture—post-Cubist, Surrealist, totemic—by Francisco Antigua, Agustín Cárdenas, Alfredo Lozano, and Eugenio Rodríguez (fig. 111). The magazine latterly focused on domestic concerns more topical to the revolutionary moment, often with underlying socialist sympathy (for example, illustrations of children's artwork celebrating the landing of the *Granma*). But its first two issues plainly grappled with questions surrounding the authorship and identity of Cuban painting; and essays such as "Cuban Painting 1959," "Painting and Revolution," and "Cuba in its Painting" pondered the moral character of revolutionary art. Abstract art was everywhere implicated, and its appraisal in *Artes Plásticas* and elsewhere during the first years of the Revolution betrayed the paradigm shift in the arts and, at least indirectly, recognized the ideological power that abstraction had ultimately procured.

atrás y en esos días trataba de hallar algo que
me permitiera burlar la mordaza. El primer "lo-
quito" apareció en enero, creo que el día 2 exac-
tamente.

—¿Entonces no publicaste nada antes del "lo-
quito"?

Nuez.—No, el loquito fué mi primer personaje
y mi debut a la vez.

—¿Desde su primera aparición hasta hoy tu per-
sonaje no ha sufrido ninguna transformación?

Nuez.—Casi ninguna. El dibujo es el mismo, aun-
que ahora tal vez un poco más sencillo. Pero su
contenido no ha variado nada. El loquito nació
combatiendo, y si muere, (que algún día tiene
que morir, aunque creo que va para largo, como
la Revolución . . .) morirá combatiendo.

CUBA IS NOT GUATEMALA

CAMISA DE 11 VARAS

—A juzgar por lo que acabas de decir, y te-
niendo en cuenta la "conducta" del loquito a lo
largo de su breve pero intensa vida, se puede
deducir que tu personaje se mezcla activamente
en la vida social de nuestro país, en el impulso
revolucionario, sin dejarse encantar por el fácil
deleite del simple juego de líneas, del dibujo por
el dibujo . . .

Nuez.—Eso es. Creo que, ahora más que nun-
ca, la caricatura debe ser social. Hacer el chiste
por el chiste no tiene ningún sentido en estos
momentos. Algunos caricaturistas de la genera-
ción anterior han caído en esa trampa, hecho que
más bien podría interpretarse como una claudi-
cación. Otros artistas, a los que, desde luego,
reconocemos muchísimo talento, se complacen en
poblar el aire de flores, ángeles y flautas, in-
sertando sus personajes en un mundo absoluta-
mente paradisíaco. Esa especie de romanticismo
es negativo e inútil, y sobre todo en la hora
actual. Inventar el paraíso mientras que los pue-
blos luchan por la paz bajo la amenaza de las
bombas atómicas, o como en el caso de Cuba,
que es agredida por la reacción nacional y ex-
tranjera, es francamente una traición.

PALABRAS DE FIDEL
a los
INTELECTUALES

*

En los días 16, 23 y 30 de junio se efectuaron, en la ciudad
de La Habana, en el Salón de Actos de la Biblioteca Nacional,
reuniones en las que participaron las figuras más representati-
vas de la intelectualidad cubana. Artistas y escritores discutie-
ron y expusieron ampliamente sus puntos de vista sobre distintos
aspectos de la actividad cultural y sobre los problemas relacio-
nados con sus posibilidades de creación, ante el Presidente de la
República Dr. Osvaldo Dorticós Torrado, el Primer Ministro Dr.
Fidel Castro, el Ministro de Educación, Dr. Armando Hart, los
miembros del Consejo Nacional de Cultura y otras figuras re-
presentativas del Gobierno.

En este folleto se recogen las palabras que, a modo de resu-
men y conclusión de los coloquios pronunció el Dr. Fidel Castro.
Compañeras y Compañeros:

Después de tres sesiones en las que se discutieron distintos
problemas relacionados con la cultura y el trabajo creador en las
que se plantearon muchas cuestiones interesantes y se expusie-
ron los diferentes criterios representados, nos toca a nosotros
subir nuestro turno. No lo haremos como la persona más auto-
rizada para hablar sobre la materia, pero sí, tratándose de una
reunión de ustedes y nosotros, por la necesidad de que expre-
semos aquí algunos puntos de vista.

Teníamos mucho interés en estas discusiones, y creo que lo ha-
mos demostrado con eso que podía llamarse "una cier pa-
ciencia". Pero en realidad no le sido necesario realizar un
esfuerzo heroico porque, para nosotros, ha sido un debate
instructivo y dicho sinceramente que también ha resultado ame-
no. Desde luego que en este tipo de discusión no somos nos-
otros, los hombres de Gobierno, los más aventajados para
opinar sobre cuestiones en las cuales ustedes se han especializ-
ado. Por lo menos... esto es mi caso.

El hecho de ser hombre de gobierno y agente de una Revo-
lución no quiere decir que estemos obligados (aunque acaso
lo estemos) a ser peritos en todas las materias. Es posible que
si hubiéramos llevado a muchos de los compañeros que han
hablado aquí a alguna reunión del Consejo de Ministros a
discutir los problemas con los cuales estamos más familiariza-
dos y, hubiera visto en una situación similar a la nuestra.

Nosotros hemos sido agentes de esta Revolución, de la Revo-
lución económico-social que está teniendo lugar en Cuba. A
su vez esa Revolución económica y social tiene que producir
inevitablemente también una Revolución cultural en nuestro
País.

Por nuestra parte hemos tratado de hacer algo (quizás en los
primeros instantes de la Revolución había otros problemas más
urgentes que atender). Podríamos hacernos también una auto-
crítica: al afirmar que hubiéramos dejado un poco de lado la
discusión de una cuestión tan importante como esta. No quiero
decir que la hubiéramos olvidado del todo: esta cuestión —que
el incidente a que se ha hecho referencia aquí infrecuentemente
contribuyó a ocasionar—, yo estaba en la mente del Gobierno.
Desde hacía meses teníamos el propósito de convocar a una
reunión como esta para analizar el problema cultural. Los acon-
tecimientos se han ido sucediendo y sobre todo los últimos han
sido la causa de que no se hubiese efectuado aún anteriormente.
Sin embargo, el Gobierno Revolucionario había ido tomando
algunas medidas que expresaban nuestra preocupación por ese
problema. Algo de lo hecho y varios compañeros del Gobierno
en más de una ocasión han insistido en la cuestión. Por lo pron-
to puede decirse que la Revolución en sí misma trajo un algu-
nos cambios en el ambiente cultural: las condiciones de trabajo
de los artistas han variado.

Yo creo que aquí se ha insistido un poco en algunas as-

cárdenas. madera

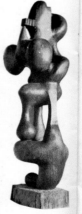
cárdenas. madera

antiguo. madera

"A CUBAN STYLE FOR 1959"

Abstraction never provoked an ideological rupture on a par with that sparked by *P.M.*, but the pregnant debates over a "Cuban style for 1959" forecast, in subtler but no less telegraphic terms, the falling out of abstract art. Highly anticipated, the Salon of 1959 constituted the Revolution's first major referendum on abstraction. Promoted as the *"salón de puertas abiertas,"* it opened on October 10 at the Palacio de Bellas Artes with the overwhelming endorsement of Cuba's artists and presented itself as a synopsis of the current trends and different generations within contemporary art.[73] The return of the vanguardia artists who had boycotted the last Salon—among them Víctor Manuel, who was honored with a sixty-four painting tribute—met a lukewarm response, however, and the preponderance of abstract art invited a panoply of critical rhetoric.[74] A sense of urgency ran through the gamut of exhibition reviews, which collectively stressed the need to analyze the contemporary situation and mindfully orient its course to the needs of the Revolution.

"To speak of a *Salón de pintura, escultura y grabado*—such as Cuba's in 1959—is tantamount to taking sides in a conflict," Pogolotti, an early champion of the onceños, began. "This Cuban Salon of 1959 would appear to be an invitation to take stock," she declared, construing its across-the-board mediocrity as "a symptom and point of reference" tied to the "anxiety and insecurity of many artists who want to relate their individual concerns to the disposition of a nation that is awakening and devoting itself to its creative endeavors."[75] Given the disorientation of the cultural field and its confusion over what even constituted "revolutionary art," Pogolotti admitted that "[i]t would be difficult, in this multifaceted and contradictory Salon, to identify a 'Cuban Style for 1959.'" Still, she implicated "the rise of abstraction, which has in recent years contributed to the impoverishment of our art," and noted, with some disapprobation, "the rise of the *'nouvelle vague,'*" which is to say the old "under-30s," who had in the course of the decade become the "under-35s."[76] She exempted a number of the "under-35s" from her censure—among them, Consuegra, Llinás, Jorge Camacho, Jorge Pérez Castaño (1932–2009), and Ángel Acosta León—but the ubiquity of abstraction implicitly indicted them all. The prior analogy between abstract art and revolutionary politics was no longer in effect, the review made clear; and although Pogolotti hedged her position here, she effectively pegged abstraction for the social bankruptcy of contemporary Cuban art.

While Pogolotti nevertheless recognized aesthetic merit in some of the "under-35s," the senior PSP principal and intellectual Mirta Aguirre argued against abstraction on uncompromising ideological grounds. "The best artistic orientation can only result from the best ideological attitude," she observed, and for Aguirre and fellow PSP stalwarts abstraction could only be the product of "anti-popular and reactionary currents of thought." She commended the *abstractos* of the Anti-Bienals" for their resistance to the Batistato, noting by comparison the passivity of many academics, but she stopped short of condoning abstraction: "The Revolution must do a great deal to help our finest

FIGURE 110
Fayad Jamís, "Entrevista con Nuez," *Artes Plásticas* 1, no. 2 (1960): n.p. Cartoons by René de la Nuez.

FIGURE 111
Fidel Castro, "Palabras a los intelectuales" and Adelaida de Juan, "La escultura en la feria," *Artes Plásticas* 3, no. 1 (1962): n.p.

painters overcome the limitations of abstraction. . . . Meanwhile, although it remains disagreeable to us and to government offices, we will continue to have abstract art. Until the day comes—and we have to cite Juan Marinello once again—that the artists who seek to preserve the freedom of their 'I' apart from all social context discover that abstraction neglects 'that there is something worth more than the spirit of one man: the spirit of many men.'"[77] Aguirre's review represented the position of the PSP, whose influence on the Castro regime had already begun to supersede the rival group around *Lunes*; and its arguments against abstraction, though not ever officially endorsed by the regime, held early sway. Her remarks touched not at all on the visual character of the artworks shown at the Salon, eschewing considerations of aesthetics for more and more precise social demands. In the same vein, the poet and later dissident Manuel Díaz Martínez (b. 1936) cautioned that the precedence of abstract art effectively "placed the Salon outside the revolutionary actuality of our country." He acknowledged the challenge of balancing a selection process "on the basis of artistic quality . . . no matter what tendencies predominate among them" and the "inescapable reality: the fact that there is no social painting in Cuba, that what predominates in Cuba is abstract painting or realistic painting without social concerns."[78] If the futurity of abstraction as a cubanista practice—universal, socially engaged, revolutionary—were endangered by the end of 1959, the reissue in October 1961 of Marinello's diatribe against abstraction lodged a clearer rebuke to the erstwhile abstractos, particularly in light of Castro's "Words to the Intellectuals," pronounced two months earlier.

Conversación con nuestros pintores abstractos [Conversation with Our Abstract Painters], first published in 1958, presented a dogmatic and largely uninspired Marxist history of abstract art with glancing allusions to the present situation in Cuba (fig. 112).[79] As much an indictment of modern art as of abstraction per se, the essay was written in open sympathy with the Soviet Union (an endorsement by Anatoly Chlenov, a Moscow art critic, is appended to the 1961 reprint). Marinello, a founding member of the PSP, may have overstated his own position in the moment; he kept abstract art in his personal collection, and his "conversations," according to Antonio Vidal, were more speculative than personally scolding.[80] "There is no doubt that we are living in the moment of abstraction in the visual arts," the essay begins. "Should we suffer this without opposition or objection?"[81] The first half of *Conversación* recounts the origins of European abstraction, taking interpretive liberties with José Ortega y Gasset's "The Dehumanization of Art" to build a case against his principal offenders—signally, Wassily Kandinsky—and the "mortal sin" of abstraction. He dismisses Kandinsky's intuitive "inner necessity" as so much pseudo-philosophical bunk, decrying its "arbitrariness and absurdity" and, ultimately, its "illegitimacy," which is to say its "negation of the social

FIGURE 112

Cover for Juan Marinello, *Conversación con nuestros pintores abstractos* (Santiago de Cuba: Universidad de Oriente, Departamento de Extensión y Relaciones Culturales, 1960).

meaning of art."[82] "The universality of abstract art—universality in the general sense of understanding—is, to be sure, unattainable," he argues, concluding that the antidote to abstraction's cosmopolitanism is art of profound national character.[83] To that end, Marinello recommends subjects that address Cuba's "social reality"—racism and the sugar monoculture; rural poverty and rising unemployment—as a means of giving artwork historical importance.[84] "If our abstract painters persist in their adventuring," he finally warns, "they will be responsible for having vitiated not only a great force of civilization, but also [our] collective unity at a decisive moment. If, however, they recognize the signs of the times and marry their invention to the injured, but impregnable heart of the people, they will be saved by their humanity, their creative mission."[85] This last passage, singled out in the foreword to the 1961 edition, flatly admonished the abstractos, dismissing their works as mere bourgeois trappings and out of touch with the country's present reality.

For all of his bombast, Marinello was light on the specifics of Cuban abstraction. He declined to mention any of Cuba's offending abstractos by name; he nodded only, and in passing, to Víctor Manuel, Carlos Enríquez, and Eduardo Abela. Abstract painting persevered, as Aguirre predicted, but in the absence of many of its most accomplished practitioners and at the periphery of Cuban culture. The intelligibility and mass appeal of art factored heavily in contemporary cultural debates, and the crux of abstraction, so publicly thrashed out at the Salon of 1959, gradually lost its earlier poignancy.

While debates over abstract art churned in Havana, the appearance and reception of Cuban art abroad amplified the pressures on the CNC to define a revolutionary aesthetic. At the very beginning, the onceños could claim small successes. Cabrera Moreno, Llinás, Martínez, and Sánchez were included in the delegation to the *V São Paulo Bienal* (1959), joining two of the concretos (de Oraá, Mijares) and others of the third-generation vangardia (Camacho, Agustín Fernández, Acosta León).[86] The CNC revived its grants program in late 1959, awarding prizes to a number of abstractos—the onceños Antigua, Cárdenas, Consuegra, and Llinás; as well as Joaquín Ferrer (b. 1929), Gina Pellón (1926–2014), and Pérez Castaño—for travel to Europe in the first half of 1960.[87] Yet by the time of the *VI São Paulo Bienal* (1961), the plurality of abstract art prompted critical questioning from the Brazilian press, who praised Consuegra in particular ("the best painter of the Cuban exposition") but also, tellingly, viewed his work and that of Llinás as "a test of the existing freedoms for the arts under Fidel Castro's government."[88] The intensification of international scrutiny came amid a traumatic two-year period stretching from the April 1961 Bay of Pigs invasion—and subsequent declaration of the "socialist character" of the Revolution—to Cuba's expulsion from the OAS (January 1962) and the Cuban Missile Crisis (October 1962). A handful of onceños (Cabrera Moreno, Consuegra, Eiriz, Oliva) represented Cuba again at the *VII São Paulo Bienal* (1963), under the curatorial direction of Alejo Carpentier. Martínez Pedro's *Aguas territoriales* marked the most cogent aesthetic statement about Cuba's contemporary political culture, but Portocarrero, who

exhibited colorful *diablitos* and carnival scenes, was deemed the most politic candidate to position for a prize (he was awarded the Premio Zembra).[89] The last of Cuba's submissions to the São Paulo Bienal for two decades, the 1963 Bienal represented one of the final instances in which the CNC exported abstract art under the national flag.

Internationalism, a cubanista code once elastic enough to contain liberal cosmopolitanism, became increasingly identified with the socialist bloc and the Third World after 1963. Hence European intellectual and artistic traditions, not least the modernist rhetoric of abstraction, were marginalized and viewed with populist suspicion. "The fault of many of our artists and intellectuals lies in their original sin," Guevara wrote in 1965. "They are not genuine revolutionaries."[90] As the "decolonization" of ideas and culture gained ground, the prospects for abstraction—perceived as elitist and reactionary, if not culturally deviant—dimmed considerably.[91] By the time of the 1968 Cultural Congress, the limits of cultural freedom were patently clear: "For us, a revolutionary people in a revolutionary process, cultural and artistic creations have a value in relation to their usefulness for the people, in relation to what they contribute to man," Castro declared in his closing address. "Our valuation is political. There can be no aesthetic value without human content."[92]

That leveling of society also manifested in the changing face of modernization as the still-building city adapted to new demographic and ideological demands. As John A. Loomis has carefully documented, perhaps no project symbolizes this turn of the revolutionary zeitgeist so well as the National Art Schools, entrusted to Porro and his Italian colleagues Garatti and Gottardi in January 1961. The idea to transform the grounds of the once exclusive Country Club Park into a school came to Castro and Guevara while there playing a round of golf, and plans were soon underway to design "the most beautiful academy of arts in the whole world," as Castro pronounced six months later. Imagined as individual structures housing Modern Dance, Visual Arts, Dramatic Arts, Music, and Ballet, the Schools were planned with attention to the existing landscape and in light of material shortages (specifically, of steel), conditions that inspired the use of the Catalan vault, whose bricked, organic curves became the Schools' defining architectural motif. Its repudiation on charges of formalism and utopianism—found narcissistic and counterrevolutionary at a time when Soviet models of standardization were favored—resulted in the stoppage of work in 1965. The construction had been highlighted as recently as the VII Congress of Architects (Union Internationale des Architectes), held in Havana in 1963 and attended by more than two thousand five hundred members. Preparations for the Congress also included the installation of granite tiles, designed by vanguardia artists from Lam and Portocarrero to Darié and Consuegra, along the sidewalk of La Rampa. Graphic and largely geometric in character, as in Antonio Vidal's contribution (fig. 113), the tiles referenced Peláez's Habana Hilton mural and, analogously, the integrationist discourse of the past decade that appeared to be reaching its peak in the construction of the Schools.[93] But tellingly, in his closing speech to the Congress,

Castro reiterated the faulty "idealism" behind the construction of high-rise public hous-
ing in Habana del Este (an adaptation of the abandoned Plan Piloto), telegraphing the
shift toward the mass, state production of low-cost housing: "And so, naturally, we don't
construct those large buildings anymore."[94]

EXPRESIONISMO ABSTRACTO (1963)

The symbolic revival of Los Once, who staged three final exhibitions between 1959 and
1963, slowly closed the book on the historical vanguardia and its already dated, cubanista
narrative. *Cuatro pintores y un escultor*, the group's first exhibition in Cuba in three years,
opened at the Lyceum amid the early euphoria of the Revolution in April 1959.[95] José A.
Baragaño, the poet and confidant of the onceños, praised the show, prudently casting
the group as the militant wing of national culture and commending its "intellectual
terrorism" as the true base of the Revolution. "We have long followed the development
of these artists," he observed, and declared the exhibition a "radical moment in the dia-
lectical process of their work" and emblematic of the "new realities" of the Revolution.[96]
With the tacit consent of Los Cinco, Baragaño conspicuously prefaced his review with
what Consuegra later called the group's "anti-Communist manifesto," in essence a clear
statement against the encroachments of the PSP into the cultural arena.[97] "The political

militance of poetry within a party line is the most despicable cowardice," Baragaño declared, and thus the onceños asserted their ideological independence from the Party.[98] Their political doubt notwithstanding, two of the onceños erected memorials to the victims of a harbor explosion on March 4, 1960—blasts to *La Coubre*, a ship carrying arms from Belgium, left more than one hundred casualties—that kindled early Cold War tensions; the United States was implicated but not proven responsible, and Cuba immediately requested Soviet military assistance.[99] White and black sculptures by Díaz Peláez and Oliva, respectively, occupy an otherwise barren park at the site (figs. 114, 115). Oliva's scrap metal assemblage, recycled from the ship's wreckage, literalizes the collision through twisted fragments splayed before a thick vertical plane; its rawness and violence are not simply formalist meditations on surface, but allegorical indictments of military brinksmanship and reckless destruction. Díaz Peláez, recently returned from New York, marked the event with a single, quasi-vertebral structure of tapering points and swollen curves. Its angles and undulations appear somatic in the way, perhaps, of Henry Moore, the body simultaneously threatening and defensive, solid and vulnerably exposed. These examples aside, the acceptance of abstraction's revolutionary bona fides—particularly, its communist partisanship—remained in question. Consuegra later remarked on the ambiguity of Castro's "Words to the Intellectuals," the all-or-nothing elision and the "to be or not to be" enigma, and on the impassive silence of critics at the time. Baragaño himself

changed course two years later, denouncing his "bourgeois past" before the June 1961
meetings at the Biblioteca Nacional.[100]

Even as the onceños pursued an increasingly solitary and impolitic path, they
staged two more exhibitions in the aftermath of Castro's speech and subsequent cultural
consolidations. The first was an exhibition at the Palacio de Bellas Artes that Consuegra
later deemed one of the group's finest; to the core "Cinco" were joined the original
onceño Díaz Peláez, Neo-Expressionist painter Antonia Eiriz, and Juan Tapia Ruano.[101]
From *Milicias campesinas* to *La Coubre*, cognizance of revolutionary iconography ran
high; for Antonio Vidal, having settled into his mature style, paintings like *Sagua de
Tánamo* reprised the prior, anti-bienalista position of the onceños and their praxis of
abstraction (fig. 116). A sugar mill city on the eastern end of the island, Sagua de Tánamo
was the site of numerous skirmishes in 1958 as the revolutionaries came out of the Sierra.
That telluric drama surfaces suggestively in the impacted, horizontal tranches of Vidal's
canvas, which collide along a curving line flanked by a black rectangle, familiar star-
shaped marks sparking from the impact. Bleeding from the top of the painting to the
lower corner, a thickening red stain breaks open the pale ground, an allegory perhaps of
the city's bombing or of the Revolution itself.

The group's swan song followed over a year later at the Galería de La Habana, in
an exhibition unapologetically titled *Expresionismo abstracto* that featured Los Cinco

along with Eiriz, Tapia Ruano, and the photographer Mayito (Mario García Joya; b. 1938), appearing with the group for the first time.[102] Later known for his cinematography, particularly in films by Gutiérrez Alea, Mayito emerged as one of the Revolution's most socially responsive photojournalists in the 1960s, training his camera on the anonymous and the everyday. In *Graduación—Milicias Serranos*, new recruits look out from under a sea of guajiros' straw hats, their uniformed solidarity a testament to the rallying, populist success of the civilian National Revolutionary Militias (Milicia Nacional Revolucionaria), established in October 1959, which welcomed all comers eager to take part in the new political process (fig. 117). The catalogue carried two texts: the first a captious introductory statement signed by the CNC; the second a philosophical essay on art appreciation, composed by the writer Edmundo Desnoes. The CNC's preface gave a qualified recommendation to the exhibition, judging its display of nonfigurative art "a pure play of forms with no direct reference to the present reality."[103] Desnoes chose not to explicitly address contemporary cultural politics in his text, however, ranging instead over the phenomenological experience of art and the existential encounter between the artwork and the viewer. "Art is a world in which men can feel fully comfortable," he professed. "Art is a world that never rejects man."[104] He proposed a classically modernist defense of art, one that preserved a privileged, humanist space against the outside world: "What always dominates in art is the presence of man. Behind a painting and in front of it there is always man. The creator and the viewer. The expression is always achieved through the concrete object, but the life of man is the sole theme. The bedrock is the human being with his anxieties, his joys and his visions. Without this, our reality would crumble."[105] Desnoes, best known for his novel *Memorias del subdesarrollo* (1965), published the first period history of Los Once in the state-backed compendium *Pintores cubanos* (1962), which unequivocally christened the abstractos—Mijares, Martínez Pedro, Darié, Martínez, Antonio Vidal, Pérez Castaño, Matilla, Llinás, and others—as contemporary scions of the historical vanguardia.[106] His text chronicled the group's activist practice from its origins in the wake of Batista's coup through the Anti-Bienal and the Anti-Salon, the latter protests virtually unknown outside of the artworld. A major and lavishly illustrated publication, *Pintores cubanos* canonized the onceños but, in so doing, pegged them to the prerevolutionary past, unwittingly writing them out of the future.

To be sure, the onceños understood the anachronism of their final exhibition. "We were aware that it marked 'the end,'" Consuegra reminisced. "It had the finality of a *fait accompli*—case closed—that gave it a melancholic sense, almost pathetic in the sense of Piotr Ilich [Tchaikovsky]'s symphony of the same name [No. 6]."[107] The exhibition constituted an "act of faith," Consuegra concluded, at a time when Cuba's artists and intellectuals were under pressure to declare their ideological allegiance.[108] The struggle inherent in the process is captured in *La cámara fotográfica*, in which the outlandishness of the public posturing and mimicry reflects back to the viewer, caught suddenly in the flash of the camera by a grotesque, jeering media scrum (fig. 118). Against a lurid, acidic ground, the gaping maws of reporters turn upward, their faces a bleary caricature of the press and

the party line. Eiriz invites us to assume the uneasy role of *comandante* (in contemporary installation works, she invites us to take the podium); in returning the gaze of the camera, we simulate the doublethink of the early, revolutionary rhetoric, contemplating, perhaps, our own culpability. That sense of misplaced trust and existential wrangling shaded the work of Llinás as well, rendered poignantly in such works as *Revenir en arrière*, among his most restrained yet immersive abstractions (fig. 119). Imaging hindsight in cloudy, jagged textures of black paint, accented with red and cerulean blue, the painting relinquishes his persistent reliance on the square and gestural flourish in favor of a more smoldering, tonal surface riven diagonally with heavy impasto. As a painterly rumination on the past decade, it registers an anticlimactic defense of abstraction; elegiac, rather than polemic, its mood matches the solemnity of the onceños as they acknowledged their end. Llinás left for Europe in May 1963, in the company of Wifredo Lam, and Consuegra eventually followed (to Madrid) in 1967. Of the twenty onceños defined by participation

in at least one of group's fifteen exhibitions, nine remained mostly in Cuba (in some cases, facilitated by long diplomatic absences): Antigua, Ávila, Cabrera Moreno, Corratgé, Díaz Peláez, Jamís, Martínez, and Antonio and Manuel Vidal. The others—Eiriz, Matilla, Mayito, Oliva, Sánchez, Tapia Ruano, and Viredo—eventually did leave Cuba; José Y. Bermúdez and Cárdenas had departed during the 1950s.

THE POSTREVOLUTIONARY VANGUARDIA

> There is a picture by Klee called *Angelus Novus*. . . . This is how the angel of history must look. His face is turned toward the past. Where a chain of events appears before *us*, *he* sees one single catastrophe, which keeps piling wreckage upon wreckage and hurls it at his feet. The angel would like to stay, awaken the dead, and make whole what has been smashed. But a storm is blowing from Paradise and has got caught in his wings; it is so strong that the angel can no longer close them. This storm drives him irresistibly into the future, to which his back is turned, while the pile of debris before him grows toward the sky. What we call progress is *this* storm.[109]
> —Walter Benjamin

At the end of 1964, around the six-year anniversary of the Revolution, Consuegra opened a solo exhibition at the Galería Habana.[110] The titles of the paintings resound with the artist's self-described "frustration and anguish within revolutionary Cuba:" *La hora nona* [The Ninth Hour; a reference to Matthew 27:46: "My God, My God, why hast thou forsaken me?"], *Comandante en Jefe* [Commander in Chief], *Sordomudo* [Deaf-Mute], *Juicio Sumarísimo* [Summary Trial], *Ícaro* [Icarus].[111] Among the fifteen paintings exhibited was *El Ángel exterminador*, a portentous, monumentally scaled image of a dark angel against a plangent ground of blue, black, and white, its lacerated wings spread dramatically along a diagonal axis (fig. 120). The expressionist chaos of the wings, delineated in a maelstrom of textures and brushstrokes, is constrained by the thickened line bounding the figure; the overall effect is one of precisely structured, psychological violence. Consuegra's painting pays tribute to Spanish filmmaker Luis Buñuel's work of the same title from 1962, a tragicomic allegory of survival, social class, and imprisonment (and, too, a rebuke to the Franco regime and the Vatican). At the close of a post-opera dinner, the film's party guests find themselves inexplicably unable to leave the drawing room of a sumptuous mansion. The absurdity of the situation devolves into anarchic depravity as basic needs of food, water, and medicine are fought over and internecine secrets come to light. Their confinement ends after the guests reconstruct their movements, returning to their exact positions at the beginning of the ordeal (to wit, reliving a Surrealist nightmare of eternal return). If Consuegra's *Ángel exterminador* presides over a similar, paralytic perpetuity, his figure also reincarnates Benjamin's "angel of history" and the powerlessness, and poignancy, of its witness to "progress." With a lingering, backward glance

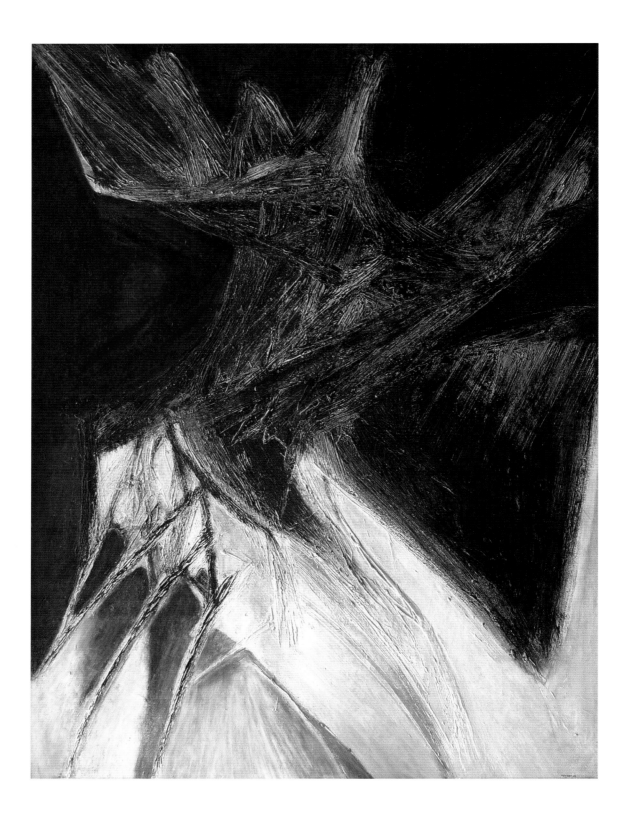

at the decade of the 1950s and its initial, utopian premise, the angel trembles before the senseless catastrophe of the present, its redemptive mission futilely inconclusive. An agonistic image of wings and spindly claws, the angel conjures the sound and fury of the decade past; and yet for all its visceral drama, the exasperation of its—and Consuegra's— disillusionment betrays a growing estrangement and, eventually, a withdrawal from that (postrevolutionary) world.

Abstract art did not come to an end in Cuba in 1963 or 1965, if it ever did. Yet abstraction came to mean something ontologically different than it had under the Batistato, and the capitulation of the abstractos marked the end of the era inaugurated a decade earlier by the "horizon of vanguards" and its precocious, modernist vision. This book has suggested that abstraction, in both its gestural and geometric expressions, represented the culmination of a vanguardia practice begun by the Generation of 1927 and sustained by the Havana School. The third-generation abstractos, long facilely dismissed as lacking the essential cubanidad of their predecessors, nourished themselves on cubanista codes of Cuban universalism, aspirationally americanista and cosmopolitan. Arguing against the supposed exceptionalism of the 1950s, the rise of Los Once channeled the national narrative of cubanía, the group's rugged, iconoclastic aesthetics tapping into the generational insurgency mythologized at Moncada. Abstraction was critically defined by its relationship to the ideology of cubanía—the teleological pursuit of cubanidad—and, in turn, by its situational forcework, that is, its capacity to reveal the power structures of its world.

The rise of the Batistato instantly radicalized the cubanista mandate, allowing the third-generation vanguardia to instantiate its practice in ideological terms. Los Once channeled the polemics of its eponymous first exhibition into a program of exhibition-manifestos over the next two years, deploying gestural abstraction with the moral, martiano, and generational values of Cuba Libre. The concurrence of abstraction and revolutionary process over the months-long course of the Anti-Bienal marked a watershed moment for the onceños. The power of art, in Ziarek's concept of avant-garde practice, as a "spatio-temporal and *nonviolent* play of forces," exacted itself in the fact of the event, which saw abstraction leveraged as a critique of political process.[112] As the onceños splintered along ideological lines and receded from the public eye, the mantle of abstract art fell to Los Diez, who adapted Constructivist vocabularies as a proxy for their vision of a forward-looking utopia. The parallel rise of concretism expanded the purview of third-generation vanguardia practice, suggesting multidimensional patterns of interaction between abstract art, cubanista belief, and radical dissent. Ideational and humanist, concretism advanced an activist program premised upon the integration of the artwork and the social landscape, its agency pinned to the promise of a different future. For both Los Once and Los Diez, the revised power formations of the Revolution proved no less inimical to the cubanista values of freedom that had become, over the long decade of the 1950s, inseparable from the rhetoric of abstraction.

FIGURE 120
Hugo Consuegra, *El Ángel exterminador* [Exterminating Angel], 1964. Oil on canvas. 63 × 47 in. (160 × 119.4 cm). Private collection.

The forcework of abstraction, so keenly manifested in its embroilments with the Batistato, became a vulnerability in the 1960s, precipitating a crisis of identity in its practitioners and in the vanguardia project to which it was tied. Abstraction was namelessly implicated in the telltale disputations over *P.M.*, which effectively collapsed cultural authority into the hands of the state, and its brief afterlife reflected an altered, dis-powered position. Although abstract art was censured for its alleged lack of social commitment, the more damning charge was its persistent identification with cubanía rebelde, the ideology of dissent radicalized during the 1950s, and its reluctance to embrace the Marxist socialism of the new cubanía revolucionaria. Thus the futurity of abstraction, and the idealist projections that had propelled its activism, appeared moot by mid-decade. The local practices of gestural and geometric abstraction no longer had truck with the illusive, modernist utopia that had underpinned the cubanista project of the 1950s. For the onceños and the concretos who persisted in abstraction, their later work could at best simulate the failed utopian moment as traces, or Warburgian "survivals." Their recursive, and in some cases obsessive repetition of earlier forms became in essence unproductive; removed of its critical faculty—its forcework—late abstraction petered out, following a decorative direction in some cases and in others a prolonged, elegiac turn.

The long decade of the 1950s witnessed the convergence of the vanguardia project and the totalizing national ideology of cubanía, movements whose twinned trajectories— this book centrally argues—underlay the forcework of Cuban abstraction. In chronicling the critical fortunes of abstraction during this period, I have suggested that this history encodes the vicissitudes of the decade's cultural politics, particularly in regard to the charged dynamics of modernism, national identity, and revolution. The sustained practices and polemics of abstract art made visible the inner determinants of Cuba's contemporary political culture, situationally transposing the relations between the artwork and its external world and, at decisive moments, disrupting the political process as it unfolded. Leveled as both critique of and counterpoint to "reality," abstraction mediated sundry present-day demands—social commitment, national style, international reach— under the auspices of a still-resilient vanguardia project unwavering in its cubanista commitment. A period style par excellence, Cuban abstraction functioned as a critical, decade-long interface between vanguardia art and the social world, and its polemical history bears the traces of both its intervening forcework at home and its contributions to an international history of late modernist practices and the historical avant-garde.

NOTES

Introduction

1. Tomás Gutiérrez Alea and Edmundo Desnoes, "Memories of Underdevelopment," in *Memories of Underdevelopment*, by Tomás Gutiérrez Alea and Edmundo Desnoes (New Brunswick, N.J.: Rutgers University Press, 1990), 35–36.

2. Raymond Williams, *The Long Revolution* (New York: Columbia University Press, 1961), 90–91.

3. The novel, published in 1962, makes reference to an exhibition of Wifredo Lam (1902–1982); the substitution of Acosta León was made in the screenplay, written collaboratively by Gutiérrez Alea and Desnoes. Among Cuba's most promising young artists, Acosta León committed suicide by throwing himself off the ship returning him from Europe to Havana in 1964 (reportedly, amid reports of increasing homophobia in his home country). Sergio commits suicide in the first version of the screenplay; the ending was later amended to allow for a more open interpretation.

4. Gutiérrez Alea and Desnoes, "Memories of Underdevelopment," 68.

5. Roque Dalton et al., in *El intelectual y la sociedad*, Colección Mínima No. 28 (Mexico City: Siglo Veintiuno, 1969), 94. "En todo desgarramiento de los intelectuales acostumbrémonos a ver primero un problema ideológico y luego, siempre como resultante del mismo, los problemas morales o sentimentales. Estos problemas resultantes sólo podrán ser resueltos sobre la base de la solución del conflicto ideológico de fondo. En ese sentido es que la revolución es un constante reto: su avance ininterrumpido hace que no baste con una aceptación genérica de sus principios últimos y más generales, sino una incorporación permanente a su práctica totalizadora."

6. Edmundo Desnoes, "After Forty Years," introduction to *Memories of Underdevelopment: A Novel from Cuba*, trans. Al Schaller (Pittsburgh: Latin American Literary Review, 2004).

7. Antoni Kapcia, *Cuba: Island of Dreams* (New York: Berg, 2000).

8. Krzysztof Ziarek, *The Force of Art* (Stanford, Calif.: Stanford University Press, 2004), 7.

9. Notable group exhibitions of this kind include *The Experimental Exercise of Freedom: Lygia Clark, Gego, Mathias Goeritz, Hélio Oiticica, Mira Schendel* (Museum of Contemporary Art, Los Angeles, 1999); *Geometry of Hope: Latin American Abstract Art from the Patricia Phelps de Cisneros Collection* (Blanton Museum of Art, Austin, 2007); *Constructive Spirit: Abstract Art in South and North America, 1920s–50s* (Newark Museum, N.J., 2010); and *América fría: La abstracción geométrica en latinoamérica, 1934–1974* (Fundación Juan March, Madrid, 2011).

10. Andrea Giunta, introduction to *Avant-Garde, Internationalism, and Politics: Argentine Art in the Sixties*, trans. Peter Kahn (Durham, N.C.: Duke University Press, 2007), 7.

Chapter 1. The Horizon of Vanguards

1. Antonio Vidal, quoted in Pedro de Oraá, "[Words at the opening of *La Razón de la Poesia*]," December 4, 2002, *Concretos* file, Museo Nacional de Bellas Artes, Havana. "Los Once fueron el resultado de un encuentro generacional. Nos agrupamos porque al ser jóvenes queríamos romper con lo que nos antedecía. Éramos un grupo de idealistas."

2. Salvador Corratgé, "Memorias de un Pintor," n.d., Corratgé file, Museo Nacional de Bellas Artes, Havana. Corratgé originally intended

for this to serve as a preface to a longer memoir, which never materialized.

3. Raúl Martínez, *Yo Publio: Confesiones de Raúl Martínez* (Havana: Editorial Letras Cubanas, 2007), 334.

4. Ibid., 335.

5. Ibid., 5.

6. Eduardo Chibás, trans. and quoted in Hugh Thomas, *Cuba, or, The Pursuit of Freedom*, rev. ed. (New York: Da Capo, 1998), 752, 767.

7. Ibid., 770.

8. Richard Gott, *Cuba: A New History* (New Haven: Yale University Press, 2004), 146.

9. Thomas, *Cuba, or, The Pursuit of Freedom*, 789–90.

10. U.S. Department of Commerce, *Investment in Cuba: Basic Information for United States Businessmen* (Washington, D.C.: U.S. Department of Commerce, Bureau of Foreign Commerce, 1956), 11, 155–62.

11. See Marifeli Pérez-Stable, *The Cuban Revolution: Origins, Course, and Legacy* (New York: Oxford University Press, 1993), 5. "During the 1950s, Cuba ranked among the top five countries in Latin America on a wide range of socioeconomic indicators such as urbanization, literacy, per capita income, [low] infant mortality, and life expectancy."

12. Basil Woon, *When It's Cocktail Time in Cuba* (New York: Horace Liveright, 1928), 31.

13. Kapcia, *Island of Dreams*, 24.

14. Ibid., 24.

15. Salah Dean Assaf Hassan, "Between Issues: The Politics of Cultural Journals in the Postwar Era, 1944–1962," Ph.D. diss., University of Texas at Austin, 1997, 35.

16. José Lezama Lima, "Recuerdos: Guy Pérez de Cisneros," *Revista de la Biblioteca Nacional José Martí* 2 (May–August 1988): 26.

17. Louis Aragon, "Poemas," trans. José Rodríguez Feo, *Orígenes* 2, no. 11 (Fall 1946): 233–37; Stéphane Mallarmé, "Un golpe de dados jamás abolirá el azar," trans. Cintio Vitier, *Orígenes* 6, no. 32 (1952): 85–109; Carlos Fuentes, "El que inventó la pólvora," *Orígenes* 7, no. 40 (Spring 1945): 423–37; and Enrique Anderson Imbert, "La muralla (cuento argentino)," *Orígenes* 5, no. 27 (1951): 188–89.

18. *Orígenes* published work by Lydia Cabrera (1899–1991), Eliseo Diego (1920–1994), Roberto Fernández Retamar (b. 1930), Virgilio Piñera (1912–79), and Cintio Vitier (1921–2009), among many others.

19. Rafael Rojas, "*Orígenes* and the Poetics of History," trans. Luis P. Aguilar-Moreno, *CR: The New Centennial Review* 2, no. 2 (Summer 2002): 181.

20. Ibid., 177.

21. Nicolás Quintana, in discussion with the author, November 5, 2008, Miami.

22. Pedro de Oraá, in discussion with the author, January 19, 2009, Havana.

23. Salvador Corratgé, in discussion with the author, January 19, 2009, Havana.

24. Felipe Orlando, letter to José Gómez Sicre, September 5, 1950, Box 10, Folder 31, José Gómez Sicre Papers, Benson Latin American Collection, University of Texas Libraries, University of Texas at Austin.

25. Richard Schweid, *Che's Chevrolet, Fidel's Oldsmobile: On the Road in Cuba* (Chapel Hill: University of North Carolina Press, 2004), 141–43, 180.

26. Luisa Yanez, "Man Wins $1 Billion Judgment Aagainst Fidel Castro, Che Guevara," *Miami Herald*, May 29, 2009; Roberto Segre, Mario Coyula, and Joseph L. Scarpaci, *Havana: Two Faces of the Antillean Metropolis*, rev. ed. (Chapel Hill: University of North Carolina Press, 2002), 77.

27. Louis A. Pérez, *On Becoming Cuban: Identity, Nationality, and Culture* (Chapel Hill: University of North Carolina Press, 1999), 435.

28. Enrique Cirules, *El Imperio de la Habana* (Havana: Editorial Letras Cubanas, 1999), 24, trans. Antoni Kapcia, *Havana: The Making of Cuban Culture* (New York: Berg, 2005), 91.

29. T. J. English, *Havana Nocturne: How the Mob Owned Cuba—And Then Lost It to the Revolution* (New York: William Morrow, 2008), xvi and passim.

30. William Galvéz Rodríguez, quoted in English, *Havana Nocturne*, xviii.

31. Graziella Pogolotti, in discussion with the author, January 29, 2009, Havana.

32. Segre, Coyula, and Scarpaci, *Havana*, 78–79.

33. Ibid., 78.

34. Eduardo Luis Rodríguez, introduction to *The Havana Guide: Modern Architecture, 1925–1965*, trans. Lorna Scott Fox (New York: Princeton Architectural Press, 2000), xvii.

35. María Luisa Lobo Montalvo, with Zoila Lapique Becali and Alicia García Santana, *Havana: History and Architecture of a Romantic City*, trans. Lorna Scott Fox (New York: Monacelli, 2000), 262.

36. CIAM was a loose association of architects organized in 1928 by Le Corbusier and Sigfried Giedion that formalized principles of modernist orthodoxy and sought to widely disseminate a functionalist, social vision of architecture. CIAM had broad international influence and reached Latin America in the 1950s, notably in urban plans for Bogotá (Sert and Le Corbusier, 1951), Brasília (Lucio Costa, 1957), and Havana (Sert and Wiener, 1956). See Segre, Coyula, and Scarpaci, *Havana*, 82–86.

37. Rodríguez, *Havana Guide*, 160.

38. Hugo Consuegra, *Elapso Tempore* (Miami: Ediciones Universal, 2001), 88. "De coña nos llamaban 'los espaciales,' porque siempre estábamos con el espacio para arriba y el espacio para abajo." The group's members included Sergio González, Manuel Mesa, Serafín Miguenes, Vicente Morales, Pablo Pérez, and Osvaldo Tapia Ruano (cousin of the painter Juan Tapia Ruano).

39. Rodríguez, *Havana Guide*, 137.

40. John A. Loomis, *Revolution of Forms: Cuba's Forgotten Art Schools* (New York: Princeton Architectural Press, 1999), 7.

41. Consuegra, *Elapso Tempore*, 150–51. The list of participants reads as a distinguished generational roll call: composer Juan Blanco (1919–2008); writers Edmundo Desnoes (b. 1930), Abelardo Estorino (1925–2013), and Severo Sarduy (1937–1993); painters Juan Tapia Ruano (1914–1980) and Manuel Vidal (1929–2004); and architects Quintana, Osmany Cienfuegos (b. 1931), Hugo D'Acosta, and Fernando Salinas (1930–1992).

42. Consuegra, *Elapso Tempore*, 88, 151.

43. "Manifiesto," *Nuestro Tiempo*, no. 1 (1951): 1–2, reprinted in Ricardo Luis Hernández Otero, ed., *Sociedad Cultural Nuestro Tiempo: Resistencia y acción* (Havana: Letras Cubanas, 2002), 19–20. "Somos la voz de una nueva generación que surge en un momento en que la violencia, la desesperación y la muerte quieren tomarse como únicas soluciones. Nos definimos por el hombre que nunca está en crisis, por su obra es una esencia permanente."

The complete list of signatories is as follows: José M. Mijares, Rafaela Chacón Nardi, Carilda Oliver, Harold Gramatges, Delia Fiallo, Dolores Torres, Eugenio Rodríguez, Hilda Perera, Surama Ferrer, Nilo Rodríguez, Eduardo Manet, Roberto F[ernández] Retamar, Guillermo Cabrera Infante, Edmundo López, Adoración G. de Chávez, Enriqueta Farías, Juan Blanco, Rolando Gutiérrez, Sabá Cabrera, Néstor Almendros, Germán Puig, Lisandro Otero, Matías Montes Huidobro, Mario Parajón, Rine R. Leal, Luis Ángel Casas, Tomás Gutiérrez Alea, and Ithiel León.

44. Ibid. "Nuestra estética es la de un arte Americano, libre de prejuicios políticos o religiosos, enaltecido por encima de concesiones, que sea síntesis de lo que estimamos vigente y permanente en América. . . . Surgimos para traer el pueblo al arte, acercándolo a las inquietudes estéticas y culturales de nuestro tiempo, precisamente ahora en que, intuyendo ya estas realidades, demanda un vehículo que le permita palparlas y asimilarlas para su más rápida formación y madurez cultural."

45. Nicolás Guillén, "Semanario habanero: noticia sobre Nuestro Tiempo," *El Nacional*, February 19, 1951, reprinted in Hernández Otero, *Sociedad Cultural Nuestro Tiempo*, 207.

46. Ibid.

47. Salvador Bueno, "La Sociedad Cultural Nuestro Tiempo," *Revista Cubana* 28 (January–June 1951): 265.

48. See Harold Gramatges, "La Sociedad Cultural Nuestro Tiempo" (paper presented at the Conferencia en la Escuela de Cuadros del Consejo Nacional de Cultura, Havana, March 14, 1974), reprinted in Hernández Otero, *Sociedad Cultural Nuestro Tiempo*, 286–89.

49. Bueno, "La Sociedad Cultural Nuestro Tiempo," 267.

50. Kapcia, *Making of Cuban Culture*, 92.

51. Ibid., 92.

52. Ibid., 102.

53. See Michael Chanan, *Cuban Cinema* (Minneapolis: University of Minnesota Press, 2004), 109.

54. See Teresa J. Fernández, *Revolución, poesía del ser* (Havana: Ediciones Unión, 1987); and Roberto Fernández Retamar and Fayad Jamís, eds., *Poesía joven de Cuba* (Lima: Editorial Popular de Cuba, 1959).

55. Luis Dulzaides Noda, "La crítica de arte en Cuba," *Estudios* (1950): 9.

56. Alejandro G. Alonso, in discussion with the author, January 15 and 27, 2009, Havana. Formal academic training in art history was instituted at the University of Havana in the years following the Revolution.

57. See Eliseo Diego, Fina García Marruz, Lorenzo García Vega, Ángel Gaztelu, Julián Orbón, and Cintio Vitier, "Homenaje a Arístides Fernández (1904–1934)," *Orígenes* 5, no. 26 (1950): 152–56; and Oscar González Hurtado, "Seis escultores [Roberto Estopiñán, Eugenio Rodríguez, Rodolfo Tardo, José Núñez Booth, Alfredo Lozano, Rolando Gutiérrez]," *Orígenes* 1, no. 2 (Summer 1944): 103–5.

58. Kapcia, *Making of Cuban Culture*, 95.

59. *Inventario* 1, no. 2 (May 1948): n.p.

60. Consuegra, *Elapso Tempore*, 135.

61. See "Nuestros Esclavos Stalinianos," *Inventario* no. 18 (October 1950): n.p.; "Mayores y menores," *Inventario* 3, no. 26 (1952): n.p.; Consuegra, *Elapso Tempore*, 135.

62. Contributing authors included Emilio Ballagas (1908–1954), Samuel Feijoo (1914–1992), Gutiérrez Alea, Marcelo Salinas (1889–1976), Texidor, and Carlos Ximénez Arroyo.

63. Guido Llinás, "Visite el mundo . . . ¡Visite Greenwich Village!" *Inventario* 3, no. 26 (1953): n.p.

64. Mario Albano, "Mis notas . . .," *Inventario* no. 18 (October 1950): n.p.

65. Dulzaides Noda, "Se quedaron con las ganas," *Inventario* 2, no. 24 (1952): n.p.

66. Mario Carreño, letter to Gómez Sicre, July 22, 1952, Box 6, Folder 2, José Gómez Sicre Papers.

67. Ibid.

68. Sandú Darié, Mario Carreño, and Luis Martínez Pedro, "Presentación," *Noticias de Arte* 1, no. 1 (September 1952): 3.

69. Gyula Kosice, letter to Sandú Darié, in *Noticias de Arte* 1, no. 4 (December 1952): 16. The letter reads, in full (emphasis in original): "*Noticias de Arte* que nos envía adjunta, nos parece una revista de todo punto de vista *trascendente*, sobre todo para la formación y orientación de la gente joven ávida de ver potenciada su época y su arte sobre todo en latinoamérica, en que son contadas las revistas que funcionan esencialmente en ese sentido.

"Si a Ud. a parece y siendo uno de los editores, me gustaría pertenecer a la lista de *colaboradores*: enviaré entonces, en la medida que lo requieran, material para la revista—ensayos, pinturas, poemas, esculturas y también irán trabajos de mis compañeros madís que recibieron jubilosamente el No. 1."

70. E[va] F[rejaville], review of *El Existencialismo es un humanismo*, by Jean-Paul Sartre, and *Los Justos*, by Albert Camus, *Noticias de Arte* 1, no. 4 (December 1952): 15.

71. "Arte y cultura en Camagüey," *Noticias de Arte* 1, no. 7 (April 1953): 13.

Chapter 2. Los Once and the Polemics of Abstraction

1. Felipe Orlando, quoted in Lisandro Otero González, "Como un pintor cubano ve a Europa," *El País Gráfico* (Havana), October 5, 1952.

2. Raúl Martínez, quoted in Shifra M. Goldman, "Painters into Poster Makers: A Conversation with Two Cuban Artists," chap. 5 in *Dimensions of the Americas: Art and Social Change in Latin America and the United States* (Chicago: University of Chicago Press, 1994), 146.

3. Juan Marinello, "Nuestro arte y las circunstancias nacionales," *Cuba Contemporánea* (April 1925): 303.

4. Wifredo Lam (1902–1982) is undoubtedly the most recognized artist of this first generation, but the trajectory of his career during this period distanced him from his vanguardia colleagues. Lam lived in Europe between 1923 and 1941 and later divided his time between New York, Havana, and Paris before permanently settling in Europe in 1952. His international renown during the 1940s and 1950s nevertheless bestowed an authority upon Cuba's third-generation vanguardia, to whom he lent his full support.

5. Alejo Carpentier, "Un pintor cubano con los futuristas italianos: Marcelo Pogolotti," *Social* 16, no. 11 (November 1931): 68. Pogolotti subsequently distanced himself from the Futurist movement, disavowing its Fascist politics and advocating a Marxist position manifested in his advocacy for "the social in art" and portrayal of the working class. As a writer for the daily *El Mundo*, he became an influential intellectual voice in Cuba in the 1940s and 1950s (he returned to Havana in 1939); although he had become blind in the late 1930s, he exhibited his work in Cuba and supported the onceños in

the Anti-Bienal and Anti-Salon. See Pogolotti, "De lo social en el arte," *Exposición Pogolotti "Nuestro Tiempo" (dibujos), 15 al 30 de mayo,* exh. cat. (Havana: Frente Nacional Anti-Fascista, 1944).

6. Martí Casanovas, "Nuevos rumbos: La exposición de '1927,'" *Revista de Avance* 1, no. 5 (May 15, 1927): 100.

7. Martí Casanovas, "Arte nuevo (de la conferencia pronunciada en la clausura de la Exposición de '1927')," *Revista de Avance* 1, no. 7 (June 15, 1927): 158, 175.

8. See Juan A. Martínez, "Social and Political Commentary in Cuban Modernist Painting of the 1930s," in Alejandro Anreus, Diana L. Linden, and Jonathan Weinberg, eds., *The Social and the Real: Political Art of the 1930s in the Western Hemisphere* (University Park, Pa.: Pennsylvania State University Press, 2006), 21–41.

9. "Declaración del Grupo Minorista (May 7, 1927)," in Ana Cairo, *El Grupo Minorista y su tiempo* (Havana: Editorial de Ciencias Sociales, 1978), 67–68. The anti-imperialist rhetoric was directed toward the notorious Platt amendment (1902–34), which permitted far-reaching U.S. involvement in Cuba's governance and international affairs.

10. Marinello, "Nuestro arte y las circunstancias nacionales," 304. "Debemos recordar, los que nunca debieron olvidarlo, que mientras Cuba no ofrezca al mundo, a falta de un imposible poder material, una significación cultural original y fuerte, no será libre sino a medias. Y ninguna disciplina como la del arte para realizar esa, nuestra toda liberación."

11. José Gomez Sicre, "Modern Painting in Cuba," *Magazine of Art* 37, no. 2 (February 1944): 51.

12. Ramón Guirao, "Exposición Nacional de Pintura y Escultura," *Grafos* 3, no. 23 (March 1935): 16–19.

13. *El arte en Cuba: Su evolución en las obras de algunos artistas,* exh. cat. (Havana: Universidad de la Habana, 1940); *300 años de arte en Cuba: exhibición de obras representativas del movimiento artístico en Cuba desde sus inicios hasta nuestros días,* exh. cat. (Havana: Universidad de la Habana, 1940).

14. Guy Pérez Cisneros, "Nuestra Pintura," *Grafos* 9, no. 97 (December 1941): 27–29.

15. Enrique Riverón, Box 1, Folder 38, José Gómez Sicre Papers. "Riverón's painting evidences continuing meditation by the artist on the varying tendencies and theories that have come into prominence in the years since 1920: one finds reflections of all the offshoots of Cubism and moves toward total abstraction that took the stage in turn throughout the succeeding decades. It should be noted in this regard that, in the late 1930s, Riverón was the first in Cuba to take up nonobjective art."

16. *Riverón, del sábado 5 al lunes 14 de febrero,* exh. cat. (Havana: Lyceum, 1955). For more on Riverón, see Giulio V. Blanc and Enrique Riverón, "Enrique Riverón on the Cuban 'Vanguardia': An Interview," *Journal of Decorative and Propaganda Arts* 22 (1996): 240–53.

17. *Girona, julio 14 al 24,* exh. cat. (Havana: Sociedad Universitaria de Bellas Artes, 1954); *Julio Girona: Dibujos, acuarelas, 6 a 20 de marzo,* exh. cat. (Havana: Galería Color-Luz, 1958).

18. *Roberto Diago: Oil, drawing, scratch-board, water-color and projects for ceramic, September 17 to October 20,* exh. brochure (Washington, D.C.: Pan-American Union, 1953).

19. Mario Carreño, "Contesta Mario Carreño a Roberto Diago," *Pueblo* (Havana), November 13, 1953; *Cuarenta dibujos de Diago, desde el 14 al 25 de marzo,* exh. cat. (Havana: Palacio de Bellas Artes, 1956).

20. Joaquín Texidor, "IV Salón Nacional de Pintura y Escultura," *Estudios: Mensuario de Cultura* I, no. 5 (August 1950): 17.

21. Roberto Estopiñán, Box 2, Folder 39, José Gómez Sicre Papers.

22. Texidor, "IV Salón Nacional de Pintura y Escultura," 50.

23. José Mijares, Box 1, Folder 50, José Gómez Sicre Papers.

24. Carlos Ximénez Arroyo, "El IV Salón Nacional de Pintura y Escultora," *Inventario* II, no. 18 (1950).

25. The critical record of this Salon is largely unknown, excepting three reviews by Carmelo González: "V Salón de pintura, escultura y grabado," *Buril: Boletín de la Asociación de Grabadores de Cuba* no. 2 (August 1951); "Los premios de grabado en el V Salón Nacional," *Buril: Boletín de la Asociación de Grabadores de Cuba* no. 3 (September 1951); "De nuevo el V Salón de pintura, escultura y grabado," *Germinal* (September 1951): 9–10, 25–26.

26. See Lowery Stokes Sims, "'Lo maravilloso' and the Antillian Ethos," chap. 5 in *Wifredo Lam and the International Avant-Garde, 1923–1982* (Austin: University of Texas Press, 2002), 115.

27. Kapcia, *Island of Dreams*, 79–93; Segre, Coyula, and Scarpaci, *Havana*, 75–80; Claes Brundenius, *Revolutionary Cuba: The Challenge of Economic Growth with Equity* (Boulder, Colo.: Westview Press, 1984), 12–18.

28. Raúl Martínez Arará, quoted in Thomas, *Cuba, or, The Pursuit of Freedom*, 828.

29. Fidel Castro, quoted in Gott, *Cuba: A New History*, 150.

30. Kapcia, *Island of Dreams*, 93–97.

31. Carreño, "La plástica cubana de hoy," *Espacio* 1, no. 5 (September–October 1952): 55. "Existe una generación de pintores que hasta hace poco se le llamó 'menores de 30 años.' A ella pertenecen José Mijares, Servando Cabrera Moreno, Luis Alonso, René Ávila, Virgilio González, Mirta Cerra, Pedro Álvarez, Sabá Cabrera, Antonia Eiriz, Fayad Jamís, Guido Llinás, Manuel y Antonio Vidal, Raúl Martínez, Zilia Sánchez y Agustín Fernández, los cuales se expresan de una manera más o menos abstracta. Esta generación, siguiendo el ejemplo de la anterior, se supera cada día."

32. Ibid., 52–53. "La ausencia de tradición plástica en nuestro país es uno de los factores decisivos en la formación de arte nuevo en Cuba, el cual se caracteriza principalmente por una profunda expresión abstracta y universal, desprovista de todo 'folklorismo' o 'tipicismo.' . . . Este desolado panorama, desprovisto de tradición plástica, es una de las causas por las cuales no podemos hablar de un auténtico 'arte típico,' o ni siquiera de un arte 'puramente cubano.' ¿Cuáles serían pues, las características definidoras de lo que pudiéramos llamar 'cubano'? . . . Creo que no es muy aventurado asegurar que la tradición plástica cubana la están haciendo los artistas actuales, para las futuras generaciones."

33. Ibid., 53 (emphasis in original). "El espíritu de una obra no está en *lo pintado*, sino en *cómo se ha pintado*."

34. "Arte joven" (Havana), 1952, Cuba file, Archives of the Art Museum of the Americas of the Organization of American States, Washington, D.C. "La agrupación de cinco artistas distintos con una común aspiración de poner énfasis en su libertad, en su liberación de las normas con que siente trabada la pintura de hoy sus cardinales, hondos, vehementes designios de erguirse nueva y no intemporal toda ella como ínsita en la universal inquietud del momento, se presta, ante todo, a entrar en la auscultación de ese espíritu joven, alerta, consciente de su ambición, animoso de su responsabilidad, valeroso en el diagnóstico del hoy, pero decidido a vivir su destino."

35. Ibid.

36. Ibid. "Guido está hecho. Tiene que decidirse a hacer. Lo que expone le obliga. No se puede decir más ante este ya cuajada facultad. Lo de la martiana manga al codo ha de serle ya a Llinás, tanto como estímulo, mandato." Cf. José Martí, "Our America," in *José Martí: Selected Writings*, trans. Esther Allen (New York: Penguin, 2002), 294. "The young men of America are rolling up their sleeves and plunging their hands into the dough, and making it rise with the leavening of their sweat."

37. René Llinás, in discussion with the author, January 21, 2009, Havana.

38. Guido Llinás addressed African iconography years later, in Paris, but during the 1950s his work avoided explicit gestures to African themes.

39. Guido Llinás, unpublished interview by Alejandro Anreus, May 10, 2003. "Fui a los USA del '53 al 1957 cada verano, un mes, creo. Era maestro de escuela y tenía las vacaciones de verano. . . . Fui a Washington, donde vi a Gómez Sicre, que era amigo de Hugo Consuegra y Estopiñán. Nunca nos llevamos bien, el gordo y yo. Visité Filadelfia y Boston. Me aprendí el MoMA y el Metropolitan, y las galerías de Charles Egan, Betty Parsons, Sidney Janis. En USA vi por primera vez originales de Picasso, Miró, Gauguin y los impresionistas. Los extraordinarios grabados de Nolde y Rouault también. Comprendí entonces lo que decía el poeta Baragaño, que le decía a la Escuela de La Habana: 'la escuela de Skira.' Conocían la pintura mundial en blanco y negro y en escala de libro."

40. "Arte joven." "En conjunto, la exposición despierta un inmediato sentimiento de responsabilidad patente en el arte y en la tarea de éstos y de tantos otros artistas jóvenes que, contra lo que con demasiada ligereza opinan algunos, lejos de intentar la facecia alegre de una pirueta tienen concepto y conciencia de lo que ansían

y devoción al arte y clara idea de la labor que les está encomendada o que ellos, con noble espíritu, se han atribuido."

41. Salvador Bueno, "El VI Salón de pintura y escultura," *Carteles*, January 25, 1953, p. 72.

42. Luis Dulzaides Noda, "VI Salón Nacional de pintura y escultura," *Inventario* II, no. 25 (1953): n.p.

43. El Duende del Capitolio, "Bellas Artes . . . ¿Bellas?" *Carteles*, January 25, 1953, p. 76.

44. Rafael Marquina, "Breve información en torno al Salón Nacional de Bellas Artes de este año," *Información* (Havana) February 8, 1953, p. 24.

45. Dulziades Noda, "VI Salón Nacional de Pintura y Escultura," n.p.

46. Ibid.

47. Carmelo González, "Consideraciones y comentarios sobre el VI Salón Nacional de pintura y escultura," *Germinal* (February 1953): 33–34.

48. Ibid., 28, 33–34.

49. Bueno, "El VI Salón de Pintura y Escultura," 72. "Las dos generaciones de pintores que dan vitalidad y altura al arte cubano en los últimos veinticinco años tenían un punto de mira y aspiraban a un horizonte más o menos esclarecido. . . . Ahora en la actualidad, ¿hacia dónde se dirigen estos artistas, contra qué pasado caduco quieren combatir? No lo advertimos. Algunos artistas jóvenes—en el VI Salón Nacional hay pruebas concluyentes y definitivas—han alcanzado estilo propio, ganado un sendero particular, una manera que se desprende de adyacentes huellas y polarizaciones absolutas. . . . Podemos señalar, sin ánimo polémico, un predominio y absorción de los artistas más nuevos por las tendencias abstraccionistas. Pero acaso en algunas es deseo de experimentación, para hacer la mano, no por un ajuste perfecto con tal o cual modalidad o tendencia."

50. Texidor, "El arte contemporáneo y el VI Salón Nacional," *Noticias de Arte* 1, no. 7 (April 1953): 3, 15. "Estamos en los primeros momentos de la renovación iniciada por los vientos de la generación del 27. . . . El arte contemporáneo en Cuba, a través de largos treinta años, ha cumplido su misión. Ha estado en primera fila en los debates más caliente y polémicos, de las grandes cuestiones que hoy afectan a la inteligencia y a la cultura. Lejos del sedentarismo académico, ha manifestado su lealtad a los principios estéticos que avala la cultura de Europa, aunque manteniendo su libertad de expresión y estilo. Ha trasuntado, en calidades innegables, lo que la pintura de taller no había alcanzado, es decir, un modo de expresión cubano dentro de la universalidad de las formas que hoy van de América a Europa y de allá y acá."

51. Ibid., 3.

52. Ibid., 15.

53. González, "Consideraciones y comentarios sobre el VI Salón Nacional de Pintura y Escultura," 17, 28. "No creo que en una época como la nuestra, de sindicalismos, de lucha por el pan, la paz y el trabajo, de espacio vital, de guerras y revoluciones intestinas, de bombas atómicas, de hidrógenos, de platillos voladores y aviones de retropropulsión, o sea una época de ambiciones prácticas, materiales, a la que no veo nada de abstracción, sea el arte abstracto el que nos represente. ¿Es abstracta la guerra de Corea? ¡No! . . . Como una de tantas expresiones del hombre en el Arte, valga, pues el Arte no es unilateral; pero unas veces por exceso y otras para defecto, ahora los muchachos abstractos creen que el artista no tiene otro camino más que el de ellos; sin darse cuenta que nadie los comprende, pues son abstractos."

54. Cf. Kapcia, *Island of Dreams*, 163. "Generations, and the accompanying notions and implications of re-generation, have the ability to justify both the faith in change that is implicit in the self-image of revolutionary legitimacy and the need for continuity. Faith in change, on the one hand, implies the hope for a future that will correct the failings of the present generation; while continuity, on the other hand, links the present dissidence to a past that is perceived to contain the essence of the denied nation. According to this perspective, each succeeding generation can be seen as taking up the preceding generations' struggle, which has been betrayed by the intervening one."

55. Texidor, "El arte contemporáneo y el VI Salón Nacional," 3. "Es el arte un órgano tan vivo y activo, como cualquiera del cuerpo humano. . . . Negarle la sal y el agua a la pintura abstracta como se hizo, sin más argumento que el que 'no era arte,' y que tenía apenas reminiscencias de elementos humanos, que no era comprensible; era negar de plano toda la riqueza que ha conquistado para la pintura

universal. . . . Con la pintura abstracta, la pintura ha vuelta a ser pintura: ha logrado una arquitectura que no sólo complace al ojo y al sentimiento por la magia del color, sino que va más allá, afectando al espíritu por su esencia intelectual. . . . Ya apuntaba Leonardo, y nos queda a bastante distancia el genio florentino, que la pintura era cosa 'mental.' Y hacia esa humana intelectuación tan pura y tan expresiva, ha retornado el arte abstracto."

56. Carreño, "El factor moral en la pintura abstracta," *Noticias de Arte* 1, no. 8 (May 1953): 11.

57. Ibid., 14.

58. "Manifiesto," *Nuestro Tiempo*, no. 1 (1951): 1–2.

59. Salvador Corratgé, quoted in Carina Pino-Santos, "Vidal, Corratgé, Oraá: El camino de la abstracción," *Revolución y Cultura* 1, no. 99 (January-February 1999): 26. "De los 23 y medio se marchan unos dos o tres artistas; entonces Texidor insiste y plantea que no se les pondrá ese nombre sino el de Irún (lugar de nacimiento de un escultor catalán abstracto de fama) y que se quedarían los que desearan hacerlo dentro de esta intención grupal, pero esta idea tampoco cuajó y así cada uno fue tomando su rumbo. Y según mi opinión, es Hugo el que crea prácticamente el grupo de los quince, que expondrían en febrero de 1953 en la Sociedad Nuestro Tiempo."

 Cf. Graziella Pogolotti, "Los Once en el viraje de los cincuenta," *Revolución y Cultura* 1, no. 99 (January–February 1999): 20–21. "A diferencia de lo ocurrido con la primera generación de la vanguardia, que trabajaron en el aislamiento, aunque coincidieron en su programa antiacademicista y en y en algún salón colectivo, los que ahora surgían percibieron la necesidad del agrupamiento. La obra seguía haciéndose en la soledad, pero su proyección en el espacio social era una conquista posible tan sólo a través de la unión. Integrar grupos, expresión de necesaria autodefensa, respondía también a la demanda de multiplicar las vías institucionales para el intercambio y la puesta en circulación de las ideas, para el enriquecimiento de un clima cultural todavía muy anémico."

60. Texidor, *15 dibujos de pintores y escultores jóvenes*, exh. cat. (Matanzas: Galería de Matanzas, 1953), n.p. "La advertencia se impone para situar con claridad la labor de cada uno de los concurrentes. Es fácil observar que constituyen un grupo heterogéneo en el continente, aunque en el contenido los une una misma aspiración, un mismo querer. Pero sobre todo no se deje de ver, que celosamente, cada una defiende su individualidad. Como cada cual ajusta, afina, logra, una formulación que sólo el resultado nos mostrará su validez, su alcance."

61. de Oraá, "Trayecto de Los Once," *La Gaceta de Cuba* 34, no. 4 (July–August 1986): 23. "Escuché decir a Antonio Vidal que esa numeración no significaba nada (o sea, respondía a un hecho accidental) y que podría estar compuesto el grupo por doce, veinte y tantos como artistas de la misma generación se moviesen en el círculo de los conocidos cuyos intereses y aspiraciones fueran afines. Ciertamente, los unía además de la amistad, la identificación del empeño en lograr un espacio para manifestarse y afirmarse desde sus individualidades. . . . En el medio insular de los años cincuenta, constituirse en grupo era más un acto de protección y apoyo mutuos y no tanto un risueño acontecimiento escolástico." See also Luis Dulzaides Noda, "Faltó uno en la Exposición de los 'Once,'" *Inventario* 2, no. 25 (1953): n.p.

62. Luis Dulzaides Noda, "11 Pintores y Escultores," *Gente* (Havana), June 7, 1953. See also Gladys Lauderman, "Once Pintores y Escultores," *El Mundo* (Havana), April 1953, n.p. "Estos jóvenes han expuesto tímidamente en otras exhibiciones, pero no se habían presentado al público con un conjunto de obras de tanta calidad estética."

63. Dulzaides Noda, "11 Pintores y Escultores."

64. "Once Pintores y Escultores," *Noticias de Arte* 1, no. 8 (May 1953): 13. "Los escultores que exponen en esta ocasión, son unos enamorados del volumen, concibiendo el espacio sólido, como una realidad concreta y no sugerida por la reciprocidad formal. Todavía no han encontrado esa armonía entre espacio vacío y forma llena. . . . Queremos decir que no hay la voluntad de forma 'a priori' que requiere la creación de un arte que se basa en postulados esenciales. Es por eso que la obra a veces se queda con un 'halo' surrealista o literario cuando en realidad el autor pretendía una construcción plástica pura."

65. Ibid., 6–7.

66. Cf. Barnett Newman, "The First Man was an Artist," *The Tiger's Eye* no. 1 (October 1947): 57–60.

67. Consuegra, quoted in Lisset Martínez Herryman, "Hugo Consuegra: A Close Up," in *Hugo Consuegra*, ed. Lisset Martínez Herryman and Gustavo Valdés (Miami: Ediciones Universal, 2006), 150. "[O]ur primary and strongest motivation was to seek a new expression that would provide us with an outlet for channeling anxiety through a different array of forms from those used by our immediate predecessors."

68. Texidor, *Once Pintores y Escultores*, *18–28 abril*, exh. cat. (Havana: La Rampa, 1953), n.p.

69. Ibid. "Puede decirse, sin llegar al eufemismo, que esta exposición constituye una saludable presencia para la afirmación de lo que es hoy en el mundo la pintura y la escultura de tendencia abstraccionista. . . . Las cuestiones de orden técnico, de logros, de eficiencias, quedan por un instante suspendidas, en sincero homenaje a la hazaña. Porque no vamos a dejar de apuntar que hay en algunos impericias técnicas, debilidades conceptuales, pero evitamos las clasificaciones y el rigor crítico y tendámosle el tenso cordel de la admiración a quienes en su primera salida al mundo de la plástica, lo hacen con tanta austeridad y responsabilidad. . . . Estos son los productos que su mente, su corazón, su imaginación han elaborado con el máximo de invención, de aventura, de atrevimiento, de creación en suma."

70. Rafael Marquina, "A Propósito de la Exposición de los Once," *Información* (Havana), June 14, 1953. "Esas palabras contienen el síntesis todos los motivos—con exclusión de los valores—que le han procurado a la Exposición de los Once su trascendencia, su significación influyente e influida, su vigencia como hecho artístico que reclama, porque la posee intrínseca, su categoría de 'data.'"

 "Once Pintores y Escultores," *Noticias de Arte*, 6. "La historia del Arte Moderno en Cuba, desde Víctor Manuel hasta el más abstracto de nuestros artistas, ha sido la 'historia de la heroicidad.' La indiferencia y la incomprensión del público cubano por el arte moderno, ha elevado a la categoría de 'héroes' a esa legión de artistas que ha dado nombre y gloria a Cuba, no sólo aquí, sino también en el extranjero. . . . Esta exposición . . . es una página más de esa historia heroica del arte moderno en Cuba."

71. Cf. "Once Pintores y Escultores," *Noticias de Arte*, 6. "Estos expositores de la más joven 'camada' artística cubana, forman la gran reserva, la vanguardia de nuestro arte que va renovándose continuamente, con la fuerza y el brío de la juventud que busca, que bucea inquietamente en nuevos horizontes plásticos."

72. Kapcia, *Island of Dreams*, 163.

73. Raúl Martínez, quoted in Goldman, "Painters into Poster Makers," 146–47.

74. See Raúl Martínez, "Los Once," *Revolución y Cultura* 1, no. 99 (January–February 1999): 31.

75. Corratgé, "Memorias de un Pintor."

76. Ibid. "El grupo *Los Once* trabajaba fundamentalmente en la búsqueda de valores expresivos iniciada ya por un grupo de pintores americanos. Considerábamos que aquel movimiento abstracto en el que se destacaban Pollock, Kline, De Kooning y Tobey eran maestros a seguir y no aquellos del apagado continente europeo." The rise of the New York School has been widely documented. See, for instance, Irving Sandler, *The Triumph of American Painting: A History of Abstract Expressionism* (New York: Praeger, 1970); and Dore Ashton, *The New York School: A Cultural Reckoning* (New York: Viking, 1972). The revisionist histories of Serge Guilbaut and David Craven, which take up the cultural politics associated with American Abstract Expressionism, are considered in chapter 4. See Guilbaut, *How New York Stole the Idea of Modern Art* (Chicago: University of Chicago Press, 1983); and Craven, *Abstract Expressionism as Cultural Critique: Dissent during the McCarthy Period* (New York: Cambridge University Press, 1999).

77. Martínez, *Yo Publio*, 298–99. "Geno me hizo cambiar mis ideas sobre el expresionismo abstracto. Estábamos en el año 1953 y ya era muy conocida esta tendencia pictórica. Los alumnos de la escuela se dividían entre quienes la defendían y quienes la atacaban. Gene me aclaró y disipó muchas dudas, convenciéndome de que 'no era tirar la pintura por el simple deseo de tirarla.'"

78. Ibid., 291.

79. See Martínez, "Los Once," 30. Consuegra and Llinás remember a slightly different version of this history, in which Consuegra invited Martínez to exhibit with Los Once following his return from Chicago. Consuegra claims to have not known of the *"mala leche"* between Martínez and Llinás, but whatever their feelings, Martínez was incorporated within Los

Once beginning with their fourth show at La Rampa in November 1953. Animosity between Llinás and Martínez is for many reasons not surprising—Martínez was a polarizing figure—and it seems unlikely that Consuegra was unaware of the personal tension between them. See Consuegra, *Elapso Tempore*, 108–9.

80. See Salvador Corratgé, quoted in Pino-Santos, "Vidal, Corratgé, Oraá," 26. "Nosotros conocimos la abstracción también por revistas. . . . Además había artistas que podían viajar. Luis Martínez Pedro, por ejemplo, tenía una biblioteca fabulosa porque había estudiado en los Estados Unidos. Nosotros nos nutríamos de lo que nos interesaba de aquella y estábamos actualizados también por la revista *Art News*." Also see Robert Goodnough, "Pollock Paints a Picture," *Art News* 50, no. 3 (May 1951): 32–38; Harold Rosenberg, "The American Action Painters," *Art News* 51, no. 8 (December 1952): 22–23, 48–50.

81. Rosenberg, "The American Action Painters," 22.

82. Antonio Vidal, quoted in José Cid, "Entrevista con Antonio Vidal," *La Gaceta de Cuba* no. 58 (July 1977): 17. "El viaje más largo que he realizado en mi vida, fue a Guantánamo como funcionario de cultura. No creo que este hecho haya formado ni deformado notablemente mi 'sensibilidad artística.'"

83. Hugo Consuegra, quoted in Martínez Herryman, "Hugo Consuegra: A Close Up," 151. "The comparison between the North American and the European expressionist movements confirms the superiority of the former. . . . We were conscious of this pictorial supremacy. Yet, we read the works of Sartre and Camus. We watched Italian, French and Japanese cinema. We listened to Hindemith and Stravinsky. And, when it was time to go abroad on fellowships, no one went to the United States; instead, we all went straight to Paris. No, Los Once was not a Yankee offspring. With the exception of Raúl Martínez, no one among us spoke English."

84. Cf. Martínez, "Los Once," 30–31.

85. Consuegra, quoted in Martínez Herryman, "Hugo Consuegra: A Close Up," 150.

86. Gladys Lauderman, *Pintura, escultura, cerámica, 18 de julio al 2 de agosto*, exh. cat. (Havana: Retiro Odontológico, 1953), n.p. See also Antonio Vidal, quoted in Ciro Bianchi

Ross, "Vidal en la mira," *La Gaceta de Cuba* 1 (January–February 2000): 41. "En efecto, algunos pintores figurativos recibieron la impronta de lo abstracto. Hay algo de eso en algún momento de Mariano [Rodríguez], y hasta en el mismo [René] Portocarrero hay un momento de pintura abstraccionada."

87. Luis Dulzaides Noda, "Exposición Retiro Odontológico," *Inventario* 3, no. 26 (1953): n.p. "Hecha con tan buena intención como la bomba H, resultó al final algo parecido a lo de Hiroshima. . . . Los únicos que ponían una nota de diferencia eran los del Grupo de los Once."

88. For a list of exhibitions held at the Lyceum in 1951–52, see *Memoria, 1951–1953* (Havana: Lyceum y Lawn Tennis Club, 1953).

89. See Luis Dulzaides Noda, "Los '11' el 19, en el Lyceum," n.p. "En otros países del mundo, un grupo de pintores y escultores, tan jóvenes y tan nuevos en el difícil arte de las plásticas, hubieran tenido necesidad de más tiempo para adquirir la madurez necesaria y poder comenzarse la labor de catalogamiento de sus valores. Aquí en Cuba, fértil tierra donde hasta el talento madura en cuatro estaciones al año, no ocurre eso. Ahí está ese grupo de los '11' como un ejemplo maravilloso. Se constituye, apenas llegan a veinte años muchos de ellos, dan tres exposiciones."

Gladys Lauderman, "Los Once y Mirta Cerra," *El País* (Havana), November 28, 1953. "En la plástica cubana el grupo de Los Once simboliza la juventud más prometedora y juntos laboran por alcanzar y superar metas ya fijadas por los artistas nuestros que le han precedido."

90. Texidor, "Exposición Hugo Consuegra: oleos, acuarelas, dibujos [May 5–29 1953]," *Inventario* 3, no. 26 (1953), n.p. "HC, no es pintor de embriaguez. No sensualiza. Es sereno. Ajusta y ordena con paciencia los elementos que integran sus cuadros. Su alto sentido arquitectónico lo lleva hasta el color, dándole a éste el valor de una estructura. Como buen exponente del arte no-objetivo, no sacrifica los valores estéticos intelectuales, a los expresivos que conllevan solamente intenciones temperamentales y románticos. Ese ir y venir directamente a lo constructivo, que algún parentesco de nutrición tiene Torres García, le permite expresarse con austeridad, de buscar el misterio de formas: con la disposición lanzada de los efectos."

Chapter 3. Anti-Bienal, Bienal, and the Dissolution of Los Once

1. Raúl Martínez, quoted in Goldman, "Painters into Poster Makers," 147.

2. Ibid., 146.

3. *Homenaje a José Martí: Exposición de plástica cubana contemporánea* [January 28–Februry 14], exh. cat. (Havana: Lyceum, 1954), n.p. The full text of the (unsigned) statement reads: "Los artistas cubanas ofrecen con esta Exposición un homenaje nacional a José Martí, apóstol de nuestras libertades. El arte plástico no podía estar ausente de esta conmemoración del Centenario, sobre todo cuando se auspician actos en desacuerdo con los principios más esenciales de la ética martiana. El Lyceum, íntimamente vinculado a toda manifestación de cultura, se complace en brindar a esta Exposición-Homenaje su cálida acogida y rendir al Maestro, conjuntamente con el grupo de artistas que representan la más genuina y libre expresión de la plástica cubana contemporánea, su fervoroso tributo."

4. Quoted in "Exposición Falangista," *Bohemia*, November 8, 1953.

5. Pablo Picasso, quoted in "Respalda Pablo Picasso a los artistas cubanos contrarios a la Bienal," *El Crisol* (Havana), February 8, 1953.

6. Mario Carreño, quoted in Salvador Bueno, "Los artistas cubanos rinden homenaje a Martí," *Carteles*, January 5, 1954, n.p. "Estoy en conversación con Mario Carreño, Cundo Bermúdez, Mariano Rodríguez, Marta Arjona, Alfredo Lozano. Ellos me explican sus puntos de vista sobre esta exposición. '¿Es verdad que sólo están aquí representados artistas cubanos de 'vanguardia?'—le pregunto a Carreño. 'Todo lo contrario. Aquí se pueden ver distintas tendencias y aun distintos grupos generacionales de la plástica cubana. Artistas de distintas escuelas y de distintas edades reunidos para homenajear libremente a Martí.'

 "'Además,' me sigue diciendo Carreño, 'lo que nos ha importado muy de veras a los organizadores no ha sido reducir el homenaje a un solo grupo, sino vincular tendencias a veces opuestos, pero siempre, claro, dentro de las normas espirituales propugnadas por José Martí.'"

7. Jorge Mañach, "Plástica cubana en el Lyceum (a guisa de preludio)," *Bohemia*, February 7, 1954, p. 77. "Pero vengamos a la exposición del Lyceum como exposición de arte cubano, y no como 'manifiesto.' En tal aspecto, la cuestión general que plantea es la muy polémica todavía de la nueva estética—que ya no es tan 'nueva.' . . . Lo que el visitante halla, pues, en estas dos espaciosas salas del Lyceum son cuadros y esculturas que, en su mayor parte, 'no representan nada,' es decir, no imitan la naturaleza, aunque algunos todavía la aluden. Son cuadros en que hay puros colores, puras formas imaginarias, puros juegos autónomos de líneas, y pretenden interesar y valer sólo por su 'pureza,' por esa 'abstracción' enteramente 'plástica.'" Texidor directed his remarks specifically to Mañach in a review of the Anti-Bienal, writing, "Todavía más: la del retorno a un arte realista, que no será más que el regreso a las viejas y ya manidas formas del arte antiguo, sin contenido, sin sustancia de ninguna clase. La vejez parece que junto con los intereses, hacen de los hombres simples sombras del pasado." See Texidor, "Índice de artes y letras," n.p. [1953], F1, Hugo Consuegra Papers.

8. Among the exhibiting third-generation vanguardia were Lucía Alvarez, Francisco Antigua, René Ávila, José Y. Bermúdez, Jorge Camacho (1934–2011), Agustín Cárdenas, Hugo Consuegra, Agustín Fernández, Fayad Jamís, Guido Llinás, Eugenio Rodríguez, Raúl Martínez, José M. Mijares, Zilia Sánchez, Juan Tapia Ruano, Antonio Vidal, and Viredo Espinosa.

9. Teresita Crego, "Preguntas para una respuesta: entrevista con Juan Tapia Ruano," *Pueblo y Cultura* 27 (September 1964): 10–13.

10. See *Ravenet: Esculturas, del 20 al 30 de julio*, exh. cat. (Havana: La Rampa, 1953).

11. Graziella Pogolotti, in discussion with the author, January 29, 2009, Havana.

12. Á[ngel]. Augier, "La exposición de plástica cubana en homenaje a José Martí," *Bohemia*, February 7, 1954.

13. Luis de Soto, "Las exposiciones del Lyceum: cinco lustros al servicio de la cultura," *Revista Lyceum* XI, no. 37 (February 1954): 97.

14. See "El Lyceum y el centenario martiano," *Revista Lyceum* 9, nos. 33–34 (February–March 1953): 87–96.

15. Kapcia, *Island of Dreams*, 95.

16. "Program Manifesto of the 26th of July Movement," in Rolando E. Bonachea and Nelson P. Valdés, eds., *Cuba in Revolution* (Garden City, N.J.: Anchor, 1972), 113, 127.

17. Kapcia, *Island of Dreams*, 164–67.

18. Raúl Martínez, quoted in Goldman, "Painters into Poster Makers," 146.

19. "Combativa posición de Artistas e Intelectuales contra la Segunda Bienal de Arte Hispanoamericana," *Marcha* [1953], 7. "Muchas medidas han sido dictadas ya por el Ministerio de Educación contra los combatientes. Entre estas destacamos el hecho que algunos, firmantes de declaraciones contra la Segunda Bienal Hispanoamericana, han sido cesanteados de sus cargos, suprimidas las miserables Becas que otros recibían, además de ser objeto de una encarnizada persecución por la Embajada de España en La Habana." See Guido Llinás, interview with Anreus.

20. Kapcia, *Island of Dreams*, 94.

21. It is not clear if new catalogues were produced for either exhibition or whether the show traveled exactly intact from Havana's Lyceum. A review of the Camagüey venue suggests that the exhibiting artists—among them, Víctor Manuel, Amelia Peláez, Carreño, Mijares, Consuegra, and Fernández—were identical, and it seems likely that the composition of the show remained the same in essentials. See Rosa Martínez de Cabrera, "La Exposición Plástica Cubana Contemporánea," *El Camagüeyano* (Camagüey), March 12, 1954.

22. Martínez de Cabrera, "La Exposición Plástica Cubana Contemporánea." "La actitud del artista moderno está en consonancia con la vida actual, inquieta, desgarrada y convulsa. La serenidad de vivir, la placidez de soñar, casi han desaparecido de la existencia. . . . El mundo de hoy es la mejor explicación del arte de hoy."

23. Consuegra, *Elapso Tempore*, 121. "En esta última exposición, gracias a mis vínculos con la FEU, yo colaboro intensamente. El diseño de catálogo es mío. . . . No guardo ninguna crítica sobre esta muestra, tal vez no lo hubo; el miedo a Batista crecía, y los periodistas tenían que tener mucho cuidado, pero nótase la fecha: 20 de Mayo, otro gesto político. Yo estoy presente otra vez con el enigmático 'Lugar de la Espera.'"

24. Luis de la Cuesta, *Primer festival universitario de arte, mayo 20–junio 4*, exh. cat. (Havana: Dirección de Cultura, Federación Estudiantil Universitaria, 1954), 3. "Nosotros, los que sabemos que Arte y Dictadura son términos tan contradictorios como Democracia y Tiranía, sólo vemos en la Bienal el gesto convertido en pirueta y la pose en caricatura de quienes incapaces de sentir y expresar el alma de dos pueblos se contentan con el cliché oficial de la usurpación; campo de resentidos, traidores e incapaces pero también abono fértil para mártires, héroes y genios. . . . El Primer Festival Universitario de Arte no es una fiesta más. Debe tomarse como expresión rotunda de una juventud en lucha abierta contra los falsos valores, los intelectuales de a uno por letra y la seudo democracia. Debe ser, en todo lo que de intento tiene, espejo de inquietudes y savia de fe, de fe profunda en los supremos valores de la cultura y en el futuro destino democrático de nuestra Patria."

25. René Anillo, "La federación estudiantil universitaria en el periodo de 1951–1957: la lucha de los estudiantes contra la dictadura de Batista," *Revista de la Biblioteca Nacional José Martí* 22, no. 2: 113–42.

26. José Antonio Portuondo, "Plástica," in *Primer festival universitario de arte*, 11.

27. Ibid., 7.

28. Ibid., 9–10. "Predomina una insurgencia de carácter estético. Los jóvenes artistas, disgustados con las circunstancias en que viven, renuncian a mirarlas con los sentidos corporales que les dan la apariencia cotidiana de las cosas, y aspiran a rehacerlas, partiendo de los últimos elementos que descubren el ojo pineal de la intuición y los nuevos sentidos mecánicos de la ciencia contemporánea. . . . El arte tiene también, como la química-física, sus investigaciones termonucleares y, más que ella, aspira a crear nuevos elementos sobre la ruina o la combinación de los ya conocidos. . . . En el fondo, lo que ocurre es que el arte entre nosotros expresa la misma inquietud y afán de evasión que buena parte de la ciencia contemporánea, el mismo empeño también de reordenar el caos de la vida presente que tantos quieren hacer pasar como modelo de un 'orden' que no se puede ni se debe alterar."

29. Ziarek, *Force of Art*, 14.

30. Ibid., 12.

31. Ibid., 13.

32. Apart from the Anti-Bienal and related internal politics, the postponements were mostly on account of construction delays in Havana. A franquista publication specifically blamed a

strike by port workers in New York for holding up the completion of the new museum. See Fernando de la Presa, *Charlas de la segunda bienal* (Havana: Editorial Rodríguez Padro, 1954), 18.

33. Francisco Ichaso, "Acotaciones: Museo y Bienal," *Diario de la Marina* (Havana), May 20, 1954.

34. De la Presa, *Charlas de la segunda bienal*, 29.

35. Ichaso, "Acotaciones: Museo y Bienal." "La misma pluralidad que se advierte en los estilos, se advierte en los temas." De la Presa, *Charlas de la segunda bienal*, 30.

36. See Julián Díaz Sánchez, *El triunfo del Informalismo: La consideración de la pintura abstracta en la época de Franco* (Madrid: Metáforas del Movimiento Moderno, 2000).

37. For a history of the Biennials and Anti-Biennials, see Miguel Cabañas Bravo, *Artistas contra Franco: La oposición de los artistas mexicanos y españoles exiliados a las Bienales Hispanoamericanas de Arte* (Mexico City: Universidad Nacional Autónoma de México, 1996).

38. Luis Felipe Vivanco, *Primera bienal hispano-americana de arte*, exh. cat. (Madrid: Afrodísio Aguado, 1952), 16. "Toda artista, verdaderamente innovador en la forma, es mucho más potenciador e integrador del arte del pasado que el falso tradicionalismo de los académicos."

39. Díaz Sánchez, *El triunfo del Informalismo*, 23. "Un arte de su tiempo, que huya de todo engañoso tradicionalismo formalista, sólo podía ser, en 1951, un arte abstracto teñido de españolidad y/o religiosidad, dos conceptos que suman en la cultura franquista."

40. "La semana de cultura," *Élite*, October 20, 1951, p. 17. "Reivindicar así para el 12 de octubre aquel significado de acontecimiento creador de vínculos de fusión histórica y espiritual entre los pueblos americanos y el pueblo español, que una acartonada tradición académica quiso siempre ocultarlos en beneficio de un criterio racista tan antiespañol como antiamericano."

41. Cabañas Bravo, *Artistas contra Franco*, 32–36.

42. The complicated politics of the Mexican Contra-Bienal are examined at length in Cabañas Bravo, *Artistas contra Franco*, 37–91.

43. The *VII National Salon* opened on August 18, 1954, and included 180 painters and 41 sculptors, who exhibited 471 works. See *Sala permanente de artes plásticas de Cuba* (Havana: Palacio de Bellas Artes, Instituto Nacional de Cultura, 1955), 8.

44. Carreño, "La plástica cubana de hoy," 55. Also see Betty Laduke, "Women and Art in Cuba: 'Feminism Is Not Our Issue,'" *Women's Art Journal* 5 no. 2 (Autumn 1984–Winter 1985): 34–40.

45. "Premios otorgados en la II Bienal Hispanoamericana," *ABC* (Madrid), June 3, 1954.

46. Fernando de la Presa, quoted in Mario Carreño, "Sobre la bienal en Barcelona," *Carteles*, April 17, 1955, p. 124. "Seguro estoy de la fuerte impresión que produciría la presencia de un salón cubano, integrado por obras de la que hemos dado en llamar 'Escuela de La Habana.' Digo la anterior porque, con la asistencia habida en las bienales celebradas, no se consiguió una muestra verdadera de la pintura cubana y la calidad de lo entonces presentado—salvo raras excepciones—fué notoriamente inferior a la calidad real de esta pintura e inclusa al mínimo decoro artístico exigible en una exposición internacional. . . . Con ser muy valiosos, no son suficientes los nombres de Mirta Cerra y demás expositores que ocupaban la única Sala cubana digna de tal nombre en la II Bienal."

47. "Radio-Moscú ataca la II Bienal inaugurada en nuestra capital," *Diario de la Marina* (Havana), May 19, 1954.

48. *III Bienal hispanoamericana de arte: Catálogo oficial, 25 septiembre 1955–6 enero 1956*, exh. cat. (Barcelona, 1955).

49. Consuegra, *Elapso Tempore*, 122. "La más ambiciosa exposición del grupo, la más numerosa en obras, y la mejor organizada hasta entonces, se celebró en el Círculo de Bellas Artes, Noviembre 27 a Diciembre 15 de 1954. La selección fue analizada cuidadosamente por el grupo."

50. "El Grupo de los Once," n.p. [1954], G5, Hugo Consuegra Papers. "Las obras de Viredo, marcadas en el catálogo, 'brillaron por su ausencia.' ¿Qué pasó?" Martínez later explained what had happened: "Viredo trajo un cuadro que no estaba seco todavía porque lo había terminado la noche anterior. En aquel mismo momento, Guido le hizo saber que ya no pertenecía al grupo por falta de interés, informal e irresponsable." See Martínez, "Los Once," 31. Antonio Vidal and Consuegra also concur in the essential facts. See Antonio

Vidal, quoted in Pino-Santos, "Vidal, Corratgé, Oraá," 25; and Consuegra, *Elapso Tempore*, 123.

51. Luis Dulzaides Noda, "Mayores y menores," *Inventario* 3, no. 26 [1953]: n.p. "Peláez y Oliva, dos escultores miembros del grupo de 'Los Once,' que con tanto acierto patrocina Joaquín Texidor, marchan a conquistar Europa con el viaje de ida. Creemos sinceramente que se merecen una despedida más entusiasta que la de Cristóbal Colón en Palos de Moguer, aquel día famosos de la historia."

52. Consuegra, *Elapso Tempore*, 122. "El carácter académico y conservador de la institución fue otro factor que evaluamos, considerando que sería simbólico presentar la extreme vanguardia en el santuario de la retaguardia. . . . La situación física del Círculo, Industria y San José, a espaldas del Capitolio Nacional y cerca de Las Antillas, fue un factor importante, ya que estaba en el corazón de la ciudad, mucho más accesible para la población que 'pasaba de largo,' diferente de la élite que frecuentaba el Lyceum."

53. Rafael Marquina, "Notas a la exposición de 'Los Once' que esta vez fueron siete," *Información* (Havana), December 19, 1954, p. F8; Pogolotti, "Los Once en el viraje de los cincuenta," 21.

54. Carreño, "Grupo de Los Once," *Carteles*, n.d. [1954], G5, Hugo Consuegra Papers. "No hay dudas de que esta vez sus conceptos artísticos que en anteriores ocasiones asomaban como balbuciente lenguaje, han fraguado sólidamente, las ideas han madurado y la técnica ha llegado a una buena saturación."

 Antonio Hernández Travieso, "Once artistas jóvenes," n.d. [1954], G4, Hugo Consuegra Papers. "Cualquiera de los cuadros y esculturas expuestas por este grupo simpático, nuevo, valiente en decir su verdad, puede figurar sin desdoro en la mejor colección cubana de obras modernas."

55. José A. Baragaño, *Los Once, noviembre 27–diciembre 15*, exh. cat. (Havana: Círculo de Bellas Artes, 1954), n.p.

56. Grupo de Artes Plásticas "los nuevos," *Los Once: Dibujos y acuarelas, diciembre 12–17*, exh. cat. (Camagüey: Orden Caballero de la Luz, 1954), n.p. "'LOS ONCE' representan la nueva generación que surge continuando la trayectoria iniciada por Víctor Manuel, Ponce y Amelia en 1926, fortalecida en 1935 por Carreño,

Mariano, Lozano y que ahora aséptica y pura se lanza al no-objetismo como culminación de la revolución plástica iniciada por los impresionistas en 1860, colocando a Cuba al día en la corriente artística mundial . . . 'LOS ONCE' aspiran a la pintura-pintura, sin tema ni literatura, a la expresión de la emoción estética por los medios plásticos: forma y color; a que el espectador se emocione ante el cuadro por sus elementos pintura."

57. Gladys Lauderman, exh. brochure, Galería Nuestro Tiempo, Havana, 1954, n.p. "La Galería que se inaugura viene a cumplir la misión divulgadora que todo país debe hacer de sus obras estéticas; y por ser iniciativa privada de una institución cultural y por adelantarse a medidas oficiales que debieron prever esta necesidad, adquiere una significación especial: la Galería NUESTRO TIEMPO será nuestro verdadero Museo de Pintura y Escultura."

 Cf. Consuegra, *Elapso Tempore*, 129. "Obsérvase la frase 'nuestro verdadero museo,' ya que el otro, el Museo Nacional, estaba en manos de la dictadura. Es aquí en Nuestro Tiempo, que conozco más de cerca a Marta Arjona y a la mayoría de los intelectuales comunistas que ya entonces controlaban la institución."

58. José Veigas, Cristina Vives, Adolfo V. Nodal, Valia Garzón, and Dannys Montes de Oca, *Memoria: Cuban Art of the Twentieth Century* (Los Angeles: California/International Arts Foundation, 2002), 408.

59. José Antonio Portuondo, "La Galería de 'Nuestro Tiempo,'" *Nuestro Tiempo* 2, no. 5 (May 1955): 13. "El grupo de Los Once es, sin duda, el que encarna del modo más completo y cabal la dirección no figurativa entre nosotros, y de ellos hay buena representación en la Galería de *Nuestro Tiempo*. . . . Hay un gran peligro en esta dirección no figurativa y es el de caer en un nuevo academismo. Cuando el artista se preocupa sólo por hallar un 'modo de expresión,' sin que este 'modo' responda a una verdadera necesidad expresiva, a una nueva visión de la realidad, es muy fácil y casi inevitable caer en la fórmula, en el simple procedimiento técnico que se repite luego y se convierte en mera receta académica. . . . El tono monocorde de algunas exposiciones recientes nos anuncia el peligro de un nuevo academismo más peligroso que el anterior,

porque éste viene con aires de gran moderni-
dad y encuentra eco propicio en un ambiente
de snobs y de nuevos ricos deseosos de cubrir
la desnudez de sus recién levantadas paredes
con algo que no les comprometa que no impli-
que una actitud estética, que son incapaces de
asumir, y se asimile, en cambio, a la inocuidad
del simple empapelado."

60. Rosenberg, "The American Action Painters,"
49.

61. Portuondo, "La Galería de 'Nuestro Tiempo,'"
14. "Una visita a la Galería de *Nuestro Tiempo*
tiene la virtud de enfrentarnos al proceso de
nuestra plástica contemporánea y de abrir ante
nosotros innumerables interrogaciones. ¿Por
qué han marchado nuestros pintores y escul-
tores, siguiendo la línea de la Escuela de París,
hacia una completa abstracción, hacia una
deliberada prescindencia de la realidad circun-
dante, ignorando la más cercana influencia del
realismo mexicano, situado en el polo opuesto
de París? ¿Por qué ha prendido y prospera
con tanta fuerza el arte no figurativo entre
nosotros, cuando apenas hemos empezado a
ver la realidad que nos circunda? ¿Qué relación
hay entre este proceso de la plástica cubana
contemporánea y el desarrollo histórico de
nuestra nación en los últimos treinta años?"

62. See Consuegra, *Elapso Tempore*, 127. "Este
escrito, muy personal, sin consentimiento
de grupo—creo que sólo Guido supo de él
antes de su publicación, y Tomás lo secundó,
después de publicado—tuvo más importancia
fuera de Cuba, gracias a Pepe Gómez Sicre,
quien lo toma por un 'manifiesto,' refiriéndose
a él varias veces y llamándome a mi 'vocero
de grupo,' que en la propia Cuba, donde pasó
inadvertido."

63. Consuegra, "Exposición de Los 11," *Espacio*
(November–December 1954): 61–62.

64. Consuegra, *Elapso Tempore*, 134.

65. Luis Dulzaides Noda, "Los once 'embotella-
dos,'" n.p. (Havana), March 17, 1955, N1, Hugo
Consuegra Papers.

66. Rafael Marquina, "Apostillas y notas margi-
nales al XXXVI Salón de Bellas Artes,"
Información (Havana), March 27, 1955.

67. Consuegra, *Elapso Tempore*, 134.

68. José A. Baragaño, "Palabras," *Exposiciones de
los 'Once'* [March 6–18]," exh. cat. (Santiago de
Cuba: Galería de Artes Plásticas, 1955), n.p. "El
arte, en su situación de piedra de toque de lo
maravilloso, despierta las analogías de la vita-
lidad máxima de hombre para ofrecer a lo exte-
rior el impulso de una relación entre lo mágico
y lo que acontece. En Cuba los nuevos actores
dentro del hecho estético tratan de sumar una
noción espiritual nueva, en una confrontación
del hombre con su paisaje para lograr la unión
ideal plástica que produzca una depreciación
de lo real inmediato. . . . Lo que los pintores
y escultores aquí presentes—ocho de LOS
ONCE—traen como un brillo nostálgico
contra la opacidad del presente. Renovando
la atmósfera y sus formas caudales traerán la
nueva materia del mito."

69. See Consuegra, *Elapso Tempore*, 138; see also
Marquina, "Notas a la exposición de 'Los Once'
que esta vez fueron siete." In his memoirs,
Consuegra notes Marquina's earlier reference
to "the magical world," but Baragaño's artic-
ulation is the more eloquent and convincing
of the two. Consuegra agreed in principle
with this interpretive stream and found in
it a supportive argument for his rejection of
American influence. "Si se pudiera documentar
este hecho, mediante un trabaja comparado
de nuestras obras de aquella época, tal vez se
pudiera encontrar un sentido muy peculiar—
y muy cubano—a nuestro abstraccionismo,
bien diferente al abstraccionismo norte-
americano, al cual se nos ha tratado de asociar,
y al cual nosotros nunca conscientemente nos
vinculamos."

70. *Cuatro pintores jóvenes: Hugo Consuegra, Guido
Llinás, Raúl Martínez, Zilia Sánchez*, exh. cat.
(Madrid: Instituto de Cultura Hispánica, 1955).
No record remains of the works exhibited.

71. "Aclaración," *Carteles*, April 17, 1955, p. 125. "Los
integrantes del Grupo de los Once deseamos
aclarar que el señor Ángel Huete solicitó de
algunos de los pintores del Grupo, varias obras
que ilustrarían unas conferencias que el señor
Huete proyectaba dictar en Madrid en relación
con el movimiento artístico cubano, pero que
en ningún momento lo hemos autorizado para
presentar nuestras obras en organismos oficia-
les. Firman: Guido Llinás, Hugo Consuegra
y Raúl Martínez." Consuegra reprints the
press accounts in his memoir; see Consuegra,
Elapso Tempore, 136–37. "Públicamente, el señor
Huete prefirió no responder; privadamente,
a su regreso de Cuba, nos dio excusas por 'el
malentendido.'"

72. "Cuatro pintores jóvenes de Cuba en el Instituto de Cultura Hispánica," *Arriba* (Spain), March 23, 1955. The article quotes Huete's remarks at the opening: "Separándose del folklorismo de la rumba, el café negro, el ron, este grupo de pintores halla, por medio de una concentración expresiva, al centro de la gravitación nacional en sus cuadros. El colorido, la intención, corresponden a una atmósfera netamente tropical."

73. *Tomás Oliva* (Madrid: Galería Clan, 1954); *Arte abstracto* (Madrid: Galería Fernando Fe, 1954); *Esculteurs de Paris* (Paris: Académie de Feu, 1955). Tomás Oliva Papers, Archives of American Art, Smithsonian Institution.

74. *Zilia: Exposición de pintura, del 9 a 16 de noviembre* (Havana: Lyceum, 1953).

75. Cf. Consuegra, *Elapso Tempore*, 138. "Nada de lo narrado hasta este punto podría indicar una extrema rivalidad, agria y vengativa, con nuestros predecesores, los artistas de la Escuela de La Habana. Existía una diferencia generacional, por razones de calendario, y junto a ello, existían intereses artísticos distintos, pero no una 'mala sangre' de personalidades. Esto cambiará dramáticamente con resultado de las palabras escritas por Raúl Martínez para el catálogo de nuestra octava exposición."

76. Raúl Martínez, *Galería Habana* [June 13], exh. cat. (Havana: Galería Habana, 1955), n.p.

77. Cf. Consuegra, *Elapso Tempore*, 139. "Carreño le envió una carta a Gómez Sicre—carta que tuve la oportunidad de leer en 1956—en la que decía 'los niños nos salieron respondones.'" See Rafael Marquina, "También los pintores y escultores hacen literatura," *Diario de la Marina* (Havana), June 15, 1955; and Marquina, "Los sucesos de la Galería Habana," *Diario de la Marina* (Havana), June 19, 1955. See also Carreño, letter to Gómez Sicre, Havana, June 25, 1955, Box 6, Folder 2, José Gómez Sicre Papers. "Pasando de otra cosa, te incluyo un catálogo de la Galería Habana que dirige Doña Gertrudis en el que Raúl Martínez hace la 'presentación' y como verás es una posición bien vanidosa, absurda y mala intencionada, tratando de negar toda obra anterior. Son unos mojones intolerables."

78. Consuegra, *Elapso Tempore*, 141. "En cualquier caso, no fue una provocación planeada, y todos fuimos sorprendidos por su efecto. Los pobres 'artistas invitadas' estaban inconsolables."

79. "Disuelta la Agrupación 'Los Once,' *Tiempo en Cuba* (Havana), June 6, 1955. "Los miembros del grupo de pintores y escultores llamados 'Los Once,' han informado que de común acuerdo han determinado no efectuar más exposiciones bajo ese nombre, quedando por lo tanto disuelta la agrupación, lo que no significa en modo alguno cambio de criterio o credo estético, sino al contrario, libertad de acción individual para seguir luchando activamente en la vanguardia del movimiento renovador de la plástica de hoy."

80. Rafael Suárez Solis, "Once nombres más y un número menos," *Diario de la Marina* (Havana), [June 1955], Hugo Consuegra Papers.

81. Martínez, "Los Once," 31. "Así sucedió cuando el Lyceum organizó una exposición homenaje a José Martí. Sabíamos que esta exposición era una excusa para protestar por todas las dictaduras de América Latina, pero cuando hizo su aparición en la Habana José Gómez Sicre, representante de la Unión Panamericana de Washington, todo cambió de color y de matices."

82. Carreño to Gómez Sicre, March 26, 1954, Box 6, Folder 2, José Gómez Sicre Papers. According to Carreño's account, the artists whose work was committed include Peláez, Portocarrero, Darié, Cundo Bermúdez, Martínez Pedro, and Mijares, though this should be considered a partial list.

83. Martínez, "Los Once," 31.

84. Carreño to Gómez Sicre, March 26, 1954. The letter is a rare window into Carreño's point of view, which has not otherwise emerged in subsequent histories. "Cuando estuviste aquí y hablamos de la exposición en Caracas, siempre te dije que iba a ser un asunto espinoso y que había que meditarlo, debido al hecho de que realizábamos una campaña anti-bienal (la cual tomó proporciones enormes durante la exposición) y que, indiscutiblemente el envío a Venezuela implicaba la negación de nuestra acción contra la bienal franquista. . . . "A lo que el hecho político significaba, pues no hay duda que si que uno consiente en enviar obras a un determinado lugar en donde se desarrolla un acto eminentemente político, uno está aprobando ese acto; a no ser que la obra se envíe en protesta, pero como eso era imposible en este caso, no había nada que hacer. Si yo no hubiera tenido una

participación tan destacada en lo de la anti-bienal no hubiera tenido importancia en que yo mandara o no a Caracas, pero como yo aparecía como el máximo dirigente de ese asunto, no podía contradecir mis acciones y mis convicciones sin ser atacado y junto conmigo todo el movimiento."

85. Ibid. "No sé si tu sabes que José Gómez Sicre en la Habana para los efectos de exposiciones, etc. es Mario Carreño, y que la culpa de que Mariano no participara en S. Paulo ni que saliera en 'N. de Arte,' era de Carreño."

86. Consuegra, *Elapso Tempore*, 143–44.

87. Martínez, "Los Once," 31.

88. Ibid., 32.

89. Ibid.

90. Consuegra, *Elapso Tempore*, 144; Martínez, "Los Once," 32.

91. Martínez, "Los Once," 32.

92. Ibid. Cf. Consuegra, *Elapso Tempore*, 143. "Mario Carreño, de pena decirlo, fue el Judas de esta misión."

93. Consuegra, *Elapso Tempore*, 145.

Chapter 4. The Offices of Abstraction

1. "La Habana crece y se moderniza," *Revista del Instituto Nacional de Cultura* 1, nos. 3–4 (June–September 1956): 26, 30.

2. Ibid., 28.

3. Virgilio Piñera, "Cultura y moral," *Ciclón* 1, no. 6 (November 1955), trans. Stephen D. Gingerich in "*Ciclón*: Post-avant-garde Cuba (Selected articles from *Ciclón* [1955–59])," *CR: The New Centennial Review* 2, no. 2 (Summer 2002): 104. Piñera was a member of the *Orígenes* group and later cofounded the literary magazine *Ciclón*, sending work from exile in Argentina. A dramatist and poet, Piñera was censured under the Revolution for his social views (and his open homosexuality).

4. The INC's advisory board included academic sculptor Juan José Sicre; Mario Carreño; Gastón Baquero, poet and editor of the conservative newspaper *Diario de la Marina*; Rafael Suárez Solis, critic and contributor to the magazine *Social*; ethnographer Lydia Cabrera; and historian Francisco Pérez de la Riva.

5. Segre, Coyula, and Scarpaci, *Havana*, 115.

6. Piñera, "Cultura y moral," 102.

7. Ibid., 103. "No one is going to think of asking what the Institute is doing or what it plans to do for what it so pompously calls culture. Is it going to help this Cuban painter realize his work without constantly suffering economic insecurity? No, because the new Institution is not a Charity House. (For some it is, gentlemen.) . . . Do they plan to take the latest Cuban pictorial works on a foreign tournée? No, but they would pay for an exhibition of mediocre German art. And now they announce a survey of Chinese art for us poor, uncultured people!"

8. Ibid., 104.

9. The Ballet Alicia Alonso had received a small bursary from the Cuban government since its founding, and the Batistato initially continued the subsidy. Alonso chose to accept the support for three years, speaking out against the regime only in 1956; she returned in 1959 at Castro's invitation to launch Cuba's Ballet Nacional. See also Alicia Alonso to Guillermo de Zéndegui, August 15, 1956, in Raúl Ruiz, *Alicia: La maravilla de la danza* (Havana: Ediciones Gente Nueva, 1988), 34.

10. Rafael Marquina, "La Sala permanente de las artes plásticas de Cuba," *Información* (Havana), August 7, 1955.

11. Mario Carreño, "Inauguración de la sala de artes plásticas del Instituto Nacional de Cultura," *Carteles*, August 7, 1955, 124.

12. See Miguel de Marcos, "Biografía de un museo," *Diario de la Marina* (Havana), May 20, 1954.

13. *Guía de la galería de arte del Museo Nacional de Cuba* (Havana: P. Fernández, 1955).

14. Cf. Marquina, "La Sala permanente de las artes plásticas de Cuba," *Información* (Havana), August 7, 1955, p. E2.

15. *Sala Permanente de Artes Plásticas en Cuba* (Havana: Ministerio de Educación, Instituto Nacional de Cultura, 1955), n.p.

16. Cf. Felipe Cossío del Pomar, quoted in Carreño, "Entrevista: cuatro preguntas a Cossío del Pomar," *Carteles*, October 2, 1955.

17. "La Sala Permanente de Artes Plásticas de Cuba," *Revista del Instituto Nacional de Cultura* 1, no. 1 (December 1955): 4.

18. Guillermo de Torre, *Revista del Instituto Nacional de Cultura* 1, nos. 3–4 (June–December 1956): 61–62.

19. *Agustín Cárdenas, sculptures; Fayad Jamís, peintures* (Paris: À l'Étoile scellée, 1956).

See Abigail McEwen, "Traveling Blackness," in *Agustín Cárdenas, May 20–July 2*, exh. cat. (London: Aktis Gallery, 2015).

20. José Pierre, "La perle noire et le rubis," in *Agustín Cárdenas, sculptures; Fayad Jamís, peintures.*

21. Guillermo de Zéndegui, "Presentación," *Revista del Instituto Nacional de Cultura* 1, no. 1 (December 1955): n.p.

22. Two exhibitions from 1940, *El arte en Cuba: Su evolución en las obras de algunos artistas* and *300 años de arte en Cuba,* had previously laid out a historical trajectory, but the work of the Institute was designed to be a more systematic and definitive undertaking.

23. "¿ . . . De Cultura?," *Nuestro Tiempo* 2, no. 9 (January 1956): 14.

24. For an extensive treatment of urban planning in Havana during this time, see Timothy Hyde, *Constitutional Modernism: Architecture and Civil Society in Cuba, 1933–1959* (Minneapolis: University of Minnesota Press, 2012).

25. See Hyde, *Constitutional Modernism,* 127–37.

26. Jorge Mañach, *El pensamiento de Dewey* (Madrid: Taurus Ediciones, 1959), 40.

27. Hyde, *Constitutional Modernism,* 151. "The new patterns would calibrate extent and center within a set of norms that applied to both and that forced upon them a conceptual, and even a perceptual, continuity. For the pattern possessed an aesthetic value—as indicated in Sert's appreciation of the 'very interesting and new pattern for the city' that would emerge in Havana from the contrast of new straight highways and the old winding roads—that would be legible as an expression of the normative structure itself. Its representational capacity would not be independent from either its functional or its performative capabilities, but rather, as the combination of all three, pattern would instance a representation founded on a normative claim that sponsored simultaneously its projective potential."

28. Le Corbusier, *The Modulor: A Harmonious Measure to the Human Scale, Universally Applicable to Architecture and Mechanics* (Cambridge, Mass.: MIT Press, 1954).

29. Josep Lluís Sert, quoted in Hyde, *Constitutional Modernism,* 169.

30. Sert, untitled address to the symposium De Divine Proportione, March 11, 1953, Folder D56, the Josep Lluís Sert Collection, ca. 1925–1983, Special Collections, Frances Loeb Library, Graduate School of Design, Harvard University.

31. See Luis Pérez-Oramas, "Caracas: A Constructive Stage," in *The Geometry of Hope: Latin American Abstract Art from the Patricia Phelps de Cisneros Collection,* ed. Gabriel Pérez-Barreiro, exh. cat. (Austin, Tex.: The Blanton Museum, 2007).

32. Hyde, *Constitutional Modernism,* 148–49.

33. For an account of Cuban muralism in this earlier period, see Juan A. Martínez, "Social and Political Commentary in Cuban Modernist Painting of the 1930s," in Alejandro Anreus, Diana L. Linden, and Jonathan Weinberg, eds., *The Social and the Real: Political Art of the 1930s in the Western Hemisphere* (University Park: Pennsylvania State University Press, 2006).

34. Orlando S. Suárez, *La revolución en la pintura mural* (Havana: Editorial Echevarría, 1960), n.p.

35. Carreño recounts this episode in his memoir; see *Mario Carreño: Cronología del recuerdo* (Santiago de Chile: Antarctica, 1991), 61–62. The encounter with Siqueiros provided the stimulus for Carreño's own experiments with large-format paintings in Duco, resulting in the triptych *Cortadores de cañas, Danza afrocubana,* and *Fuego en el batey* (1943).

Gómez Sicre also relates the episode in his interview with Alejandro Anreus; see Anreus, "Conversaciones con José Gómez Sicre," November 15, 1990, Washington, D.C. He concludes by noting the limited interest of muralism in Cuba relative to Mexico, like Kapcia attributing it to differences in national character. "La influencia del muralismo en Cuba fue bastante aislada. En una época Siqueiros influyó sobre Carreño. Rodríguez Lozano influyó sobre Mariano, de quien fue maestro. Guerrero Galván influyó en Cundo. Más nada. Son dos sensibilidades nacionales muy diferentes. La cubana es íntima, sensual, llena de humor, más bien pagana. La sensibilidad mexicana es más bien monumental, morbosa, amarga, creo que religiosa."

36. Kapcia, *Making of Cuban Culture,* 91–92. Kapcia points to certain social distinctions between the Mexican and Cuban citizenries to explain the relative failure of the Vasconcelos model in Cuba. "However, certain differences emerged, notably the cultural elite's relative marginalisation from a social elite that, more managerial and commercial, based less on lineage, historical ties and family connections,

and with different aims, attitudes and models and a more fragile economy behind it, was less respectful of culture, seeing it more as another commodity, fashions being more North American than European."

37. Suárez, *La revolución en la pintura mural*. "En busca de esos conocimientos, fuimos a México en 1952, luego en 53, 55, 56 y 1958. Hemos tenido el honor de conocer y recibir, libremente, orientaciones y enseñanzas muy valiosas de los principales maestros muralistas mexicanos. Como un resultado de nuestras investigaciones, escribimos un libro en 1958, titulado 'Guía del Movimiento Muralista Mexicano,' que será editado por la Universidad Nacional Autónoma de México."

38. See Enrique del Moral, *Ensayos sobre el estilo y la integración plástica* (Mexico City: Instituto Nacional de Bellas Artes, Departamento de Arquitectura, 1964).

39. Xavier Icaza, "Anticipo a 'El México de Diego,'" *Nuestro Tiempo* 4, no. 15 (February 1957): 1.

40. Gastón Baquero, "Los murales del edificio 'Esso,'" *Diario de la Marina* (Havana), February 11, 1951.

41. Jorge Mañach, "Los murales de la Esso," quoted and trans. in Sims, *Wifredo Lam and the International Avant-Garde*, 130.

42. For a thorough account of Lam's relationship to Cuba during this time, see Sims, "'Lo maravilloso' and the Antillian Ethos," 109–38. "Whereas writers in the 1940s tended to emphasize Lam's artistic pedigree on the international art scene, the writers of the 1950s refined his relationship with the Cuban art scene and Cuban culture."

43. Wifredo Lam, quoted in Carlos Franquí, "El retorno de Wifredo Lam," *Carteles*, December 12, 1954, p. 98.

44. Sims, "'Lo maravilloso' and the Antillean Ethos," 138.

45. Sims, "Mediating the Sacred and the Profane," chap. 2 in *Wifredo Lam and the International Avant-Garde*, 59–61.

46. Sims, "'Lo maravilloso' and the Antillean Ethos," 132.

47. "Rolando López Dirube," Written works, Box 2, Folder 42, José Gómez Sicre Papers.

48. Rafael Marquina, *Rolando López Dirube: Presentación de 30 obras de artes plásticas en la arquitectura cubana contemporánea, octubre 30*, exh. cat. (Havana: Galería de Arte de Editorial Lex, 1956), n.p. "Pero estamos ya en camino—y esta exposición lo demuestra—de 'cotidianizar' esta nueva forma de integración que—repitámosla—es procurarle al hombre una cabal norma para vivir su ser."

49. Ibid.

50. Consuegra, *Elapso Tempore*, 175. Consuegra acknowledges in a footnote his more recent awareness of the murals from the 1930s, but his original statement still holds true for his modernist vision of muralism as an integrated art. "El primer experimento en gran escala de integración de las artes plásticas con la arquitectura, en Cuba, fue el de las pinturas de Guido Llinás y las de Raúl Martínez, junto a las esculturas de Tomás Oliva, en el restaurante La Roca, obra ésta de los arquitectos Hugo D'Acosta y Modesto Campos. . . . El éxito fue tan sensacional que prefiguró el futuro de lo que sería el Departamento de Artes Plásticas del Ministerio de Obras Públicas. Creo recordar que la Roca se terminó en el año de 1957."

51. Hugo Consuegra, "La integración de las artes plásticas," *Artes Plásticas* 1, no. 1 (1960): 39.

52. Guy Pérez Cisneros, *Pintura y escultura en 1943* (Havana: Ucar, García, 1944); Pérez Cisneros, *Características de la evolución de la pintura en Cuba* (Havana: Dirección General de Cultura Ministerio de Educación, 1959).

53. *Exposición Homenaje en memoria de Guy Pérez Cisneros, del 12 al 29 enero*, exh. cat. (Havana: Lyceum, 1956), n.p. The full text reads as follows: "El Lyceum, que ha roto también más de una lanza en favor del arte cubano moderno, desde los días de su fundación, y en cuyos salones recibieron por primera vez el espaldarazo de la crítica la mayor parte de nuestros artistas, ha querido revivir en su casa, y en lo que cabe, aquel 'salón' imaginario en que hace trece años el inolvidable crítico situó a las figuras más representativas de la pintura y escultura de entonces.

"Hoy algunos nombres han caído, otros nuevos se han levantado. Entre los de ayer, los de hoy, y quizás los de mañana, el Lyceum ha querido hacer 'su salón' como lo hubiera hecho él mismo si en la actualidad se entrara entre nosotros, agradeciendo con ello la colaboración siempre pronta de Guy Pérez Cisneros en este empeño común por el arte cubano moderno."

54. Adela Jaume, "Exposición colectiva en el Lyceum," *Diario de la Marina* (Havana), January 24, 1956.

Rafael Marquina, "La Exposición en homenaje a la memoria de Guy Pérez Cisneros," *Información* (Havana), February 5, 1956, p. E2.

55. Marquina, "La Exposición en homenaje a la memoria de Guy Pérez Cisneros," E2.

56. *VIII Salón Nacional de Pintura y Escultura, del 28 de noviembre al 28 de diciembre*, exh. cat. (Havana: Instituto Nacional de Cultura, Ministerio de Educación, Palacio de Bellas Artes, 1956); *Exposición de pintura y escultura contemporánea* [December 21, 1956–January 3, 1957], exh. cat. (Havana: Asociación Cubana por la Libertad de Cuba, 1956).

57. Ramón Loy, "Exposiciones," *Boletín de la Comisión Nacional Cubana de la UNESCO* (December 1956): 14–15.

58. Rafael Marquina, "VIII Salón Nacional," *Información* (Havana), November 29, 1956. See also Marquina, "Primera visita al VIII Salón Nacional de Pintura y Escultura," *Información* (Havana), December 2, 1956.

59. Loló de la Torriente, "VIII Salón," *Alerta* (Havana), November 29, 1956.

60. For more on the Congress, see Jorge Domingo Cuadriello, "Asociación Cubana del Congreso por la Libertad de la Cultura," *Espacio Laical* 4 (2010): 80–81.

61. The published list of signatories is as follows: Víctor Manuel, Marcelo Pogolotti, Alfredo Lozano, Eugenio Rodríguez, Manuel Couceiro, Guido Llinás, Tomás Oliva, Enrique Moret, Raúl Martínez, José Antonio Díaz Peláez, Ruperto León, Lino Pedroso, Marta Arjona, José Y. Bermúdez, Hugo Consuegra, Manuel Vidal, René Vidal, Sabá Cabrera, Julio Matilla, Arturo Buergo, José A. Baragaño, Lázaro Fresquet, and Miguel Collazo. León and Bermúdez signed the Declaration but did not show work; René Ávila, Margie Gavilan, Jesús González Armas, Sergio Ruiz, Juan Tapia Ruano, Antonio Vidal and Thelvia Marin showed but did not sign.

62. The absent onceños were Antigua (who showed at the official Salon), Viredo Espinosa (expelled), and Cárdenas and Jamís (both in Paris).

63. Domingo Cuadriello, "Asociación Cubana del Congreso por la Libertad de la Cultura," 78–82.

64. "All Aboard! American Republics at the New York World's Fair," *Bulletin of the Pan-American Union* 73, no. 7 (July 1939): 387–412.

65. Cf. Helen Delpar, *The Enormous Vogue of Things Mexican: Cultural Relations between the United States and Mexico, 1920–1935* (Tuscaloosa: University of Alabama Press, 1992). See also "Dances will go on even if Cuba objects: they represent island life, concession head says," *New York Times*, May 14, 1939; and "La Guardia Champions Cleaner Shows: MAYOR PUTS CURB ON NUDIST BACKERS Finds Organizers of Contest at Fair Guilty, but They Get Suspension of Penalties CASE IS CALLED A LESSON La Guardia Says That He Will Not Tolerate Impropriety for Sake of Publicity," *New York Times*, June 6, 1939.

66. Royal Cortissoz, "Modern Pictures out of Cuba," *Herald Tribune*, March 26, 1944. "Only the other day, Mr. David E. Finley, director of the National Gallery, announced the establishment of an Inter-American Office, created by a grant in aid from the Department of State, to act as the government's official clearing house for the exchange of information concerning art activities in the American republics. He added: 'In the present cultural interchange between this country and the other American republics, it is expected that a co-ordinated program prevent duplication of effort and assure the maximum realization of art exchange possibilities. Traveling loan exhibitions of art from the Latin-American countries will be arranged for showing in museums in the United States, with reciprocal exhibitions prepared by museums here for showing in the other American republics. The Inter-American Office also will serve in an advisory capacity on the interchange of artists, art students, research workers and others in the field of art.' All this points to auspicious developments."

67. *Modern Cuban Painters, March 17–May 4* (New York: Museum of Modern Art, 1944). The participating artists were: Felsindo Acevedo; Cundo Bermúdez; Mario Carreño; Roberto Diago; Carlos Enríquez; Felipe Orlando; Mariano Rodríguez; Luis Martínez Pedro; Rafael Moreno; Amelia Peláez; Fidelio Ponce de León; René Portocarrero; and Víctor Manuel. The absence of Wifredo Lam, who took issue with the exhibition's

essentialization of Cuban art and who also had an antagonistic relationship with Gómez Sicre, was noted at the time by Barr and other contemporary critics. Lam held a solo show at Pierre Matisse Gallery during the time of the exhibition and later regretted that his iconic *Jungle* was not shown in the Museum of Modern Art (which later acquired the work through its Inter-American Fund).

68. Alfred H. Barr, Jr., "Modern Cuban Painters," *Bulletin of the Museum of Modern Art* 11, no. 5 (April 1944): 4.

69. The exhibition traveled to the Arts Club of Chicago; the St. Paul Gallery (Minnesota); the University Gallery, University of Minnesota; the Portland Art Museum (Oregon); the Seattle Art Museum; the San Francisco Museum; the J. B. Speed Art Museum (Louisville, Kentucky); the Alexandria Art League (Louisiana); the Person Hall Art Gallery, University of North Carolina, Chapel Hill; Rollins College (Florida); the Munson-Williams-Proctor Art Institute (New York); and the National Gallery of Art (Washington, D.C.).

70. Alfred H. Barr, Jr., letter to A. Conger Goodyear, September 30, 1943, in Modern Cuban Painters Exhibition Files, Exh. #255, Museum of Modern Art Archives, New York. "The Cuban proposal brings up the question of our future policy toward Latin American art. It is possible that during the past three years we have done too much about Latin America. . . . But I do most urgently recommend that we continue our interest in Latin American art, both through exhibitions and acquisitions. I feel all the more strongly about this because with the most successful progress of the War there is now an obvious official tendency to restrict or abandon our efforts to bring about cultural interchange with Latin America. . . . The Latin Americans are no fools and have looked forward cynically to the gradual collapse of the Good Neighbor Policy, at least on the cultural level. It seems to me that our Museum as a private institution working on its own initiative should continue a more modest but still active policy of friendly interest and interchange, particularly when this can be carried on with private or unofficial groups in the other countries.

"I hope that we may continue after the War to explore and cultivate Latin American art. In the meantime the Cuban exhibition offers us a chance to maintain continuity."

71. Héctor de Ayala, quoted in Mario de la Viña, "Obras pictóricas cubanas recorrerán capitales europeas," *El País* (Havana), May 9, 1947.

72. *Les peintres modernes cubains, du 18 janvier au 4 février*, exh. cat. (Port-au-Prince: Centre d'Art, 1945); *Colección de pinturas de la legación de Cuba en Moscú* [March], exh. cat. (Moscow: Dirección Nacional de Cultura de la República de Cuba, 1945); *11 pintores cubanos, del 2 al 25 julio*, exh. cat. (Buenos Aires: Museo de Bellas Artes, 1946); *Exposición de pintura cubana moderna, junio de 1946*, exh. cat. (Mexico City: Palacio de Bellas Artes, 1946); *7 Kubanska målare, 29 oktober–27 november*, exh. cat. (Stockholm: Liljevalchs Konsthall, 1949).

73. The Museum of Modern Art curtailed its Latin American exhibition schedule following the end of the Second World War. Latin American architecture was exhibited twice: *Two Cities: Planning in North and South America* (June 24–September 21, 1947), which looked at Chicago and Rio de Janeiro; and *Latin American Architecture since 1945* (November 23, 1955–February 19, 1956). Modern Latin American art was not again featured until the major retrospective of the Chilean artist Roberto Matta (September 11–October 20, 1957), a favorite of curator William Rubin and mostly associated with the New York School; *Ancient Arts of the Andes* (January 25–March 21, 1954) was the only other identified Latin American exhibition held at the museum in the 1950s.

74. Following the Ninth International Conference of American States, held in Bogotá in 1948, Washington's Pan-American Union formally became the Organization of American States, its twenty fellow members (including Cuba) pledged to fight communism in the Americas. The hard containment policies of the Truman Doctrine and the early rumblings of the Cold War in the Americas (for example, in Guatemala and Venezuela) are background to the softer diplomacy channeled through the OAS and the work of its museum. Note that usage of the term "Pan-American Union" persisted through the 1950s, even though the organization had been reconstituted as the OAS. See Claire F. Fox, *Making Art Panamerican: Cultural Policy and the Cold War* (Minneapolis: University of Minnesota Press, 2013).

75. For the documentary history of these exhibitions, see Annick Sanjurjo, ed., *Contemporary Latin American Artists: Exhibitions at the Organization of American States, 1941–1964* (Lanham, Md.: Scarecrow, 1997).

76. *Seven Cuban Painters: [Cundo] Bermúdez, Carreño, Diago, Martínez-Pedro, Orlando, Peláez, Portocarrero, August 15–September 20* (Washington, D.C.: Pan-American Union, 1952). Leslie Judd Portner, "A Handsome Show at Pan Am," *Washington Post*, August 24, 1952.

77. The evolving "Cold Warrior" identity of Gómez Sicre at the OAS, in regard to Latin American art more broadly, has been taken up by a number of scholars in recent years. See Fox, *Making Art Panamerican;* Alejandro Anreus, "José Gómez Sicre and the 'Idea of Latin American Art,'" *Art Journal* 64, no. 4 (Winter 2005): 83–84; Michael Wellen, "Pan-American Dreams: Art, Politics, and Museum-Making at the OAS, 1948–1976," Ph.D. diss., University of Texas at Austin, 2012; and Olga Ulloa-Herrera, "The US State, the Private Sector, and Modern Art in South America, 1940–1943, Ph.D. diss., George Mason University, 2014. On Cold War cultural diplomacy, see also Gisela Cramer and Ursula Prutsch, eds., *¡Américas unidas! Nelson Rockefeller's Office of Inter-American Affairs (1940–46)* (Madrid: Iberoamericana, 2012); and Darlene J. Sadlier, *Americans All: Good Neighbor Cultural Diplomacy in World War II* (Austin: University of Texas Press, 2012).

78. "Tenth Inter-American Conference," *American Journal of International Law* 48, no. 3, Supplement: Official Documents (July 1954): 123.

79. See Monica Boulton, "The Politics of Abstraction: The Tenth Inter-American Conference, Caracas, Venezuela, 1954," *SECOLAS Annals*, 52 (2008): 83–94.

80. Gómez Sicre consulted for the Whyte Gallery (1707 H Street NW, Washington, D.C.) and arranged a number of exhibitions of Cuban art there. Reviews suggest the increasing recognition of Cuban artists in the United States; see, for example, Gladys Harrison, "Gallery Gazer," *Times-Herald*, November 1, 1953: "Most of the artists have met with popular approval in Washington thru the Pan American Union." For other coverage, see Marcelino Blanco, "Brillante exposición de pintores cubanos," *El País* (Havana), October 20, 1953; Leslie Judd Portner, "Catlin's Indians; Cuban Exhibit," *Washington Post*, October 18, 1953; Gladys Lauderman, "Pinturas cubanas en los Estados Unidos," *El País* (Havana), October 31, 1953.

81. *Cuban Tempos* (New York: American Federation of Arts, 1956). Over forty works were shown by the following artists: Arcay, C. Bermúdez, J. Y. Bermúdez, Cabrera Moreno, Carreño, Cerra, Consuegra, Darié, Lam, Martínez Pedro, Martínez, Milián, Peláez, and Portocarrero.

82. Consuegra, *Elapso Tempore*, 171–72.

83. The exhibition subsequently traveled to Dallas, Boston, Utica, Pittsburgh, and Colorado Springs.

84. D. A. [Dore Ashton], "Cubans Join Trend toward Abstraction," *New York Times*, October 19, 1956.

85. The history of the midcentury market for Cuban and Latin American art is itself a topic deserving of greater study.

86. An earlier group exhibition, *5 Cuban Painters* (November 1–21, 1954), included C. Bermúdez, Carreño, Milián, Portocarrero, and López Dirube. Solo exhibitions include: *Enrique Riverón, April 8–27, 1957; Mirta Cerra, October 21–November 10, 1955; Carmen Herrera, January 30–February 18, 1956;* and *Emilio Sanchez, 1958.*

87. *Recent Paintings from Cuba: [J. Y.] Bermúdez, Carreño, Consuegra, Darié, Mijares, Milián, Orlando, Portocarrero, Riverón, October 5–25,* exh. cat. (New York: Roland de Aenlle Gallery, 1956). See D. A., "Cubans Join Trend toward Abstraction." Ashton had particular praise for Bermúdez, Consuegra, and Riverón.

88. S.P. [Stuart Preston], "Art: Cuban Abstractions," *New York Times,* February 2, 1957. His review was translated and published in Havana: "Cuidadosa, atractiva, ordenada y sensual la pintura cubana dice el crítico del *New York Times*," *Prensa Libre*, February 6, 1957. Amelia Peláez won an award for a still life; other exhibitors included Carreño, Darié, Gattorno, López Dirube, Martínez Pedro, and Mariano Rodríguez.

89. W. Scott, quoted in "Darán a conocer en New York las artes plásticas cubanas," *Diario de la Marina* (Havana), July 4, 1956. "Nuestro propósito es ayudar en lo posible a popularizar la obra de los pintores cubanos en los Estados Unidos."

90. Zegrí, quoted in "Darán a conocer en New York las artes plásticas cubanas."

91. Hector de Ayala, "Avant-propos," *Art cubain contemporaine, février-mars*, exh. cat. (Paris: Musée National d'Art Moderne, 1951), n.p.; [La Délégation Culturelle de Cuba en Europe], "Introduction," *Art cubain contemporaine*, n.p. "Ce sera une surprise pour beaucoup de ne pas voir dans ces œuvres les thèmes 'folkloristes' habituels ou les funestes motifs 'typiques' dont a souffert notre peinture sous l'égide de l'Académie. Ces peintres ne sont pas des artistes *'criollos.'*"

92. Cf. R. V. Gindertael, "El arte cubano contemporáneo en el Museo de Arte Moderno," *Diario de la Marina* (Havana), April 15, 1951, p. 4A. "El más joven, Arcay, desarrolla en este momento, por el contacto con lo abstractos lógicos, un sentido muy seguro del equilibrio de las formas en que el purismo se libra con elegancia de toda aridez. Herrera, a quien habíamos visto ya en 'Realités Nouvelles,' hace la parte bella a la sensibilidad, en los límites ensanchados de la no figuración. Esta pintora es un colorista fino y está entre los mejores del grupo."

 See also Pierre Descargues, "L'Art cubain contemporain," *Arts*, March 2, 1951. "Arcay n'a pour le moment de cubain que l'origine. Il vit dans le monde abstrait de l'école de Paris, aux côtés de Dewasne et de Vasarely."

93. Rosa Oliva, "De artes plásticas cubanas, en la Embajada de Cuba en París," *El Mundo* (Havana), September 1956.

94. The exhibiting artists were: C. Bermúdez; Cabrera Moreno; Carreño; Darié; Diago; Orlando; Víctor Manuel; Girona; López Dirube; Martínez Pedro; Milián; Mijares; Peláez; Portocarrero; and Mariano Rodríguez. Lam, Enríquez, and Ponce were invited but did not show, due ostensibly to the difficulty in obtaining works (in the case of Lam there was, additionally, a long history of hard feelings dating back to the MoMA exhibition). See Carreño, "La pintura cubana en la XXVI Exposición Bienal de Venecia," *Noticias de Arte* 1, no. 1 (September 1952): 8–9. For other coverage, see Rosa L. Oliva, "Pintura cubana en la Bienal," *El Mundo* (Havana), June 1, 1952; "Cubanos en la próxima exposición de Venecia," *Información* (Havana), June 7, 1952; Willy de Blank, "Cuba en la Bienal de Venecia," *Boletín (Comisión cubana de la UNESCO)* 1, no. 9 (September 1952): 9–12.

95. Umbro Apollonio, *Luis Martínez Pedro, agosto 5–14*, exh. cat. (Venice: Galleria del Cavallino, 1955); Umbro Apollonio, *Luis Martínez Pedro, dal 29 Gennaio al 7 Febbraio*, exh.cat. (Milan: Galleria del Naviglio, 1956). See also Rafael Marquina, "La pintura cubana en Europa: exposición de Martínez Pedro en Venecia," *Información* (Havana), October 2, 1955. In West Germany: *Luis Martínez Pedro* (Recklinghausen: Städtische Kunsthalle, 1956); *Luis Martínez Pedro* (Frankfurt: Frankfurter Kunstkabinett, 1956); *Luis Martínez Pedro, April 27–June 2* (Bengsberg: Museum der Stadt Bengsberg, 1957).

96. Cuba sent five artists to the *I São Paulo Bienal* (October 20–December 1, 1951): Peláez, Martínez Pedro, Carreño, C. Bermúdez, and Portocarrero. The delegation to the *II Bienal* (December 1953–February 1954) included the following: Portocarrero, Peláez, C. Bermúdez, Acevedo, Carreño, Darié, Estopiñán, López Dirube, Lozano, Martínez Pedro, Mijares, Milián, and Moreno. A smaller contingent traveled to the *III Bienal* (1955): Arcay, Darié, Martínez Pedro, Peláez, Portocarrero, Estopiñán, and Milián. Finally, Cuba sent sixteen artists to the *IV Bienal* (1957): Abela, Acevedo, C. Bermúdez, Cabrera Moreno, Camacho, Carreño, Cerra, Darié, Fernández, Félicie Lancereau, López Dirube, Martínez Pedro, Mijares, Peláez, Portocarrero, and Milián.

97. José Gómez Sicre, quoted in Octavio de la Suarée, "Nos representan en el Brasil 13 artistas plásticos," *El Avance* (Havana), February 8, 1954. "Si hay característica definida en general para el arte cubano actual, ésta es su ausencia de provincianismo en lo que a éste significa en retardo y cerrazón a nuevas ideas. En el arte cubano de ahora hay un eco constante de movimientos universales, un repercutir de soluciones y direcciones de muchas otras partes. Los que conocemos de cerca la obra de cada uno de estas artistas sabemos que no acogen por mandato de la moda los movimientos del arte universal con un traje prestado, sino que los adaptan gradualmente y los hacen evolucionar dentro de su sensibilidad, como hombres que responden al desarrollo de su época."

For Gómez Sicre's comments on the *I Bienal*, see "Cuba en la Bienal de São Paulo, según el crítico Brandao," *El Avance* (Havana), February 2, 1952. "La obra de estos artistas se caracteriza por la preocupación formalista, a lado de una notoria despreocupación por lo convencional y la anecdótico." See also Julia Rodríguez Tomeu, "La I Exposición Bienal del Brasil y los pintores cubanos," *El Mundo* (Havana), October 14, 1951. "En la órbita de la pintura moderna universal le está cabiendo a Cuba ya, sin duda, un lugar, que se le reconocerá en la medida en que la intensificación del intercambio cultural facilite la comunicación, como con esta Bienal Internacional del Brasil."

98. See Eva Cockcroft, "Abstract Expressionism, Weapon of the Cold War," *Artforum* 12, no. 12 (June 1974): 39–41; Elizabeth Cobbs, *The Rich Neighbor Policy: Rockefeller and Kaiser in Brazil* (New Haven: Yale University Press, 1992); Frances Stonor Saunders, *The Cultural Cold War: The CIA and the World of Arts and Letters* (New York: New Press, 2000); Michael L. Krenn, *Fall-out Shelters for the Human Spirit: American Art and the Cold War* (Chapel Hill: University of North Carolina, 2005); Serge Guilbaut, "*Ménage à Trois*: Paris, New York, São Paulo, and the Love of Modern Art," in Barbara Groseclose and Jochen Wierich, eds., *Internationalizing the History of American Art* (University Park: Pennsylvania State University Press, 2009); and Adele Nelson, "The Monumental and the Ephemeral: The São Paulo Bienal and the Emergence of Abstraction in Brazil, 1946–1954," Ph.D. diss., New York University, 2012.

99. See Gabriel Pérez-Barreiro, ed., *The Geometry of Hope: Latin American Abstract Art from the Patricia Phelps de Cisneros Collection* (Austin, Tex.: The Blanton Museum, 2007).

100. José Gómez Sicre, quoted in "Cuba en la Bienal de São Paulo, según el crítico Brandao." "Hecho curioso es que la revolución estética de Cuba fue iniciada en la misma época en que hacíamos aquí, en São Paulo, una 'Semana de Arte Moderno,' que, como sabemos, señala también nuestro punto de partida para una batalla que nosotros también estamos llevando a cabo y en la que indiscutiblemente ganamos terreno día a día. ¿No será acaso nuestra I Bienal una gran victoria artística?"

101. Note that José Y. Bermúdez exhibited as a "Guest Draughtsman" at the *III Bienal*, as part of the Pan-American Union's pavilion.

102. "8 pintores cubanos exponen mañana domingo en la A.V.P.: García Cisneros muestra obras de Cundo Bermúdez, Amelia Peláez, Mirta Cerra, Matilla, Cabrera Moreno, [Fernández] Travejos, Zilia Sánchez y Fayad Jamís," *El Nacional* (Caracas), March 22, 1958. "Dará el carácter de exposición-remate al estilo norteamericano." García Cisneros later directed the Cisneros Gallery in New York, where he gave exhibitions to, among others, Herrera (1965) and Consuegra (1971).

103. El Diablo Cojuelo [pseud.], "Wilfredo [*sic*] Lam: el pintor de los grandes misterios," *El Nacional* (Caracas), February 7, 1957.

104. Lam, quoted in "Volvió Wilfredo [*sic*] Lam," *El Nacional* (Caracas), October 27, 1955. "El arte abstracto está en un callejón sin salida y ya comienzan a desesperarse, aunque la crítica francesa, que es con frecuencia excesivamente favorable a los de casa, aparente no darse cuenta cabal del asunto." The article is careful to note that "Lam is not, however, an 'enemy' of the abstract."

105. "Cuba en Venezuela [1957]," Cuba file, Archives of the Art Museum of the Americas of the Organization of America States. "Y ya que hablamos de la Galería Cubana, justo y gratísimo es hablar de la hazaña cumplida por su animoso fundador, Florencio Cisneros. . . . Animado por el buen suceso—y según ha declarado en Caracas—se propone establecer un regular y normal intercambio de exhibiciones en Venezuela y Cuba y hasta la fundación en ambos países de Galerías que atiendan las sendas manifestaciones artísticas nacionales, al unísono, con toda la realidad de las secuencias encaminadas a un fomento práctico que asegure en ambos países un mayor auge artístico."

106. "Abstractos y figurativos," n.p. [1957], X1, Hugo Consuegra Papers.

107. Loló de la Torriente, *Pintura abstracta cubana en Venezuela, julio 10 al 1 agosto*, exh. cat. (Caracas: Galería Sardio, 1957), n.p.

108. José A. Baragaño, *Pintura abstracta cubana en Venezuela*, n.p.

109. Severo Sarduy, *Pintura abstracta cubana en Venezuela*, n.p.

110. "8 pintores cubanos exponen mañana domingo en la A.V.P." De Oraá, "Una experiencia plástica: los Diez Pintores Concretos," in *Visible e invisible* (Havana: Letras Cubanas, 2006), 107. "La Galería Cubana (en un pequeño local en Calzada y 10, Vedado), establecida por el único marchand de tableaux reconocido en aquella época, el decorador Florencio García Cisneros."

111. *Exposición de pintores y escultores cubanos*, exh. cat. (Camagüey: Lyceum de Camagüey, 1955).

112. Paul T. Frankl, *New Dimensions: The Decorative Arts of Today in Words & Pictures* (New York: Brewer & Warren, 1928), 16.

113. Armando Zegrí, *Contemporary Cuban Group: Hugo Consuegra, Guido Llinás, Raúl Martínez, Antonio Vidal, Tomás Oliva, November 11 to December 1*, exh. cat. (New York: Galería Sudamericana, 1955), n.p.

114. Ibid.

115. Dore Ashton, "About Art and Artists," *New York Times*, November 10, 1955.

116. Carlyle Burrows, *Herald Tribune* (1955), quoted in press materials for "Contemporary Cuban Group," Galería Sudamericana, Archives of the Art Museum of the Americas, Organization of American States, Washington, D.C.

117. Consuegra, *Elapso Tempore*, 146–47. "No sé cómo Zegrí consiguió la crítica de Dore Ashton, del *New York Times*, y la de Carlyle Burrows, del *Herald Tribune*, pero las consiguió, y los comentarios fueron buenos y llegaron 'calientes' a La Habana. . . . Serían de las más importantes de nuestra carrera." Cf. Gustavo César Echevarría, *Antología de un artista: Raúl Martínez* (Havana: Casa Editora Abril, 1994), 21.

118. Antonio Hernández Travieso, "Los jóvenes," *El Mundo* (Havana), December 31, 1955.

119. Ibid. "Hasta en política, en un país de tan malos políticos, han sido los jóvenes quienes mejores muestras han brindado de saberla entender y manejar. Desde el pasado más remoto a nuestros días, Cuba ha progresado política y socialmente cada vez que los jóvenes han influido en la marcha de tan delicados menesteres nacionales."

120. *Exposición de Collages: José I. Bermúdez, Hugo Consuegra, Guido Llinás, Raúl Martínez, Antonio Vidal, Tomás Oliva, abril 20 a mayo 1*, exh. cat. (Havana: Lyceum, 1956). "Dentro del concepto abstracto expresionista en que culmina la búsqueda de un lenguaje plástico a lo largo de cincuenta años, el actual renacimiento del 'collage' como medio de experimentación con materiales y formas libres reunidas por la sensibilizada, que no responde a los valores lógicos de la realidad, nos permite situar la plástica cubana en el mismo punto de partida de los principales centros artísticos donde se trabaja por dar forma y expresión al sentido estético de hoy, sin recurrir a soluciones formales superadas desde hace veinticinco años. La escultura, al emplear nuevos materiales y formas creativas que no necesitan de la semejanza por comparación, deja de PARECER para SER, apartándose de un sentido unilateral de pieza de adorno."

121. Consuegra, *Elapso Tempore*, 179.

122. The exhibition included works by Cárdenas; Consuegra; Couceiro; Díaz Peláez; Joaquín Ferrer; Llinás; Martínez; Oliva; Sergio Ruiz; Soriano; Tapia Ruano; and Manuel Vidal. The Centro de Arte Cubano, open since the beginning of 1956, was directed by Hungarian expatriate Sepy Doboronyi and Enrique Conil; it occupied a location at the Plaza de la Catedral in Old Havana below a gallery run by Martínez Pedro's wife, Gertrudis (Galería La Plaza).

123. Stuart Preston, "Art: Carzou's Elegance," *New York Times*, March 14, 1959. José Antonio Inventory and Card (25–1035), Art, Box 22, Nelson A. Rockefeller Papers, Rockefeller Archive Center.

124. *Hugo Consuegra of Cuba, May 21 to June 19*, exh. cat. (Washington, D.C.: Pan-American Union, 1956). Consuegra was the only member of Los Once whose work Gómez Sicre admired. See Alejandro Anreus, "Conversaciones con José Gómez Sicre," March 17, 1989, Washington, D.C. "AA: ¿Cuáles son los artistas cubanos que le interesan del 1950 para acá? JGS: De Los Once, Hugo Consuegra. No me interesaron el resto de ese grupo. En los cincuentas ellos fueron muy duros con Mario Carreño. Mario trabajaba para el gobierno de Batista en ese momento y no actuó bien, pero no fue por maldad ni nada por el estilo. Creo que hacía lo que le pedía su jefe, Guillermo Zéndegui, que hiciera. La obra Pop de Raúl Martínez me parece buena."

 Consuegra's show was warmly received. See Leslie Judd Portner, "Fine show by one of

'The Eleven,'" *Washington Post*, June 3, 1956; and Florence S. Berryman, "Cuban's First," *Sunday Star*, June 3, 1956.

125. R.W[arren].D[ash]., "Consuegra," *Arts* 32, no. 4 (January 1958): 57–58.

126. See Octavio de la Suarée, "Pintores cubanos en el extranjero," *Avance* (Havana), August 27, 1957. The review notes three exhibitions: *Serra Badué*, May 13–31 (The Contemporaries, New York, 1957); [J. Y. Bermúdez, Consuegra, Darié, Orlando, and Milián] (Roland de Aenlle, New York, 1957); and [Matilla] (Asociación Venezolana de Periodistas, Caracas, 1957).

127. See Guilbaut, *How New York Stole the Idea of Modern Art*, passim.

128. David Craven, "A Legacy for the Latin American Left: Abstract Expressionism as Anti-Imperialist Art," in *Abstract Expressionism: The International Context*, ed. Joan M. Marter (New Brunswick, N.J.: Rutgers University Press, 2007), 80. See also Craven, *Abstract Expressionism as Cultural Critique: Dissent during the McCarthy Period* (New York: Cambridge University Press, 1999).

129. Cf. Alejandro Anreus, "Conversaciones con José Gómez Sicre," unpublished interview, February 21, 1991, Washington, D.C. Gómez Sicre did not identify a (negative) American influence in Latin American art until the rise of Pop and conceptual art in the 1960s. As Anreus notes in the preface to his interview, Gómez Sicre was in general cool to the political dimensions of postwar art and viewed the influence of the New York School somewhat more benignly in countercultural, rather than explicitly anti-imperialist terms. Note that Cuba was suspended from the OAS in 1962. "Solo los Stalinistas ven el Expresionismo Abstracto de esa manera negativa [como influencia negativa del arte de los Estados Unidos]. En Latinoamérica, la abstracción después de la Segunda Guerra Mundial viene también por vía de los Europeos, del Informalismo en Francia y España. Además, la pintura de De Kooning, de Pollock y los demás, tuvo una influencia libertaria en Latinoamérica, sobre todo oponiéndose estéticamente al indigenismo y al muralismo trasnochado. Marta Traba y yo hablamos mucho de este tema. Ambos estábamos abiertos a la abstracción, pero no al Pop."

130. Carlos Fuentes, quoted in Jean Franco, *The Decline and Fall of the Lettered City: Latin America in the Cold War* (Cambridge, Mass.: Harvard University Press, 2002), 38–39.

Chapter 5. Cuba's Concretos and the Constructivist Turn

1. Carreño, "¿Qué es el arte *concreto?*" *Carteles*, May 29, 1955, p. 125.

2. Stuart Preston, "Currently on View," *New York Times*, October 30, 1949.

3. Carlebach Gallery, "One Man Exhibition by Sandú Darié—Oct. 24–Nov. 5, 1949," Sandú Darié Artist File, Museum of Modern Art Library, New York.

4. Sandú Darié, *Estructuras pictóricas 1950, del 9 al 20 octubre*, exh. cat. (Havana: Lyceum, 1950), n.p.

5. Sandú Darié, letter to Gyula Kosice, November 26, 1949, trans. Michael Agnew, in *Cold America: Geometric Abstraction in Latin America (1934–1973)*, ed. Osbel Suárez (Madrid: Fundación Juan March, 2011), 465.

6. Sandú Darié, letter to Gyula Kosice, January 30, 1950, trans. Michael Agnew, in *Cold America*, 466.

7. Sandú Darié, "Pensamiento madista," *Arte Madí Universal* 5 (October 1951): n.p.

8. Ibid.

9. Darié was included in a number of Madí exhibitions, including *Exposición y conferencia ARTE MADI, Julio* (Ateneo del Chaco, Resistencia, Argentina, 1953); *Arte madí internacional* (Galería Bonino, Buenos Aires, 1956); *Groupe argentin madí: exposition internationale—dessin, peinture, sculpture, architecture, du 18 au 28 février* (Galerie Denise René, Paris, 1958); and *Los primeros 15 años de arte madí, noviembre 23–diciembre 13* (Museo de Arte Moderno de Buenos Aires, Buenos Aires, 1961).

10. Stuart Preston, "Of this our day: 'Some Areas of Search'—Matta Again—Kingman," *New York Times*, May 6, 1951.

11. Darié, *Estructuras pictóricas 1950*, n.p. "Las Estructuras pictóricas que presento fueron plasmadas bajo una hipótesis de trabajo e ilustran mis ideas, dominadas por las siguientes características: Iniciar la división del rectángulo por medio de la diagonal, obteniendo la forma-cuadro elemental del triángulo. La variación de los triángulos como forma-cuadro en un espacio continuo, de

aspecto dramático-sorprendente. El aspecto estructural espacial organizado bajo un ritmo ortogonal con elementos agregados (coordinadas rectilíneas planas) que componen y sugieren la prolongación del plano allá donde no es posible imaginar el fin . . . al infinito."

12. Ibid. "La función de las exposiciones de pintura es conducir ideas. . . . La visión de estas estructuras, evoca una belleza de ritmo arquitectónico, correspondiendo a la voluntad formal de la época, imponiendo la armonía directa de la poesía pura, como manifestación espiritual y constructiva."

13. Metaphysical themes—notably, in regard to Jewish cosmology—resurfaced in Darié's work during the 1960s and 1970s.

14. For a chronology, see Jesús Fernández Torna, *Mario Carreño: Selected Works, 1937–1957* (Miami: Torna & Prado Fine Art Collection, 2012).

15. The *New School Bulletin* lists Carreño as an instructor in the 1947–48 and 1950–51 annual catalogues. See *New School Bulletin: Art Classes, 1947–1948* 5, no. 2, September 8, 1946, Course catalogs, NS.05.01.01, box 9, folder 18, New School Archives and Special Collections, The New School, New York; and *New School Bulletin: Art Classes, 1950–1951* 8, no. 2, September 11, 1950, Course catalogs, NS.05.01.01, box 9, folder 20, New School Archives and Special Collections.

16. *Mario Carreño: March 13 to April 15* (New York: Perls Galleries, 1944); *Mario Carreño: Recent Paintings, November 5–December 1* (New York: Perls Galleries, 1945); *Mario Carreño: Recent Paintings, November 10–December 6* (New York: Perls Galleries, 1947). The Pan-American Union published a book on Carreño as part of the series, Contemporary Artists of Latin America; see José Gómez Sicre, *Carreño* (Washington, D.C.: Pan-American Union, 1947).

17. Carreño, quoted in Torna, *Mario Carreño: Selected Works, 1936–1957*, 333.

18. Octavio de la Suarée, "'*La pintura abstracta e incomprendida de hoy será la clásica y tradicional de mañana*,' asegura el pintor Mario Carreño," *El Avance* (Havana), November 29, 1951.

19. Octavio de la Suarée, "Éxito del ciclo de conferencias de Mario Carreño," *El Avance* (Havana), March 27, 1952.

20. Rafael Soriano, *Rafael Soriano: exposición, del 18 al 25 de enero de 1947*, exh.cat. (Matanzas: Colegio de Abogados, 1947).

21. "Rafael Soriano," Written Works, Box 2, Folder 33, José Gómez Sicre Papers.

22. Antonio Viqueira Hinojosa, "El suicidio de un pintor," n.p., n.d., "Roberto Diago," Artist Files, Box 9, Folder 14, José Gómez Sicre Papers.

23. Oral history interview with José Maria Mijares, January 17, 1998. Archives of American Art, Smithsonian Institution; José María Mijares Fernández and Roberto J. Cayuso, *The World of José Mijares* (Coral Gables, Fla.: Marpad Art Gallery, 1992), n.p.

24. Corratgé, "Memorias de un Pintor."

25. Rafael Marquina, "En torno a la exposición de pinturas de Luis Martínez Pedro," *Información* (Havana), July 26, 1953. "Y a la puerta de su tienda puede leerse en letras incisas por la experiencia sobre la imaginación: No entre quien no sea geómetra."

26. Jorge Romero Brest, "Primera Bienal de San Pablo," *Ver y Estimar* 8, no. 26 (November 1951): 28.

27. José Gómez Sicre, *Luis Martínez Pedro, September 24 to October 20*, exh. cat. (Washington, D.C.: Pan-American Union, 1951).

28. Walter Gropius, *Exposición de óleos de Luis Martínez Pedro, mayo 29 1953*, exh. cat. (Havana: n.p., 1953).

29. Marquina, "En torno a la exposición de pinturas de Luis Martínez Pedro."

30. Luis Amado Blanco, "Martínez Pedro," *Información* (Havana), June 3, 1953. He reviewed the show once more: Blanco, "El ojo vuelto," *Información* (Havana), July 29, 1953.

31. "Entregan cuadro de Martínez: ha sido distribuido por la Unesco a sus filiales," *El Mundo* (Havana), January 26, 1955.

32. Cuba participated in the first seven São Paulo Biennials (1951–63) and then returned for the eighteenth edition in 1985.

33. Luis Martínez Pedro, quoted in Mario Carreño, "Entrevista: itinerario de Martínez Pedro," *Carteles*, February 20, 1955.

34. Ibid.

35. *Luis Martínez Pedro, dal 5 al 14 agosto*, exh. cat. (Venice: Galleria del Cavallino, 1955); *Luis Martínez Pedro, dal 29 gennaio al 7 febbraio*, exh. cat. (Milan: Galleria del Naviglio, 1956). Cardazzo (1908–1963) played an essential role

in promoting transatlantic artistic exchange, and in the postwar period he lent support to both historical and contemporary avant-gardes: Lucio Fontana and the Spatialist movement; American Abstract Expressionism; the CoBrA group; the School of Paris. See Luca Massimo Barbero, *Carlo Cardazzo: una nuova visione dell'arte* (Milan: Electa, 2008).

36. Loló Soldevilla, *Ir, venir, volver a ir: crónicas (1952–1957)* (Havana: Ediciones R[evolución], 1963).

37. Marc Ducourant, "L'art d'Edgard Pillet," *Edgard Pillet* (Grenoble: Musée de Grenoble, 2001), 12.

38. De Oraá, "Una experiencia plástica," 114.

39. See Nicola Pezolet, "Spectacles Plastiques: Reconstruction and the Debates on the 'Synthesis of the Arts' in France, 1944–1962," Ph.D. diss., Massachusetts Institute of Technology, 2013.

40. Wifredo Arcay, *Je vous écris: entretiens avec Wifredo Arcay et Francis Delille* (Paris: Herscher, 1986), n.p.

41. Arcay, *Je vous écris*, n.p. "Mais tu te rends compte, moi à Cuba, je ne connaissais ces noms que par des reproductions, par des livres. Je ne comprenais plus rien. Sortir d'un livre pour entrer dans la réalité." The album included work by sixteen artists: Hans Arp, Giacomo Balla, Robert Delaunay, Sonia Delaunay, Albert Gleizes, Auguste Herbin, Wassily Kandinsky, Paul Klee, František Kupka, Fernand Léger, Alberto Magnelli, Piet Mondrian, Francis Picabia, Sophie Taeuber-Arp, Theo Van Doesburg, and Jacques Villon; see Wifredo Arcay, *Art d'aujourd'hui: maîtres de l'art abstrait* (Boulogne: Édition Art d'Aujourd'hui, 1953).

42. "Guy Habasque sur Arcay," in *Wifredo Arcay, novembre*, exh. cat. (Paris: Galerie Denise René, 1962).

43. Hans Arp, quoted in *Wifredo Arcay, novembre*.

44. *Loló: esculturas, 23–27 noviembre*, exh. cat. (Havana: Lyceum, 1950). There is no accompanying text on Soldevilla's work; the catalogue contains excerpts from Pierre Courthion, "Prenez garde à la sculpture," *XXe siècle* no. 1 (1939): 21–44. Ossip Zadkine, quoted in *Loló Soldevilla* (Havana: Galería Edificio MINSAP, 1971).

45. María Vicenta Pastor Ibáñez, *Eusebio Sempere* (Alicante: Instituto de estudios alicantinos de la diputación provincial de Alicante, 1978), 7, 11.

46. Ibid., 7, 10.

47. *Loló Soldevilla*, exh. cat. (Havana: Galería Edificio MINSAP, 1971). The biographical chronology included in Soldevilla's 1971 retrospective exhibition names her as an author of a "Manifesto" published to accompany the *Relieves luminosos*. Later publications of Sempere's work do not credit her as a coauthor, though it seems likely that Soldevilla contributed to the text in light of their collaboration on the reliefs.

48. Eusebio Sempere, "Manifeste," reprinted in *Eusebio Sempere* (Alicante: Instituto de Estudios Alicantinos de la Excma. Diputación Provincial, 1978).

49. Carmen Herrera, in discussion with the author, January 8, 2009, New York. Herrera worked in near obscurity for decades in New York, but her work has experienced a critical resurgence in the past decade, and she is lately among the best-known and exhibited artists of this generation. Major recent exhibitions include: *Carmen Herrera: The Black and White Paintings, 1951–1959*, exh. cat. (New York: El Museo del Barrio, 1998); *Carmen Herrera: Five Decades of Painting* (New York: Latin Collector, 2005); *The Forms of Silence: Carmen Herrera Abstract Works, 1948–1976*, exh. brochure (Miami: Miami Art Central, 2005); and *Carmen Herrera*, exh. cat. (Birmingham, England: Ikon Gallery, 2009). See Ann Landi, "Shaping Up," *ARTnews* 109, no. 1 (January 2010): 68.

50. Rafael Marquina, "Aterrizaje en el espacio y vuelo en la tierra: exhibición de Martínez Pedro y Sandú Darié," *Información* (Havana), May 15, 1955, p. F8. "En suma: Luis Martínez Pedro se adentra en la pintura; Sandú Darié se evade de ella. La cuarta dimensión los obsesiona; al primero, en la fijeza de lo estático; al segundo, en la obsesión de lo movible."

51. Rafael Súarez Solis, "Luis Martínez Pedro y Sandú Darié dan una lección de arte en la Universidad," *Diario de la Marina* (Havana), April 29, 1955.

52. Piet Mondrian, "Neo-Plasticism: Its Realization in Music and in Future Theater," in *The New Art—The New Life: The Collected Writings of Piet Mondrian*, ed. Harry Holtzman and Martin S. James (Boston: G. K. Hall, 1986), 162.

53. Harry Cooper, "Mondrian, Hegel, Boogie," *October* 84 (Spring 1998): 127.

54. Jorge Romero Brest, quoted in *Sandú Darié y Martínez Pedro, abril 25 a mayo 10*, exh. cat. (Havana: Universidad de La Habana, Pabellón Ciencias Sociales, 1955).

55. Marquina, "Aterrizaje en el espacio y vuelo en la tierra."

56. Michel Seuphor, *Dictionary of Abstract Painting, with a History of Abstract Painting* (New York: Paris Book Center, 1957), 74.

57. "Inventionist Manifesto," *Arte Concreto-Invención* 1 (August 1, 1946), reprinted in *Geometric Abstraction: Latin American Art from the Patricia Phelps de Cisneros Collection*, exh. cat. (Cambridge, Mass.: Harvard University Art Museums and Fundación Cisneros, 2001), 146.

58. Mario Carreño, *Pintura de hoy: vanguardia de la escuela de París* (Havana: Instituto Nacional de Cultura, 1956).

59. Mario Carreño, "Explica Sandú Darié el arte abstracto," *Carteles*, April 19, 1956.

60. Severo Sarduy, "Dibujos de Mijares," *Lunes de Revolución*, September 28, 1959, p. 9.

61. Mario Carreño, letter to José Gómez Sicre, April 13, 1957, Box 6, Folder 2, José Gómez Sicre Papers. "Esto me da mucha pena decírtelo, pero tu mejor que nadie conoces las cosas de esta bendita tierra y no creo que necesite mucho para explicarte como funcionan, o mejor dicho como no funcionan las cosas aquí.

"Desde luego que este contratiempo no ha sido por dejadez o abandono, sino porque verdaderamente el INC ha pasado y está pasando por momentos muy difíciles, pues aparte de los acontecimientos ocurridos, desde el punto de vista económico ha tenido grandes tropiezos . . . ; los presupuestos no alcanzan, los subsidios no llegan a tiempo, los disgustos no tienen fin. Bueno, un verdadero Franke[n]stein."

62. See Carreño, *Mario Carreño: Cronología del recuerdo*, 78.

63. *El mundo nuevo de los cuadros de Carreño, 1950–1957*, exh. cat. (Havana: Instituto Nacional de Cultura, 1957). The critical response was extensive and exuberantly positive. See Rafael Marquina, "La mescalina de Carreño," *Información* (Havana), February 21, 1957; Marquina, "Dos grandes acontecimientos de arte en el Museo Nacional," *Información* (Havana), March 21, 1957; Fernando de la Presa, "Figuras de Carreño," *Pueblo* (Havana), February 23, 1957; A. Martínez Bello, "La exposición pictórica de Mario Carreño," *Pueblo* (Havana), February 23, 1957; Octavio de la Suarée, "El 20 expondrá en Bellas Artes, Carreño, pintor a quien un proceso de depuración estilística ha impulsado hacia lo abstracto," *El Avance* (Havana), February 11, 1957; de la Suarée, "Temiendo que no sepan de pintura abstracta los críticos, Carreño hizo que un pintor le prologase el catálogo de su Exposición," *El Avance* (Havana), February 20, 1957; de la Suarée, "De la pintura en general como jeroglífico y de la abstracta en particular como ecuación, con ayuda de O. Gasset y óleos de Carreño," *El Avance* (Havana), March 14, 1957; de la Suarée, "Arte de abstracción y arte de imitación o cómo la pintura actual de Mario Carreño registra la lucha de ambos por desplazarse," *El Avance* (Havana), March 30, 1957; and Adela Jaume, "Mario Carreño y su pintura," *Diario de la Marina* (Havana), March 9, 1957.

64. Sandú Darié, "Mario Carreño en la aventura plástica de este siglo," in *El mundo nuevo de los cuadros de Carreño, 1950–1957*, n.p. "La evolución de su pintura es guiada por la dialéctica creativa de nuestro siglo. . . . La mirada del espectador hará el viaje óptico de una forma a la otra, descubriendo el ritmo del cuadro, atravesando el espacio tiempo del mismo."

65. Rafael Marquina, "Dos grandes acontecimientos de arte en el museo nacional," *Información* (Havana), March 21, 1957. "La Exposición Carreño en el Instituto Nacional de Cultura significa en Cuba—significará allende Cuba—un momento decisivo para el arte abstracto que ahora, por en medio del confusionismo que, agravado por la fácil audacia de los improvisadores, se había creado. Ahora Mario Carreño ha 'explicado'—de la mejor manera—para que todos 'sepamos,' que el arte abstracto no es un vano capricho, sino una profunda, raigal, humana, universal preocupación del artista en busco de lo que, en el mundo, vale y significa y exije la verticalidad de la criatura racional; en busca del signo que hermana y que identifica el quehacer del hombre."

Fernando de la Presa, "Figuras de Carreño," *Pueblo* (Havana), February 23, 1957. "Y, finalmente, en quinto puesto: pintura universal que se nacionaliza en Cuba, por la luz abierta de su color."

66. "Se abre hoy exposición del cubano Mario Carreño," *El Nacional* (Caracas), September 22, 1957. Carreño's exhibition received positive reviews from the Venezuelan press; see "Llegó el cubano Carreño para exponer en Bellas Artes," *El Nacional* (Caracas), September 7, 1957; "Inaugurada en Bellas Artes la exposición de Mario Carreño," *El Nacional* (Caracas), September 23, 1957; and "Hoy conferencia de Carreño sobre pintura moderna de Cuba," *El Nacional* (Caracas), 1957, Cuba file, Archives of the Art Museum of the Americas of the Organization of America States.

67. Rafael Marquina, "Una exposición cubana en un banco de Miami," *Información* (Havana), March 23, 1958.

68. Ibid.

69. Octavio de la Suarée, "El cincuentenario de la pintura abstracta," *Avance* (Havana), September 12, 1957.

70. De Oraá, "Noticia comentada sobre la Galería Color-Luz," in *Visible e invisible*, 103.

71. See Loomis, *Revolution of Forms*, 10–15.

72. De Oraá, "Noticia comentada sobre la Galería Color-Luz," 103. "El nombre escogido—*Color-Luz*—guarda estrecha relación con los 'relieves luminosos' que Loló construía como variante creativa de su obra pictórica plana. . . . Uno de estos relieves sirvió de identificación de la galería, junto al lumínico de neón a la entrada del local."

73. *Exposición inaugural: pintura y escultura cubana 1957, 31 de octubre*, exh. cat. (Havana: Galería de Arte Color-Luz, 1957). The participating artists were drawn from all three vanguardia generations. The onceños Francisco Antigua, Agustín Cárdenas (not included in the catalogue), Hugo Consuegra, Raúl Martínez, and Tomás Oliva showed alongside the concretos Arcay, Soldevilla, Mijares, de Oraá, Álvarez, and Darié. The other artists were as follows: Eduardo Abela, Amelia Peláez, Agustín Fernández, Cundo Bermúdez, Joaquín Ferrer, Wifredo Lam, Mariano Rodríguez, Mirta Cerra, Servando Cabrera Moreno, Rolando López Dirube, Roberto Estopiñán, Alfredo Lozano, Tony López, and Carlos Sobrino.

74. Lezama Lima, "Nuestra galería," *Exposición inaugural: pintura y escultura cubana 1957*, n.p.

75. De Oraá, "Noticia comentada sobre la Galería Color-Luz," 105.

76. Ibid., 108. See Rafael Marquina, "'El arte abstracto europeo' en la Galería Color-Luz," *Información* (Havana), July 20, 1958.

77. De Oraá, "Noticia comentada sobre la Galería Color-Luz," 108.

78. R. Hart Phillips, "Fighting in Cuba Said to Increase: Army-Rebel Clashes Sighted in 3 Eastern Provinces—British Protest Slaying," *New York Times*, August 7, 1958.

79. De Oraá, "Noticia comentada sobre la Galería Color-Luz," 106.

80. Ibid., 109.

81. Ibid., 106.

82. Pedro de Oraá, "Una experiencia plástica," 116.

83. Cf. Paula Barreiro López, *Arte normativo español: procesos y principios para la creación de un movimiento* (Madrid: Consejo Superior de Investigaciones Científicas, 2005).

84. Cf. de Oraá, "Una experiencia plástica," 118. Cuban Minimalism was a diasporic phenomenon, seen most prominently in the work of Carmen Herrera and Waldo Díaz-Balart; it did not develop further, beyond Los Diez, in Havana.

85. Los Diez evidently exhibited together three times. No documentary material survives from the third exhibition, held at the Galería de Artes Plásticas in Camagüey. The group's debut exhibition, *10 pintores concretos exponen pinturas y dibujos en el 2do aniversario de la Galería, 6 al 30 de noviembre* (Galería Color-Luz, Havana, 1959) included works by Álvarez, Arcay, Corratgé, Darié, Martínez Pedro, Menocal, Mijares, de Oraá, Soldevilla, and Soriano. The printed catalogue gives the exhibition dates as November 6–30, but handwritten corrections change the dates to November 25–December 20. The same ten artists participated in the second exhibition, *10 pintores concretos, 9 al 16 de enero* (Matanzas, Cuba: Biblioteca Ramón Guiteras, 1960). See de Oraá, "Una experiencia plástica," 110–25.

86. No documentary material pertaining to the exhibition in Camagüey survives. Corratgé and de Oraá confirm that the exhibition took place, but unfortunately no further details are known to exist.

87. De Oraá, "Una experiencia plástica," 116.

88. *7 Pintores Concretos*, a collection of serigraphs produced by Corratgé, included work by Darié, Soldevilla, Martínez Pedro, Mijares, de Oraá,

and Rosabal. The same artists contributed to the edition *A*, also produced by Corratgé. Soldevilla later published a book, *El farol* (Havana: Ediciones Revolución, 1964), in support of the literacy campaign. According to the book jacket (whose cover was designed by Raúl Martínez), "En *El Farol*, trata de resaltar el patriotismo de un niño que fue a alfabetizar a Oriente y narra la vida de los campesinos con sus propias palabras y sentido poético."

89. Sandú Darié, quoted in Edmundo Desnoes, "1952–1962 en la pintura cubana," in Oscar Hurtado and Edmundo Desnoes, eds., *Pintores Cubanos* (Havana: Ediciones Revolución, 1962), 47. "'Es pintura concreta,' considera Darié, 'porque cada cuadro es una nueva realidad.'" De Oraá, "Una experiencia plástica," 119. "En un segundo orden de ideas, la obra de arte concreto planteaba en el proceso creativo las premisas de su connotación social. Insertarse en el mundo es incluirse en la marea social."

90. De Oraá, "Una experiencia plástica," 118.

91. Ibid., 119.

92. Loomis, *Revolution of Forms*, 14.

93. De Oraá, "Una experiencia plástica," 119–20.

94. "Cuban revolt depicted in paintings shown here," *Washington Post and Times Herald*, February 20, 1959.

95. Frances Rowan, "Like Artist Exhibiting Them: Paintings are Pro-Castro," *Washington Post and Times Herald*, February 20, 1959.

96. Sarduy, "Dibujos de Mijares," 9.

97. De Oraá, "Una experiencia plástica," 120 (emphasis in original). "Las áreas abiertas 'verdes' y las propias construcciones carecían de un mínimo de estetización; las edificaciones de servicio público aplicaban la plástica con carácter accidental, esto es, como un aditamento y no 'pensada' desde la elaboración de los planos y maquetas. *La necesidad de arte* se ha visto relegada por los múltiples obstáculos—foráneos y locales—, interpuestos al crecimiento del proceso, pero la noción de esa necesidad ha ganado conciencia y espacio—contra el prejuicio más ideológico que económico de su suntuosidad y gratuidad—, en el nivel institucional. Era, es, si se quiere, una utopía estética de inmediata realidad."

98. In 1963, Soldevilla published a book of vignettes from her years in Paris, *Ir, venir, volver a ir: crónicas (1952–1957)*. Other works from this period include the ballet *Filo diez mil* (1965) and the plays *Bombardeo* (1965) and *Samuel dos veces* (1965).

99. Caroline Rae, "In Havana and Paris: The Musical Activities of Alejo Carpentier," *Music and Letters* 89, no. 3 (August 2008): 375. See also Roland E. Bush, "'The Art of the Fugue': Musical Presence in Alejo Carpentier's 'Los pasos perdidos,'" *Latin American Music Review* 6, no. 2 (Autumn–Winter 1985): 129–51.

100. Juan Blanco, quoted in "Entrevista a Juan Blanco con Motivo del XX Aniversario del Primer Concierto de Música Electroacústica organizado en Cuba," Juan Blanco file, Museo Nacional de la Música, Havana.

101. See Neil Leonard III, "Juan Blanco: Cuba's Pioneer of Electroacoustic Music," *Computer Music Journal* 21, no. 2 (Summer 1997): 10–20.

102. Alfredo Hidalgo Gato, "Programme of concert: Cuban Electroacoustic Music," Laboratorio Nacional de Música Electroacústica, Havana.

103. Cf. Jesús Ortega, "Juan Blanco, 70° aniversario: siempre joven," *Clave* 13 (1989): 9.

104. Darié et al., *Cosmorama* (Havana: Instituto Cubano del Arte e Industria Cinematográficos, 1964).

105. Marshall McLuhan and Bruce R. Powers, *The Global Village: Transformations in World Life and Media in the 21st Century* (New York: Oxford University Press, 1989), 9.

106. Sandú Darié Artist File, Museum of Modern Art Library, New York. This quotation appears in conjunction with photographs of Darié and Roberto Matta's dealer, taken by Tana de Gámez, during one of Matta's trips to Cuba. De Gámez cites it in her article, "The Position of the Artist in Cuba Today," *ARTnews* 63, no. 5 (September 1964): 61.

107. *Luis Martínez Pedro: Aguas territoriales, 9 al 28 de abril*, exh. cat. (Havana: Galería de La Habana, 1963).

108. James S. Olson and Judith E. Olson, *Cuban Americans: From Trauma to Triumph* (New York: Twayne, 1995), 59.

109. Sandú Darié, "4 dibujos de Luis Martínez Pedro," *Lunes de Revolución*, November 30, 1959, p. 8.

110. On the creative conjunctions of music and serialism in a different context, see Kermit Swiler Champa, *"Masterpiece" Studies: Manet,*

Zola, Van Gogh, & Monet (University Park: Pennsylvania State University Press, 1994). The musicality of *Aguas territoriales* has long been recognized. Cf. Manuel López Oliva, "Martínez Pedro, el dibujante," *Revolución y cultura* 8 (August 1989): 42.

111. Fernando G. Campoamor, "El mar cubano de Martínez Pedro," *Bohemia* 1972: 17; Loló de la Torriente, "Luis Martínez Pedro," *El Mundo* (Havana), April 1963; Lezama Lima, "Rayas y pez raya en el papel rayado de L. Martínez Pedro," *Luis Martínez Pedro: Aguas territoriales*, n.p.

112. H. H. Stuckenschmidt, *Carlos Fariñas: cincuenta aniversario, treinta años de vida artística* (Havana: Ministerio de Cultura, 1984).

113. Pedro de Oraá, quoted in Pino-Santos, "Vidal, Corratgé, Oraá," 29.

Chapter 6. The Endgame of Abstraction

1. Virgilio Piñera, "La inundación," *Ciclón* 4, no. 1 (January–March 1959), trans. Gingerich in "*Ciclón:* Post-avant-garde Cuba," 128–29.

2. Hugo Consuegra, quoted in Nicolás Quintana, "Parallel Lives: Personal Recollections of Hugo Consuegra," in Martínez Herryman and Valdés, eds., *Hugo Consuegra*, 139.

3. Ambrosio Fornet et al., in *El intelectual y la sociedad*, Colección Mínima No. 28 (Mexico City: Siglo Veintiuno, 1969), 48.

4. Ibid., 48.

5. Congreso Cultural de la Habana, "Responsabilidad del intelectual ante los problemas del mundo subdesarrollado," *Casa de las Américas* 47 (1968): 103, quoted and trans. in Jean Franco, "From Modernization to Resistance: Latin American Literature, 1959–1976," *Latin American Perspectives* 5, no. 1, special issue (Culture in the Age of Mass Media) (Winter 1978): 82. "The intellectual can serve the revolutionary struggle from different fronts: ideological, political, military. . . . The activity of the intellectual may follow different paths: he/she may provide the ideology of the revolutionary classes, may participate in the ideological struggle; may conquer nature on behalf of the people by means of science and technology or by creating and popularizing artistic and literary works, and where the occasion reasons, he or she may commit themselves directly in the armed struggle."

6. Piñera, "La inundación," 133.

7. Among the many histories of the Cuban Revolution, see Richard Gott, *Cuba: A New History* (New Haven: Yale University Press, 2004); Julia E. Sweig, *Inside the Cuban Revolution: Fidel Castro and the Urban Underground* (Cambridge, Mass.: Harvard University Press, 2002); and Hugh Thomas, *Cuba, or, The Pursuit of Freedom*, rev. ed. (New York: Da Capo, 1998).

8. The principal groups were the Movimiento Nacional Revolucionario (MNR), led by Rafael García Barcena; the Organización Auténtica (OA), the armed wing of the Auténticos founded by former president Prío Socarrás; and the armed offshoot of the Federation of University Students (FEU) in Havana, the Directorio Revolucionario Estudiantil (DRE), led by José Antonio Echeverría.

9. Mario Llerena, *The Unsuspected Revolution: The Birth and Rise of Castroism* (Ithaca, N.Y.: Cornell University Press, 1978), 38, quoted in Kapcia, *Island of Dreams*, 90.

10. See Thomas, *Cuba, or, The Pursuit of Freedom*, 942–1034.

11. Piñera, "La inundación," 134.

12. See Kapcia, *Island of Dreams*, 89–90.

13. Cintio Vitier, quoted in Pablo Armando Fernández, "A Refutation of Vitier," *Ciclón* 4, no. 1 (January–March 1959), trans. Gingerich in "*Ciclón:* Post-avant-garde Cuba," 137.

14. For a comprehensive history of *Ciclón*, including an index and retrospective commentaries by many of its contributors and contemporaries, see Roberto Pérez León, *Tiempo de Ciclón* (Havana: Ediciones Unión, 1995).

15. Virgilio Piñera, "Borrón y Cuenta Nueva," *Ciclón* 1, no. 1 (January 1955), trans. Gingerich in "*Ciclón:* Post-avant-garde Cuba," 85–86. "Reader, I give you *Ciclón*, the new journal. With it, we wipe the slate clean with one stroke. Erasing *Orígenes*, which, as everyone knows, is currently no more than dead weight after ten years of effective service to culture in Cuba. Let it be stated at the outset, then, that *Ciclón* wipes away *Orígenes* with one stroke. As far as the *Orígenes* group is concerned, we need not repeat, a long time has passed since it was eaten by its own father, just like the children of Saturn."

16. Piñera, "Cultura y moral," 101, 103–4.

17. José Rodríguez Feo, "La neutralidad de los escritores," *Ciclón* 4, no. 1 (January–March 1959), quoted in Pérez León, *Tiempo de Ciclón*, 30–31.

18. "Cuban Revolt Depicted in Paintings Shown Here," *Washington Post and Times Herald*, February 20, 1959.

19. Judith A. Weiss, *Casa de las Américas: An Intellectual Review in the Cuban Revolution* (Chapel Hill, N.C.: Estudios de Hispanófila, 1977), 39–40.

20. Rodríguez Feo, "La neutralidad de los escritores." "Hoy que volvemos a la luz, tenemos la obligación de enjuiciar a esos escritores que por inconciencia, o afán de lucro personal no vacilaron en poner sus talentos y sus plumas al servicio del máxime representante de la cultura bastistiana. Muchos de ellos se escudaron en la neutralidad de la cultura; otros estimaban que hacer acto de presencia en un organismo oficial de aquel gobierno no constituía una falta grave. Sin embargo, si los congresistas de la Oposición han sido depurados por prestarse a las farsas electorales de 1954 y 1958 y ocupar un escaño en el Congreso, ¿cómo eximir de culpa a los intelectuales que honraron con su colaboración escrita y oral los programas culturales del Gobierno de Batista? ¿No era una forma de apoyo incondicional el formar parte del organismo oficial de la cultura de Batista?"

21. Salah Dean Assaf Hassan, "Introduction: 'Origins' of Postmodern Cuba," *CR: The New Centennial Review* 2, no. 2 (Summer 2002): 11. He continues: "When read outside of the current Cuban context, it is somewhat difficult to perceive any explicit politics in *Orígenes* and *Ciclón*, which on the surface appear to be fairly conventional literary journals. But it is precisely because of their apparent insularity within the literary world of Cuba that their politicization—in the sense that they became sites of political controversy—is remarkable."

22. For an index to the journal, see Ernestina Grimardi, *Nuestro Tiempo, 1954–1959: Índice* (Havana: Ministerio de Cultura, Biblioteca José Martí, 1978). A selection of articles is published in Ricardo Hernández Otero, ed., *Revista Nuestro Tiempo: compilación de trabajos publicados* (Havana: Editorial Letras Cubanas, 1989). A second volume published further selections from the journal along with period and retrospective tributes; see Hernández Otero, ed., *Sociedad Cultural Nuestro Tiempo: resistencia y acción* (Havana: Editorial Letras Cubanas, 2002).

23. José Antonio González, "Apuntes para la historia de un cine sin historia," *Cine Cubano*, 86–88, quoted and trans. in Chanan, *Cuban Cinema*, 106. See also Harold Gramatges, "La música en defensa del hombre," *Revolución y Cultura* 52–54 (1976–77), quoted and trans. in Chanan, *Cuban Cinema*, 106.

24. Chanan, *Cuban Cinema*, 108.

25. "Restablecimiento de las garantías constitucionales," *Nuestro Tiempo* 5, no. 21 (January–February 1958): 11, in Hernández Otero, ed., *Sociedad Cultural Nuestro Tiempo*, 65. "Nuestras tareas se realizan dentro de la frontera de la cultura y el arte, mas éstas sólo pueden cumplirse—como cualquier actividad creadora—en el imperio absoluto, total, incondicional, excluyente, de las libertades."

26. See "Posición ante graves acontecimientos políticos nacionales," *Nuestro Tiempo* 4, no. 18 (July–August 1957), 19, reprinted in Hernández Otero, ed., *Sociedad Cultural Nuestro Tiempo*, 63–64.

27. "La cultura y la tiranía," *Nuestro Tiempo* 6, no. 27 (January–February 1959), 1, reprinted in Hernández Otero, ed., *Sociedad Cultural Nuestro Tiempo*, 67.

28. Ibid. "¿Cinco, diez, quince? Quizás no sea posible hacer un cálculo exacto de los años que fue retrocediendo el desarrollo de nuestra cultura por la tiranía. Porque nuestra cultura agonizó durante la tiranía."

29. Linda S. Howe, *Transgression and Conformity: Cuban Writers and Artists after the Revolution* (Madison: University of Wisconsin Press, 2004), 4. For a more comprehensive accounting of the cultural politics of the 1960s, with particular attention to the notorious Padilla affair of 1971, see Roger Alan Reed, "The Evolution of Cultural Policy in Cuba: From the Fall of Batista to the Padilla Case," Ph.D., Université de Genève, 1989.

30. David Kunzle, "Public Graphics in Cuba: A Very Cuban Form of Internationalist Art," *Latin American Perspectives* 2, no. 4 (1975): 90.

31. Suárez, *La Revolución en la pintura mural*; *Cuba construye* (Havana: Colegio de Arquitectos de Cuba, 1961).

32. Severo Sarduy, "Pintura y revolución," *Revolución*, January 31, 1959, p. 14.

33. Werner Haftman, "*Einführung: Malerei nach 1945*," in *II. documenta '59*, vol. 1, *Malerei* (Cologne: M. DuMont Schauberg, 1959), 17.

34. Sarduy, "Pintura y revolución," 14.

35. Ernesto Guevara, "Man and Socialism in Cuba," trans. in *¡Venceremos! The Speeches and Writings of Ernesto Che Guevara*, ed. John Gerassi (New York: Macmillan, 1968), 396. "But the realistic art of the nineteenth century is also class art, perhaps more purely capitalist than the decadent art of the twentieth century, where the anguish of alienated man shows through. In culture, capitalism has given all that it had to give and all that remains of it is the foretaste of a bad-smelling corpse; in art, its present decadence."

36. Ibid.; Fidel Castro, interview with Claude Julien, *Le Monde*, March 23, 1963, quoted in Thomas, *Cuba, or, The Pursuit of Freedom*, 1465. Cf. Nikita Khrushchev, quoted in Seymour Topping, "Khrushchev scolds abstract painters," *New York Times*, December 2, 1962. Khrushchev famously denounced one of the first exhibitions of abstract art held in the Soviet Union, admonishing the participating artists: "This must be pondered on by people who call themselves artists and create such pictures that you cannot tell if they have been painted by men or have been daubed by the tail of a donkey."

37. Official favor proved short-lived, however; his homoerotic drawings were censored, and he lost his faculty position at the National Art School. See Manuel Díaz Martínez, "Personajes de la revolución," *Artes Plásticas* 2, no. 1 (1961): n.p. "El caso de Servando Cabrera es ilustrativo a este respecto. Sin ir más lejos, cuando nos detuvimos frente a la tela que Servando Cabrera envió al Primer Salón Nacional de Pintura y Escultura, en 1959, sabíamos que él integraba todavía la fila de los artistas que no habían entrado en contacto con los cambios que se operaban en nuestra vida nacional. Esto, naturalmente, no era un fenómeno exclusivo de Servando Cabrera; respondía también a que la Revolución era aún demasiado joven para poseer la fuerza espiritual necesaria que removiera las antiguas estructuras mentales que padecíamos. . . . Pero, quizás entonces, ya Servando Cabrera, como

artista consciente de su momento histórico, que es el momento histórico de la colectividad en que vive, pensaba y repensaba acerca de su nueva orientación como artista."

38. Written works, Box 4, Folder 3, José Gómez Sicre Papers.

39. Law of March 24, 1959, which created ICAIC, as quoted in Kunzle, "Public Graphics in Cuba," 91.

40. Martínez, quoted in Goldman, "Painters into Poster Makers," 151.

41. On Cuba's anti-homosexuality campaign, which peaked in 1971, see Lillian Guerra, *Visions of Power in Cuba: Revolution, Redemption, and Resistance, 1959–1971* (Chapel Hill: University of North Carolina Press, 2012), 245–55.

42. Raúl Martínez, "Raúl Martínez' statement," *Cuba: Revolution et/and Culture* 7 (1965): 48.

43. Susan Sontag, "Notes on Camp," in *Against Interpretation, and Other Essays* (New York: Farrar, Straus and Giroux, 1966), 275, 277, 280.

44. Jorge Rigol, "Arístides Fernández y las brigadas de apreciación plástica," *Artes Plásticas* 3, no. 1 (1962): n.p. "La Escuela de Brigadistas para la Apreciación de las Artes Plásticas 'Arístides Fernández' tiene como principal objetivo poner en contacto a nuestro pueblo con la plástica nacional y universal de todas las épocas, capacitarlo para poder discernir esos valores permanentes, y estimular, al mismo tiempo, su potencia creadora. Para ello, tras un curso intensivo, cada brigadista será situado en cada uno de los municipios de la república. Equipado convenientemente con un proyector, laminarios y textos adecuados, residirá durante un año en el municipio a que se le destine, cuya zona recorrerá, trasladándose periódicamente de un lado a otro."

45. Consuegra, *Elapso tempore*, 246–47.

46. Roberto Gottardi, quoted in Loomis, *Revolution of Forms*, 15.

47. Consuegra, "La integración de las artes plásticas," 39. "Sin duda alguna la integración se producirá como una función social, como un arte plenamente socialista." The early Soviet example is an interesting comparison in many ways, particularly in the handling of collectivism, the avant-garde, and public artworks. Cf. T. J. Clark, "God is Not Cast Down," chap. 5 in *Farewell to an Idea: Episodes from a History of Modernism* (New Haven: Yale University Press, 2001).

48. Consuegra, "La integración de las artes plásticas," 38.

49. Ibid., 39.

50. Ibid., 38.

51. Cf. Ziarek, *The Force of Art*, 27. "Thus staying 'true' to the work of art is not limited to the event of the work itself but extends beyond it into the practice that 'preserves' the power-free disposition of relations in the social sphere."

52. Fidel Castro, quoted and trans. in Carlos Ripoll, *Harnessing the Intellectuals: Censoring Writers and Artists in Today's Cuba* (Washington, D.C.: Cuban American National Foundation, 1985), 14.

53. Humberto Medrano, quoted and trans. in Ripoll, *Harnessing the Intellectuals*, 15.

54. Ripoll, *Harnessing the Intellectuals*, 14–16 and passim.

55. Carlos Franquí, *Family Portrait with Fidel: A Memoir* (New York: Random House, 1984), 9. For a comprehensive history of *Lunes*, see William Luis, *Lunes de Revolución: literatura y cultura en los primeros años de la Revolución Cubana* (Madrid: Editorial Verbum, 2003).

56. *Lunes de Revolución*, March 23, 1959, p. 2, quoted and trans. in William Luis, "*Lunes de Revolución*: Literature and Culture in the First Years of the Cuban Revolution," in *Guillermo Cabrera Infante: Assays, Essays and Other Arts*, ed. Ardis L. Nelson (New York: Twayne, 1999), 18.

57. Franquí's wariness of the PSP dates to his decision to cut ties with the Party (and thus with Nuestro Tiempo, which he had helped to found) and to join Castro in the Sierra. He later remained suspicious of Party operatives, whom he viewed as usurpers of a Revolution that they had not worked to achieve. The considerable animosity between Franquí and Alfredo Guevara, the head of ICAIC who remained in the Party and worked in the llano, is related to this tension and also informs the rivalry between *Lunes* and ICAIC.

58. Heberto Padilla, *Lunes de Revolución*, December 7, 1959, p. 6, quoted and trans. in Luis, "*Lunes de Revolución*," 21.

59. *Lunes* was characterized by ample and high-quality illustrations. Of the third-generation vanguardia, contributors included: Cabrera Moreno, Consuegra, Corratgé, Darié, Díaz Peláez, Antonia Eiriz, Fernández, Jamís, Llinás, Martínez, Martínez Pedro, Mayito, Mijares, Oliva, de Oraá, Rosabal, Sánchez, Soldevilla, A. Vidal, and M. Vidal.

60. Luis, "*Lunes de Revolución*," 16–17.

61. Michèle Firk, "Naissance d'un cinéma," *Positif* 53 (June 1963): 15.

62. See Consuegra, *Elapso Tempore*, 268–69.

63. Fidel Castro, "Words to the Intellectuals," trans. in *Radical Perspectives in the Arts*, ed. Lee Baxandall (Harmondsworth, England: Penguin, 1972), 269, 272, 280. The July–August 2001 issue of *Gaceta de Cuba* featured a selection of articles that reexamined Castro's speech on its fortieth anniversary: Roberto Fernández Retamar, "Cuarenta años después"; Lisandro Otero, "Cuando se abrieron las ventanas a la imaginación"; Julio García Espinosa, "Memorias de desarrollo"; and Graziella Pogolotti, "Un debate en el torbellino de la historia." Franquí gives his account in *Family Portrait with Fidel*, 129–35.

64. José Antonio Portuondo, "Sobre la crítica y el acercamiento recíproco de los artistas y el pueblo," Report to the First National Congress of Writers and Artists, Havana, quoted and trans. in Howe, *Transgression and Conformity*, 19–20.

65. Cf. Consuegra, *Elapso Tempore*, 266. "'Los comunistas tienen todo el poder'—nos dijo Baragaño en un reunión que tuvimos, Guido, Tomás, él y yo. 'Acabo de estar en el periódico (Lunes de Revolución) y las órdenes que acaban de llegar del mismo Fidel Casto son esas.... El que no sea comunista está eliminado.... Todo el mundo tiene que definirse ahora.'"

66. Mariano Rodríguez, letter to José Mijares, September 16, 1964, Box 11, Folder 34, José Gómez Sicre Papers.

67. Howe, *Transgression and Conformity*, 37.

68. See, for example, Ambrosio Fornet and Luisa Campuzano, *La revista Casa de las Américas: un proyecto continental* (Havana: Centro de Investigación y Desarrollo de la Cultural Cubana Juan Marinello, 2001); Nadia Lie, *Transición y transacción: la revista cubana Casa de las Américas, 1960–1976* (Gaithersburg, Md.: Hispamérica, 1996); and Judith A. Weiss, *Casa de las Américas: An Intellectual Review in the Cuban Revolution* (Chapel Hill, N.C.: Estudios de Hispanófila, 1977).

69. Franco, *Decline and Fall of the Lettered City*, 45.

70. In 1968, Padilla's book of poetry *Fuera del juego* [Out of the Game] was awarded a national prize by UNEAC, inciting public outcry over its "counter-revolutionary" import. Padilla was placed under house arrest and forced to publicly confess to his "crimes" and to accuse other writers (among them, his wife) of harboring similar beliefs. Held at the headquarters of UNEAC, his trial marked a line in the sand for many Latin American and European intellectuals (notably, Borges, Fuentes, Sartre, and Sontag) who had previously supported the Cuban Revolution.

71. *Artes Plásticas* published four issues between 1960 and 1962 under the direction of Vicentina Antuña and Alejo Carpentier. Contributors included Fayad Jamís, Eva Frejaville, Severo Sarduy, Graziella Pogolotti, Manuel Díaz Martínez, and Mario García Joya (photography).

72. Vicentina Antuña, [Untitled statement], *Artes Plásticas* 1 (1960): n.p.

73. Antuña, *Salón Anual 1959, Año de la Liberación: Pintura, Escultura y Grabado*, exh. cat. (Havana: Dirección General de Cultura, 1959), n.p.

74. Artists from the third-generation vanguardia who exhibited included the following: onceños Antigua, Cabrera Moreno, Consuegra, Eiriz, Jamís, Llinás, Martínez; Oliva, Sánchez, A. Vidal, and M. Vidal; and concretos Álvarez, Corratgé, Darié, Menocal, Mijares, de Oraá, Rosabal, Soldevilla, and Soriano.

75. Pogolotti, "Salón 1959," *Nueva revista cubana* 1, no. 3 (October–December 1959): 206–7.

76. Ibid., 207.

77. Mirta Aguirre, "Pintura abstracta en el Salón Anual," *Hoy*, October 22, 1959, p. 2.

78. Díaz Martínez, "Salón Anual de Pintura, Escultura y Grabado," *Hoy Domingo*, October 18, 1959, pp. 4–5.

79. A version of the text first appeared in the journal *Mensajes* in April 1958; it was also included in Juan Marinello, *Meditación americana* (Buenos Aires, 1959). The edition cited from here is *Conversación con nuestros pintores abstractos* (Santiago, Cuba: Universidad de Oriente, 1961).

80. Luz Merino, in discussion with the author, January 23, 2009, Havana; Antonio Vidal, in discussion with the author, January 24, 2009, Havana.

81. Marinello, *Conversación con nuestros pintores abstractos*, 22.

82. Ibid., 73–74.

83. Ibid., 79.

84. Ibid., 105–6.

85. Ibid., 106–7.

86. *V Bienal do Museu de Arte Moderna de S. Paulo: Catálogo geral*, exh. cat. (São Paulo: Museu de Arte Moderna de São Paulo, 1959), 137–40.

87. For a diaristic account of the time in Paris and Madrid, see Consuegra, *Elapso tempore*, 208–45.

88. "Sexta Bienal, el esfuerzo de los cubanos," *O Estado de São Paulo* [Prensa Latina], October 22, 1961, quoted in Consuegra, *Elapso tempore*, 249.

89. Consuegra assisted with the installation of the Cuban delegation in São Paulo in both 1961 (with Tapia Ruano) and in 1963; for his account of the latter exhibition, see *Elapso tempore*, 288–301.

90. Guevara, "Socialism and Man in Cuba" (1965), in *Che Guevara Reader*, ed. David Deutschmann, 2nd ed. (Havana: Centro de Estudios Che Guevara, 2003), 224.

91. See Edmundo Desnoes, "El mundo sobre sus pies," in *Punto de vista* (Havana: Instituto del Libro, 1967), 99–108.

92. Fidel Castro, quoted in Eusebio Mujal-León, *The Cuban University under the Revolution* (Washington, D.C.: Cuban American National Foundation, 1988), 22.

93. Loomis, *Revolution of Forms*, 19–29, 31–6, 111–33.

94. Castro, quoted in Segre, Coyula, and Scarpaci, *Havana*, 206.

95. *Cuatro pintores y un escultor, abril 29 a mayo 10*, exh. brochure, Lyceum, Havana, 1959. The artists were the core "Cinco": Consuegra, Llinás, Martínez, Oliva, and Antonio Vidal.

96. José A. Baragaño, "Cinco artistas revolucionarios en el Lyceum," *Revolución*, May 12, 1959.

97. Consuegra, *Elapso Tempore*, 207.

98. Baragaño, "Cinco artistas revolucionarios en el Lyceum." "La militancia política de la poesía dentro de una línea de partido es la más vil de las cobardías."

99. Aleksandr Fursenko and Timothy J. Naftali, *One Hell of a Gamble: Krushchev, Castro, Kennedy, 1958–1964* (New York: W.W. Norton, 1997), 40–43.

100. See Consuegra, *Elapso Tempore*, 267, 286.

101. *8 pintores y escultores, diciembre 19 a enero 3*, exh. announcement, Palacio de Bellas Artes, Havana, 1961. See Consuegra, *Elapso Tempore*, 256.

102. *Expresionismo abstracto 1963, enero 11 al febrero 3*, exh. cat. (Havana: Galería de La Habana, 1963).

103. Consejo Nacional de Cultura, introduction to *Expresionismo abstracto 1963*, n.p.

104. Desnoes, "Expresionismo abstracto / 1963," in *Expresionismo abstracto 1963*, n.p.

105. Ibid.

106. Edmundo Desnoes, "1952–62 en la pintura cubana," in Oscar Hurtado and Edmundo Desnoes, eds., *Pintores cubanos* (Havana: Ediciones Revolución, 1962).

107. Consuegra, *Elapso Tempore*, 288.

108. Ibid.

109. Walter Benjamin, "On the Concept of History," in *Selected Writings, Volume 4: 1938–1940*, ed. Howard Eiland and Michael W. Jennings (Cambridge, Mass.: Harvard University Press, 2006), 392.

110. [*Hugo Consuegra*], December 29–January 31 (Havana: Galería Habana, 1964).

111. Consuegra, *Elapso tempore*, 321, 382.

112. Ziarek, *The Force of Art*, 22.

ILLUSTRATION CREDITS

The photographers and the sources of visual material other than the owners indicated in the captions are as follows. Every effort has been made to supply complete and correct credits; if there are errors or omissions, please contact Yale University Press so that corrections can be made in any subsequent edition.

Rare Book Division, Department of Rare Books and Special Collections, Princeton University Library, Photograph © Princeton University Library (fig. 3); The Wolfsonian-Florida International University, Miami Beach, Fla., The Vicki Gold Levi Collection, XC2002.11.4.26, Photograph © Lynton Gardiner (fig. 4); © Eduardo Luis Rodriguez, used by permission (figs. 6, 8); © 2015 Artists Rights Society (ARS), New York/CREAIMAGEN, Santiago de Chile, Photograph by Abigail McEwen (fig. 7); Courtesy Charles Deering McCormick Library of Special Collections, Northwestern University Library (fig. 9); Courtesy John Hay Library, Brown University Library (figs. 10, 12–14); Courtesy of the Estate of José Ygnacio Bermúdez (fig. 11); Digital Image © The Museum of Modern Art/Licensed by SCALA/ Art Resource, N.Y., Courtesy of THE AMELIA PELAEZ FOUNDATION (fig. 15); © 2015 Artists Rights Society (ARS), New York/CREAIMAGEN, Santiago de Chile, Photo © Christie's Images Limited 2015 (fig. 18); Courtesy of the artist's daughter, Patricia Riverón Lee, Photograph © Steven Brown (fig. 19); Courtesy of the heirs of Julio Girona (fig. 20); Courtesy J. Roberto Diago, Photograph © Gary Nader Art Centre (fig. 21); Courtesy Mariana Ravenet Ramírez, daughter of the artist and main executor of his works and archive (figs. 22, 35); Courtesy of the Estate of Roberto Estopiñán (fig. 23); Artists Rights Society (ARS), New York/ADAGP Paris, Photograph © Wifredo Lam Estate (fig. 24);

Courtesy Christoph Singler, Guido Llinás Estate (figs. 25, 71, 119); Courtesy OAS AMA | Art Museum of the Americas Archives (figs. 26, 30, 32, 33, 36, 38, 40, 42, 60, 62, 66, 67, 72, 80, 85, 88–91, 107); Courtesy of the Estate of Tomás Oliva, Photograph © Raúl Martínez (fig. 27); Courtesy Richard S. Frazer, Photograph © Mariano Costa Peuser (fig. 28); Courtesy Elena Cárdenas Malagodi (figs. 29, 50); Courtesy of the Cuban Heritage Collection, University of Miami Libraries, Coral Gables, Fla. (fig. 31); Courtesy Galerie Lelong, New York, Photograph © Zilia Sánchez (fig. 41); Courtesy Avery Architectural and Fine Arts Library, Columbia University (figs. 53, 54); Courtesy University of Kentucky Special Collections Research Center (figs. 55, 99); Artists Rights Society (ARS), New York/ADAGP Paris, Photograph © Estate of Jesse Fernandez (fig. 57); Courtesy of THE AMELIA PELAEZ FOUNDATION (fig. 58); Courtesy of The Agustín Fernández Foundation, Photograph © Eduardo Luis Rodríguez (fig. 59); Courtesy Corina Matamoros, Estate of Raúl Martínez (fig. 61); Courtesy Richard S. Frazer, Archives of American Art, Smithsonian Institution (fig. 63); Archives of American Art, Smithsonian Institution, Courtesy Corina Matamoros, Estate of Raúl Martínez (fig. 64); Courtesy of the Estate of José Ygnacio Bermúdez, Photograph © Jorge Palomino (fig. 65); Courtesy Rockefeller Archive Center (fig. 69); Courtesy of the Estate of Tomás Oliva (fig. 70); Photograph © Christie's Images Limited 2015 (fig. 73); © 2015 Artists Rights Society (ARS), New York/CREAIMAGEN, Santiago de Chile, Photograph (fig. 74); Courtesy of The Rafael Soriano Foundation (fig. 75); Courtesy of The Rafael Soriano Foundation, Photograph courtesy Tresart (fig. 76); Courtesy J. Roberto Diago, Photograph © Christie's Images Limited 2015 (fig. 77); Courtesy Columbus Memorial Library, Organization of American States

(fig. 79); Courtesy Jérôme Arcay, Photograph © Etienne Weill (fig. 81); Courtesy Martha Flora, Photograph courtesy Tresart (fig. 82); Courtesy Eusebio Sempere Family (fig. 83); © Carmen Herrera, Courtesy Lisson Gallery, Photograph © Ken Adlard (fig. 84); Courtesy of Arévalo Gallery (fig. 86); Courtesy Martha Flora (fig. 92); Courtesy Pedro de Oraá, Photograph courtesy Tresart (fig. 93); Courtesy of the Estate of Salvador Corratgé (fig. 94); Courtesy of Tresart (fig. 96); © Magnum Photos, Burt Glinn (fig. 97); Reproduced from the original held by the Department of Special Collections of the Hesburgh Libraries of the University of Notre Dame (fig. 98); Photograph © Fernando Fors (fig. 103); Courtesy Corina Matamoros, Estate of Raúl Martínez, Center for Southwest Research, University Libraries, University of New Mexico (fig. 104); Courtesy Hoover Institution Library & Archives, Stanford University (fig. 108); Photograph by Abigail McEwen (fig. 113); Courtesy of the Estate of Tomás Oliva, Photograph by Abigail McEwen (fig. 114); Photograph by Abigail McEwen (fig. 115); Lowe Art Museum, University of Miami, Fla., USA/Bridgeman Images (fig. 116); © Mario García Joya (fig. 117); Courtesy Manuel Gómez and Susana Barciela, Trustees of the Estate of Antonia Eiriz, Photograph © Jorge Palomino (fig. 118); Courtesy Richard S. Frazer, Photograph © Jorge Palomino (fig. 120).

INDEX